Da Vinci For Dummies

W9-CHD-484

Cheat Sheet

A Quick Timeline of Highlights in Leo's Life and Work

Leonardo's life was almost as interesting as the artwork and notebooks he left behind. The following chronology lists the highlights of his life and career. For a complete timeline, go to Appendix A.

April 15, 1452	Leonardo is born in Anchiano or Vinci, in Tuscany, Italy.
1469	Around this time, Leonardo starts his apprenticeship with Andrea del Verrocchio in Florence.
1472	Leonardo officially becomes an independent painter; he assists with Verrocchio's *Baptism of Christ.*
1473	Leonardo paints his earliest dated work, the *Landscape Drawing of the Arno Valley.*
1474	He paints *Portrait of Ginevra de' Benci.*
1480	Leonardo paints *Madonna Benois, Madonna with the Carnation,* and *St. Jerome* around this year.
1481	Leonardo fails to deliver *Adoration of the Magi* on time.
1482	Leonardo starts his military engineer career and moves to Milan to work for Duke Ludovico Sforza.
1483	The Church of San Francesco Grande in Milan commissions Leonardo to paint *Virgin of the Rocks.*
1490	Leonardo starts, but never completes, the equestrian statue of Francesco Sforza for Ludovico. He also begins *Madonna Litta.*
1495	Leonardo paints his greatest failure, *The Last Supper,* in Milan's Santa Maria delle Grazie.
1499	Leonardo begins *Burlington House Cartoon* and leaves Milan.
c. 1500-10	He paints *Madonna with the Yarnwinder.*
1502	He travels with Cesare Borgia as a military engineer throughout Central Italy.
1503	Leonardo starts his masterpiece, the *Mona Lisa.*
1508	He completes a second version of *Virgin of the Rocks.*
c. 1508-10	Leonardo returns to Florence and paints *The Virgin and Child With St. Anne.*
1513	He begins *St. John the Baptist.*
1516	Leonardo moves to the court of the French king, François I, to paint and work on his scientific studies.
May 2, 1519	Leonardo dies in France.

Leo's Trademark Style

Beyond the sheer beauty of his sketches and paintings, a few stylistic characteristics mark a Leonardo as a Leonardo (thank goodness, because he didn't sign many of his paintings). When you look at a Leonardo, pay attention to the following components:

- ✔ Balanced, pyramidal compositions
- ✔ Blurred, soft edges around figures
- ✔ Contrast of light and dark colors and shadows
- ✔ Mysterious inner expressions and smiles
- ✔ Innovative poses, from busts to racy three-quarter turns
- ✔ Anatomically correct figures, from head to toe
- ✔ Realistic plants and landscapes

A Traveler's Guide to Leo's Works

Leonardo's works are all over the place. If you find yourself out and about the world and want to drop in on a Leonardo or two, you can use this list of his works and their locations.

Name of Work	Museum	City
Adoration of the Magi	Uffizi Gallery	Florence, Italy
Annunciation	Louvre	Paris, France
Bacchus	Louvre	Paris
Baptism of Christ	Uffizi Gallery	Florence
Battle of Anghiari	Louvre	Paris
Burlington House Cartoon	National Gallery	London, England
Portrait of Ginevra de' Benci	National Gallery of Art	Washington, D.C.
La Belle Ferronière	Louvre	Paris
Lady with an Ermine (Cecilia Gallerani)	Czartoryski Museum	Cracow, Poland
Leda and the Swan	Uffizi Gallery	Florence
The Last Supper	Convent of Santa Maria delle Grazie	Milan, Italy
Madonna Benois	The Hermitage	St. Petersburg, Russia
Madonna Litta	The Hermitage	St. Petersburg
Madonna with the Carnation	Alte Pinakothek	Munich, Germany
Madonna with the Yarnwinder	Private collection	Drumlanrig, Scotland
Mona Lisa	Louvre	Paris
Portrait of Isabella d'Este	Louvre	Paris
Portrait of a Musician	Biblioteca Ambrosiana	Milan
Salvator Mundi	Private collection	Paris
St. John the Baptist	Louvre	Paris
The Virgin and Child With St. Anne	Louvre	Paris
Virgin of the Rocks, first version	Louvre	Paris
Virgin of the Rocks, second version	National Gallery	London

Copyright © 2005 Wiley Publishing, Inc. All rights reserved.

Item 7837-5.

For more information about Wiley Publishing, call 1-800-762-2974.

Da Vinci FOR DUMMIES®

by Jessica Teisch, PhD, with Tracy Barr

WILEY

Wiley Publishing, Inc.

Da Vinci For Dummies®

Published by
Wiley Publishing, Inc.
111 River St.
Hoboken, NJ 07030-5774
www.wiley.com

WILEY

About the Authors

Jessica Teisch, PhD (Berkeley, CA), is Managing Editor of *Bookmarks* magazine and has written hundreds of profiles and book reviews for this award-winning publication. She has also written books and articles on subjects ranging from literature to technological, environmental, intellectual, and cultural history.

Tracy Barr has been a part of the *For Dummies* phenomenon for almost a decade. In that time, she has served as editor, editorial manager, writer, and consultant to folks who write and edit *For Dummies* books. Most recently, she helped write *World War II For Dummies* with Keith D. Dickson and *Religion For Dummies* with Rabbi Mark Gellman and Monsignor Thomas Hartman. She also is the author of *Yorkshire Terriers For Dummies* and coauthor of *Latin For Dummies* and *Adoption For Dummies*.

Author Dedication

This book is dedicated to Joel and Fran Teisch.

Author Acknowledgments

Many thanks to Wiley editors Stacy Kennedy and Alissa Schwipps, without whom this project could not have taken place. Special thanks to Tracy Barr for her expertise in all areas. My great appreciation also goes to Rafael Escandon, Jonathan Graf, Natasha Graf, Jeff Maltz, Allison Nelson, Jon Phillips, Abigail Teisch, Rachel Teisch, and Liza Wallach for their encouragement.

Publisher's Acknowledgments

We're proud of this book; please send us your comments through our Dummies online registration form located at www.dummies.com/register/.

Some of the people who helped bring this book to market include the following:

Acquisitions, Editorial, and Media Development

Senior Project Editor: Alissa Schwipps

Acquisitions Editor: Stacy Kennedy

Copy Editor: Kristin DeMint

Technical Editor: Professor William Greiner

Senior Permissions Editor: Carmen Krikorian

Editorial Manager: Jennifer Ehrlich

Editorial Assistants: Hanna Scott, Nadine Bell

Cover Photos: © WidStock/Alamy

Cartoons: Rich Tennant (www.the5thwave.com)

Composition Services

Project Coordinator: Adrienne Martinez

Layout and Graphics: Andrea Dahl, Kelly Emkow, Lauren Goddard, Joyce Haughey, Barry Offringa, Melanee Prendergast, Jacque Roth, Heather Ryan, Erin Zeltner

Proofreaders: Laura Albert, Leeann Harney, Jessica Kramer, Carl William Pierce, TECHBOOKS Production Services

Indexer: TECHBOOKS Production Services

Publishing and Editorial for Consumer Dummies

 Diane Graves Steele, Vice President and Publisher, Consumer Dummies

 Joyce Pepple, Acquisitions Director, Consumer Dummies

 Kristin A. Cocks, Product Development Director, Consumer Dummies

 Michael Spring, Vice President and Publisher, Travel

 Kelly Regan, Editorial Director, Travel

Publishing for Technology Dummies

 Andy Cummings, Vice President and Publisher, Dummies Technology/General User

Composition Services

 Gerry Fahey, Vice President of Production Services

 Debbie Stailey, Director of Composition Services

Contents at a Glance

Table of Contents

Part II: Building on What Others Knew: Leonardo's Scientific Mind ..101

Chapter 5: The Art of the Human Body103

Chapter 6: An Inquiring Mind: Leonardo and the Natural World127

Introduction

What with Dan Brown's bestselling *The Da Vinci Code* and the block-buster movie based on the novel, Leonardo da Vinci is the hot ticket today. Hankering to get the real scoop on the man you've heard so much about?

Leonardo *was* the quintessential Renaissance man, a fitting symbol of Italy's 15th-century rebirth of art, culture, and scientific thought. He tested his skill in painting, architecture, mathematics, engineering, astronomy, military machinery, flight, optics, geology, botany, hydrodynamics, anatomy, and city planning. That plethora alone lifted him head and shoulders above his peers. But Leonardo was no mere dilettante. You name it; he mastered it. In experimenting with everything around him and combining great bodies of knowledge into one larger, unified whole, he earned the reputation of being one of humankind's first modern minds.

Yet, for all his brilliance, Leonardo was such a perfectionist that he rarely managed to finish projects, from paintings to scientific treatises. Nor did he actually construct most of his inventions, like the helicopter or car. And though he left thousands of pages of musings and sketches, his notebooks weren't rediscovered until a few centuries after his death. Leonardo's reputation thus overshadowed his small *oeuvre* — and history marched on without his contributions.

Why this happened, and how Leonardo harnessed his genius, satisfied his endless curiosity, and mastered each subject, makes for a great story with modern-day relevance.

About This Book

This book covers various aspects of Leonardo's life, from his childhood, inspirations, and masterpiece paintings to his revered (and sometimes mocked) place in popular culture today. You don't need advanced degrees in, say, Renaissance studies, art history, or astronomy to understand the contributions that Leonardo made to these fields. I present the whole deal in an easy-to-understand way, for artists and nonartists, scientists and nonscientists, alike.

You can also use this book as a reference. Although it's helpful to read some of the background material in Chapters 2 and 3 before you delve into some of the specifics of Leonardo's accomplishments, you can jump around as you please, heading straight to the subject that most interests you. The table of contents at the front of the book and the index at the rear help guide your way.

Conventions Used in This Book

Make sure you get one thing straight right off the bat: The main man's name is *Leonardo,* not *da Vinci.* (The title of this book caters to the popular perception of him as *da Vinci.*) Leonardo likely hailed from the town of Vinci, so calling him *da Vinci* is like calling you "from Jonestown."

Many times, Leonardo said things so perfectly that I don't want to rain on his parade. So I include some quotes from his notebooks here and there throughout the book to bring you up close and personal with the man himself. To keep these morsels short and sweet, I left the citation info out of the chapters. But rest assured that what you see is legit — you can check them all out for yourself in *The Notebooks of Leonardo da Vinci,* edited by Edward MacCurdy and published by Reynal & Hitchcock, 1938. (And in case you're wondering, that book is a compilation of all the different notebooks that you can read about in Chapter 16.)

I also use certain conventions throughout the book that refer to time periods. *BC* is the same as *BCE* (or *Before the Common Era*), and *AD* (*Anno Domini,* or "In the Year of Our Lord") is the same as *CE* (or *Common Era*). The *quattrocento* refers to 15th-century Italy (the early 1400s), the start of the Renaissance. And the *High Renaissance* indicates the artistic style developed at the end of the 1400s and extending through the early 1500s.

A note about spellings and dates: You'll find a lot of Latin or Italian words in this book. Don't worry if you don't know these languages; everything's translated as necessary. But some spellings have changed or have been spelled differently over time, particularly the names of Renaissance painters, philosophers, and scientists. Other people have more than one name (Sandro Botticelli was also Alessandro di Mariano Filipepi!). Also, because sometimes an event, publication, or person's date of birth or death wasn't recorded until after the fact, the dates you see here may differ slightly from the dates you see in other books. So although you may find discrepancies from book to book, in this book, I make matters simple:

- ✔ I spell names the same way throughout.

- ✔ I use the name by which the folks are most commonly known. Michelangelo is Michelangelo, not Buonarrti, and Raffaello Sanzio is simply Raphael.

Finally, I use the following conventions throughout the text to make things consistent and easy to understand:

- ✔ All Web addresses appear in `monofont`.
- ✔ New terms appear in *italic* and are closely followed by an easy-to-understand definition.
- ✔ **Bold** is used to highlight the action parts of numbered steps.

What You're Not to Read

I've written this book so you can find information quickly and easily; when in doubt, check out the table of contents or index. But I've also included extra information that you can skip over and still get the nuts and bolts of Leo's story. This information includes

- ✔ **Text in sidebars:** Although interesting, sidebars aren't necessary to your understanding of the subject at hand. They're okay to skip — you won't miss anything you absolutely *need* to know.
- ✔ **Any text with a Technical Stuff icon:** You should also feel free to pass over anything with this icon, which marks technical, oftentimes scientific, information.

Foolish Assumptions

Every book has a specific audience in mind. In writing this book, I made some assumptions about the reader (yes, you):

- ✔ You've heard about how great Leonardo da Vinci was, but you still call him da Vinci.
- ✔ You want to know more basic information about Leonardo, but don't necessarily want to addle your brain with an academic treatise.
- ✔ You've seen Leonardo all over the place — in books, movies, and the news — and want to know if he's all that he's cracked up to be.
- ✔ You've read *The Da Vinci Code* by Dan Brown and want some answers about Leonardo, secret societies, and Renaissance art in general.
- ✔ You heard that Leonardo invented the helicopter, the bicycle, and the telescope, to name a few, and you're scratching your head wondering whether one man possibly could've invented *all* of these things. It's time for some answers.
- ✔ Finally, you want to know why Leonardo is important to people today and how he relates to *your* life.

How This Book Is Organized

Condensing one man's large life into one book is no small task. This book is divided into six parts so you can easily find the information you want. Each part contains chapters relating to a particular topic about Leonardo, and a section at the end of each chapter relates Leonardo's contributions to your world, your way of thinking today. When in doubt, return to the table of contents or index.

Part I: The Mind of the Renaissance

You've heard of the Renaissance, for sure. You can even mention some key terms: *Mona Lisa,* Medici dynasty, Florence, humanism, patronage. But what was the Renaissance really about? This part deals with the fundamentals of Renaissance history and thought. It offers a brief history of Renaissance Italy, including the Catholic Church, art patronage, and the Italian Wars. Then I delve into the major events and artistic and scientific influences in Leonardo's life. For an overview of Leo's life, Chapter 3 is the best place to start.

Part II: Building on What Others Knew: Leonardo's Scientific Mind

Part II explores Leonardo as a Renaissance scientist. He asked lots of questions about the natural world — and wanted some answers. These chapters cover Leonardo's scientific ideas, explorations, and experiments, from botany to geology to anatomy. Sure, he built on what others already knew — but as you'll see, his scientific method and ceaseless curiosity led him far beyond the traditional Renaissance mind and into a modern mode of thinking.

Part III: Reinventing the Wheel: New Machines for a New World

Imagining life without the spit roaster or air conditioning is tough, isn't it? This part explores Leonardo's contributions to mechanics and modern technology, from the helicopter to military weapons. In all his inventions, Leonardo made some logical (and some not-so-logical) assumptions about human and mechanical power and tested out how different pieces of technology fit together. As you'll see, some of his ideas were truly ahead of his time. Others were left in the dustbins of history.

Part IV: The Divinity of the Painter and Architect

Despite his artistic genius, Leonardo didn't work in a historical vacuum. He drew inspiration from other Florentine artists to develop a uniquely "High Renaissance" style and technique. This part explores some of Leonardo's more influential predecessors and colleagues and shows where Leonardo diverged from the tried-and-true and evolved his trademark style to create masterpieces like the *Mona Lisa.* This part also touches on a less-studied aspect of Leonardo's career: his role as an architect and city planner.

Part V: Leonardo, His Religious Artwork, and The Da Vinci Code

If you've seen the Renaissance's most famous wannabe fresco, *The Last Supper,* or read *The Da Vinci Code,* it's time to rethink your assumptions. One chapter provides information on Leonardo's views of religion and how he combined religious allegories and symbols into his paintings. Another examines *The Last Supper* — its historical context and the controversies it has generated. The last chapter in this part tries to answer any lingering questions you have about claims made about Leonardo, his art, and his times in *The Da Vinci Code.*

Part VI: The Part of Tens

Every *For Dummies* book contains a Part of Tens. Here, you'll find some easy-to-reference information about Leonardo's notebooks, his best-known paintings and their locations, and more.

Appendixes

One last thing: If you want to check a date or historical event, Appendix A provides a chronology of major events in Renaissance history and Leonardo's life. Appendix B offers a list of book and Web resources on Leonardo — where to go if you want to find out more about a particular aspect of his life.

Icons Used in This Book

This book uses different icons to point out different kinds of information:

You'll see this icon anywhere there's a strong connection between Leonardo and today's culture.

I use this icon to point out information you'll want to — remember? Was that it?

This icon alerts you to interesting, but not necessary, information, like historical background, scientific information, or scholarly opinions. It's okay to skip this stuff if you're so inclined.

Where to Go from Here

Because this book as a whole isn't chronological, you can skip around as much as you want — it'll still make sense if you start in the middle. If you want to discover more about Leonardo's anatomical studies, go to Chapter 5. Or, if you're more interested in his faux fresco, *The Last Supper,* you may want to go directly to Chapter 14.

However, if you want the context in which to place Leonardo's scientific, mechanical, or artistic triumphs, it's best to start at the beginning, with Part I. This part gives you a broad understanding of Leonardo's life, inspirations, and influences and shows how the whole shebang fits into a larger Renaissance history.

Part I
The Mind of the Renaissance

The 5th Wave By Rich Tennant

RENAISSANCE BABY

"He won't let me change his diapers until he analyzes the contents, notes its properties, and then creates a fresco out of it."

In this part . . .

What the heck was life like in Renaissance Italy, anyway? How did Leonardo shape it, and how, in turn, did the Renaissance influence his scientific and artistic ideas, methods, and inventions? Besides impressing people with your knowledge about some key events in Renaissance history, in this part, you find out how Leonardo fit into his era and why people today think of him as the quintessential Renaissance guy.

Chapter 1

Leonardo: The Big Picture

Leonardo da Vinci (1452–1519) enjoys mythical status as the genius of all geniuses, yet people know precious little about him. He was handsome, charming, and kind. He saw patterns in nature and revered all forms of life. He believed in the power of human endeavor and thought that people in his lifetime might fly as high as the heavens, if they so chose.

Despite his faith in people and progress, Leonardo questioned everything around him, from religion to standards of beauty. He distrusted human nature, expected the worst from friend and foe, and fell headlong into existential despair on a few occasions. Though well liked and recognized as the genius that he was, he remained generally aloof to the world around him.

To deepen the paradox, Leonardo possessed unsurpassed artistic skill, but left fewer than two-dozen paintings, half of them unfinished. Artistic patrons from dukes, popes, and kings to murderous despots wooed him into their courts, yet he never found lasting security with them. His insatiable curiosity led him to constantly observe, experiment, theorize, and invent. He made immense strides in many fields: art, anatomy, engineering, geology, and physics. Yet, his scientific studies had relatively little impact during his lifetime.

In short, Leonardo is a study in opposites.

For all his genius, Leonardo was, in many ways, a tragic figure. Like so many 20th-century creative geniuses, from John Nash to Sylvia Plath, his life was filled with great contradiction. Unlike Nash or Plath, he attempted so much in so many areas. But he left his notebooks a mess and never published the treatises that could've modernized science during his lifetime.

Still, during his time, people revered Leonardo as the embodiment of Renaissance ideals. If a few scholars today call him a failure for his almost absent-minded, dilettante behavior, you can still call him a peerless genius,

both of and ahead of his time. In this chapter, I give you a taste of all the reasons why. If you find yourself hungry for more at the end of the chapter, you have this whole book to satisfy your cravings.

Knock, Knock. Who's There? Leonardo . . .

No doubt about it — Leonardo was a genius. If you give only superficial consideration to his paintings and ignore all his other bodies of work, you have to credit him with redefining the artistic standards and techniques of the Renaissance and producing works with unparalleled beauty and composition (an amazing feat considering that he didn't even finish many of them!). Look a little closer, and you can see evidence of the talent that gave viewers, for the first time in history, a glimpse into the personality or soul of the person being painted.

Ignore the paintings (the things for which he's probably best known) and focus solely on his mechanical drawings, and you can't help but be astounded at the prescient inventions and mechanical gadgets from a man who lived in a time of superstition and religious zeal. Focus on his civil engineering projects, and you can see at work the mind of a man who believed that nature itself could be redirected to benefit humankind. Throw out his contributions in the fields of art and civil and military engineering so that you can devote all your attention to his anatomical studies, and you notice an advanced understanding of the systems in the body and a (usually) correct representation of how they work.

What makes Leonardo so astounding, and what separates him from the other greats of his time, is that his genius wasn't limited to one field. True, he was an artist without parallel, but he was also an inventor, an anatomist, a mathematician, an engineer, a musician, a mapmaker, and — if you consider that he sought to understand the underlying causes and principles of reality — a philosopher.

From humble beginnings

For a man who attained such fame, hobnobbed with dukes, popes, and kings, and whose name today is synonymous with unrivaled genius and accomplishment, Leonardo's birth was inauspicious, to say the least. No stars aligned in the heavens, and people probably didn't make much fanfare when an unmarried peasant girl (probably named Caterina, who's mentioned in his notebooks) gave birth to her illegitimate son.

Leonardo, most likely born in Anchiano, Italy, spent his childhood in Vinci, a small town west of Florence. When Leonardo was a teenager, his biological father arranged for him to apprentice with the Florentine painter and sculptor Andrea del Verrocchio, known as "True Eye" for his artistic talent. (Chapter 4 discusses the apprenticeship system in greater detail; for the details on Leonardo's life, go to Chapter 3.)

Leonardo spent about six years apprenticing with Verrocchio. While there, he drew the attention of Verrocchio's prime patron, Lorenzo de' Medici (Lorenzo the Magnificent; you can read more about the Medici rulers in Chapter 2). This valuable contact put Leonardo in touch with the movers of the Florentine Renaissance, VIP philosophers, mathematicians, and artists that greatly influenced his intellectual development.

But alas, Leonardo's time in Florence eventually came to an end, and in 1482 he sent a cover letter and résumé of sorts to Ludovico Sforza, duke of Milan. Sforza needed someone to design weapons, not paint pretty portraits. (During the Renaissance, war was the most important of all the arts; for details on how the Italian Wars influenced Leonardo's career path, head to Chapter 2.) So Leonardo reinvented himself as a military engineer. He found Sforza's court more to his liking than the Medicean court and gathered around him a brilliant set of astrologers, musicians, mathematicians, and scientists. But in 1499, the French drove Sforza into exile, and Leonardo was left without a patron and had to move on again.

He spent a brief time in Venice, which was at war with the Turks, but returned to Florence around 1500, after an absence of nearly 20 years. He left Florence in 1502 to take up an appointment as chief engineer to the bloodthirsty commander of the papal armies, Cesare Borgia. They traipsed around Italy while Leonardo produced defense maps and designed military machines.

When Borgia met his downfall, Leonardo returned to Florence. But in 1506, Milan came a-calling again, and back he went. Ludovico was gone, replaced by the French, and Leo stayed in Milan until Ludovico's son, Maximilian, came and kicked out the French. Leonardo, by then 60, fled to Rome, where he sought the patronage of Giuliano de' Medici, son of Lorenzo the Magnificent and brother of Giovanni, the new Medicean pope also known as Leo X. But Michelangelo and Raphael, both younger competitors, had beaten the aging Leonardo to the Vatican, and he found no permanent home there.

When Giuliano died, Leonardo and his small entourage of students and servants traveled to the Loire Valley, where François I, the baby-faced king of France, had invited them to reside. François I was Leonardo's last patron, and perhaps the only one among Leonardo's many fans who fully appreciated the singular nature of his genius. Although a stroke rendered Leonardo unable to paint, he designed a mechanical lion, decorated the court, and spent hours philosophizing with the king. He died on May 2, 1519.

Jack-of-all-trades

The saying goes, "He was a jack-of-all-trades, master of none." Well, the remarkable thing about Leonardo was that he wasn't just a master of one trade, but of many. Although he probably never left the European continent, Leonardo's career was extraordinarily diverse and included some pretty different occupations — painter and portraitist, anatomist, civil and military engineer, botanist, and mapmaker, to name a few.

Artist

Throughout his career and in every court save the last one (when a stroke left him unable to paint), Leonardo created or worked on the pieces for which he is best known. His works include religious paintings, such as *Virgin of the Rocks, The Virgin and Child with St. Anne, Adoration of the Magi, St. John the Baptist,* and the unparalleled *The Last Supper,* along with portraits, including everyone's favorite girl, *Mona Lisa,* and others, like *Ginevra de' Benci.* The fact that some of his paintings are only half-finished or that one, *The Last Supper,* started to deteriorate as soon as it was finished, is irrelevant; they're still superior to those rendered by his colleagues around the same time. Chapters 11, 13, and 14 offer more details on these paintings' unique subjects and styles.

Although Leonardo's paintings were few and far between, he left abundant and magnificent drawings. Many served as understudies for his paintings. These sketches include human poses, plants and flowers, horses and other animals, human anatomy, water, and machines. Many of his drawings, especially his anatomical ones (as you see in Chapter 5), were ahead of his time. In others, including his car, scuba gear, and military weapons (discussed in Chapters 7, 8, and 9), Leonardo put together old parts in new ways.

Unfortunately, Leonardo left no pieces of sculpture that historians can definitely attribute to him (save for designs for some equestrian monuments and tombs), even though he mastered this craft, as well, in Verrocchio's studio.

Military and civil engineer

Leonardo first sold himself to the Milanese duke Ludovico Sforza as a military engineer and thereafter dabbled in the design and creation of defense tools and weapons of war. He applied mechanics and physics to the study of war machines. Though the militia used few (if none) during his lifetime, many, such as the submarine and armored tank, were deployed hundreds of years later.

Closely, but not solely, tied to his military designs, Leonardo often contemplated how natural forces and structures could be altered to suit human purposes. One of his most ambitious plans was the rerouting of the Arno River. Although it ostensibly served a military purpose (to reduce the risk of an invasion of Florence from rival city-state Pisa), it promised a more navigable

river, a reduced risk of flood, and more reliable irrigation of the surrounding farmland.

Leonardo took on smaller, more pedestrian public works projects as well, such as maintaining and expanding Lombardy's canal system. To find out more about Leonardo's stint as a military engineer and his water projects, march to Chapter 8.

Scientist

There are few areas of Renaissance science that Leonardo didn't engage in. Anatomy, astronomy, botany, geology, paleontology — you name it — Leonardo probably had a few thoughts and a number of sketches about the subject.

Through observation and experimentation, Leonardo was able to uncover — if not always accurately understand — the workings of natural systems. His anatomical drawings, based primarily on his own observations of dissected cadavers, were far superior to anything else produced at the time, and in fact are still a model for modern anatomical drawings. His ideas about the stars and heavens prefigured later great thinkers, like Copernicus and Galileo. And his studies of fossils and the resulting theories (for example, that fossils are actually the remains of once-living creatures rather than the skeletal remains of God's mistakes — a common theory of the time) foreshadowed later observations from the likes of Charles Darwin and others.

Had Leonardo organized and published his papers on these myriad subjects, he would've greatly influenced Renaissance science and beyond. As it was, his musings remained in the dark until centuries later, and the fields advanced without him. You can read more about Leonardo's world-class scientific thinking in Chapters 5 and 6.

Mechanical engineer and inventor

Leonardo sketched a flying machine, helicopter, parachute, three-speed gear shift, snorkel, hydraulic jack, the world's first revolving stage, canal locks, olive press, water-powered alarm clock, a crane for clearing ditches, and thousands of other designs. Oh, and a robot, too, though he most likely did *not* invent the bicycle.

Although some of his designs were entirely unique for the time, others made use of common tools or principles in a new way, which was, in itself, revolutionary. Leonardo's inventions, most undiscovered during his lifetime, foreshadowed principles and designs of the Industrial Revolution. Chapters 7 and 9 examine his inventions and machines.

Architect and city planner

Though we don't view him as primarily an architect, Leonardo mastered this field. He focused on general principles of designs and consulted on some cathedrals in Milan and Pavia. He also designed defense fortifications and

palaces for kings. He even created the ideal city — an innovative city plan for Milan, discussed in Chapter 12 — which was never built, but utopian in principle.

To find out more about his architectural plans, head to Chapter 12.

Philosopher and thinker

Despite the myriad subjects he studied, all Leonardo's endeavors were connected by his never-ending quest to discover and understand the underlying principle, or design, of the universe. Leonardo, who himself may have been a *synasthete* (one who experiences a concurrent sensory perception other than the one being stimulated; for example, literally seeing musical sounds as a symphony of colorful images), observed an integrated, universal design in unrelated objects and natural phenomena.

He saw the world as interconnected, with things at the micro level mirroring designs at the macro level (for example, human arms and legs functioning sort of like tree branches do). For some reason, Leonardo abandoned this micro-macro analogy late in life, as he delved further into his scientific studies and realized that the universe held greater mysteries than he originally thought. But if he eventually found these analogies inadequate, another concept guided his thinking: the importance of human perception, sight in particular. He studied everything relating to optics, in the belief that people, by using their own little eyes, hands, ears, and whatever other body part, could ferret out the universe's secrets. Human perception and experience, then, rather than religious teaching, mysticism, superstition, alchemy, or even Aristotelian logic, provided the real core of understanding of the universe.

Inspiring Leonardo's genius

If historians knew exactly what made Leonardo tick, they'd have copyrighted the formula years ago. Many factors contributed to his genius. Most of all, he seems to have possessed certain qualities that thrived in Renaissance Italy.

Creating the man, the myth, the legend

In *How to Think Like Leonardo da Vinci: Seven Steps to Genius Every Day* (Delacorte, 1998), author Michael J. Gelb dissects Leonardo's genius to show how others can cultivate the qualities that lifted this man head and shoulders above his peers. Whether or not you succeed, the idea is helpful because it catalogues the characteristics Leonardo possessed:

> ✔ **An insatiable curiosity and quest for knowledge:** Leonardo's passion differed from others around him. As Daniel Boorstin described Leonardo's genius in *The Creators,* Leonardo, unlike Florentine poet Dante Alighieri (1265–1331), who was inspired by his idealized love for a woman named Beatrice, didn't love women. Nor did he exhibit the same civic loyalty as

the Florentine fresco painter Giotto di Bondone (1266–1337) or architect and goldsmith Filippo Brunelleschi (1377–1446). Leonardo's commissions from the warring Medici, Sforzas, Borgia, and French kings showed him to be quite fickle, nationalistically speaking. Nor did Leonardo funnel all his energy into the church, like his notorious competitor, Michelangelo. Instead, he searched for beauty and truth in life, from the human body to mathematical perspective. This quest for truth freed him from medieval scientific convention, though in some instances he unthinkingly accepted the statements of ancient and medieval thinkers. Overall, his endless search led him to develop a rudimentary version of the modern scientific method, as shown in Chapters 5 and 6.

✔ **Questioning and repeated testing of conventional knowledge through experience:** Leonardo repeatedly tested, then corrected, his vast body of knowledge. Such testing started in Verrocchio's studio, which emphasized experience (like preparing canvases or casting bronze) over art theory. Leonardo's desire to test accepted theories went far beyond the studio, for example, to the relationship of fossils to the Bible's Great Flood story. With constant testing, he developed new ideas and theories (and, of course, recognized his mistakes, from his disastrous *Last Supper* to his heavier-than-air flying machines). He wasn't always right, but who is?

✔ **Using and sharpening the senses to learn from experience:** Leonardo believed that firsthand experience unlocks the key to nature's secrets. (This point is where he diverged from the humanists, who generally believed that knowledge derives from reason and logic.) He thought that human perception, especially vision, allows people to design principles explaining perspective in art, for example, or the placement of the stars. Sight, compounded with the other senses (Leonardo was an excellent musician), dictates experience.

✔ **The willingness to deal with ambiguity and uncertainty:** Leonardo, a paradox himself, embraced incongruities. He searched for beauty, but painted grotesque caricatures. He loved riddles and puzzles, yet learned math on an abacus. As he researched the universe, he discovered some unifying principles — and put a big question mark over others. Leonardo embraced this ambiguity in his artwork. His use of *sfumato* ("going up in smoke") creates the hazy, mysterious characteristic of his painting style, and the famous questioning, pointing gesture in *St. John the Baptist,* shown in Chapter 13, perfectly reflects Leonardo's approach to the world.

✔ **Whole-brain thinking:** No doubt, Leonardo was both a right- and left-brain thinker, artistic *and* logical. In fact, scholars beg people not to understand Leonardo's artistic and scientific studies separately, as each informed the other. His anatomical drawings are logically rendered *and* beautiful. And he applied mathematical principles, such as perspective and pyramidal compositions, to his paintings.

✔ **Grace and poise, with a balance of mind and body:** Leonardo was beautiful — really. He had a full head of hair, an impressive physique, a sweet-as-honey singing voice, athletic prowess, moral vigor, and

Mensa-quality intelligence. Leonardo even devised certain rules for living, which included monitoring his moods, exercising, eating well (in accordance with his respect for all life, he was a vegetarian), and not visiting the doctor *too* often. Sound like anyone you know?

✔ **Recognizing how the small and large things in life all interconnect in one unified system:** For most of his life, Leonardo developed theories about the micro- and macrocosmos. He compared the circulation of the Earth, for example, to the circulation of the human body; both living systems seemed to operate according to similar rules. He saw patterns in everything (correctly or not); swirling waters resembled the Star of Bethlehem's curly petals and a woman's braided hair.

Living with history

As Karl Marx once wrote about the French Revolution and its aftermath, men make their history, but not as they please. Instead, they work with traditions handed down from the past. Let's face it: History never disappears, does it?

Leonardo was the quintessential Renaissance man. As most scholars would have it, he was the ultimate man, too, a Superman hero. But had he not lived during a specific junction in history, when firsthand experience, knowledge, and logic were beginning to replace the superstition of medieval times (and when people revived the Greek concept of the globe and then sailed around it), who knows what course his genius may have taken?

Chapter 2 discusses the culture and economics of the Renaissance in greater detail, but it's worth noting here that many factors cloaked Leonardo in a culture that embraced (for the most part, anyway) his creative genius:

✔ The Black Plague broke down traditional patterns of wealth, opening the door for self-made aristocrats (like Milan's Sforzas, for example) to emerge. These men (and a few women), in turn, became great patrons of the arts.

✔ When Leonardo was born, artists were small craftsmen; by the time he died, the great ones had become superstars.

✔ Technical innovations facilitated the spread of new knowledge. The printing press, large sailing ship, astrolabe, and discovery of the New World spurred new scientific knowledge and international trade.

✔ An emerging worldview privileged human power and rationality over superstition and all-encompassing religion.

✔ The ideals of classical antiquity, combined with humanism, created a new culture of innovation, particularly in Florence.

These factors, among many, many others, helped usher in the Renaissance. No doubt Leonardo would've found other ways to apply his genius had the Renaissance never occurred, but in this perfect milieu for his talents, his genius thrived.

Lost in Time: Leo's Limitations

For a man with so much talent and brainpower, the world should've been his oyster. Yet the historical circumstances that encouraged Leonardo's genius to flourish also built some walls between him and endless opportunity. And for a man who approached everything with so much curiosity (perhaps his defining feature), he lacked certain other qualities that may have ensured greater success during his lifetime.

The agony and the ecstasy (Or, the perfectionist and the procrastinator)

Although religious fury and passionate love neither inspired nor tormented Leonardo in quite the same way they did Michelangelo (as Irving Stone argued in his biography of Michelangelo called *The Agony and the Ecstasy*), Leonardo had his own angels and demons. Could an artist embody any worse combination than the drive for perfection and an innate tendency toward procrastination? That dilemma was exactly what Leonardo had. It was this combination that stymied completion of his projects, but also enabled him to become the quintessential Renaissance man. Sure, Leonardo sometimes doodled for nothing; not *every* sketch or sentence deserves a gilt frame. But his distractibility and endless curiosity brought him to explore new subjects time and time again — even as he abandoned the one before him.

During and after his lifetime, Leonardo's reputation as an artist surpassed all his peers, save for Michelangelo and Raphael, the other two High Renaissance giants. As Chapter 10 explains, Leonardo pioneered techniques that helped define the High Renaissance style — the epitome of painting to date. But his desire for perfection — to render each detail, from a petal to a finger, strikingly realistic — hindered his productivity. Rumor has it that as busy as he was working for Ludovico Sforza in Milan, he'd visit the refectory in Santa Maria delle Grazie, where he was painting *The Last Supper* (introduced in detail in Chapter 14). He'd stare at the wall for a few hours, perhaps fix one tiny little thing or make one small brush stroke, and then return home to work on other pressing projects. In fact, Leonardo worked so slowly that his patron threatened to cut off all funds (which delivered the well-needed kick in the pants).

Leonardo rarely finished a painting. His reputation as someone who couldn't finish a job hung like a cloud over him wherever he went. Some of this incapacity related to his inbred desire for perfection. But much of it also had to do with circumstance. Not to make too many excuses, but war, politics, and personal feuds impeded Leonardo's progress. He had a seven-month deadline to paint an altarpiece for a church, for example; two decades later, after some legal disagreements, Leonardo produced (a second) *Virgin of the Rocks*. And unlike some of his rivals, including Michelangelo, Leonardo experienced

some trouble with his patrons, which can also account for the irregularity with which he finished projects. He didn't choose patrons very well — they kept dying or getting ousted by enemy lines. Although wooed by other patrons such as François I toward the end of his life, Leonardo never found the type of security that Michelangelo or Raphael found in the Vatican courts.

A man without letters

Leonardo was a love child, born to a respected notary (lawyer) and a woman of unknown origins named Caterina. As I discuss in Chapter 3, this uncertain status meant that certain professions — not to mention the prospect of attending the equivalent of an Ivy League institution — were closed to him. A few scholars claim that had Leonardo not been born out of wedlock, he may have become a doctor, not a painter.

Despite the limitations that a class-conscious Italian society imposed on him, Leonardo made the best of his situation. Throughout his life, he called himself an *uomo senza lettere,* a man without letters. But he was self-schooled and incredibly well read, describing himself as a *discepolo della esperienza,* or disciple of experience, as well. Being a man without letters, then, wasn't too shabby if you could lift yourself up by the bootstraps and apply yourself.

Join the club . . . or, better wait a while

Leonardo was both a procrastinator and a perfectionist. Recently, psychologists have shown that these two qualities usually represent two sides of the same coin. Procrastination, which derives from the Latin *pro* (for) and *cras* (tomorrow), entails putting things off that require immediate action. (Do you ever wonder why you *must* clean the house or bake cookies when you have other, more important work to do?) And perfectionism is a condition in which fear about one's own abilities and judgment by others cause great anxiety. Leonardo was plagued by both. And he wasn't alone. Many great figures have suffered similarly:

✔ **St. Augustine:** He struggled between maintaining chastity now (well, in the fourth century AD) and going to heaven, or sleeping around and risking an eternity of hell. Original sin? There you have it.

✔ **Samuel Taylor Coleridge:** This British Romantic poet rarely finished anything. He never completed one of his most famous works, *Kubla Khan,* claiming that a fictitious "Person from Porlock" interrupted his opium-inspired dream.

✔ **Agatha Christie:** She wrote more than 80 books, yet feared starting each new one.

✔ **SpongeBob SquarePants:** Yes, even he didn't want to start an essay in a 2001 episode called "Procrastination."

Leonardo knew that time runs out. On his deathbed he reputedly begged to know if any of his inventions had been built. Clearly, he hadn't read Stephen Covey's bestselling book, *The Seven Habits of Highly Effective People.*

Leonardo wasn't initially so great at math (he had trouble calculating square roots), but he studied it more formally after finishing his apprenticeship with Verrocchio. Failing to grasp some unproven mathematical principles, he also devised some of his own mathematical symbols. In an age that admired ancient Greece and Rome, a middle-aged Leonardo also taught himself Latin in order to read the classic texts (and to question some ancient assumptions about art, science, and life). He owned an extensive library, with works ranging from the Bible (though he wasn't religious) to Ovid, Pliny the Elder, Petrarch, and Renaissance texts on agriculture, anatomy, mathematics, and medicine — you name it. Basically, he studied all ancient and medieval texts on subjects that interested him. He was undoubtedly more well read than his peers who *had* attended university. He even befriended professors in different fields, like the famous mathematician Luca Pacioli and some anatomists. This focus on hands-on experience — a substitute for official schooling — led to some of Leonardo's most stunning inventions in art and science.

A product of history?

Leonardo, like his colleagues, worked in a specific historical time that embraced logic and innovation, as you can see in Chapter 2. But the culture that gave him great freedom also circumscribed his projects.

- **The Church:** Although slowly waning in power, the Catholic Church still influenced people's lives on a daily basis. Religious themes dominated art, despite the slow intrusion of pagan themes derived from classical antiquity. And the Church still governed the production of knowledge. Different Renaissance popes embraced scientific progress to different degrees, but overall they frowned upon human dissection, for example — one of Leonardo's favorite pastimes.

- **The Italian Wars:** These regional wars — the ins and outs of gaining and then losing power for ruling Florentines, Milanese, and French — spelled disaster for Leonardo's patrons, and as a result eliminated any chance Leonardo had for security. The wars were the main reason for his turncoat diplomacy and why he hopped from patron to patron. But they also provided Leonardo with new opportunities. For example, when Ludovico Sforza was ousted from Milan, Leonardo found his way to the Vatican — for a while, anyway. And in the French king François I's court, he experienced great intellectual and artistic freedom.

Leonardo overcame many of the obstacles that could've squelched his creativity. He still cut up humans, even if he worked alone, at night. And he always sniffed out new patrons, even if he had to reinvent himself, for say, the military industrial complex, in order to do so.

Communicating effectively — or not

Leonardo left thousands of drawings of his inventions: a helicopter, scythed chariot, scuba gear, parachute, 33-barrelled gun, lifting machines, and so on (and on and on and on). And he left just as many prescient observations about all fields of science. But he never communicated most of his ideas effectively.

Deciphering the messy notebooks

First, Leonardo didn't use standard notation or writing. Instead, he wrote backwards, from right to left, in a style called *mirror writing*. Making matters worse, he left his notebooks an absolute jumble. A stream-of-consciousness rather than synthetic thinker, he drew relationships among everything he observed, from blood vessels to rivers. He thus sketched seemingly incongruous stuff side by side. And because paper was expensive and scarce, he often tucked new ideas into any corner he could. (For more on Leonardo's notebooks, go to Chapter 16.)

Second, with few exceptions, Leonardo never built and tested most of his designs. If he had, people may have gloried in some modern machinery (and some pretty nifty toys, too) centuries earlier than they did. Many of his inventions, given the limitations of human power, would never have moved by themselves.

It's publish or perish, baby

Leonardo's colleagues universally heralded him as a genius during his lifetime, and many of his works, including the *Mona Lisa* and *The Last Supper,* attracted hordes of followers. But because he published nary a word during his lifetime, few of his colleagues knew about his scientific thoughts or mechanical inventions.

Evidently a few people looked at Leonardo's notebooks and copied some of his ideas and sketches during his lifetime, but had more people in Leonardo's day known about his designs, they may have tried to improve upon them. Instead, Leo's contributions remained undiscovered for years, and other scientists, inventors, and researchers had to reach their own conclusions and make their own discoveries without benefit of the ideas that predated their own "breakthroughs" by centuries.

Leonardo neither compiled his thousands of pages of musings nor published much of anything during his lifetime. (Some scholars even estimate that about two-thirds of his notebooks have been lost.) Sure, a few of his drawings, such as those of geometric solids, appeared in certain volumes, like Pacioli's *De divina proportione* in 1509. And some evidence suggests that

Leonardo influenced other scientists, artists, and inventors of his day. A few examples to whet your appetite:

- ✔ The Venetian painter Titian and German painter Albrecht Dürer looked at Leonardo's anatomical drawings and pirated some of them in their own work.

- ✔ The Italian clockmaker Lorenzo della Volpaia copied some of Leonardo's instruments in his own manuscripts.

- ✔ Leonardo's work on geometry in François I's court influenced Claude de Boissière, a mathematician to the king of France after Leonardo.

- ✔ Leonardo was interested in compasses and designed a specific proportional one that found its way to other European cities. Galileo eventually claimed to have invented a similar type of compass, though he likely studied a string of inventions that derived from Leonardo's original design.

The fact remains that the bulk of Leonardo's ideas essentially disappeared. Despite his best intentions to publish separate treatises on everything from anatomy to mathematics and hydraulics, he never did. That the heirs to Leonardo's manuscripts scattered them after his death sealed his fate: In the world of publish or perish, most of Leonardo's brilliant thoughts perished — for a few centuries, anyway.

Revisiting the Beloved Leo Today

Leonardo lived 500 years ago, but his legacy seems as near and dear to people today as if the Renaissance happened only yesterday. Who can resist the *Mona Lisa*'s allure — or, with all the hype, ever forget her? Who else invented models of a helicopter and car years before their time? And which other Renaissance man has become a pop culture icon, a modern symbol of ultrahuman intellect and achievement?

Although Leonardo lived generations and worlds away from today's society, his work still exerts a powerful hold over people in this day and age. Like Thomas Edison or Albert Einstein, who represented the inventor's spirit to perhaps lesser degrees, Leonardo surpassed human limits and changed the Western world's way of thinking in noticeable ways. His notes, diagrams, and drawings offer clues to his ceaseless search for truth. And his paintings, portrayed with a beauty never before or since paralleled, relate a timeless immediacy to artists and scientists today.

In a changing time, one that desperately tried to free itself from the shackles of medieval convention, Leonardo was an extraordinary thinker. In some ways he adhered to tradition, building on existing bodies of knowledge. But in other areas, he was a true explorer, a pioneer whose fertile imagination grasped and prophesied unheard-of possibilities.

In fact, many of Leonardo's inventions have greater value for their far-reaching implications to the Scientific or Industrial revolutions than to their own immediate applications. Most of Leonardo's dreams, including the great fantasy of flight, had to wait a few centuries to be realized. Some of his inventions were considered ludicrous or impractical at the time; others wouldn't have worked at all. Just imagine strapping on a pair of feathers and jumping off a roof, or running as fast as you can on a Renaissance-style treadmill to power a crossbow! Not surprisingly, 15th-century Italy, while ushering in a modern age, didn't readily embrace such advances.

Today you have the historical perspective to understand just how revolutionary Leonardo's ideas and inventions were, feasible or not, in his time. After all, the Leonardos of the world — those visionary, audacious thinkers — are the ones who break ties with an antiquated past and move the world forward one step at a time. Some are lauded during their lifetime, while others, like Galileo, are accused of heresy and imprisoned for contradicting established teachings. (Perhaps it's a good thing that Leonardo didn't publish his theory about the origin of fossils!)

If today's culture values one thing, it's progress — whether people recognize it at the time or not. Although Leonardo was recognized for his great artistic gifts, many of his scientific nuggets and mechanical inventions went unnoticed. But when they were rediscovered, the world came to understand Leonardo's great legacy as both pioneer and precursor to the modern world. As each part of the world (and universe) gets closer together through technology, markets, and scientific knowledge, Leonardo's accomplishments resound perhaps even louder than they did during his lifetime.

Chapter 2

Living in Renaissance Italy

*I*f you're going to discover a few things about Leonardo's life and art, you need to know something about the era in which he lived — the Italian Renaissance (which I refer to simply as the Renaissance, to avoid confusion with *other* Renaissances). Meaning literally "rebirth," the Renaissance saw the reemergence of classical ideas, artistic and literary creativity, and reliance on and faith in the human intellect to understand and shape the world.

Many factors brought about the Renaissance: the growth of international banking and trade, geographical discoveries, the Catholic Church's power, the creed of humanism, patrons like Florence's wealthy Medici family, and contests that drew artistic talent to different cities to showcase their talents (Chapter 4 explains this last bit some more) — unlike today, when museums literally *beg* for money. No doubt the Italian Renaissance witnessed the most powerful wave of intellectual and creative energy that the European continent had yet seen.

And yet, some terrible in-house fighting also marked the period. France and Spain invaded Italy over and over again, the Italian city-states constantly shifted alliances, and the Catholic Church sent out warrior kings to cement its rule throughout Italy. It's a miracle that, amid all this violence, any Renaissance art — commissioned, by and large, by the Church and warring ruling families — survived at all!

Introducing . . . Drumroll, Please . . . the Renaissance

The term *Renaissance* is one of those slippery concepts, intuitive to grasp but hard to define. Generally, it describes the period of European history between the mid-14th and late 16th centuries. Meaning "rebirth," it signifies the revival of classical antiquity *and* the subsequent flowering of art, literature, and early modern science in European culture. Although the Renaissance happened gradually at different places and times (historians sometimes divide it into Early, High, and Late periods), most people acknowledge that the Renaissance started in Florence, Italy, in the 14th century.

Despite general agreement as to *when* the Italian Renaissance occurred, historians disagree about *what* exactly it produced, changed, or otherwise did to Italy:

- Was the Renaissance truly the sign of a modern age?

- Did it signify a *real* rebirth of classical knowledge and its cultural application? Or was it the logical extension of a more recent historical period, an outgrowth of the Middle Ages called the *early modern* phase of European history?

- Was the Renaissance traditional in nature (a society of kin and family, for example) or revolutionary (a collection of forward-thinking individuals)?

- Did the Renaissance affect only an elite, wealthy few, or did it spread its magic to the general masses as well?

- Did the Renaissance bring material as well as ideological and intellectual change, or did most Italians experience severe financial hardships?

- To what extent did people living in Renaissance Italy buy into the idea that they were living in a new, modern era?

Depending on whom you ask or what book you read, you'll get different answers to many of these questions. Basically, it all comes down to one point: This era both conformed to and broke with tradition.

Interestingly, the educated people living during this era had some idea that the times, they were a-changin'. By the 16th century, many scholars, philosophers, scientists, and artists were using the word *modern* to describe their era (historians used the term *renaissance* later on). For example, Giorgio Vasari (art historian and Leonardo biographer), Leonardo, and others described Renaissance art and architecture as modern. They used the word *rinascita* (rebirth) to describe how the art of that time had broken from Gothic and Byzantine tradition, delivering it from barbarism. Barbarism! Many people had some inkling that they were living in a different day and age, even if the boundaries between their barbaric past and modern era blurred. Still, many of the Renaissance's

modern ideas and material trappings may have laid just outside the reach of the common man or woman.

Without diving into Ivory Tower nonsense, keep the questions about the nature of the Renaissance in mind, because they're important to understanding the relationship between Leonardo's contributions in the fields of art, technology, and science and the larger social, cultural, political, and economic context. (Like, why he designed military technology, and why he hopped around from city to city, always on the hunt for his next commission.)

In one of the first authoritative books on the subject, published in 1867 and still a widely read classic, Jacob Burckhardt's *The Civilization of the Renaissance in Italy* suggests that the Renaissance marked a departure from the Middle Ages and brought forth a model of a modern European culture. Burckhardt argues that the Renaissance not only breathed new life into aspects of the olden days, but also drew on more regional, contemporary cultural customs to bring about the modern Italian spirit. Since then, historians have challenged, adapted, and revised Burckhardt's thesis to no end.

Giving birth to the Renaissance

So what brought about the Renaissance? Historians would be tarred and feathered if they pointed to a single cause of this flowering of art, science, and culture in Italy. Nobody wants to look like a simpleton, of course. Everything, including something as complex and far-reaching as the Renaissance, had many historical subtexts. Here are some things that more or less spurred or heralded the changing times:

- **Doom and gloom:** Life was sad. Okay, maybe not sad, but pre-Renaissance Italians had some chips on their shoulders. They lived with memories of their own history — their past glory and the more-recent humiliations starting in 309 BC, when the barbaric Gauls sacked Rome. Whether or not the pre-Renaissance Italians were really spiritless is hard to say, but by the 14th century, many poets and artists voiced the desire to reclaim their splendid past.

- **The poet hero:** In 1341, Francesco Petrarch (1304–74), after begging his fellow Italians to rescue themselves from political chaos and foreign invasions and unify themselves into a powerful nation and culture, was crowned Poet Laureate — marking, for many historians, the start of the Renaissance.

- **The Black Death:** The bubonic plague swept through Europe in the mid-1300s, killing an estimated one-third of the population, about 25 million people. Survivors deserted villages and towns, social obligations eroded as peasants left their lands, and general economic depression killed off fledgling businesses. But eventually this tragedy had an upside: In the urban areas, labor shortages encouraged economic diversification and

technological innovation, stimulating capital accumulation, trade, and industry. For example, in 1454 (or thereabouts), Johann Gutenberg's printing press made literature (especially the ancient classics and spread of humanist ideals) more accessible throughout Europe.

✔ **The lay of the land:** Italy was geographically desirable at a time that mattered. Bordering the Mediterranean Sea and nestled between the majority of Europe and the Byzantine Empire, Italy had many advantages when it came down to international trade — which allowed for the influx of goods, technologies, and ideas. For example, the fall of Constantinople, the center of the Byzantine Empire, to the Ottoman Turks in 1453 inspired an exodus of Greeks and works of art and literature to the Italian city-states.

✔ **The rise of city slickers:** When the Roman emperor Justinian conquered Italy in AD 533, he basically wiped out all of Italy's fledgling commercial areas. Until AD 1000, Italy was mostly rural, with a few small urban centers. By the 12th century, new agricultural organization, technology, and trade between Europe and the Byzantine states to the east, among other factors, encouraged the growth of cities. In the 1200s, Italy saw a resurgence in urban life.

✔ **The great bread exchange:** As the Italian cities grew, many rose as centers of banking and commerce, leading to an extraordinary growth and concentration of wealth — and the ability to throw it all at artists, architects, and scholars, as many of these wealthy families did! Florence, brave Florence, took the lead in bankrolling all manners of artists and philosophers, spreading their influence far and wide.

✔ **An independent streak:** The Italian city-states were individual regions ruled centrally from a single city, empowered by the concentration of wealth. Through most of the late Middle Ages, the pope and the Holy Roman Emperor concentrated so hard on fighting over Italy that they unknowingly let these entities grow and prosper. As a result, the city-states were politically autonomous and governed according to the preferences and style of their ruling families.

✔ **The religious folk:** Somewhat unified under one pope, the Catholic Church, its headquarters relocated to Rome after a stint in France, encouraged the construction of grand churches, elaborate tombs, and impressive pageantry to glorify itself.

Together, all these things produced the birth of a new kind of culture in Italy.

Out with the new; in with the old

Who said the Roman Empire fell? It merely tripped, stumbling forward into history nearly 1,000 years later in Florence. As a result, all of Italy's disorganized collection of Papal States, small kingdoms, republics, and city-states on the boot-shaped peninsula — not to mention all of Western civilization — changed forever. (For the better, right?)

The past certainly had a strong foothold during the Renaissance. *Classical antiquity* meant Greco-Roman heritage, the period of European history between the seventh century BC and the fifth century AD, which started with Homer (no, not Simpson; the Greek poet), witnessed the birth of Christianity, and ended when the Western Roman Empire fell — er, stumbled. When you hear or read about the Renaissance looking back to classical antiquity, keep in mind that the term refers to an idealization of this period as a whole, and not necessarily to one specific event, person, or decade.

By the time the Renaissance rolled around, a unified Roman Empire had long since vanished — technically speaking, it was trampled on and kicked to the curb. Excavations in both Rome and Greece commemorated some of their former physical glory. But Italians had experienced some troubling times and wanted more: They wanted to combine the ideals of days past into their own way of life. This section outlines some of the definable features of classical antiquity (specifically from the Golden Age of Greece, c. 450–400 BC, and the Roman Empire, c. 31 BC–AD 476) that pop up from time to time in Renaissance jingo.

Raising up big brother

In Greece, the city-states evolved into small kingdoms on mainland Greece. They had some colonies, but most of the action happened on the mainland. The people of Athens came up with the idea of political democracy (despite the existence of slavery and the socially unjust position of women) in 510 BC. Some parts of Renaissance Italy, like other parts of the world, drew broadly on this idea of democracy, though it played out differently at various times and places.

Rome was a republic before Caesar Augustus reorganized it into an empire around 27 BC (meaning it was one of many siblings before it became big brother who got to boss all the others around). At its height, imperial Rome had over a million inhabitants, and after the *Pax Romana* (200 years of peace), when Augustus came to power the empire gathered even more people under its wings, extending to all the states bordering the Mediterranean and the Celtic regions of Western Europe. The Empire became so big that it eventually split into East-West halves. The rule of the western half centered in Rome. The eastern empire — called the *Holy Roman Empire* — survived in Byzantium and tried to control Italy for the next millennium.

The Italian Renaissance drew a lot from Rome's first days as a republic and its first days as an empire. And that's the story of how the *Senate* (the body of prominent men that advised Rome in various capacities) was born.

Building blocks and architectural styles

The Greeks developed three different styles of architecture (Doric, Ionic, and Corinthian), as well as new uses of pediments, capitals, and columns (basically, decorative and functional elements that they used religiously, in both senses of the word). These parts reflected ideals of symmetry, order, and harmony and

had both religious and political purposes. The best known Greek structures include the Parthenon and the Acropolis. From these structures, architects of the Italian Renaissance adopted new ideas about geometric proportion, harmony of design, and the use of private and public (inner and outer) space.

The Romans were true pioneers as well. Take Vitruvius, for example, who straddled the first centuries BC and AD (I discuss him in Chapter 12), or Rome's sophisticated aqueducts. Like the Greeks, Romans focused on public and private space and harmonious architecture. The best known Roman structures include villas, the Arch of Titus, Coliseum, Hippodrome, catacombs, Pantheon (whose dome was the largest for about 1,000 years), Roman baths, and aqueducts. As Emperor Augustus allegedly boasted, he found Rome a city of brick and left it a city of marble.

The Romans essentially adopted the architectural style of ancient Greece but changed it enough over time to create a distinct style. During the republican period, Roman architecture copied Greece but added the arch and the dome. Around the first century BC, the use of concrete inspired more innovation, which allowed architects to build immense pillars supporting arches and domes and create colorful mosaics with insets of stone.

A thousand years later, Italian architects adopted elements of both Greek and Roman architecture (collectively considered "classical architecture," for better or for worse). From Rome, they adopted the arch and dome; as you see in Chapter 4, capping the Florence Cathedral with one the largest domes since antiquity posed one of the early Renaissance's greatest architectural feats.

Shaping the ideal human

In Greek sculpture, naked gods like Athena or Poseidon and *caryatids* (sculptured female figures) graced religious structures, modeled with *contrapposto,* or counterbalance. The goal of classical sculpture was to portray a perfect balance and harmony of human form and nature, which mirrored Greek philosophy.

Italian Renaissance artists brought the sculpted figure back to life. Stiff and stuffy figures disappeared as naked, godlike mortals, heavily muscled, hippy, and full-breasted, reappeared. Renaissance sculptors also used contrapposto to give their figures more realistic poses and mirror what the Greeks had tried to achieve: to show the ideal human form. Ancient Roman sculpture, also relatively realistic, didn't influence Renaissance artists as greatly — perhaps because the Greeks had inspired the bulk of it!

Finding cures and discovering math and science

Greek doctors like Galen (though he worked in Rome for a time as Emperor Marcus Aurelius's private physician) made some advances that dominated medicine through the Middle Ages (see Chapter 5). The Greeks also made a significant contribution to mathematics and the natural sciences, from Euclidean geometry to Ptolemy's astrological studies and Archimedes's

mechanical experiments. The Romans contributed some advances in *cartography* (mapmaking), aqueducts, and sewage systems. Overall, math and science weren't as up and coming in Rome as they were in ancient Greece.

As Chapter 5 explains, many Renaissance thinkers, artists, and scientists drew on many of the scientific ideas introduced in ancient Greece. For example, Hippocrates's and Galen's theories about anatomy and medicine held sway for more than 1,000 years, even influencing Leonardo's own anatomical studies. Other scientific inventions — like the Archimedes screw — were a big part of Leonardo's flight designs, which I jump into in Chapter 9.

Reading, writing, and thinking

The Greek Sophocles, Euripides, Socrates, Plato, and Aristotle were all big guys on campus in the olden days known as classical antiquity. Plato, for example, talked about virtue, right and wrong, the reality of ideas, happiness, knowledge, and the ultimate harmony of the universe that connects the soul, state, and cosmos. Aristotle, who studied under Plato at the Academy, emphasized direct observation of nature and, above all, logic. Renaissance Italy and all of Western civilization were overflowing with these ideas.

Ancient Romans looked to the Greeks, from Homer to Aristotle. At the same time, Roman authors weren't too shabby, either; Virgil, Ovid, and Cicero, for example, changed the face of Western literature. (No, Shakespeare *wasn't* a Roman. He only immortalized such Roman heroes as Augustus and Julius Caesar, Antony, and Cleopatra in his very English, very 16th-century, literature.)

Again, Renaissance thinkers looked to the ancient Greeks for their answers. After the printing press came into fashion, the work of the ancients circulated widely, into the hands and new libraries of the rich and powerful rulers of Italy. Plato, Aristotle, and their philosophical heirs thus played an important role in informing all the sitting around and discussing the meaning of life that Renaissance scholars engaged in.

Renaissance courts also celebrated ancient history. Florentine carnivals under Lorenzo the Magnificent (or Lorenzo de' Medici, the head honcho of Florence for a time), for example, celebrated the military triumphs of ancient Roman commanders. In 1500, warlord Cesare Borgia, in possible honor of himself, celebrated the triumph of Julius Caesar by commanding a grand procession of chariots. New forms of recording history became all the rage, modeled, in part, after Cicero's dialogue. To top it all off, Renaissance parents began giving their children Greek and Latin names, like Agamemnon, Achilles, and Minerva!

Paying tribute to the gods

The pagan god Zeus reigned over a collection of lesser (but still supernatural) gods and goddesses, like Hades (god of the underworld) and Athena (goddess of wisdom, war, and justice). Taken together, this tight family group represented the forces of nature, explained the origin of the world, and

succumbed to the powers of fate and destiny. Like the Greeks, the Romans had a set of gods — in place of Zeus, Jupiter ruled the heavens and earth.

Renaissance Italians didn't backtrack into the mythological netherworld of yore, but they did use ideas from Greek and Roman mythology. In art, painters used gods and goddesses to portray an emotion or tell a story — like Leonardo's *Leda and the Swan,* for example (see Chapter 10). The use of mythology and paganism also extended to religion. As people started to embrace Neoplatonic ideals (a pantheistic and philosophical system of ideas inspired by Plato), some combined elements of Christianity and classic mythology into a new kind of religion. Lorenzo de' Medici renewed pagan orgies in his carnivals — but then, on his deathbed, called for the fanatical monk Girolamo Savonarola!

Ushering in new ideals: Humanism

Classical antiquity had a major influence on all aspects of the Italian Renaissance. What happened to symmetry, harmony, and the splendor of days of yore, Italians wondered, and why are things such a mess now? The artists, philosophers, and others thus turned back the clock and embraced some ancient principles, bringing them up-to-date to suit new, quasi-modern conditions. In so doing, they challenged the status quo of their time.

The concept of humanism, one of the major currents in Renaissance Italy that predominated from around AD 1400 to 1650, encompasses a good chunk of Renaissance thought. Known as *umanista,* humanism wasn't a single movement, but rather a collection of ideas spanning all aspects of society, from literature to religion to art. Because it introduced new ideas about the relationship of the individual to him/herself, society, and God, it wasn't always too popular with Church officials. But ruling families in Florence, Venice, Milan, Ferrara, and Urbino ate it up, justifying their more or less illegitimate rule with their honorable alliances with intellectuals.

Introducing humanism's major players

Major Italian humanist thinkers included Francesco Petrarch (1304–74), who decided that the Roman Empire had reached the heights of human accomplishment, Desiderius Erasmus (1466–1536), Niccolo Machiavelli (1469–1527), and Francesco Guicciardini (1483–1540). England had counterparts in Sir Thomas More (1478–1535) and Francis Bacon (1561–1626), as did France.

Another important member was a young nobleman named Pico della Mirandola (1463–94). When he wanted to organize a congress in Rome for all scholars, Pope Innocent VIII squelched it and called it heresy. But, the Platonic Academy (followed by another, called the Florentine Academy) set the standard for intellectual pursuit throughout Italy.

Florence, in particular, hailed as the "New Athens," initiated humanist thought. But far from blanketing the Italian peninsula at once, humanism fanned out slowly and informally. It eventually provided many parts of Europe with a common starting point for understanding how the classical past fit into a more modern future.

Following are some general (if not all-encompassing) humanist principles:

- **Ancient thought had gotten a lot of things right.** Humanists studied ancient texts in Latin, Greek, and Hebrew dealing with history, literature, medicine, and moral philosophy. Some Italians in the Middle Ages had read Plato, Aristotle, Virgil, Cicero, and Ovid, but humanists now looked to these heroic ancestors for models of how to govern a state, wage war, and create art, for starters. Humanists saw parallels between their own changing lives and social values and those of classical writers who, incidentally, discussed how to live a purposeful life. This zeal for classics both caused and resulted from an increasingly secular view of life — and the invention of the printing press, of course.

- **They leaned toward science and away from God.** Humanists straddled medieval supernaturalism and modern scientific thought, as well as faith and reason. As a whole, they questioned the dogmatic world of Christian teachings, in which God dictated every natural phenomenon. Instead, they worked toward discovering scientific principles and casting away superstition, as you can see with Leonardo's dissections, discussed in Chapter 5. At the same time, they adapted the merits of a pagan civilization into the Christian one. Suddenly, Venus expressed the concept of love just as convincingly as did depictions of Madonna and Child. This reemphasis on ancient Greek and Roman mythology and classical texts offered an alternative to many for whom Church dogma was slowly but surely losing its appeal. Yet, paganism and Christianity were strange bedfellows, existing awkwardly side by side.

- **They looked inward instead of upward.** Humanists' views on religion and nature weakened their faith in God and the afterlife and focused more on the individual's rationality, self-reliance, intellectual freedom, the collective good, and dignity.

- **The ideal became an obsession.** Humanists idealized reality, viewing beauty as the sum of all its parts — physical, intellectual, and spiritual. This ideal was a big part of art and architecture, leading to a new appreciation of pagan idols like Venus (nude, no less!) and figures like Julius Caesar in painting and statuary. Roman arches and Greek orders started to replace the basic, rather dull flatwall structures of the time, and public spaces reflected the cities' newfound grandeur.

- **They revered learning for learning's sake.** As early as the late 14th century, governments began employing scholars to educate their children in Latin and the classics, pen eloquent correspondence, and record public events for posterity. By the 15th century, all the ruling families had library collections, and a century later, some municipal libraries opened.

Breathing new life into Plato's Academy

Remember Plato, Socrates's student? He founded the ancient school of philosophy known as Platonism around the fourth century BC. His school, called the Academy, existed on some parkland just outside of Athens. It gathered together intellectuals to ponder some very important matters, such as virtue, justice, love, and whether or not the reality on earth reflects higher truths. The school, rumored to have founded mathematics, also considered Pythagoras's mathematical studies about 150 years earlier. (More than 1,500 years later, our very own Leonardo drew some *Platonic solids* — triangles making up some solid forms — for mathematician Luca Pacioli's 1509 book *The Divine Proportion.*)

Plato's Academy closed down in AD 529, when Christian Emperor Justinian sadly proclaimed it a pagan institution. But it inspired *Neoplatonism,* which emerged in the third century AD and expressed its ancestors' philosophy in new ways: Neoplatonists combined, for example, Platonic ideas with Aristotle's idea of a hierarchical, ordered universe. A God, "The One," took up the top shelf. This new philosophy also rallied for paganism, though paganism and Christianity influenced each other in weird ways. Renaissance philosophers, in turn, revived these Neoplatonist ideals to fit their own times.

Plato's Academy wasn't the last of its kind, however. During the Renaissance, Florentine statesman and patron of the arts Cosimo de' Medici, the head honcho of the Medici clan, may have crushed some political freedoms, but he gathered philosophers around him like gold coins. In 1445, he formed the Platonic Academy in Florence, which embodied all the new-old ideas floating around. By 1462, a noted humanist, physician, and Plato scholar, Marsilio Ficino (1433–99), led the Academy in hope of reconciling Christianity with Platonism (and forging, as a result, a wide-ranging synthesis called Neoplatonism). After all, humanist moral teachings emphasized individual obligations and the collective good — and neither of those ideas contradicts the Ten Commandments or other biblical doctrines.

Despite some rather unsurprising setbacks, this progressive institution had a huge influence on the literature, painting, and architecture of the times. But by the end of the 16th century, humanism, criticized by the Counter-Reformation, as a whole had lost its grip on the Italian mind.

Keep in mind that the principles I outline in the preceding list are just that: general guidelines for understanding the important shift in Renaissance thought. Yet different branches of humanism backed different concepts. They ranged from *civic humanism* (examining the role of the individual in civic life), *artistic humanism* (copying forms from classical times), *poetic humanism* (imitating ancient literature), and *Christian humanism* (studying ancient languages to understand the Bible).

Sorting Out All Those Italian City-States

After you have a taste of what the Renaissance *was* (see the preceding section), you need to know a little history of the region, so that when Leonardo

traipses back and forth between Florence, Milan, and Rome, you have a sense of what historical circumstances conspired to bring him there.

By the start of the Renaissance, Italy had five major city-states, each with different forms of government (see Figure 2-1), as well as other political entities:

- ✔ **The Papal States (Romagna):** Ruled by the pope, a series of semi-autonomous states around Rome and the northeastern Italian peninsula.

- ✔ **The Republic of Firenze (Florence):** A republic, ruled in name by a senate, but in reality by wealthy, autocratic families.

- ✔ **The Republic of Venezia (Venice):** Like Florence, a republic.

- ✔ **The Kingdom of Napoli (Naples):** Stretching across the entire southern half of the Italian peninsula, a standard monarchy.

- ✔ **The duchy of Milano (Milan):** An autonomous *duchy* (a region ruled by a duke).

- ✔ **The others:** Other Italian entities included the Kingdom of Sicily, the Republic of Genoa, and the city-states of Mantua, Urbino, and Ferrara.

Two of these Italian city-states are particularly important: Florence and Milan. Patrons in both of these regions embraced Leonardo, sheltering him and shaping him into the quintessential Renaissance master that he became.

The growth of the Italian city-states brought about some important new, wide-ranging shifts in power and social relations. Most of the region's power and newfound wealth came not from the nobility and aristocracy, but from a rising merchant and capitalist class. You could potentially witness the grand festivals of a duke, only to realize that he'd risen from a mercenary soldier (*condottiere*) who sold his services to the highest bidder and now possessed the dignity, wealth, and power of nobility!

Budding business also redistributed the region's wealth and land. Nobility tended to borrow money from bankers at about 45 percent interest and then default on their loans, thus being forced to fork it all over. By the late 1400s, the new commercial class had their pockets full with much of Italy's wealth and land. Class divisions, however, still existed; the poor, for example, constituted about a third of the urban population in Renaissance Italy. And, of course, a few domestic slaves still washed the linens, cooked, and took the kids to school, or something like that.

Strolling the streets of Florence

What would you have seen if you lived in Florence in 1452, the year of Leonardo's birth and the smack center of the Renaissance? You would've seen the rise of a grand city determined to outdo its neighbors in art, architecture, and culture.

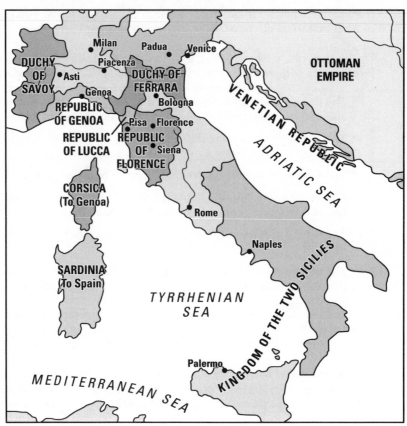

Figure 2-1:
Map of
Renais-
sance Italy.

Leonardo spent his formative years in Florence, generally considered the birthplace of the Renaissance. Consider that Florence had these firsts, and you'll see why:

- ✔ First Renaissance city built in the classical style of antiquity

- ✔ First scientific system of linear perspective developed by sculptor and architect Filippo Brunelleschi (see Chapter 10)

- ✔ First public library and public museum (established by the Medicis)

- ✔ First Platonic Academy, for the study of Greek and Renaissance philosophy

- ✔ First major book on (modern) political science, statesman Niccolo Machiavelli's *The Prince*

- ✔ First medical association of doctors and first prescription pharmacy

✔ First home for babies of unwed mothers and first children's adoption society

✔ First research botanical garden for study of international plants

✔ First international banking system (including the loan system for popes and kings that spelled some of their downfalls!)

No wonder Florence was the quintessential Renaissance city!

Experiencing daily life

During the Middle Ages, Italian culture centered on Tuscany (the area around Florence). By 1425, Florence boasted a population of about 60,000 people. Other parts of Italy were still in recession, but Florence flourished mainly through the manufacturing of a special kind of wool. But if textile manufacturers did well for themselves, bankers did even better. The Florentine gold coin was so reliable that it was the standard exchange rate throughout Europe!

For most inhabitants of Renaissance Italy, though, daily life perhaps proceeded in the same humdrum way. How humdrum depended on your gender and class standing:

✔ **Education:** If you were a middle-class guy, your life probably revolved around kinship and family ties. If you came from a good family, you learned how to read and write and studied Latin (if you were of the landed or self-declared aristocracy, you'd learn those things if you were a girl, too). By the mid-16th century, around 40 percent of the urban population was literate, though in rural areas (outside the wealthy villas), the literacy rate was shamefully low.

✔ **Labor:** If you were a middle- or upper-class male, you learned your craft in one of a couple dozen guilds that regulated trade. They ranged in specialty from wool workers to judges, notaries, pharmacists, furriers, or silk weavers, and protected you from unfair competition and the laws of supply and demand. If you were of lesser stature, you may have entered into an oil and cheese, tanner, ironworker, baker, woodworker, butcher, blacksmith, or shoemaker guild. If you were a woman, you were prohibited from entering most of the guilds altogether.

These guilds, which lasted through 1571, represented only a small fraction of Florence's population, yet held all the power and performed social and religious functions along with their economic one.

If you weren't in a guild, you were probably either a working man (Florence had 72 unions of working men who far outnumbered the guild men), one of thousands of poor day laborers, or — at the very bottom of the class heap — a slave (yes, Florence had a few slaves).

> ✔ **Gender:** Women of all classes were first and foremost property of their husbands. Peasant women worked alongside their husbands and ran the household; middle-class women sometimes helped out their shop-owner or merchant hubbies. Even the aristocracy, though aided by servants or slaves, did much of the housework and entertaining.

> ✔ **Politics:** In order to hold a political office, a Florentine had to belong to one of the guilds listed previously (hence the importance of the guilds). Few men, however — only the upper-crust guild members, and no women — could vote.

As Chapter 3 explains, Leonardo, born outside Florence as a bastard son of an established notary but trained by one of the city's leading artists, Andrea del Verrocchio, in many ways represented both the opportunities and limitations of 15th-century Florentine society.

Bankrolling high art: The Medici dynasty

The Medicis, the most powerful bankers in Florence at a time when bankers were the crème de la crème, ruled Florence as a behind-the-scenes oligarchy (kind of like America's 19th-century political machines) from the 15th to the 18th centuries. Under Medici rule, Florence flowered, as they say, as the cultural center of the Renaissance. Its rulers glorified their wealth, power, and prestige by patronizing all aspects of society: the arts, literature, philosophy, science, and architecture. The Medicis vowed to match their civic pride with matching artistic achievements — and a grand new skyline. Who ever said that money can't buy happiness, or at least respect?

Florence had technically been a democratic republic for about 100 years when the Medicis rose to power. From humble beginnings, the family became a royal banking and merchant dynasty, with control over Florence's purse strings and a mercantile fleet that transported silk from China and spices from India and exported woolen cloth from Florence. The family's power extended far beyond Florence — it produced three popes (Leo X, Clement VII, and Leo XI), two queens of France (Catherine de' Medici and Marie de' Medici), and some cardinals of the Roman Catholic Church. In fact, the Medicis were second only to the pope in power during their reign. Leonardo, incidentally, worked with Pope Leo X (Giovanni de' Medici) on a few projects in Rome.

When it came to Florence, the Medicis outdid all others in the accumulation of wealth. And with their wealth, they bankrolled all manners of artists and designed artistic contests (such as, who can design the best doors to the cathedral?) to improve social conditions and build a city to reflect a new civic pride. If the enlightened family crushed political freedom and convinced Florentines that they were still living in a republic instead of a financial oligarchy resembling a democracy, no matter. And if, during the Italian Wars

(see "Duking It Out, Literally: The Italian Wars"), these kindly tyrants were ousted from power and expelled from Florence a few times — between 1433 and 1434, 1494 and 1512, and 1527 and 1530, to be exact — they came back in fine form, always ready to commission another cathedral.

Here are the noteworthy Medicis:

- **Giovanni de' Medici (1360–1429):** The golden age of Medici rule basically began with this guy. He was the banker to the Papal Court, who established his headquarters for his multinational banking company in Florence in 1397 and became an upstanding citizen.

- **Cosimo the First (1389–1464):** Giovanni's son. Cosimo de' Medici took over the family business when his father died. After some struggles, Cosimo ousted another powerful Florentine family, the Albizzis, and installed his own political machine without ever taking office himself. Then he cultivated a classical revival. He founded the Platonic Academy and supported artists including Lorenzo Ghiberti, Filippo Brunelleschi, Donatello, Leon Battista Alberti, Paolo Ucello, Fra Angelica, and Filippo Lippi (you can find a more detailed discussion of all these Renaissance artists — Leonardo's precursors and colleagues — in Chapter 4).

- **Lorenzo (1449–92) and Giuliano (1453–78) de' Medici:** Cosimo's grandsons. These men walked in Cosimo's footsteps. When Giuliano was assassinated in 1478 by a conspiratorial group of evildoers, Lorenzo the Magnificent *(il Magnifico),* raised as a hereditary prince, took over. Despite some financial straits, he threw more money at more artists, including Sandro Botticelli, Domenico Ghirlandaio, Michelangelo Buonarroti, Verrocchio (Leonardo's master), and yours truly, Leonardo. He thus continued to develop Florence as the epicenter of Renaissance high culture. Machiavelli called Lorenzo "the greatest patron of literature and art that any prince has ever seen." Lorenzo did stuff to improve the plight of the poor, too, though class struggle, that bane of human history, never ceased.

Florence's golden age ended with Lorenzo, who begat sons who begat more sons who in turn ruled Florence and the environs (Lorenzo's son became Pope Leo X, and his adopted son from Giuliano, Pope Clement VII). But then the fanatical religious reformer Girolamo Savonarola (1452–98) entered the scene. His power-hungry tactics and attacks on Renaissance values — not to mention the Italian Wars lurking in the background — spelled the end of Florence's glory days.

Moving up in Milan: The Sforza dynasty

Florence had the Medicis; Milan had the Sforzas. Both patronized Leonardo and shaped his artistic development. The Sforzas, initially peasants, are a textbook case example of the *condottieri.* That is, they rose to independent power

through mercenary and military achievements, ousting the evil Viscontis (the family that ruled Milan from the 13th century until 1447, poisoning their own family members and waging war all around them) and ruling the duchy of Milan between 1450 and 1535. Known as "the forcers," the Sforzas governed by — what else? force — playing vicious games of political hardball. Still, they must've done *something* right, for under their tutelage (tutelage? How about dictatorship?), Milan flourished.

You don't need to know all the Sforza characters, just two important ones:

✔ **Francesco I Sforza (1401–66):** In 1450, Francesco I Sforza, a professional soldier, took the throne from his father, who fought in the service of the Italian states and wrested power as a result. Some marriages between the Sforzas and the last remaining Viscontis solidified his power.

✔ **Ludovico Sforza (1452–1508):** One of Francesco's 20 or so children was Ludovico Sforza, called *il Moro* (the Moor) for his dark coloring. Around 1480, Ludovico wrested control of the duchy after the assassination of his cruel brother. An excellent Latin scholar himself and interested in art, he entered the famed architect Donato Bramante and Leonardo into his protectorship (as a military engineer, no less!). With his acclaimed teenage wife, Beatrice d' Este, he donated immense sums of money to further the arts and sciences.

Unfortunately, in 1494, Ludovico courted disaster, messing things up for all of Italy. A subtle if shortsighted diplomat, he invited the French invasion and started, some say, the Italian Wars (see the next section). Afterwards, he was sorry and focused on the welfare of Milan — and what Leonardo could do to improve (and defend) the city. But Ludovico never recovered his former glory. He was expelled from his duchy once and for all by the French king Louis XII in 1499, and after trying fruitlessly to reclaim his lands, he was captured in 1500 by the French, only to die in a dungeon in France.

Duking It Out, Literally: The Italian Wars

The Italian Wars greatly affected Leonardo's patrons and, as a result, his work. Ironically, the wars helped spread Renaissance ideals while ultimately contributing to the downfall of Italy's Renaissance culture. European powers preyed upon the Italian city-states, even killing off some of the rulers who funded the arts.

What with all the city-states, Papal States, and interference from and wooing of foreign powers by Italy's ruling families, you don't have to be a genius to guess that Renaissance Italy had some tyranny, some strange diplomatic bed-fellows, and a lot of nasty political rivalry. All this intrigue and back-stabbing didn't just result in a messy diplomacy. It resulted in warfare.

Existing and imminent warfare also produced rather uncomfortable situations for itinerant artists traipsing from court to court in search of commissions. Leonardo, for example, spent considerable time moving about the Italian city-states when one of his most important patrons, Ludovico Sforza of Milan, experienced a tragic downfall (see Chapter 3 for details). Other artists, like Michelangelo, were a bit luckier: He lived through the reigns of multiple popes but stuck most closely to Pope Julius II in the early 16th century. (For more understanding of how such patronage affected Leonardo and set in place some Renaissance ideals, go to Chapter 4.)

The nutshell version

Between 1494 and 1559, the Italian city-states waged a series of wars among themselves and with France and Spain. The latter powers saw Italy as fair game, and most of the Italian city-states, in turn, needed foreign alliances to help them increase their own relative power. Interestingly, the city-states viewed the outcome of war not as divine judgment anymore, but as a triumph of personal merit and skill. Still, no one was trustworthy.

So here's what you absolutely need to know about the Italian Wars: They were a mess. City-states and foreign rulers were forming alliances and attacking enemies only to form new alliances and attack their old allies before re-forming alliances again and going at it anew. All this in an effort to gain power, keep power, and expand power.

The long version

Placing blame on the origin of these wars is tough, but it's easy to point a finger at Ludovico Sforza of Milan. The trouble started way before him, with an alliance forged in 1454 among Florence and its rivals Milan and Naples against an increasingly powerful Venice. But the treaty fell through when Pope Alexander VI, Florence, and Naples betrayed Milan by having Naples invade Milan! In turn, Milan's displeased ruler, Ludovico, begged the French king for help.

And the beat(ing) goes on . . .

France and Spain continued to invade Italy for many years to come. Here are a few notable events that have little bearing on Leonardo (he was dead by then) but great relevance to Renaissance history:

- In 1527, Holy Roman (Hapsburg) Emperor Charles V sacked Rome, extinguishing the power of the Papal States.

- The Italian Wars officially ended with the Treaty of Cambrai in 1529 and the renunciation of François I's claims in Italy.

- By 1550, Spain had conquered almost all of Italy. Spain remained the dominant power in Italy until the War of Spanish Succession (1701–14) gave Italy to Austria, and a series of political and military coups forged a unified Italian kingdom out of a fractured peninsula in 1861, with Rome as its capital.

Charles VIII of France (the Renaissance's version of Hannibal, the Carthaginian general who, in the third century AD, invaded and conquered nearly all of Italy only to be stopped at the gates of Rome) came to Ludovico's rescue. In 1494, Charles invaded Italy, seized Milan's enemy, Naples, and scared all the other city-states to death. But his power was short-lived — an alliance called the League of Venice, a coalition of Spain (Ferdinand of Aragon), the Holy Roman Emperor (Maximilian I), the pope (Alexander VI), Venice, and eventually Milan, which had rethought its strategic alliances, forced him to retreat.

But the French weren't done with Italy. Charles VIII's successor, Louis XII, invaded and conquered Milan and Genoa in 1499, and in 1500, took Naples (which, in a fit of generosity, he gave to Spain). Alexander VI quit the League of Venice and allied himself with the French king. But nothing worked out as planned. The shaky bonds holding the city-states together shattered, and more chaos followed.

The formidable Pope Julius II, who ruled the Papal States starting in 1503, tried to evict the French once and for all from Italy by forming the Holy League in 1510. But after a few more uneasy alliances and betrayals, the Swiss — yes, the Swiss got involved — stormed Milan in 1512, giving it back to the Sforzas (in name, at least) and controlling Lombardy until the new king of France, François I, defeated them at Marignano in 1515. A year later, a peace treaty returned Milan to France and Naples to Spain. The Papal States and France cut a deal that gave François I control over his clergy and the pope control over church councils.

Confused? Well, I have good news and bad news. The bad news is that the intrigue doesn't end here. It went on for a couple hundred more years. The good news is that to understand what was going on in Leonardo's life, you don't have to know anything else about the Italian Wars. And here's a bonus: If you're one of those people who can't stand an unfinished story, you can read about what happened next in the sidebar "And the beat(ing) goes on. . . ."

Coping with Renaissance Religion

Sorting out the religious streams and tensions that affected the Italian Renaissance is no easy matter. Start with the fact that most of Renaissance Europe — just think of it as one big Christendom rather than a modern-day European Union — embraced the Roman Catholic Church, a branch of Christianity. And the Church, in turn, commissioned a lavish amount of paintings, sculptures, and architecture on its behalf, which is why the religious aura of the day is significant to understanding Leonardo.

During Leonardo's time, however, the Catholic Church was in a bind. Not only did new humanist ideas strike it at its core, leading to a gradual loss of faith in its power from both outside and inside the Church, but also the financially and morally bankrupt Church badly needed some reforms (whoever *heard* of selling church offices?) that would clean it up and make it palatable to its people once again.

Struggling for power: The Holy Roman Empire versus the papacy

First, a few words about the two dominant religious forces in Renaissance Italy: the Holy Roman Empire and the papacy, which were always vying for religious and political control of the Italian peninsula.

Those holy Romans

The *Holy* Roman Empire wasn't the Roman Empire. (The Roman Empire fell, remember?) The Holy Roman Empire (846–1806) was a political collection of lands in western and central Europe in the Middle Ages, founded, depending on who's speaking, either in 800 with the crowning of Charlemagne as emperor of the Romans, or in the tenth century by Otto I the Great. It lasted through 1806, when the last Holy Roman Emperor Francis II, of Austria, resigned.

The Holy Roman Empire, as its name suggests, saw itself as a direct descendent of the Roman Empire. Most of the rulers and subjects of the Holy Roman Empire were German, though the empire had a sort of feudal power far beyond the _Reich_ (the Holy Roman Empire's name in German). Though it was never a nation-state, at its height, its sort of religious confederation (governed in respective territories by dukes) stretched throughout today's Germany, Austria, Switzerland, Belgium, France, the Netherlands, Poland — and northern Italy.

The leader of the pack: The papacy

The _papacy,_ the office of the pope, held the _real_ power. It was responsible not only for heading the Catholic Church, which affected politics all over Europe, but also for governing the Papal States in Italy (refer to the earlier section "Sorting Out All Those Italian City-States" and Figure 2-1).

When the Roman Empire became Christianized in the fourth century AD, the popes received civil authority within the state and spiritual authority within the Church. In other words, popes governed both politically and religiously. Within a couple of centuries, the pope was the most important imperial civilian official in Rome. Although the papacy had been located in Avignon, southern France, since 1305, it returned to Rome in 1378, bringing with it the prestige and wealth necessary to rebuild the city — and expand its sphere of influence (with Medici money, of course — see the section "Bankrolling high art: The Medici dynasty").

But all wasn't well. Through the 14th and early 15th centuries, Rome stood meekly in the shadow of its former glory. To make matters worse, the Papal States around Rome sporadically revolted for political independence from the Church. And Rome had untold factions and hired assassins just waiting for their big chance to seize power. But the Church clutched tightly to its possessions, interlocking church and state.

By the mid-1400s, under Pope Nicholas V, Rome was the up-and-coming Renaissance city. But the popes were, ironically, their own worst enemies. Growing ever more corrupt as Rome's grandeur increased, they ruled like kings over a large portion of the Romagna and other parts of the Italian peninsula. As warrior popes, many donned full armor more frequently than silk and velvet. Acting like conquerors, they focused their attention on invading other places and snatching up more land. During their Renaissance reign, the popes destroyed the duchies of Ferrara and Urbino, thwarted the political aspirations of French kings, masterminded the downfall of Venice, commanded armies against Florence, and helped destroy Constantinople.

In addition, popes had rights that extended far beyond the Papal States. This power was based on the belief that the Church had a legal supremacy over _all_

Christian kings. The pope could, at will, grant or deny certain kings the collection of taxes. And because these more or less German kings weren't considered true emperors of the Reich until the pope in Rome crowned them, they felt inferior to Rome.

Not surprisingly, then, the king of the Holy Roman Empire and the papacy butted heads over Italy. Why? Because both the Holy Roman Emperors and the pope claimed Italy as their domain. The end result? They created a constant battleground out of the Italian peninsula.

Listing Church ideals and then straying from them

Churchgoers living in Renaissance Italy had lots of reasons to doubt the Church. Part of their growing wariness had to do with Church dogma, which was starting to sound a little unfashionable given new economic and cultural developments, like expanding markets and humanism. Some of the more questionable dogma included tried-and-true practices that, without considerable reform, would stick out like a sore thumb in a more modern world:

- ✓ **The role of the Church as the go-between for believers and God:** According to Catholic dogma, only the Church can reveal the teachings of Jesus and the apostles because only the pope and his clergy (such as priests and deacons) can understand and translate biblical mandates to the masses. Other practices that alienate people's direct relationship with God include praying to the Saints instead of God and a belief in the necessity of *sacraments,* Christian rites administered by the clergy as a sign of God's grace. Again, sacraments assume that Catholics have to go through the clergy first to access God, which created an unpleasant bureaucracy. For example, according to Catholic liturgy, sins can only be forgiven through the sacrament of *reconciliation* (when you confess your sins to a priest and he gives you tasks to perform for penitence).

- ✓ **The insistence on the infallibility of the pope:** He ruled "God's Church" (and, in fact, was believed to have been appointed by the Big Guy himself), and who could argue with that? Anyone who did risked excommunication (read that, damnation).

- ✓ **The immunity that criminal priests had from secular legal action:** As Jesus's representatives on earth, only Church courts could slap the wrists of or punish wayward priests. And the Church was remiss, to say the least, in punishing its own kind.

Renaissance-era churchgoers weren't concerned with abortion, pedophilia, or stem-cell research, like today (though sodomy was a big no-no). But as complaints and indiscretions piled up, the Church, by now an elite men's club, found itself boxed in from all sides. In its attempt to consolidate power presumably for religious purposes, it was, in reality, trying to secure more wealth and power. This power translated into abuses, blatant corruption, and unethical practices. Many of the popes (and clergy) lived extravagantly, had extramarital affairs, and sired illegitimate children. The Church reached some new levels of financial, moral, and political corruption during the Renaissance:

✔ **Simply put, the Church was growing more secular.** Many popes embraced humanist principles, pagan-inspired scientific progress, and other New World logics, turning away from the focus on religion. Church officials routinely commissioned works of art depicting Greek or Roman deities and stories. Furthermore, as the power of the Italian city-states grew, the papacy started to act more like an international politician than a spiritual leader.

✔ **Papal spending reached some all-time highs.** In order to fund the restoration of Rome to its former glory, the papacy raised vast sums of money through loans from the Medicis. They also raised money through taxes. The Church continued to tax everything around it, including the precincts of the Holy Roman Empire. But as European nations became more nationalistic, they resented the high taxation they were forced to pay to the mother ship.

✔ **The Church also raised money through other means, putting modern-day crooks to shame.** The sale of *indulgences* (a reduction of the time spent in hell for sinners) generated great revenue — and even greater controversy. Their reputation got even worse under Renaissance-era popes. In 1517, for example, Pope Leo X sold indulgences to help finance the construction of St. Peter's Basilica in Rome — which spurred Martin Luther (1483–1546) to post his Ninety-five Theses to the church door at Wittenberg in 1517 (and in turn led to the formation of the Protestant Church). The sale of Church offices to the highest bidder — or greatest beneficiary — raised a huge outcry as well. Because popes used Church offices as a way to reward relatives or clients who, in turn, wanted personal advancement, people regarded offices more as a source of income than a sacred appointment. This practice didn't die down until some Counter-Reformation popes like Pius V (1566–72) tried to set things back on course.

Loosening the Church's iron grip

The tide of change was brewing, and Italians weren't to be left behind. During the Renaissance, scholars, humanists, and even religious figures began to

challenge, or at least ignore, some Church practices. Their questioning came on the eve of great social, economic, and political changes that all contributed to a growing resentment of the wealth, power, and position of the elite clergy — and a sense that the Church was morally and financially corrupt, anyway. Just look at how those popes spent money, all those illegitimate children, their secular interests! What shame and scandal for such a holy institution! Machiavelli summed it up: "We Italians are irreligious and corrupt above others, because the Church and her representatives set us the worst example."

At the same time, expanding European nations increasingly resented the high taxes they had to pay to Rome. By around 1500, the Church's prohibition on charging interest and forming unions enraged those who wanted to take advantage of new markets and business opportunities.

A few factors contributed to the weakening of the Church's power:

- **Humanism:** The humanist emphasis on individualism severely put the power of God — and hence the Church — into question. Citizens started looking to themselves for answers, rather than to God or religious institutions. By contrast, the Church equated individualism with arrogance, rebellion, and sin. And its disdain for individualism only demanded more unquestioning loyalty to clerical practices.

- **The Protestant Reformation:** Humanism challenged the Church's doctrines, but the real confrontation came from the Reformation in the 16th century. The Reformation didn't occur in a vacuum; rather, it was the climax of brewing dissent, when reformists decided to put their theories in action. After Martin Luther posted his Ninety-five Theses at Wittenburg criticizing papal policies, he unleashed a storm. Luther's desire to correct the abuses of the Church (such as the sale of indulgences) inspired tens of thousands of followers.

- **Changing political factors:** The Church and Papal States, though still powerful, were in constant conflict with their neighbors. Alliances, betrayals, and realliances challenged the relative position of the Church. As Italian city-states gained strength, particularly in the North, the Church experienced some difficulty reining everyone in.

- **Economic factors:** The world was expanding, and Italians jumped on the bandwagon. The Renaissance occurred simultaneously with the so-called discovery of the New World, causing the growth of new markets around the world for merchants. The Church, which prohibited the charging of interest and formation of new guilds, restricted new businesses. Simply put, the Church was becoming less and less the center of people's lives.

Responding to secular threats

The heretical humanism, the Protestant Reformation, new nationalisms, and changing political and economic factors jeopardized the future power of the

Catholic Church. The Church reacted to these threatening factors in different ways, generally varying from pope to pope.

From the mid-1300s onward, the popes and Papal States pursued a few main goals. They wanted to resume their authority over all Christians and take back their political power so they wouldn't get mixed up in European power plays. They also hoped to free Constantinople from the Turks and remove them as a (very real) threat to all of Europe, and hence Christianity.

Some humanists, however, convinced the popes that they needed to use their skills to create official propaganda and forge an image of themselves as enlightened modern rulers. Here's a rundown of how the various popes responded:

- **Pope Nicholas V (1447–55),** a good friend of Cosimo de' Medici, turned a deaf ear toward pure Catholicism and supported humanism. Like the Medicis, he patronized the arts, rebuilt Rome's skyline, founded the Vatican Library, and supported intellectual endeavors. (Earlier, he ran into debt by buying manuscripts of the classics.) He did all this not to embellish his own reputation, supposedly, but to give the Roman Catholic Church greater authority and dignity.

- **Pope Callistus III (1455–58),** Nicholas V's successor, hated the Renaissance spirit and spent more money on warfare than on art, as did his next half-dozen or so successors.

- **Pope Julius II (1503–13),** a highly secular pope and a masterful politician who consolidated power in the Papal States, embraced the arts and beautified the city. In 1506, Julius laid the foundation stone of the new St. Peter's Basilica (financed with the sale of indulgences!), and he supported Bramante, Raphael, and Michelangelo. Ironically, humanists used his secular activities as examples of everything that was wrong with the papacy.

- **Pope Leo X (1513–21),** called the "Prince of the Renaissance" (the former Giovanni de' Medici and son of Lorenzo the Magnificent), altered the general pattern of indifference to, even outright disdain for, Renaissance ideals. Under his enlightened, extravagant, and corrupt leadership, he made the Vatican the most brilliant court in Italy. He embraced classical scholarship, entertained the humanists' skepticism, and invited the greatest philosophers, scholars, statesmen, poets, musicians, and painters (like Raphael) to Rome. Leonardo himself went to Rome in 1513 at Leo's invitation, and Michelangelo painted the Sistine Chapel ceiling under his reign. Considering that the Reformation would soon topple the Church's power once and for all, Leo's antics may not have done much to herald the transformation of the Church from an exclusively religious body to a secular political power. Nonetheless, it was an impressive, and timely, sure sign of these changing times.

Examining the Legacy of the Renaissance

The Renaissance left a lasting legacy throughout Europe and the Western world. It established canons in art, music, and literature. It created the multi-faceted *universal man* who was as comfortable dissecting the human heart as he was selling a plan for urban renewal to a city (see Chapters 5 and 12, respectively). Finally, it focused human attention on understanding the world through critical thought rather than blind faith in religion.

Whether the Renaissance was a gradual process, an outgrowth of the Dark Ages, or an outburst of lasting creativity doesn't matter today. What matters are the legacies that touch almost all aspects of modern-day life:

- **Science, math, and engineering:** Galileo Galilei (astronomy), Leonardo (engineering, anatomy), Michelangelo (anatomy, architecture), Andreas Vesalius (anatomy), Luca Pacioli (math), Marco Polo (maps, exploration)

- **Religion:** Humanism; the Reformation

- **Literature:** Petrarch, Dante, Machiavelli

- **Painting, sculpture, and architecture:** Science of perspective ushered in a modern era of architecture; Raphael, Leonardo, Michelangelo

- **Education:** New subject matter in the classics, from rhetoric to algebra and astronomy; revival of the teaching methods of independent thinking and comparative studies of classical languages; experimental schools

- **Music:** New developments in harmony; invention of new types of the harpsichord; bridge between secular and religious music

- **Politics:** Machiavelli's views on Italy's inner workings of politics and the power of the state

- **Technology:** Printing press, clocks, telescope, submarine, artillery, and the microscope (you can find out more about Leonardo's inventions in Part III)

Chapter 3

Uncovering the Life and Mind of a Genius

..

In This Chapter

▶ Understanding Leonardo's childhood

▶ Mastering his art: Leonardo's apprenticeship with Verrocchio

▶ Examining Leonardo's Florentine periods and his relationship with the Medicis

▶ Taking note of his time in the Sforza Court of Milan

▶ Looking at his final years in France

..

*B*ecause Leonardo da Vinci left most of his musings and sketches behind, people today know more about his great range of thought than about the actual events of his life. Unlike other artists or inventors, he didn't write an autobiography or keep a journal — just some messy notebooks. Still, historians have been able to piece together the key points of his life through the records of his friends, artists, family members, and historians who kept records at the time. As befitting a great man, Leonardo has been the subject of — thousands of? — biographies and studies, and here I provide a general chronology and understanding of his life.

If you're not familiar with what Italy was like during Leonardo's lifetime, you're going to have a difficult time following the course of events that I outline in this chapter — particularly during his adult years. His commissions, where he set up shop, and even the way he sold himself to his various patrons all relate in some way to the political situation — the competing city-states, the Italian Wars, and so on — in Italy at the time. If you haven't read Chapter 2, you may want to before you read this chapter. Or you can jump right in and refer to Chapter 2 as necessary.

Chilling in Vinci: Leonardo's Childhood

Every human being is somewhat of an enigma, and Leonardo, shown in old age in Figure 3-1, was no different. His childhood was particularly unusual — but it may have done this self-taught genius some good. Whether or not the image in Figure 3-1 is truly a self-portrait, this image is the one that many people have of him.

Figure 3-1:
Copy of possible self-portrait, c. 1512, Science Museum, London.

Science Museum / HIP / Art Resource, NY

The love child

Shocking, but true: Leonardo (christened *Lionardo*) was a love child. His parents welcomed him into the world with open arms, it seems, but he was illegitimate nonetheless. People today know some details about Leonardo's birth because his grandfather recorded the event. Leonardo was born on April 15, 1452 — Tax Day (though it wasn't back then). Nobody recorded the full name of Leo's mother, though her first name was Caterina. She may have been from a good family ("good blood," as people in that day called it), but most likely she was the lowly daughter of a woodcutter or farmer. Some scholars even speculate that she was possibly even a slave of Middle Eastern origin who'd converted to Christianity — but never took a new last name. What historians do know, however, is that she probably worked in Leo's father's household.

Leonardo's father, on the other hand, *was* a big man on campus, and he was of a different class. Ser Piero da Vinci, 25 years old when Leonardo came into the world, was a notary with a prestigious practice in Florence. He descended from a middle-class family full of prominent notaries, chancellors, and ambassadors of the Florentine Republic, with roots stretching back to the 13th century in Vinci. Leonardo was called "Leonardo di Ser Piero da Vinci," or "Piero's son," which stressed the family's genteel, rather than aristocratic, status.

Some historians debate about where, exactly, baby Leonardo was born and whom he lived with for the first few years of his life. He may have been born in Vinci, a Tuscan village perched just west of Florence. Or he may have been born in a farmhouse at Anchiano, just a few miles away from Vinci.

Where he spent his youth is pieced together from documents (tax records, of all things) filed by his grandfather, his stepmother's (Donna Albiera's) mother-in-law, and his dad, Ser Piero. (**Note:** These records may or may not be complete. Everyone knows how truthful people can be about dependents when it comes to paying taxes.)

Exploring the town of Vinci

Vinci, where Leonardo possibly spent most of his youth, was a rather typical little town in Tuscany. Situated between Montalbano and the valley of the Arno River, it boasted, at the time of Leonardo's birth, a fortified castle, an almshouse, the church of Santa Croce, and a few homes. Florence had acquired and held the town as a vassal in the mid-13th century.

The town name, Vinci, refers both to the town and the castle (the *Castrum Vinci*) within it. The name *Vinci* actually derives from the plants that grow beside the local stream, called the *Vincio*, which, back then, were woven throughout the Tuscan countryside. Leonardo, like other artists of the region, used these woven plants as one of his famous emblems in his paintings, including the *Mona Lisa* and *Lady with an Ermine*.

Today, the town of Vinci boasts two main highlights:

- ✔ **Casa Natale di Leonardo:** In this large stone building, the ruins of a Renaissance house on a hill above the town of Vinci, Leonardo was supposedly born. The place is a bit of a tourist trap, because Leonardo's exact birthplace remains unknown.

- ✔ **The Leonardo Museum:** Located in the medieval Castello Guidi, the museum doesn't house Leonardo's masterpieces. Rather, the building is a shrine for would-be inventors and others who appreciate Leonardo's many gadgets. Its highlight is a model of Leonardo's automobile, which historians believe was the world's first invention of a self-propelled vehicle (I cover it in detail in Chapter 7).

Leonardo's family tree

Leonardo's childhood didn't follow the "normal" parental course. In addition to unmarried parents who never lived under the same roof, he had many stepmothers, a stepfather, several half-sisters, and a half-brother. (**Note:** Given hazy records, some dates are approximate.)

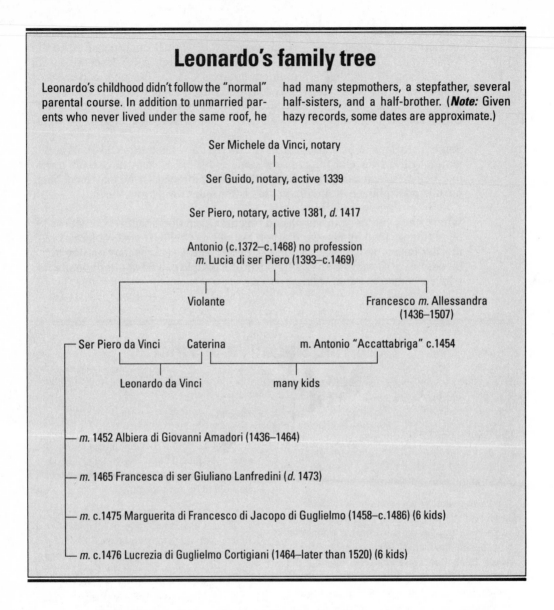

Ser Michele da Vinci, notary

Ser Guido, notary, active 1339

Ser Piero, notary, active 1381, *d.* 1417

Antonio (c.1372–c.1468) no profession
m. Lucia di ser Piero (1393–c.1469)

Violante

Francesco *m.* Allessandra
(1436–1507)

Ser Piero da Vinci Caterina *m.* Antonio "Accattabriga" c.1454

Leonardo da Vinci many kids

— *m.* 1452 Albiera di Giovanni Amadori (1436–1464)

— *m.* 1465 Francesca di ser Giuliano Lanfredini (*d.* 1473)

— *m.* c.1475 Marguerita di Francesco di Jacopo di Guglielmo (1458–c.1486) (6 kids)

— *m.* c.1476 Lucrezia di Guglielmo Cortigiani (1464–later than 1520) (6 kids)

Nevertheless, these records suggest that Leonardo may have lived with Caterina his first few years and then departed to his father's house when Caterina married a potter or a cowherd, depending on the source, in a nearby village. They also indicate that Leonardo lived with his grandparents in Anchiano in 1457, when he was 5 years old, but that shortly thereafter, he may have moved from his grandfather's home to live in Vinci with his father

and his stepmother, Albiera di Giovanni Amadori, a wealthy 16-year-old Florentine girl, whom Ser Piero married a few months after Leonardo's birth. (Poor Albiera died in childbirth in 1464, and Ser Piero subsequently roosted other wives and children.) To complicate matters even further, the possibility exists that Leonardo spent the bulk of his childhood with his father's younger brother, Francesco.

Not a boy, not yet a man

Leonardo's contemporaries described him as charismatic, handsome, and self-confident, a boy (and later man) who embraced the beauty around him. He also showed touches of fear, perhaps because of his awe for the mysteries of the natural world. In *The Lives of the Artists,* Giorgio Vasari, Leonardo's *effusive* biographer, wrote that his "personal beauty could not be exaggerated, his every movement was grace itself. . . . He possessed great personal strength, combined with dexterity, and a spirit and courage invariably royal and magnanimous. . . . His charming conversation won all hearts . . ." (Oxford University Press, 1998). Not to mention his musical prowess and voice, which evidently was on key, all the time.

Leonardo's friends, students, and colleagues also saw him as a warm and generous friend and supporter. Others (including his admirer, Vasari) have called Leonardo fickle — mostly for his inability (or, apparently, lack of desire) to complete projects and his near-crippling desire for perfection.

The man who knew all (about art, anyway): Vasari

In 1546, a Roman cardinal asked Giorgio Vasari (1511–74), a Florentine painter, architect, and historian, to assemble a list of artists and art. His request resulted in *The Lives of the Most Excellent Painters, Sculptors, and Architects,* first published in Florence in 1550 and dedicated to the Grand Duke Cosimo de' Medici. Nearly all the basics that people today know about Renaissance artists come from this monumental work. Vasari discussed the most famous Italian artists at the time, including Duccio, Ghiberti, Pisano, Masaccio, Donatello Giotto, Uccello, Brunelleschi, Alberto, Botticelli, Pierro della Francesca, Verrocchio (Leonardo's master), Raphael, Titian, Michelangelo, and, of course, Leonardo, among others. Besides sketching out Leonardo's life, he had some rather interesting trivia to say about the master: Supposedly, striking men with strange hair fascinated Leonardo, who followed them and then drew them. And when Leonardo painted the *Mona Lisa,* he hired jesters to keep his subject entertained. More important, however, Vasari noted one of Leonardo's defining qualities: His desire to invent constantly overrode his will to complete a project.

Mirror writing: Trick or devil's spawn?

Leonardo had a very peculiar way of writing. He used his left hand and wrote from right to left, in a manner resembling the Hebrew and Arabic languages today. In his time, reason was only slowly starting to crowd out superstition, and southpaws were seen as, sad to say, the devil's spawn. Often, parents forced natural-born lefties to use their right hands. Leonardo, however, was stubborn, so his left hand prevailed.

A few historians think that Leonardo's mirror writing was intentional, an attempt to keep his writings secret. (You could only easily read the text in a mirror, and because Leonardo used strange spellings and abbreviations, it was still difficult to read. He had others write his formal correspondence, however, so people could read it.) He had a lot of inventions that he wanted few people to see. He also held ideas that ran counter to the teachings of the Roman Catholic Church (such as the formation of the earth). Had people discovered his writings, he would've been in some hot water. Leonardo could've used mirror writing for these reasons as well:

- He was left-handed, and writing from right to left felt more natural. But on occasion he drew with his right hand as well, and was, some say, ambidextrous. (His left-handedness has been instrumental in identifying drawings that he may have done; a southpaw shades in drawings with the lines going from the left down to the right, exactly the opposite of a right-handed artist.)

- No one corrected his writing when he was a child.

- Simply, this method was easier for him. In writing with pen and ink, Leonardo didn't smudge his words as he wrote them.

Whatever the reason, Leonardo made it quite difficult for future excavators to decipher his brilliant musings.

Schooling himself

Although Leonardo came from a well-bred family, he lived in the countryside among peasants. Despite the intellectual bent of his family, his grandfather worked his own lands, his uncle had a mill, and one of his half-brothers was a butcher. So to put it gently, Leonardo wasn't exactly raised a gentleman.

Until he was 15 or so, his father's wife, Donna Albiera, probably schooled the young Leonardo, but no one knows for sure. Records show that Leonardo learned geometry and writing, but he picked up more from observing his surroundings than from studying books. To his chagrin, he probably received little if no instruction in Latin and never properly learned the classical languages, which made him an unlettered man in everyone's eyes. (Only later in life did he teach himself Latin and some Greek.) But he was an accomplished musician with the *lira da braccio,* a seven-stringed precursor to the violin.

Perhaps because of his lack of formal education, Leonardo taught himself, particularly in art. Sixteen Romanesque churches, each with their own decorations

and art, populated his town and the larger countryside. Leonardo possibly gained his first appreciation for art — Art 101, so to speak — from visiting and studying these pieces of religious art.

Respecting human (and animal) life

Leonardo held the highest respect for animal life. Supposedly, he purchased birds in the marketplace and set them free. He was also a vegetarian, which was very unusual for people in the 15th century. In his notebooks, he expressed his dietary preferences, which included cereals, fruits, mushrooms, pasta, and minestrone. He had completely humanitarian motives and viewed the murder of animals as the murder of men, proclaiming that animals' tombs were people's stomachs. (The fact that he later designed war machines is a contradiction that is neither easily nor totally explained.)

The world was a closed oyster

By today's standards, the status of illegitimate children in 15th-century Italy was rather abominable. Leonardo's father's profession (a notary) refused the entry of love children (and gravediggers, priests, and criminals) into its guild. Basically, Leonardo couldn't enter into a career that required a formal education from a university. Thus, many of the noble professions remained quite unfairly closed to Leonardo at birth, including medicine, law, and even Ser Piero's occupation. Leonardo would've had to belong to one of the Florentine dynasties, say, the Medici, to have any real job status as a bastard child.

Clearly, Leonardo had to search for a vocation in some other field, including literature, the arts, or even the army; many *condottieri,* or mercenaries, were illegitimate. But Leonardo showed great promise at drawing as a youth. Vasari suggested that he sketched landscapes, horses, and portraits as a child, and artists recognized his talent early on. Possibly for this reason, Ser Piero dumped him off to be apprenticed to one of Florence's renowned artists, Andrea del Verrocchio.

That was how Leonardo became an artist.

Honoring Thy Master: In Andrea del Verrocchio's Workshop

Leonardo cut his teeth just like all other artists in Renaissance Italy: He worked with a master artisan, specifically the great Florentine sculptor Andrea di Cione,

called Verrocchio (and nicknamed "True Eye"). Without this apprenticeship, not only would the as-yet-unknown Leonardo *not* have received any great commissions, but also he wouldn't have received the valuable training that he did.

Here's how Leonardo hooked up with Verrocchio: About 1468, Ser Piero moved his family from Vinci to Florence, which was then rising as the center for intellectual and artistic aspirations and achievements, a home of painters, sculptors, architects, and engineers. When Leonardo was about 16 or 17 years old, rumor has it (and Vasari's story confirms it) that Ser Piero showed one of Leonardo's drawings to his friend, Verrocchio. At the time, Verrocchio was in his mid-30s, one of the leading artists of the city, and despite possibly killing a woolworker with a stone the year of Leonardo's birth, a most outstanding Florentine citizen.

Artists and patrons alike admired Verrocchio both for his correct anatomical drawings and his perspective. He was also a craftsman who made metal objects of art for religious purposes and designed and constructed instruments. His studio carried out commissions for work in silver, bronze, marble, and wood, including helmets and cannons. His great accomplishment, one of the greatest engineering feats of the day, was the construction of the immense copper orb on top of the lantern of Brunelleschi's cathedral dome, the Duomo in Florence.

After Verrocchio saw one of Leonardo's drawings, he was simply never the same (according to Vasari, anyway). He took on Leonardo as an apprentice, possibly in his own home, and tried out Leo's abilities with the angel in *Baptism of Christ* (c. 1472–75), which you can read about in Chapter 13. Such was Leonardo's skill that after seeing Leonardo's angel, Verrocchio swore to never pick up a paintbrush again!

Working in Verrocchio's workshop

Verrocchio's workshop was typical of the period. Like other masters, Verrocchio used assistants ranging in age and experience to help him with his commissions. Leonardo's landing with Verrocchio represented the teenage artist's most prestigious turn of events to date.

Leonardo excelled in Verrocchio's workshop, which placed a heavy reliance on painting. In the workshop, Leo, like other apprentices, probably learned a smorgasbord of techniques, including how to

- Grind and mix pigments
- Apply geometry to the study of perspective and space

✔ Prepare panels for paintings

✔ Paint in oils

✔ Work clay and cast bronze

Different artists worked in Verrocchio's workshop during Leonardo's tenure, and most collaborated on different projects. Among them were some (nearly) household names:

✔ **Sandro Botticelli (1445–1510):** Sistine Chapel frescoes; *Primavera; Birth of Venus*

✔ **Piero Perugino (c. 1450–1523):** Sistine Chapel frescoes; *Adoration of the Magi*

✔ **Cosimo Rosselli (1439–1507):** Sistine Chapel frescoes

✔ **Domenico Ghirlandaio (1449–93):** Sistine Chapel frescoes; fresco cycle in Sta. Maria Novella, Florence; *Scenes from the Lives of the Virgin and St. John the Baptist*

✔ **Lorenzo di Credi (1459–1537):** *Annunciation; Portrait of Perugino; Venus*

Collaborating, the name of the game

As a group, Verrocchio's studio helped define humanism, a style that meshed Tuscan painting with elements of the classic revival (head to Chapter 2 for more information about humanism). Each artist contributed to a painting, sculpture, or other artistic work; some painted angels, and others touched up on colors, while still others filled in the background.

In Verrocchio's studio, Leonardo aided in the following pieces, although none are *definitively* attributed to him except for the landscape painting:

✔ *Annunciation* **(c. 1472–75):** Attributed to Leonardo (and possibly Verrocchio's workshop). I discuss it in Chapter 13.

✔ *Baptism of Christ* **(c. 1472–75):** Leonardo painted the angel. I discuss it in Chapter 13.

✔ *Landscape of Santa Maria della Neve* **(1473):** Leonardo reworked his native landscape with new perspective, light values, and emotion. See Chapter 12.

✔ *Portrait of Ginevra de' Benci* **(c. 1474):** Fully attributed to Leonardo. Head to Chapter 11.

Leonardo's apprenticeship seems to have officially ended in 1472, when he was 20 years old and first joined the artists' guild, the *Compagnia de San Luca* (the Company of Painters). His membership signified his independence as a professional painter. He probably remained with Verrocchio, however, about four more years, working alongside him in the studio and even possibly living in his household. Leonardo didn't decide right away to pursue individual glory.

Although Leonardo lived in Florence for only about 20 of his 67 years, he's nonetheless known as a child of Florence for his rich training and great artistic debt to Verrocchio.

Gaining Independence: Leonardo's First Florentine Period

Between 1476 and 1478, Leonardo possibly set up his own workshop. Even though he was slowly making a name for himself, he probably received only small-scale commissions during these years. The Florentine art market was crowded with good painters, including Antonio del Pollaiuolo, Sandro Botticelli, Domenico Ghirlandaio, and Andrea del Verrocchio. To put it bluntly, Leonardo had some tough competition.

If this period marked Leonardo's first stabs at being an independent artist and built his reputation as a painter of exquisite skill, it also brought attention — and accusations — regarding his sexual preferences. Leonardo's sexuality has never been determined, though most historians think he was homosexual and point to these reasons as indications: No record shows that he was interested in women (except his mother and motherly figures, as Sigmund Freud pointed out), and he wrote in his notebooks that male-female intercourse disgusted him. He worked very closely with handsome male apprentices, including Giacomo (known as Salai for his "demonic" behavior), who started working with Leonardo around 1490, and Francesco Melzi, who joined Leonardo's household around 1507, as a teenager. Both followed Leonardo until his death. Still, no solid proof exists one way or another. Nevertheless, his years in Florence ended when he had a nasty brush with the law regarding this very issue.

Receiving his first commissions

Despite the fierce competition, Leonardo received a few commissions during his first Florentine period, which historians date from 1478 to 1483. Leonardo, like many job seekers today, mainly relied on word-of-mouth recommendations,

as well as the influence of his father. He also garnered some attention from Lorenzo de' Medici's court, though he never became the Medicean court artist. He received commissions for these works:

- ✔ *Madonna and Child* **(c. 1478):** Also called *Madonna with the Carnation, Munich Madonna,* and *Madonna of the Vase,* this mother-son portrait was possibly Leonardo's first solo work — although, like many other paintings, its authorship is debatable. (See Chapter 13.)

- ✔ *Altarpiece for the Bernhard Chapel in the Palazzo Vecchio, the seat of government in Florence* **(1478):** Leonardo's father may have had a hand in this commission. But in what was becoming increasingly characteristic form, Leonardo never completed the painting, which only added to his reputation as a flaky artist.

- ✔ *Small Annunciation* **(1480–81):** Although Leonardo's studio received the commission for this work, Leo himself may or may not have authored it. Lorenzo di Credi, who worked in Verrocchio's workshop, may have authored the painting.

- ✔ *St. Jerome* **(c. 1480–83):** Also called *St. Hieronymus,* this painting depicts a repentant St. Jerome, beating his breast with a stone. But, like other paintings, Leonardo never finished it, choosing to skip off to Milan instead. (See Chapter 13.)

- ✔ *Adoration of the Magi* **(c. 1481–82):** Leonardo was commissioned to paint a magi scene for the church of San Donato Scopeto near Florence. Although it was his most innovative painting to date, Leonardo never finished it because he left Florence for Milan. (See Chapter 15.)

By the late 1470s, Leonardo had fully established himself as a painter. But a few years later, he was ready to move on. For one thing, he was disappointed that he wasn't chosen as one of four masters to paint the walls of the Sistine Chapel. For another, he had a brush with the law that probably tarnished his reputation. So he left Florence — perhaps willingly, perhaps not (some evidence points to a Leonardo, perhaps not *our* Leonardo, being banished from Florence for his "bad life") — for greener pastures.

Considering Leonardo's sexuality

Although inhabitants of Renaissance Italy were fascinated with classical Greek mythology and, as a consequence, homoerotic male love, sexual mores were pretty strict. In many of the Italian city-states, homosexual relations between men were punished severely, often with burning at the stake. The crime? Sodomy, which many people viewed both as a sin against nature and God *and* as an affront to the political and religious establishment. In 1432,

Applying Freudian psychology to Leonardo's sexuality

Sigmund Freud, one of the most influential figures of the 20th century, had, like the Renaissance man's contemporaries, many questions about Leonardo's sexuality. In *Leonardo da Vinci and a Memory of His Child-hood,* originally published in 1910 (W.W. Norton, 1989), he applied his theory of infantile sexuality to Leonardo, arriving at these conclusions:

✔ Leonardo probably lived alone with his mother for his first five years.

✔ Leonardo's mother doted on him.

✔ Leonardo's father neglected him.

✔ Leonardo experienced a strange emotional life during infancy and childhood.

✔ As a result of this rather unusual Oedipal development, where Leonardo internalized his father's absence and his mother's domination into his sexual preferences, Leonardo developed homosexual tendencies.

Taken together, these clues pointed to homosexuality. Still, Leonardo may have repressed his erotic instincts through art, scientific research, and a thirst for knowledge. According to Freud, the master "did not love and hate, but asked himself about the origin and significance of what he was to love or hate."

Despite Freud's status as one of the giants of psychoanalysis, he speculated at best. What's more, he misread a translation of a dream in one of Leonardo's notebooks, which led him to perhaps false conclusions about the artist's sexuality. Today, current psychoanalysis research has debunked many of Freud's doctrines, but he nonetheless still exerted a great impact on the way that people today view sexuality. (See Chapter 9 for more discussion of Leonardo's sexual bird dream.)

Florence founded a special authority, called the *Uffiziali di Notte* (the evil-sounding Officers of the Night), which hauled in suspect lovers and prosecuted the sodomizers. The Officers of the Night's greatest coup was bringing in a by now well-known artist named Leonardo.

In 1476, while he was still living in Verrocchio's house, Leonardo was accused (twice) and denounced, along with four others, to the Florentine authorities for alleged acts of sodomy, once with a teenage model or prostitute, Jacapo Saltarelli. His accuser? No one knows. In those days, squealers put accusations in a wooden box, called a *tamburo,* which lay outside the front of the Palazzo Vecchio. The authorities reputedly held Leonardo in confinement for about two months, but due to lack of evidence, finally released him.

Still, the trial made Leonardo suspicious of gossip in general (he often drew grotesque portraits of malicious gossipers). It also raised several unresolved questions about Leonardo: Was he homosexual? Was his relationship with

Verrocchio romantic or merely professional? Were his relationships with his handsome students homosexual? Why didn't he marry? And perhaps the most important, how did his sexuality affect his life and art? Despite the speculation and theories about Leonardo's sex life, at least for now, his sexuality remains a mystery.

Romping through the Sforza Court of Milan

Leonardo departed for Milan soon after he finished (for the first time, anyway) with Florence. But he'd probably already met his Milanese patron, Ludovico Sforza, around 1478, when he was still living in Florence.

Known as "Il Moro" (The Moor) for his swarthy coloring, Ludovico was the son of Francesco Sforza and a famed patron of the arts. How to define this man? Suffice it to say that the whole era was a mess, and Ludovico was firmly embedded within it.

Milan, a city three times larger than Florence and surrounded by high walls with seven gates, held a highly strategic position in southwestern Europe, and as a result, often fought military battles. In 1494, years after Leonardo began working for him, Ludovico received the ducal crown from the Milanese nobles. That year he also involved Charles VIII of France and the Holy Roman Emperor, Maximilian I, in Italian politics — initiating, sorry to say, the Italian Wars involving France, Spain, and Italy for control over the states of Italy (see Chapter 2 for the excruciating details of this imbroglio). Despite this ghastly situation, under the Sforza Court of Milan, Leonardo achieved some of his lasting works.

Highlighting strengths as military engineer

You think job applications are hard to write today, right? Just think if you had to tout your skills as an engineer *and* an architect *and* an artist.

In 1482, Leonardo set his mind to working for Ludovico and penned a letter outlining his capabilities. Because Italy was besieged by the wars between the various city-states (soon to be followed by a French invasion) and Ludovico feared invasion from enemies on all sides, particularly Venice from the east,

but also by the papal armies from the south and the French from the north, Leonardo, who needed a job, focused mostly on his skills as a military engineer rather than an artist.

Leonardo offered to acquaint the duke with his skills, which included

- Plans for light, strong, and indestructible bridges to thwart the enemy
- Knowledge about how to cut off water from trenches, how to construct battering rams, and how to build scaling ladders
- Plans for destroying every fortress (except for those built with rock)
- Plans for building vessels suitable for both attack and defense, for fights at sea
- Secret transportation for navigation under trenches
- Plans for armored cars (tanks) and cannons
- Plans for making mortars and light weapons
- Plans for catapults and other weapons in those situations when cannons wouldn't work

(None of these machines were ever built, as Chapter 8 shows.) In times of peace, Leonardo could design everything else: public and private buildings, canals, and other urban designs. His services as a sculptor and painter also served him well. In particular, he wanted to build the famed — and doomed — bronze horse.

Serving as court artist

When Leonardo arrived in Milan, Ludovico had changed faces, replacing his warlike tactics for diplomacy. Therefore, he didn't need Leonardo's military services — at least for the moment.

Between 1487 and 1490, Leonardo took the high position of court artist. During this time, he ran his own workshop with his very own apprentices, experimented in the fields of architecture and anatomy, and embarked upon a number of projects. He organized court festivities, designed costumes and pageants, devised puzzles for the fine ladies of the court, and sketched military devices, machines, and vehicles.

Designing the bronze beast

Leonardo's greatest commission — indeed, one of the largest projects of its kind for the time — was working on a bronze equestrian statue of Francesco

Sforza, Ludovico Sforza's father (see Figure 3-2). Ludovico intended it not only as a memorial to his father's military successes, but also as a means of boosting his own reputation.

Figure 3-2:
Study for the Trivulzio Equestrian Monument, 1508–10, Royal Library, Windsor.

Scala / Art Resource, NY

Leonardo viewed the statue as one of his greatest commissions. After he received the commission, he began to study the movement of horses, made countless anatomical horse sketches, experimented with different horse poses (the rider was somewhat of an afterthought), and invented new bronze casting techniques.

Around 1489, after spending a few years thinking about it until Ludovico threatened to find another sculptor, Leonardo finally started work on the *Gran Cavallo* horse statue. Around 1492, the year that Columbus sailed the ocean blue and discovered the New World, Leonardo built a huge clay model of a rearing horse, over 23 feet high and weighing nearly 80 tons — just in time for Ludovico's illegitimate daughter's wedding.

However, in line with his growing trend, he didn't finish the statue. From his drawings (and the uncompleted equestrian monument), you clearly can tell that he never mastered how to balance the weight of all that metal on two legs of a prancing (or rearing) horse. Then, tragedy struck. Leonardo had set aside about 80 tons of bronze to use for the statue, but in 1494, the duke embroiled his city with French troops. The bronze intended for the casting of Ludovico's father's memorial was turned into cannons instead. So, all that remained of the equestrian statue — which, incidentally, would've been Leonardo's only major sculptural work — was his clay model. The intended statue nonetheless made Leonardo famous throughout the region.

Re-creating the horse that never was

No complete drawing of Leonardo's equestrian monument to Sforza survives. In the late 1970s, however, a pilot and amateur sculptor named Charles Dent read an article about Leonardo's plan in *National Geographic*. He decided to sculpt an 8-foot model of the horse, with the intention of building it in its full splendor and then offering it to Italy as an expression of gratitude for bringing on the Renaissance. Dent founded the nonprofit Leonardo da Vinci's Horse Incorporation in 1982 to raise funds for the project, but only after his death was the necessary money raised to actually build the horse. Led by sculptor Nina Akamu, who designed an 8-foot

model, the Tallix Art Foundry in New York manufactured the full work in bronze, in multiple pieces (Leonardo, though he planned to build his statue in one piece, never could've swung it). In September 1999, 500 years after Leonardo's original model met its destruction from the French archers, the bronze horse took its place at the San Siro Hippodrome in Milan. (Since then, an American version has been cast and now resides in Grand Rapids, Michigan.)

The horse's specs? It weighs around 15 tons, is 24 feet tall, and cost $6 million.

Leonardo's larger-than-life-sized model hung out in Milan for a while, arousing the admiration of visitors and residents. But when the French troops (under the new French king, Louis XII) invaded Northern Italy in 1499, Milan fell and Ludovico Sforza was overthrown. Rumor has it that archers used Leonardo's equestrian model for target practice, destroying it. Many sketches and preparatory studies survive (refer to Figure 3-2) — but that was the end of Leonardo's famous horse.

Leonardo revived his equestrian statue about 15 years later, when he designed a similar monument for the tomb of Marshal Gian Giacomo Trivulzio, who ruled Milan as governor for the French after 1499.

Embarking on other artistic adventures in Milan

Very little is actually known about Leonardo's work in Milan in the late 1480s, but it's certain that he started some other projects besides organizing court festivities and working on the ill-fated equestrian statue. He addressed, for example, heating problems of the ducal palace. He also developed a working style that defined his life's endeavors: He worked on a couple of major public projects, did a few portraits here and there, and conducted scientific research in his spare (!) time.

More important, during this time Leonardo made a name for himself as a portraitist and accomplished painter. Undoubtedly, Leonardo's greatest lasting

accomplishment (if you disregard its disrepair) was his famous mural, *The Last Supper* (which I discuss in depth in Chapter 14). During his Milan years, he also painted

- *Madonna Litta* **(c. 1490):** Like many of his portraits, its authorship is disputed. Because of its awkward composition, some art historians attribute the painting to Leonardo's student, Giovanni Antonio Boltraffio. (See Chapter 13.)

- *The Virgin of the Rocks* **(1483–86, c. 1495–1508):** Two versions of this painting exist, one in the Louvre, and one in the National Gallery in London. I'll just say that Leonardo's inability to meet deadlines created the need for the two versions. (See Chapter 13.)

- *Lady with an Ermine* **(c. 1482–83):** Again, speculation exists about this portrait's authorship and the identity of its subject. (I discuss it in Chapter 11.)

- *Portrait of a Musician* **(c. 1482–83):** Otherwise known as *Portrait of a Young Man*. If this painting is really by Leonardo, it's the only portrait he did of a man. (Also in Chapter 11.)

- *Sala delle Asse* **(c. 1496 and 1498):** The last surviving commission that Leonardo carried out for Ludovico Sforza was the *Sala delle Asse,* which he painted in Sforza's castle. Here, he decorated a whole room with the intertwined branches of several trees and the Sforza coat of arms.

When Ludovico's reign came to an end in 1499 (see the sidebar "A little note on the sorry political condition"), Leonardo remained in Milan for a few months. Soon, however, he set out for greener pastures — and new patrons.

A little note on the sorry political condition

Too bad that Ludovico didn't take Leonardo's plans for the defense of Milan more seriously, for unfortunately, Ludovico wasn't the sharpest tool in the shed when it came to politics.

He broke his alliance with Charles VIII, the French Louis XI's son, and joined their enemies, the pope and the Republic of Venice. This alliance drove Charles back into France, and Louis XII succeeded him. But Louis exercised his right to rule Milan, and the Venetians and the pope abandoned their uneasy alliance with Ludovico and joined the French king in their attack on the duchy. Ludovico, predicting his imminent downfall (he never even tested the strength of his fortifications around his city!), fled to Innsbruck and the safe haven of his niece's husband, the Emperor Maximilian I. In 1499, Louis XII took over Milan.

Ludovico regained possession of Milan in early 1500, but he was captured by French forces and thrown into a French dungeon, where he remained until his death in 1508.

Returning to Florence: Leo's Second Florentine Period

The fall of Ludovico to the French and Louis XII's invasion of his previous haunting ground spelled disaster for Leonardo's most important patron to date. Despite this unfortunate set of events, Leonardo was already famous within Italy and had made many valuable contacts throughout Europe.

When he left Milan, Leonardo went to Mantua with his mathematics teacher, Luca Pacioli, a famed mathematician whom he met and befriended at Ludovico Sforza's court, and one of his favorite students, Salai. There he met Isabella d'Este, a great patron of the arts and wife of a mercenary duke of Mantua, whose portrait he painted before moving on to Venice in the spring of 1500. (Despite her nagging, he never completed the portrait; even worse, through her Florentine agent Isabella persecuted him for many years with would-be commissions.) Leonardo's visit to Venice in 1500 is his only documented visit, although he probably consulted on Venetian architectural matters on and off for a few years. A month or so later, Leonardo left for Florence, where he found new clients and activities and reached the height of his fame.

Florence looked different this time around: The Medicis, the ruling family (refer to Chapter 2), had been exiled, the French army of Charles VIII had invaded and now occupied the city, the Florentines had bribed the French to leave, and the Pisans were revolting. What a messy political situation, but Leonardo somehow navigated through it.

First up: An altar painting

When he returned to Florence at age 48, Leonardo had experienced some successes — and as the bronze equestrian statue showed, some failures. In Florence, he experienced a bit of both.

First, he accepted the commission for an altar painting for the friars of the Order of the Servites at Santissima Annunziata. Leonardo made a *cartoon* (a drawing to be used as a model for the finished work) with the Madonna, Saint Anne, and the baby Christ. (Now, experts consider it one of Leonardo's unfinished masterpieces, known as *The Burlington House Cartoon,* c. 1499–1500; you can read more about it in Chapter 13.) But in a typical change of heart, he probably abandoned his work to paint the portrait of the beautiful Ginevra,

which he may never have finished either. Only years later, probably around 1508–10, did Leonardo paint an oil version of the scene, called *The Virgin and Child with St. Anne,* which differed considerably from the earlier cartoon.

A slight detour: On the march with Cesare Borgia

During his second Florentine period, Leonardo took a little — well, okay, a rather lengthy — side trip around Italy. In the summer of 1502, at age 50, Leonardo sharpened his military skills and went to work as a military engineer for the notorious General Cesare Borgia ("Duca Valentino"). The illegitimate son of Pope Alexander VI and commander of the pope's army, Borgia led the military campaign to unite the warring state of Italy under one unified Papal State — that is, under the rule of his father. Known as a violent man, he probably murdered his brother and other relatives and terrorized all of Italy during his conquests. Generally, his name is now synonymous with cruelty, impiety, deception, and, yes, even incest.

Leonardo was a pacifist who talked at great lengths about the rights of all men. But he was also pragmatic and couldn't afford to turn down a dream job. Not to mention, he'd already designed war machines under Ludovico Sforza, so why not try to put some of them to use and go along with Borgia's plans? Perhaps Leonardo and his protector even took a liking to each other, because both liked powerful, strong, and inventive men.

Meeting Machiavelli

While Leonardo traveled throughout Italy with Cesare Borgia, he met the villainous-looking secretary of the Florentine Republic: Niccolò Machiavelli. Machiavelli, anxious to get in on the action himself, had schemed to ally the powerful Borgia with the Tuscan authorities. (Borgia's personality and actions, set against the backdrop of the political unrest of the Italian Wars, subsequently inspired Machiavelli's 1513 masterpiece, *The Prince*.) Leonardo, perhaps ignorant of Machiavelli's motives, admired him for his objective studies of humankind. For three months, Machiavelli traveled with Borgia's entourage, and he and Leonardo possibly influenced each other's thinking and designs. They did, after all, scheme to change the direction of the Arno River. Their friendship resulted in one of Leonardo's greatest commissions: the fresco in the great hall of the Palazzo Vecchio, *The Battle of Anghiari.*

Leonardo spent about a year traveling with Borgia throughout Central Italy, the Romagna. Borgia intended to conquer that region before he moved on to the rest of the peninsula, which France and Spain were fighting over. During this year, Leonardo involved himself in designing the various fortifications that Cesare Borgia ordered. His designs included civilian and military buildings, canals, cisterns, ramparts, and moats. Any plans he may have presented to Borgia's construction men didn't survive.

Leonardo couldn't have failed to notice the sacking of towns, massacres, and general mayhem that accompanied Borgia's army, even though he didn't travel often with the army and probably witnessed only one town capture. Still, he left no records of his thoughts on the subject. By early 1503, he left Borgia (who was rapidly losing his power) and returned to Florence to paint.

Back to the drawing board: Fending off his rivals

Back in Florence, Leonardo wasn't alone in his high artistic success. Michelangelo, another great artist who was younger by a generation, inhabited Florence's artistic space as well (check out his achievements in Chapter 10). The two seemed to be more rivals than friends, spurred, perhaps, by the younger artist's nonstop teasing about Leonardo's inability to finish a project.

In 1503, Leonardo started two of his great masterpieces: *The Battle of Anghiari,* a mural intended to adorn the hall of the Palazzo Vecchio, and the *Mona Lisa.*

The battle scene

In 1503, Leonardo and Michelangelo had the fortunate opportunity to work together when they were commissioned to paint large murals for the Palazzo Vecchio's great hall in celebration of the Republic of Florence, which came into being (again, after the death of Lorenzo the Magnificent) in 1494. The two murals were intended to suggest the new republic's self-confidence and recent military victories.

Leonardo's wall painting, which he left unfinished in the spring of 1506 and which was destroyed a few decades later, depicted the Battle of Anghiari of 1440. The idea was to juxtapose this scene with Michelangelo's so-called *Battle of Cascina.* Together, the two paintings (known only through their contemporary copies, because Michelangelo never finished his scene, either)

would've been the most impressive decoration of any public interior at that time. It would've placed two masters side by side for all the world to see. But in 1504, the Florentine government called Leonardo away to oversee the actual defenses at Pionbino, and that was the end of that.

Figure 3-3 shows a copy of Leo's painting, done by Peter Paul Rubens around 1603. Rubens, although he based his painting on an engraving done after Leonardo's original, changed some details. Still, it possesses all of Leonardo's original's power.

Overall, despite what must've felt like a threatening rivalry, Leonardo was impressed with Michelangelo's High Renaissance figures — powerful depictions of male bodies and tensions of muscles. He even did sketches of Michelangelo's *David* (1501–4). Michelangelo, in turn, seems not to have admired Leonardo's sinewy action figures quite as much — too wimpy, perhaps?

Figure 3-3:
Copy of the Battle of Anghiari by Leonardo, by Peter Paul Rubens; black chalk, pen, and ink heightened with lead white, overpainted with watercolor; 45.2 x 63.7 centimeters (17.8 x 25.1 inches); Louvre, Paris.

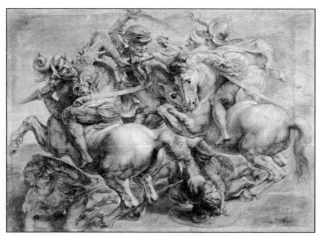

Réunion des Musées Nationaux / Art Resource, NY

A simple little portrait

Also around 1503, Leonardo started what arguably would become not only his most famous portrait, but also perhaps the most famous portrait in history: the *Mona Lisa,* a portrait of the woman thought to be Lisa Gherardini (see Chapter 11 for an in-depth look at her and all the identities she's assumed over the years). Even before he finished it, the portrait greatly affected Florentine painters, including the young Raphael, who visited Leonardo's workshop many times and adopted his schema (head to Chapter 10 for more on him). Overall, it created a new form of portraiture.

Leonardo never delivered the *Mona Lisa* to his client, Francesco del Giocondo (Lisa's hubby), because in 1503 he received a much larger commission: to paint the Grand Council Chamber in the Palazzo Vecchio. And what was a simple little portrait when greater projects called from the government, no less?

Heading Back to Milan

Around 1506, the French governor of Lombard, Charles d'Amboise, summoned Leonardo to Milan. Back on his old haunting ground, Leonardo also began work for d'Amboise's uneasy ally, Maximilian Sforza, the duke of Milan and son of Leonardo's former patron, Ludovico.

It seems as if Leonardo relaxed a bit for the six years he remained in Milan, collecting a hefty income from the French rulers. Nobody's exactly sure what Leonardo did during these years, though he seems to have continued the anatomy studies he began in Florence. He also tried to finish projects he'd already started and been paid for, including *The Battle of Anghiari* and the second version of *Virgin of the Rocks.*

Leonardo's friendship with Francesco Melzi

During his time in Milan, Leonardo met his long-time friend, companion, student, and later heir, Francesco Melzi. No one knows much about Melzi, except that he was about 40 years younger than Leonardo and, according to Leonardo's biographer Giorgio Vasari, exceedingly handsome (a *bellisimo fanciullo,* or beautiful boy) and possibly of noble Milanese birth.

Possibly, Leonardo and Melzi had a father-son relationship, though some historians have hinted at more. In any case, Melzi inherited all of Leonardo's manuscripts, instruments, books, and drawings, providing Vasari with important notes for his biographical sketch. And most importantly, he never left Leonardo's side.

Leonardo also had the opportunity to revive his plans for a grand equestrian statue — this time not for the ousted Ludovico Sforza, but for Gian Giacomo Trivulzio, who helped take Milan as commander of the French troops. Like his first commemoration to the Milanese ruler, Leonardo never completed this monument.

Living the High Life at the Papal Court in Rome

When Charles d'Amboise, the French governor of Milan, died in 1511, the alliance between Maximilian Sforza and the French king dissolved (refer to the preceding section). Leonardo once again found himself without a patron.

Take note that until now, Leonardo had never exactly established himself with the great family, the Medicis. In his early days in Florence, he'd met and even won haphazard patronage with Lorenzo the Magnificent. Although Lorenzo was impressed with his artistic and mathematical abilities, he was more interested in the philosophers, writers, and artists associated with his Platonic circle, so a general lack of sympathy may have existed between Leonardo and the Medicean court. In fact, Lorenzo was the one who had encouraged Leonardo to go to Milan — and subsequently had made no effort to bring him back to Florence. But Leonardo restored his dignity — and funds — when he accepted the protection of Prince Giuliano de' Medici (the Magnificent), a son of Lorenzo the Magnificent, in the fall of 1513. (Lorenzo also bankrolled Michelangelo, Raphael, and Botticelli.) With his students and friends Melzi and Salai in tow, Leonardo parked himself at an apartment at the Belvedere, a villa inside the Vatican, close to the papal palace in Rome.

Why Rome, and not Florence, the hot seat of Medici power? The Medicis, after a big kick in the pants, had returned to power in Florence. But shortly prior to this generous invitation, Giuliano's brother, Giovanni, had succeeded to the Throne of St. Peter as Pope Leo X. Leonardo thus traveled with Giuliano to the papal court in Rome. Despite his highest hopes and a lavish life inside the Vatican, however, he didn't become the court artist. Nor did he receive the kind of large commissions that the younger Raphael and Michelangelo, at the height of their careers, were receiving at the time.

Yet, in Rome, Leonardo still managed to experiment with flight, optical puzzles, botany, and new types of art oils and varnishes. He also tried to make giant, round mirrors, similar to ones used in modern telescopes. And because the Medici dynasty depended on the dye industry, he attempted to invent a solar reflector that would help make better dyes. He also tried to design a machine to coin money for the mints of Rome, design a stable for Giuliano,

and aid in Leo X's project to drain the Pontini marshes south of Rome. If that's not enough, he also probably painted *St. John the Baptist* (discussed in Chapter 13) during this time. Unfortunately, though he wished to continue with his anatomical studies, the Church put its foot down on the cutting up of dead bodies, so he studied animal anatomy instead (head to Chapter 5 for more on Leonardo's anatomical studies).

In 1515, political events again took a turn for the worse in Leonardo's respect. French king Louis XII died. François I of France (Louis XII's cousin and father-in-law, and not yet 20 years old!) retook Milan and tried to overthrow Maximilian and reestablish French control. You may think this fiasco shouldn't have affected Leonardo at all, because he was no longer in Milan. But in the convoluted political alliances and shenanigans of Renaissance Italy, Giuliano de' Medici stepped in to defend Milan and was killed. Once again, Leonardo was without a patron.

Somewhere along the way, Leonardo had met the French king, possibly during secret meetings between Leo X and the king, who was aware of Louis XII's high regard for him. So Leonardo stayed in Rome for a few months before accepting yet another attractive invitation from yet another strong suitor: the French Court.

Philosophizing in France with François 1

In 1515 François I, king of France, welcomed his so-called enemy, Maximilian Sforza, into his court as a fake cousin. A year later he hired the aging Leonardo, who by then was sickly and paralyzed in his right hand from a stroke. Leonardo, with students Melzi and Salai in tow, arrived at the palace — actually, a small castle called Cloux, or Clos Lucé, about 20 miles away from the death dungeon of his first patron, Ludovico Sforza (Maximilian's dad), and connected by an underground tunnel to the king's Royal Château at Amboise, in the Loire Valley. Once again, Leonardo raked in the dough from the French.

Despite his growing illness, Leonardo undertook different professional activities. He organized his notebooks (which were later reorganized), undertook hydrological studies, planned an irrigation project in the Sologne (south of the Loire, between Amboise and Orleans), and designed a royal palace for a small town south of Blois, at Romorantin.

One of his more interesting projects this time involved a mechanical lion, the symbol of Florence. Leonardo's lion, able to walk a few steps, had a chest that opened to show, instead of a heart, a bunch of *fleurs-de-lis,* irises as an emblem for the French royal family. Leonardo and the king trotted the lion out for special occasions, such as festivities and for the peace talks in Bologna between François I and Pope Leo X.

One can only speculate about the qualities that François saw in Leonardo, who by then was unable to paint. It seems as if François simply enjoyed their conversation (in French? Italian?), deeming Leonardo to be one of the greatest philosophers and men alive.

On April 23, 1519, a few days before he turned 67, Leonardo, who didn't believe in life after death, asked a notary to record his last will and testament. He died on May 2. He received the sacraments of the Church whose teachings he questioned and was buried in the cloister of Saint-Florentine in Amboise, in the heart of the king's castle. But after the destruction of the church, Leonardo's remains traveled thither and yon during the Wars of Religion. They were eventually transferred to the Chapel of St. Hubert in the castle of Amboise — Leonardo's final resting place.

A Life in Full

Leonardo's career path, though unsurpassed in many ways by anybody before him or after, was actually pretty common for other painters, sculptors, or architects of the period. Like Leonardo, most good ones worked from commission to commission, traipsed from court to court, and largely caved in to the demands of their patrons. But Leonardo's itinerant lifestyle, in large part due to changing political conditions, perhaps gave him greater freedoms to explore and experiment with different demands and problems (such as his equestrian horse and his plan to change the course of the Arno River).

What *does* differentiate Leonardo from other Renaissance masters is his sheer mastery of all the subjects he tackled. He studied every field under the sun: geology, optics, music, mathematics, mechanics, hydraulics, botany, anatomy, astronomy, painting, sculpture, architecture, and more, as the following chapters show. Some say he worked out the principle of gravity before Isaac Newton, explained astronomy before Johannes Kepler, understood the human body before later anatomists, and pioneered a new realism in painting and portraiture. At the same time, Leonardo wasn't always the revolutionary inventor that some make him out to be. He also drew extensively on existing research and methods, improving on everything ranging from artistic perspective to military machines. So in the greatest sense, Leonardo was both an unequaled inventor and a product of his era's achievements.

Renaissance Italy, like the golden age of Greece, represents a major pinnacle of human achievement, and Leonardo, perhaps more than any of his colleagues, symbolizes that age. At the same time, despite rough accounts of his life and the musings he left in his notebooks about — well, everything — he remains one of history's most mysterious figures.

Chapter 4

Influencing Leonardo

In his study on Leonardo, Sigmund Freud wrote, "He was like a man who awoke too early in the darkness, while the others were still asleep." Freud presented a view of Leonardo as a modern mind emerging out of the Dark Ages, shedding superstition and the unscientific ways of yore.

Freud's idea that Italy was still asleep while Leonardo enlightened the world isn't exactly true, for Leonardo didn't work in isolation. Even though people think of him as the quintessential Renaissance guy today, he was one of many geniuses in his field. Before his birth, a new culture of art, innovation, science, and engineering had sprung up in Italy, creating a context for his genius to thrive. This setting included the heightening of the artist to near pop-star status, the culture of patronage, and new developments in art, math, and science, to name a few.

Don't worry; I'm not taking Leonardo down even a notch. I'm just acknowledging that he had some pretty important precedents and inspirations — a little help, if you will — on the way to genius. In this chapter, I set the stage for the main man.

Ushering in Renaissance Art

Who would've thought that sculpting a door could make an artist and a city so famous? In Renaissance Florence, that's exactly what happened. A famous door contest officially gave artists the reputation for which they'd been hankering for centuries. Almost overnight, artists went from craftsmen to near celebrities. The competition also upped the ante when it came to linking public art and civic pride, as well as created a new culture in Florence and all of Italy.

The door contest

The doors in question were those on the baptistery of the Florence Cathedral (also known as Santa Maria del Fiore or the Duomo). The door contest was just that: a juried competition that brought the greatest existing talent together to glorify the new Renaissance art and ideals.

Construction of the Gothic-style cathedral began in 1296 and continued for a few centuries. In the 1330s, the Italian sculptor and architect Andrea Pisano (c. 1290–1349) sculpted an impressive pair of gilded bronze doors depicting the life of St. John the Baptist on the east side of the baptistery. His work brought such fame to the city that in the early 1400s, the Florentine Republic announced a competition for a second set of baptistery doors, open to all sculptors and painters. This time, the subject, continuing the biblical theme, would be the sacrifice of Isaac.

Seven great Tuscan artists entered the contest. But in the end, it came down to only two: Filippo Brunelleschi (1377–1446) and Lorenzo Ghiberti (1378–1455). Brunelleschi and Ghiberti, barely out of their teenage years, set about depicting their scenes in similar styles. Both submitted designs that broke with their predecessors' flatter, less realistic relief sculptures and incorporated perspective into their religious scenes — showing the transition to the more convincing, expressive Renaissance style.

And the winner is . . .

Amid much hoopla, Ghiberti, perhaps because his panel was easier to understand from a narrative point of view, won the treasured commission.

The doors took Ghiberti and his Florentine workshop, which included his talented students Donatello (c. 1386–1466), a rising sculptor, and Paolo Uccello (1397–1475), an experimental painter, about 20 years to complete. Each door contains 14 quatrefoil-framed scenes from the Bible, including the life of Christ.

When Ghiberti and his pupils finished them in 1424, the doors replaced the ones by Pisano, which moved to the south side of the baptistery. The Florentines were so pleased that the government again commissioned Ghiberti to complete a second set of doors with five bronze panels, which Michelangelo later named the "Gates of Paradise." This set replaced his original doors, which were subsequently moved to the north entrance.

Ghiberti's second doors, sculpted between 1425 and 1452, showed his evolution as a Renaissance sculptor. Dedicated to Old Testament stories, they place biblical figures and sibyls within new perspectival settings that evoke real landscapes, from forests to buildings (see Figure 4-1). They thus illustrated a new technical perfection that melded classical ideals of unity with realistic conceptions of space, nature, and human expression.

Figure 4-1:
Isaac and
Esau, from
the bronze
doors of the
baptistery
by Lorenzo
Ghiberti,
Florence.

Scala / Art Resource, NY

Capping the dome: Brunelleschi's feat

Brunelleschi lost the door competition, but he made an amazing comeback
with the greatest architectural feat of the day: designing and building the
dome, or cupola, on top of the Duomo (see Figure 4-2).

Figure 4-2:
Dome of the
Florence
Cathedral,
by Filippo
Brunelle-
schi.

Alinari / Art Resource, NY

In 1366, the Florentine government decided that in the spirit of antiquity, all
new architecture should dump the Gothic forms — those tall, narrow arches,
pointed spires, and flying buttresses that could trip even a giant — and
embrace more harmonious ancient Roman forms, like the dome. But because
it posed unheard-of challenges, the question of how to build a dome that
would reflect Florence's new spirit occupied discussion for many years.

Brunelleschi rose to the task. He studied the construction of domes, like the Roman Pantheon, and applied modern engineering methods to ancient design to create a wholly unique cupola. Around 1415, he drew a design for a complex octagonal dome that would span more than 40 meters (131 feet) at the east end of the nave. It had two layers — an inner dome and an outer shell for a smoother appearance. Two-dozen geometrically precise stone half-arches, or ribs, and other stone and wood supports held up the dome, which was overlaid with brickwork laid in herringbone fashion. Brunelleschi designed a marble lantern to cap his creation, which was completed after his death by another Florentine sculptor and architect who worked with Donatello, Michelozzo (1396–1472).

Sounds simple, right? Wrong. Between 1420 and 1436, Brunelleschi and his men built the dome without the aid of buttresses, which all previous Roman and Gothic architecture had required. Brunelleschi even designed special wooden carlike machines to move the materials up and down, back and forth.

In the end, the dome wasn't only the greatest engineering coup of the early Renaissance — it was also the most impressive dome since antiquity, advertising on the skyline that Florence was the quintessential Renaissance city.

When Brunelleschi died in 1446, the cupola was still waiting for a little something — which didn't get added until Andrea del Verrocchio, the master under whom Leonardo worked, took the job. See the section "The Culture of Patronage" for more about apprenticeship in Renaissance Italy.

Artists, the new rock stars

Leonardo, despite his dapper looks and charm, probably didn't fend off hordes of teenage girls as he put brush to canvas. Nor did he attract the kind of cult following that rock stars do today. Still, during the Renaissance, artists like Leonardo obtained a status previously reserved for visiting dignitaries or nobility.

Florence's door contest created a new culture of competition and fame for artists, who came to symbolize the city's cultural rebirth. Over the course of a few decades, the city's elite realized that they could use artists not only as vehicles to beautify their city, but also as propaganda that advertised their wealth and progress to the rest of the world — or Italy, at least. Thus, during the Renaissance, artists came to occupy a special place. And as the more successful ones escaped the guilds and became independent artists, fame (and sometimes fortune) followed in their footsteps.

The new environment that embraced artistic ideals greatly affected Leonardo and his contemporaries, including Raphael and Michelangelo. Fame mostly extended to painters, sculptors, and architects; goldsmiths or tapestry weavers were considered more plebeian artists because of their relatively

standardized work. Courts invited prominent artists into their domain to glorify their power even more. Forget that Leonardo had to wrangle an invitation to enter the court of Ludovico Sforza in Milan; by the end of his career, even though he was ill, Leonardo's fame was so widespread that French king François I considered himself lucky to include the aged artist among his entourage.

Keeping It Real: The New Renaissance Style

One of the hallmarks of the new Renaissance style was the return to realism. Italian artists' workshops tried to master techniques that would enliven their subject matter, from perspective to anatomy to light. "The painter will produce pictures of small merit if he takes for his standard the pictures of others," Leonardo wrote on a page in the *Codex Atlanticus*. "But if he will study from natural objects he will bear good fruit." So, like their ancient Greek and Roman teachers, Renaissance artists tried to keep it real.

Leonardo came of age smack dab in the middle of this flowering of realism. Although he must have looked at many medieval forms of art, from painted church altarpieces to architecture, he learned from masters and colleagues who were already applying more naturalistic principles to art, from anatomical to botanical design.

Breaking away from medieval art

Medieval painting, the precursor to Renaissance art, was anything but realistic. The Middle Ages (or Dark Ages) represented that period in European history between the collapse of Rome and the Renaissance, between AD 476 and approximately 1400. This long historical period encompassed many different subperiods: early Christian, Byzantine, Islamic, early Medieval, Romanesque, Gothic, and late Gothic.

Forget about the early stuff; concern yourself with the transition from the late Middle Ages (around AD 1000 and on) to the Renaissance. Late Middle Age artists held some very different ideas than their Renaissance heirs about what art should look like and what purpose it should serve.

- They worked for the glory of God; faith showed them the way.
- The desire to portray religious and spiritual truths rather than the real, physical world inspired their art. As a result, any theory of mathematical perspective had no use, and figures more or less resembled expressionless Flat Stanleys, stuck to the page.

✔ Medieval artists focused on tradition and copied what they learned in the workshop. Whereas the Renaissance favored innovation and experimentation, the late Middle Ages relied on the tried and true.

✔ In architecture, Romanesque structures (based on ancient Roman design, like the baptistery of Florence) had sprung up around Europe. Around 1200, the Gothic style took over in Italy, with its pointed arches and airier design, like Florence's Duomo or the Chartres Cathedral in France. This style, though modified, lasted through much of the Renaissance.

The late Gothic period represents the bridge between the Middle Ages and the Renaissance. The first Renaissance genius in painting, sculpture, and architecture, Giotto di Bondone (c. 1270–1337) emerged during this period. A transitional figure, he influenced many great artists, from early Renaissance painters like Masaccio (Tommaso di Ser Giovanni di Mone Cassai, 1401–28) to High Renaissance artists Michelangelo, Raphael, and Leonardo. Critics generally call Giotto the first Renaissance realist for these reasons:

✔ He tried to master the idea of architectural space and create illusory three-dimensional spaces on flat surfaces, though he lacked the technical knowledge of anatomy and perspective that came later.

✔ He based his paintings on what he saw in nature, instead of copying what he saw in the studio. In fact, as one of the first to break from the standard practice of copying a master's work, he set the precedent for future artists to copy *his* work, propagating that nasty cycle that Leonardo so decried.

✔ Although Giotto dealt primarily with religious subjects, he imbued them with new expression and meaning.

Figure 4-3, one of Giotto's many Madonna and Child scenes, reveals his attempt to capture three-dimensional space and human expression. Indeed, he helped pave the way for a new culture of artistic innovation during the early Renaissance. Yet, he had some imperfections himself, including some rather anatomically odd figures (just look at the baby Christ in Figure 4-3) and a stylized form of human expression.

Nonetheless, Giotto and other late Medieval/early Renaissance artists set the stage for artists of the High Renaissance, a topic that I introduce in Chapter 10. Giotto's conception of interior space, for example, greatly influenced how Leonardo conceived of the space in his painting *The Last Supper* (for more on this work, go to Chapter 14). And Leonardo recognized the problem of portraying realistic figures, impressive as Giotto's were for their time. As I explain in Chapter 10, Leonardo blurred lines to create more vague, less stiff figures.

By the late 15th century, certain techniques that Giotto and his colleagues had slaved to master were givens, such as ideas of mathematical proportion, linear perspective, full-bodied forms, and individual expression in painting. Leonardo and his colleagues inherited these artistic advancements, imperfect and experimental as they were, and sought to carry Renaissance art to new heights.

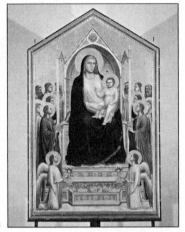

Figure 4-3:
Madonna Enthroned with Child, Angels, and Saints, by Giotto, 1306–10, Uffizi, Florence.

Inventing, Renaissance style: Three greats

As the Renaissance took roots, Italy became an increasingly crowded place for artists. Nonetheless, three fathers of Renaissance art stand out for their great influence over future generations of artists: Donatello (Donato di Niccolo, 1386–1466) in sculpture, Brunelleschi in architecture (see the section "The door contest"), and Masaccio in painting.

This trio believed in progress, a grand theme of their era. They wanted to improve upon the art of antiquity through modern methods and rational inquiry. They searched for mathematical laws of proportion for architecture and the human body and created realistic and ideal natural forms, improving, as it were, on the physical world.

But skill was no longer enough. Medieval artists had perfected their craft through copycat methods. Now, however, it was important to understand others' discoveries — and add to them.

Masaccio

Masaccio, born near Florence as Tommaso Cassai, is considered the first great Renaissance painter (after Giotto, that is, who was more of a transitional figure that created a new prototype for painters). Masaccio used scientific perspective to create the illusion of three dimensions, which distinguished his work from the flatter style of medieval art. He used light to define the human body and played with light and shadow *(chiaroscuro),* which Leonardo later perfected, to create a sense of depth. His use of linear perspective forged new realistic and emotional relationships between the painting and viewer. Overall, as one of his most famous paintings, *The Expulsion from the Garden of Eden* (see Figure 4-4), shows, Masaccio inaugurated a new naturalistic approach to painting.

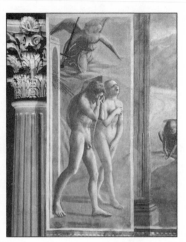

Scala / Art Resource, NY

Masaccio borrowed from classical antiquity to paint forms more full of emotion and suffering than his medieval predecessors. Compared to Leonardo and other High Renaissance masters, however, his figures still look somewhat wooden.

This attempt at realism extended to Leonardo's schooling. Simply put, when Leonardo painted a baby Christ, he wanted his figure to resemble a real child, not a miniature adult, like the baby in Giotto's *Madonna Enthroned with Child, Angels, and Saints* (refer to Figure 4-3). He wanted to substitute symbolic representation for the real, dress his figures in convincing clothes, and set them against normal landscapes. In order to do so, at Verrocchio's workshop, apprentices took plaster casts of hands, feet, legs, and torsos (whether the limbs were broken or not!) and fashioned models out of clay. They then draped their models with heavy fabrics and faithfully drew what they saw. As Leonardo said, "the spirit of the painter will be like a mirror." With some inventiveness too, of course.

Donatello

Donatello, born in Florence as Donato di Niccolò di Betto Bardi, was the first great Renaissance sculptor. Taught by Ghiberti (of bronze door competition fame), Donatello mastered a powerfully realistic human form in both marble and bronze. He pioneered the shallow relief technique, which creates a sense of great depth. In the 1430s, he worked for the Medici family, supplanted by Verrocchio after his death. Later, he worked with noted architect Filippo Brunelleschi. Donatello's *David* (see Figure 4-5), one of the Renaissance's first nude statues (if not *the* first), shows graceful, soft, and curved lines that characterize a new spiritual intensity and create an illusion of fanciful reality.

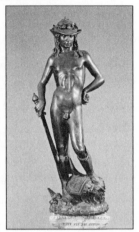

Figure 4-5:
David, by
Donatello,
c. 1409,
marble, 1.9
meters (6.3
feet) tall,
Museo
Nazionale
del Bargello,
Florence.

Scala / Art Resource, NY

Leonardo no doubt knew of both Ghiberti and Donatello's work, but no one knows what he actually accomplished in sculpture. He may have carried out a number of sculptural works under Verrocchio's tutelage, especially because the latter was known for his sculpture and decorations. The famed biographer Giorgio Vasari recorded a young Leonardo as having made some female busts. Then, of course, you have Leonardo's planned equestrian monument to Francesco Sforza and the Trivulzio Monument, which I examine in Chapter 3, along with a few other pieces of sculpture not definitively attributed to him. But he must have sculpted some missing Madonnas and angels. Now, where did he put them?

Brunelleschi

You've probably already seen with your very own eyes (or heard rumors about, anyway) Brunelleschi's greatest accomplishment: the dome of the Florence Cathedral, which epitomized Renaissance art's new focus on mathematical and geometric proportion (skip back to the earlier section "Capping the dome: Brunelleschi's feat" for details).

Throughout his life, Brunelleschi was most interested in uncovering precise optical laws that would produce the greatest realism. He's especially famous for one of his experiments on perspective. Around 1410, he painted on a small panel a scene well known to anyone who was anybody in Florence: the Piazza San Giovanni, seen from the cathedral doorway. When he was through, he pierced a hole through the painting's center and exhibited it in the very spot from which he'd painted it. When he asked some viewers to describe what they saw when they looked at the piazza through the hole and then held up a mirror, what did they say? It wasn't a miracle, exactly, but an extraordinarily faithful reproduction of the piazza!

Brunelleschi's genius influenced just about *everyone.* Leonardo, for example, inherited his dedication to realism, science, observation, analysis, and experimentation. These concepts formed the foundation of Leonardo's theories of both art and science.

The Culture of Patronage

Renaissance Italy had no real open market for art. Unlike today, where artists hawk their wares at street fairs and in galleries, Renaissance artists solicited (or were offered) commissions from patrons who lent influential support to the arts.

The term *patron* comes from the Latin for "like a father." Although patronage existed in different cultures throughout history, it emerged quite strongly in ancient Rome. In ancient law, the lord — the *patronus* — protected his freedmen, or clients, whom he represented in the senate. During the reign of the Roman Empire, the term *patron* began to apply to people who sponsored and supported artists, writers, and musicians. By the time the Renaissance rolled around, the patron-artist relationship had reached new heights.

Leonardo thrived in the cult of patronage that nurtured artistic genius in Renaissance Italy. Under some patrons, he achieved a high degree of artistic and scientific freedom; under others, he bowed to protocol and demand.

Living off the upper crust: The patrons

In those dark medieval days of yore, most art patronage came from the church, which commissioned religious images for cathedrals and churches as a sign of its never-ending devotion to God. A second, smaller group of patrons included the ruling classes, nobility, and aristocracy, which commissioned works of art, still mainly religious, for their homes.

Then along came the Renaissance, when the spirit of patronage reached its height. Whereas the church had been the mother ship of most commissions through medieval times, the new economic prosperity of Florence in the 1400s changed the situation. Now others could afford to support the arts: Merchants, bankers, and self-appointed rulers such as the Medicis became major patrons, showing to the world their sophisticated culture and high social standing. In Florence, the patronage system became a deeply rooted network of artists, workshops, and wealthy families. Throughout Italy, the church and ruling families like the Medicis in Florence and Sforzas in Milan upped the ante for artists.

Patronage happened other ways besides through the church or a ruling family. A well-to-do family could take an artist into its household and employ

him for various purposes. Such art wasn't meant to hang in galleries or museums, but grace the walls of a home or estate. A religious confraternity could also commission an artist for a work. Leonardo painted his *Virgin of the Rocks,* for example, as well as other paintings, for monasteries that paid him and his workshop to undertake the project. A patronage relationship could also develop backwards, with an artist seeking out an employer. Leonardo, for example, applied for a military engineer position with Duke Ludovico Sforza of Milan, who subsequently became his patron.

The nuts and bolts of patronage

Patronage was a complicated affair, but it generally had a few set rules. Suppose, for example, that a patron such as the Medici family wanted to commission a painting. A Medici member would visit the painter in his *bottega,* or small artisan workshop, and discuss the project and the price. It was usually up to the individual artist, and not the larger *guild* (the professional group to which artists belonged), to draw up a contract that outlined the payment schedule, completion date, and other legal niceties. The patron usually made a down payment to the artist, who then received more money after he produced a *cartoon* (a preliminary drawing) of the work, and the remainder after he finished it.

Patrons usually demanded familiar subjects, including religious scenes or mythological allegories (particularly during the High Renaissance), but not all patrons were alike. Sometimes a patron stipulated weird things, such as the solicitation of expert advice — at times, historians or humanist scholars would be called in to prep a painter in mythology or history before he started painting. The more powerful a patron was, the more he usually got his way. As an artist's status rose, he had more say in the commission.

The pros and cons of patronage

Art patronage had far-reaching effects on both a city and an artist. First, in an age where the Italian city-states and republics vied for prominence, commissions to famous artists like Michelangelo and Leonardo gave a place prestige. From the artist's perspective, patronage opened the door to social status and livelihood. In fact, artists could usually only move up the social ladder with the aid of a wealthy backer, like a duke or the church. In fact, second-rate artists had to attach themselves to a patron — or a workshop with a patron — to survive. Finally, the patronage system transformed artists from small craft artisans into true professionals. It ensured the continuation of the workshop and apprenticeship system while allowing stellar artists to chart their own paths. And by creating a monetary relationship between artist and buyer, the patronage system helped commercialize art and made it into a more valuable commodity.

Chivalry — er, patronage — isn't dead yet

Some say patronage reached its height with Pope Julius II, Michelangelo, and the Sistine Chapel ceiling. Yet, patronage only declined, not died, after the Renaissance. In fact, some of the 20th century's best-known works resulted from patronage. The Spanish Republican government commissioned famed cubist artist Pablo Picasso (1881–1973), for example, to paint something for the Spanish Pavilion during the 1937 World's Exposition in Paris. Picasso produced *Guernica* (1937), an abstractly violent depiction of the Spanish Civil War. This famous antiwar statement is probably not what the Spanish government had in mind, and the painting continues to garner controversy. A less controversial, private commission was Marc Chagall's (1887–1985) famous stained glass windows, dedicated in 1962 at the Synagogue of the Hadassah University Medical Center in Jerusalem. The Chagall Windows depict the 12 tribes of Israel in dreamlike, floating colors, symbols, and images. And in architecture, just think of all the "prairie" homes that Frank Lloyd Wright (1867–1959) designed for private patrons! Thus, patronage today, if it rarely (or never) involves adopting an artist as family or inviting him or her into a royal court, survives on a commission-by-commission basis.

Despite the great benefits the patronage system brought to artist, client, and city alike, however, it could sometimes be a double-edged sword.

Remember, patrons weren't out to feed the poor, hungry masses. Rather, they were looking for ways to augment their power and interests. Whether an artist's creativity flourished or was squelched depended on the patron to which he was attached.

Take Ludovico Sforza. A greedy, scheming ruler, he hired Leonardo as a military engineer without fully acknowledging his artistic abilities. Milan's court certainly embraced self-aggrandizing works of art (like the equestrian statue that Leonardo never finished) but had little use for Leonardo's bold ideas about aviation, botany, and optics, for example. Simply put, Ludovico wasn't interested in what he considered to be Leonardo's superfluous and esoteric studies. He needed someone to design military machines, and that was that. Leonardo had much more freedom, however, when he worked under Pope Leo X and the French king François I. These patrons were more forgiving of the artist's temperament, embraced humanist principles and so-called Renaissance ideals, and allowed Leonardo to experiment without ever producing much in the way of art.

Even when patrons controlled, more than encouraged, artistic creation, artists still had the ultimate upper hand, as they could choose to finish something — or not. In Leonardo's case, he was notorious for leaving patrons high and dry, usually in times of political turmoil. The fact that Leonardo still got hired after some boondoggles and unfinished pieces is a testament to his awe-inspiring genius.

Apprenticing in the Artist's Workshop

In Renaissance Italy, art was more often than not a collaborative rather than individual enterprise. All young artist wannabes cut their teeth in the *bottega* before moving on and founding their own workshops with their own sets of apprentices. And Leonardo was fortunate to latch on, as a teenager, to the workshop of Andrea del Verrocchio (c. 1435–88), a Florentine sculptor and painter.

Verrocchio was a man who straddled two generations. He worked at the end of the early Renaissance, after the magnificent contributions of Donatello, Masaccio, and Brunelleschi, the famed trio of sculpture, painting, and architecture (discussed in more detail in the earlier section "Inventing, Renaissance style: Three greats"). Possibly overshadowed by their greatness, Verrocchio was also a precursor to the High Renaissance masters that he helped nurture, including Leonardo.

Some see Verrocchio as a minor figure in Renaissance art; others rank him second only to Donatello in sculpture. Although his own artistic merit may be up for debate, no one can deny that Verrocchio offered first-rate training for his students, including Pietro Perugino (1450–1523), Lorenzo di Credi (c. 1458–1537), Sandro Botticelli (1445–1510), and Leonardo.

Becoming an apprentice

An artist's training followed the pattern of other artisans, from woolworkers to notaries. An apprentice's father identified an appropriate workshop, approached the master, and, if everything was kosher, paid the master some sort of tuition. The father then dumped his boy off at the workshop, where he would live, eat, and learn for the next decade or so before becoming a master himself.

Apprentices started off at the bottom of the totem pole. They ran errands, cleaned paintbrushes, tempered plaster, and supervised the heating of varnish, for example. They sketched on tablets, familiarized themselves with materials, learned how to make paintbrushes, and prepared glazes and pigments. As they gained new skills, their status grew. And as they became more competent in their craft, they learned to color, decorate, and work directly on a wall, fresco style. Older apprentices filled in backgrounds, color, and drapery of their master's commissioned paintings.

The *bottega* itself wasn't a big, loftlike space like artists' studios today; from the outside, it may have been a butcher or tailor shop. A set of ground floor rooms or one big room opened up directly onto the street, with living quarters in the back. Each workshop had about 30 apprentices and assistants, give or take a dozen, working together at once.

Verrocchio's background

Verrocchio apprenticed himself with the goldsmith Giuliano de' Verrocchio and, per tradition, adopted his name. Goldsmithing sounds rather arcane today, but it combined all artistic trades into one, requiring skills in drawing, engraving, and modeling three-dimensional forms. In fact, Paolo Uccello, Brunelleschi, Ghiberti, and the Florentine painter Domenico Ghirlandaio (1449–94) all started out as goldsmiths.

Verrocchio, who proved to be best at sculpture, followed in the steps of Donatello — first, perhaps, as his student, then afterwards as his collaborator. After Donatello's death in 1466, he took Donatello's old post as sculptor to the Medici family, which cemented his reputation throughout Italy.

Painting, then, had all the markings of a skilled trade. Even when methods or styles changed (artists dumped gold ornaments and halos, for example, sometime during the Renaissance and focused more on perspective), apprentices like Leonardo still had to learn certain, fixed steps to the trade.

Living in Verrocchio's workshop

Verrocchio ran a first-class gig. His *bottega* was kind of like summer camp — but with classes and homework. It didn't have the avant-garde reputation that the workshop of the Pollaiuolo brothers, Antonio and Piero, had, but it held its own as a center for young Florentine artists. They gathered in Verrocchio's studio to exchange models, plans, sketches, and recipes for varnish. They also played music, discussed the philosophical quandaries of the day, and compared notes on dissection and antiquity. All in all, a spirit of experimentation and deep belief in progress drove these artists together. They learned about mathematical perspective, anatomy, and light, thus differentiating their time from their predecessors. Together, they tried to realize the ambition of the age: to master the rational and scientific method that would unlock the secrets of the natural world and convey greater realism to art.

Learning from the master

The Medicis commissioned a few significant pieces of art during and after Leonardo's stint with Verrocchio. Verrocchio's first major commission involved sculpting the tomb for Giovanni and Piero de' Medici in the Old Sacristy of San Lorenzo. He completed the porphyry sarcophagus in 1472, using colored marble and rich bronze ornamentation with twisting foliage. Besides commissioning decorative kitsch, the Medicis also hired Verrocchio to execute two important sculptures: the *Putto with Dolphin* (c. 1470) and the magnificent bronze *David* (supposedly modeled on the young Leonardo, completed around 1475). Verrocchio's group statue, *Christ and Doubting Thomas* (see Figure 4-6),

shows a concern for realistic physiognomy, clothing, and position. This sculpture was unprecedented in its three-dimensional forms, realistic gestures, and convincing drapery and expression — all qualities passed on to Verrocchio's protégé, Leonardo. Rumor has it that Leonardo even helped sculpt the head of Christ — or at least used it as a model for his own Christ in *The Last Supper* (see Chapter 14).

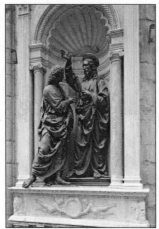

Figure 4-6: *Christ and Doubting Thomas,* by Andrea del Verrocchio, 1476–83, bronze, 2.3 meters (7.5 feet) high, Orsanmichele, Florence.

Alinari / Art Resource, NY

The first project that Leonardo probably saw (or experienced) from start to finish in Verrocchio's workshop hearkened back, once again, to the Florentine skyline. When Brunelleschi completed the dome of the Florence Cathedral in 1436, he left a piece missing on top, the copper sphere on top of the marble lantern that he designed before his death. Verrocchio was asked to crown the top of the lantern with the ball and cross specified by Brunelleschi.

This challenging project possibly inspired Leonardo's interest in engineering, architecture, physics, metallurgy, and mechanics. Leonardo watched Verrocchio cast the metal, assemble the large sphere (weighing more than 2 tons and panning 16 feet in diameter and more than 72 feet in height!), and hoist it, probably with a crane running on circular rails that Brunelleschi devised to lift large weights to the top of the dome. When the sphere capped the Duomo in May 1471, all of Florence turned out to witness this accomplishment. (Unfortunately, lighting struck Verrocchio's globe; what you see now is a 17th-century reproduction.)

Leonardo, inspired by this highly technical project, drew Verrocchio's bronze sphere and Brunelleschi's moving crane in his notebooks. Nearly 50 years later, Leonardo applied the Duomo's engineering problems (and solutions) to his own work on optics and the creation of parabolic mirrors. Thus, he took the tried and true, fooled around with it (in the spirit of the age), and produced new uses for innovative technologies.

Learning from his peers

Leonardo learned his craft from Verrocchio, far surpassing expectations of workshop production of the time. He also adopted some techniques from other apprentices in the workshop. Botticelli, for example, pioneered a highly individual, graceful style that meshed classical and religious themes and focused on human expression and contoured forms. At the same time, Botticelli was the quintessential early Renaissance painter; he made little attempt to carve rational spaces and focused, instead, on decorative details, as his *Birth of Venus* (see Figure 4-7) shows. Inspired by mythological themes, this painting epitomized Neoplatonic ideals and the new spirit of the Renaissance. Leonardo, for one, found Botticelli pleasant and amusing, but criticized his lack of perspective and highly unrealistic landscapes.

Figure 4-7:
The Birth of Venus, by Sandro Botticelli, c. 1485, tempera on canvas, 1.7 x 2.8 meters (5.7 x 9.1 feet), Uffizi Gallery, Florence.

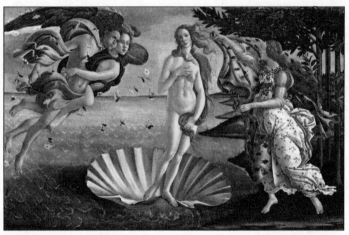

Alinari / Art Resource, NY

Perugino also studied with Verrocchio at the same time as Leonardo. Although he returned to Perugia after his stint in Florence, he greatly influenced High Renaissance artists, including Raphael (c. 1483–1520). *Christ Handing the Keys to St. Peter* in the Sistine Chapel, commissioned by the Vatican, pays homage to ancient architecture. Its organized figures (apostles) stand in front of an open piazza, which leads viewers' eyes to an octagonal temple and triumphal arches in the background. It displays the convincing use of space, harmony, and spatial clarity that marked the vanguard of Leonardo's High Renaissance style.

Expanding beyond the bottega

Leonardo, though he worked with Verrocchio for more than a decade, didn't find himself confined to his workshop. Instead, *bottegas* generally welcomed any member of the guild with open arms. Leonardo probably visited other

workshops, particularly that of the Pollaiuolo brothers. He was most likely interested both in their humanist leanings and their anatomical experiments — they probably dissected cadavers to study human anatomy, a revolutionary practice at the time. Leonardo may also have frequented the workshop of Paolo Uccello, who studied geometry, mathematics, and perspective. And of course, he would've been familiar (though not necessarily on personal terms) with Leon Battista Alberti (c. 1404–72), another all-around Renaissance genius. Thus, workshops all around Florence introduced Leonardo to the new spirit of the age.

Imitating the master — or not

Because apprentices lived, worked, and breathed the same air as their masters, not surprisingly, they learned their master's style to a *T.* And because apprentices and masters worked together, often on the same piece, workshops privileged imitation over originality. When an apprentice became a master, only then could he develop his own unique style. Still, many apprentices' styles, even after they ran their own studios themselves, resembled that of their original teachers. Perugino, for example, who apprenticed with Verrocchio, taught Raphael — whose works bear some stylistic resemblance to his master's. And Fra Filippo Lippi trained Botticelli; the latter, in turn, taught Filippino Lippi, and the works of all three look alike.

Leonardo followed a normal apprenticeship route. One may guess that his technique and style would, to a certain extent, match that of his master.

They didn't.

Verrocchio left few surviving paintings, including an altarpiece of the *Madonna and Child with Saints* (c. 1475–83) in the Donato de' Medici Chapel of the cathedral at Pistoia. That piece is generally credited to his student, Lorenzo di Credi. But no matter who's responsible, it reveals a careful composition, replete with the architecture of the day, and detailed, realistic props, including a fringed oriental carpet. The figures, if a little plastic and lacking that certain vibrancy of later Renaissance sitters, are anatomically correct.

Leonardo took in Verrocchio's style, to be sure, but decided to do things a bit differently. Besides his sheer (dare I say superior?) talent, he experimented with different poses and compositions, tried out oil paints to achieve more subtle gradations of color and shadow, and teased the inner expressions of his subjects. These advances, combined with his technical expertise, differentiated Leonardo from his master.

Verrocchio recognized Leonardo as a great talent very early on, so the master possibly gave his student an unusual degree of freedom when it came to filling in the blanks. In *Baptism of Christ* (c. 1472–75), commissioned by the monastery church of San Salvi near Florence, Verrocchio painted a realistic, grand-looking Christ, with two angels on the riverbank for compositional balance. He painted the one closest to Christ and then invited Leonardo to try his hand at the other (for more details about this painting, go to Chapter 13).

Leonardo's first biographer, Vasari, claimed that Leonardo's angel was so superior to the rest of the work that Verrocchio laid down his paintbrush once and for all. According to Vasari, Verrocchio was simply dumbstruck by Leonardo's knowledge about poses (his angel boasts a three-quarters turn) and use of oil paint on the tempera-based painting. As a result, Leonardo's angel possesses a luminous quality that distinguishes it from the painting's other figures.

Joining the old boys' club: The artists' guild

Throughout Renaissance Italy and Europe, the guild system bound like minds and trades together. Arising during the Middle Ages, guilds assured that men (and rarely women) who learned a certain craft, from painting to making shoes or saddles, would be treated fairly and be subject to standard practices — after they paid their dues with a long and arduous apprenticeship, that is.

Artists greatly benefited from guild membership and its self-policing system. In 1472, Leonardo, now considered a master, joined the painters' guild in Florence; his name appears beside Perugino's and Botticelli's in its register.

Strangely enough, the painters' guild was originally a subsection of one of Florence's seven major guilds, the company of physicians and pharmacists, perhaps because of the similar way that medicines and pigments were ground. Doctors and painters both had St. Luke, an artist and a physician, as their patron saint. The painters' guild became an independent branch of the physicians' one in 1378.

The painters' guild acted more like a confraternity than a full guild. It met in the church of Santa Maria Nuova and participated in religious processions, but rarely intervened in painters' businesses, such as in the drawing up of contracts. Instead, the guild simply required good conduct and financial responsibility from its members. If you paid your one-florin membership fee, you were enrolled in the guild and were a member of good standing.

Membership indicated that you were now ready to open your own *bottega* and receive your own commissions. Yet, nothing ever turned out as expected. Botticelli, for example, had a workshop in his own name in 1470, two years before his name lay side-by-side with Leonardo's in the guild register. And though Leonardo joined the guild in 1472, signifying his independence from Verrocchio, he continued to work alongside Verrocchio for a number of years, which gave him more free time and fewer responsibilities! But no worries: Leonardo eventually did acquire a following.

Over time, many of the more acclaimed artists broke away from the guild system to become independent artists in hot pursuit of fame and fortune. Generally speaking, by the late 1700s, free trade and belief in individual enterprise had begun to break down the traditional guild system.

Demystifying a Mysterious World

The world seemed smaller in the 15th century. Literally. When Christopher Columbus sailed the ocean blue in 1492, he wasn't the first European to reach the New World. But he was the first to garner worldwide fame because of his "discovery," which challenged the limits to the finite European world that Ptolemy's geography had laid out. Columbus's discovery prompted massive trade between the Old and New Worlds and initiated some good and bad biological, human, and capital exchange, not to mention the propagation of Christianity and slavery.

The point is, this culture of discovery also marked the period of the Italian Renaissance. The world was rapidly changing, and people wanted to understand it.

This sentiment extended to Renaissance painting and science, from human anatomy to botany and astronomy. "Science is the captain, practice the soldiers," Leonardo wrote. This approach characterized his lifelong struggle to demystify a world and examine it, piece by piece, in a way that helped bring about the so-called Scientific Revolution of the 17th century.

Burning the candle: Leonardo's library

Leonardo read widely in the literature relating to art and painting, such as Leon Battista Alberti's ten books on architecture and Piero della Francesca's treatise on perspective, math, and geometry in painting. But he also had an insatiable curiosity about the world around him, not just the world on canvas, and read widely in all fields of science as well.

Around 1503, Leonardo compiled a list of books he owned. If he was unlike most people today, he may have actually read everything on his bookshelf. Among his collection included books on every topic imaginable: anatomy, medicine, natural history, plant sciences, arithmetic, geometry, geography, astronomy, philosophy, religion, architecture, geology, military science, mythology, astrology, grammar, poetry, and prose. Many early thinkers informed Leonardo's ideas about the natural world, but a few stand out:

- ✔ **Hippocrates (460–377 BC):** Leonardo, like other Renaissance-era anatomists and physicians, relied, to some extent, on the writings of this ancient Greek physician, called "the father of medicine." Leonardo questioned Hippocrates's beliefs, of course, as Chapter 5 explains.

- ✔ **Aristotle (c. 384–322 BC):** Leonardo probably read Aristotle's works on philosophy and natural history from commentaries by medieval scholars. But he disagreed with a few ideas. Aristotle's notion of science was qualitative, not quantitative. He didn't, like Renaissance men, attempt to understand the world through experimentation. Rather, he relied on what the human senses and mind told him to think, through observation and reason alone. Leonardo, not surprisingly, diverged from this way of thinking in all his scientific inquiries, even though Aristotle had, in a sense, set some rudimentary groundwork for the scientific method that modern scientists embraced.

- ✔ **Vitruvius (c. first century BC):** Leonardo, like other Renaissance architects, studied the writings of this Roman architect and engineer. His *De Architectura,* or *Ten Books of Architecture,* held all kinds of goodies about ancient architecture, planning philosophy, and human proportions. It was popular through the Middle Ages and Renaissance, as Chapter 12 shows.

- ✔ **Pliny the Elder (AD 23–79):** Around AD 77, Pliny the Elder collated all known ancient Greek and Roman scientific thought, including topics on astronomy, meteorology, geography, anthropology, marine and land animals, trees, plants, flowers, pharmacology, mineralogy, stones, and art, among other subjects. Sadly, Pliny perished in the lava and ashes of Mount Vesuvius (he probably should've added volcanology to his list), but his 27 encyclopedic volumes of *Natural History,* published in Venice in 1476, influenced scientific thought for more than a millennium.

- ✔ **Ptolemy (c. AD 85–165):** Leonardo probably read this Greek geographer, astronomer, and astrologer's works, which proposed a *geocentric* (earth-centered) model of the solar system, the generally accepted model until Copernicus developed his *heliocentric* (sun-centered) model in the 16th century.

- ✔ **Roger Bacon (1214–94):** Bacon was an English philosopher who, inspired by Arab alchemists and Aristotle's theory of induction, is credited with introducing an early version of the modern scientific method. Leonardo refers to his work in astronomy, geography, alchemy, astrology, and physics, particularly his studies of optics and lenses; Leo incorporated some ideas of the use of convex lenses as instruments of magnification in his own work.

These books represent only some of the basics. I'm omitting most, such as the Bible, Ovid's *Metamorphoses,* Dante's *Divine Comedy,* and *Aesop's Fables,* though Leonardo was also a clever allegorical storyteller. It's a wonder he had time to read at all, but he seems to have been well versed in his contemporaries' work, too, as the following chapters show.

See me; hear me; touch me; feel me

Won't let a black cat cross your path? Welcome to the Middle Ages, where superstition, religion, astrology, alchemy, and fear of the unknown reigned. Science and magic, religion and superstition — the terms were nearly synonymous. Even in the face of the growing presence of hospitals and doctors, many people still believed in superstition and folklore — such as the thoughts that onions cure baldness, that birds in houses portend death, that prayer alone heals illnesses, and that nuns remedy wounds as effectively as physicians. To make matters worse, if you failed to take the proper precautions (like saying "God bless you") when you sneezed, a devil could enter your mouth. Now that's a reason to keep it shut.

Leonardo believed very little of this nonsense, mostly because experience told him otherwise.

Mastering — or at least dabbling in — the scientific method was a key to unlocking the secrets of the natural world and doing away with all this medieval brouhaha. Folks before Leonardo — notably the English Franciscan philosopher Roger Bacon — saw the benefits of a more pragmatic approach. Bacon described a way to understand the natural world through a repeating cycle of observation, hypothesis, and experimentation (others extended these ideas and methods; see the sidebar "Other early dabblers in the scientific method" for details).

Basically, the modern scientific method had a few discrete steps:

1. **Observe and describe the phenomenon.**

2. **Ask questions about what you're looking at.**

3. **Formulate a hypothesis that will help you determine a causal explanation for the phenomenon, and make some deductions about it.**

4. **Test by means of experiments, which will either confirm or falsify your hypothesis.**

5. **Formulate a theory about the phenomenon . . . then start testing that theory all over again!**

These steps provided a rational, observational approach to nature that did away with reliance on superstition.

Other early dabblers in the scientific method

Roger Bacon isn't the only one who can take credit for giving birth to what would eventually become the scientific method as you know it today. A few others thumbed their noses at superstition, too:

- Another English philosopher, Francis Bacon (1561–1626), tried to establish a link between causation and natural phenomena.

- Galileo Galilei (1564–1642), an Italian physicist and astronomer, heralded the Scientific Revolution with his focus on quantitative experimentation and mathematical analysis, which he used to figure out the world's governing physical laws.

- Isaac Newton (1642–1727), an English jack-of-all-trades when it came to physics, science, astronomy, and alchemy, systematized these laws and developed a modern scientific method, which I outline more in Chapter 5.

Leonardo, as you can read in Chapters 5 and 6, relied on many of these concepts to further his own scientific inquiries. That fact makes him a precursor to modern scientific thinking. Two caveats, though. First, superstition, occultism, and alchemy didn't just disappear overnight. At times, it entered the thinking of even the staunchest of Renaissance minds. Second, because Leonardo wasn't exactly the most methodical of scientists (you'll find sketches of machines next to drapery in his notebooks), people can't necessarily classify his experiments as strictly adhering to the modern scientific method.

Adding it all up: Math and the Renaissance

Math offered one convincing alternative to superstition as a way of exploring the world's natural laws. Leonardo, like other great painters and scientists of the time, was a math head. The fact that Renaissance art and the underpinnings of the Scientific Revolution originated largely in Italy within the same couple of centuries is no great coincidence. Mathematics was essential to each discipline and key to the scientific discoveries posed by astronomers Nicolas Copernicus (1473–1543), Johannes Kepler (1571–1630), and Galileo (1564–1642); philosophers René Descartes (1596–1650) and Gottfried Wilhelm von Leibniz (1646–1716); and physicist Isaac Newton (1642–1727). Both art and science combined experimental attention to nature with the analytical power of math.

For Leonardo, mathematics unlocked the door to nature's patterns and mysteries in mechanics, astronomy, anatomy, and botany. As both an experimental scientist and artist, Leonardo tried to discover the underlying reality of the natural world and depict what he saw. He had great use for math in many of his fields:

- ✔ **Painting:** Translating three-dimensional objects to two-dimensional surfaces, as the painter was required to do, and creating perspective and convincing pyramidal compositions (discussed in Chapter 10)

- ✔ **Architecture:** Building unified and geometrically harmonious structures, such as temples (see Chapter 12)

- ✔ **Astronomy, cartography, and geography:** Figuring out the placement of objects in the universe through mathematical measurement (go to Chapters 6 and 12)

- ✔ **Anatomy:** Correctly proportioning the human body, as seen in Chapter 5, through measuring and examining cadavers' body parts and seeing the relationship among the human body's musculature, circulation, skeleton, and organs

Because Leonardo took a similar mathematical approach to art and science, he was able to tie all his work together thematically and find patterns in everything. He espoused similar underlying principles about the relationship between the small things and larger things in life, the *microcosm* and *macrocosm,* a theme running throughout his early and middle work.

The mathematical science of painting

Brunelleschi was the first to carry out a series of optical experiments that led to a mathematical theory of perspective. In fact, he found a mathematical key to portraying three dimensions on a flat surface — a vanishing point that determined a horizon line and the lines defining the object of inquiry (go to Chapter 10 for more on perspective). But because he never published a word about his new mathematical system, Brunelleschi doesn't take the cake for being the "father of perspective." That honor goes to Leon Battista Alberti (1404–72), whose *Della Pitture (On Painting,* published in 1435) outlined mathematical principles for other Italian artists to follow.

Renaissance painting had a couple of other math-head pioneers. Piero della Francesca (c. 1420–92), one of the great artists of the early Italian Renaissance, painted simple, geometrically clear religious works. Masaccio did as well, using mathematical perspective to create fully three-dimensional spaces. But the application of mathematical and geometric proportion and perspective to art didn't reach its height until the High Renaissance with Raphael, Michelangelo, and your knowledge-hungry friend, Leonardo.

Anatomy and math

Not surprisingly, the Renaissance interest in ferreting out the mathematical and scientific principles of the natural world extended to anatomy as well. Renaissance artists used math to determine the correct proportions for the figures they drew. Leonardo, for one, measured the entire human body, trying to develop a relationship between proportion in architecture and the human form, as discussion of his *Vitruvian Man* in Chapter 5 shows.

But Leonardo worked with old and new ideas alike. His predecessors, from ancients like Hippocrates and Galen (AD 131–201) to anatomists and physicians of his time, greatly influenced his thinking about the human body. One of the first artists to perform actual human dissections to improve his anatomical knowledge may have been Antonio Pollaiuolo (c. 1432–98); Vasari reports him as flaying several corpses, though he may have exaggerated a bit, as scholars generally credit Leonardo as being the first Renaissance artist to carry out dissections. Luca Signorelli (c. 1441–1523) also applied the study of anatomy to his figures in his paintings. But the greatest achievements were once again brought to perfection by Raphael, Leonardo, and Michelangelo; the latter two pursued dissections to further their knowledge of the human body's correct proportional relationships.

Don't underestimate the power of mathematical knowledge. It's a good thing to know that if the width of your shoulders isn't one-fourth of your height, you might be an alien species.

Leonardo's mentors

Leonardo, despite his limited schooling, was no stranger to math. He probably learned a lot in Verrocchio's studio and was, of course, influenced by Brunelleschi and Alberti. Later, he befriended the chair of mathematics and other scholars at the University of Pavia, with whom he discussed major treatises on optics. Optics, in turn, provided Leonardo with a base for understanding perspective.

Luca Pacioli (1445–1517), perhaps the most distinguished mathematician of the Italian Renaissance, also greatly influenced Leonardo's thinking. (Luca appears in greater detail in Chapter 10). His *Summa de aritmetica, geometria, proportioni et proportionalita* (1494) encapsulated most knowledge of math at the time. He and Leonardo became friends at Ludovico Sforza's court in Milan, and he taught Leonardo all about geometry. Leonardo, in turn, contributed to some of Pacioli's own work.

Influencing the World

New developments in Renaissance art, science, and math cocooned Leonardo in a snug culture of discovery. No one person or event inspired his genius.

Instead, everything around him — from the artist's workshop to the "invention" of perspective — drove his insatiable desire for knowledge.

As the following chapters show, Leonardo's thinking, in turn, influenced the course of Western civilization in all sorts of ways. Although his notebooks scattered far and wide for generations and weren't rediscovered until the 19th century, it's clear that many of Leonardo's contemporaries read his notebooks, mirror script and all, and worked from them.

The myriad Renaissance discoveries that inspired Leonardo and other artists, scientists, philosophers, and mathematicians of his time left a great legacy as well. In particular, the growing empirical way of looking at the world — observing, experimenting, analyzing, hypothesizing, and theorizing — left its mark in the centuries following Leonardo, leading up to the Scientific Revolution. This so-called revolution (a loose and controversial description, at that) started roughly around the 17th century, when Galileo, Kepler, Leibniz, and Newton heralded great theoretical and experimental developments in science (or, "natural philosophy").

In fact, the start of modern science drew on developments made during the Italian Renaissance — most important, the mathematical foundation of artistic and scientific inquiry. Galileo, for example, drew directly on mathematical knowledge about physical reality put forth by Renaissance artists and served as a transitional figure to later whiz kids Newton and Leibniz. And by the time *they* rolled around, science was mathematical, empirical, and mechanical rather than Aristotelian, ushering in the foundation of today's modern age.

Part II

Building on What Others Knew: Leonardo's Scientific Mind

The 5th Wave By Rich Tennant

La Marve

"Hey, Leonardo! Drawing another one of your
still lifes? Get it? Still lifes!"

In this part . . .

Sure, science had been around for a few thousand years at Leonardo's birth, but practically nothing about it was modern. During the Renaissance, Leonardo's insatiable curiosity about the natural world led to some pathbreaking studies in botany, geology, mechanics, and, in particular, anatomy. He presaged the modern scientific method by observing natural phenomena, from fossils to the human body, asking questions, formulating theories, and dispelling others. His work, though lost for a few centuries after his death, nonetheless helped usher in an age that dumped superstition and alchemy for more modern scientific methods. In this part, you step inside Leo's brain and observe the many directions it took him in his courses of study.

Chapter 5

The Art of the Human Body

Although artists and anatomists served different functions in Leonardo's day, most Renaissance artists, from Giotto (c. 1270–1337) to Donatello (c. 1386–1466) to Verrocchio (c. 1435–88), studied some form of anatomy. After all, they had to duplicate the human body in painting and sculpture, didn't they? As early as 1435, in his book *On Painting,* Leon Battista Alberti (the most important art theorist of the Renaissance) instructed artists how to sketch the bones, add the sinews and muscles, and then add the flesh and skin. And most studios, including Verrocchio's, had casts of torsos and limbs for the artists and apprentices to copy. The teaching of human and animal anatomy in Verrocchio's studio may very well have inspired Leonardo's greater interest in the subject.

Whatever the inspiration, Leonardo's inquiries into the human body resulted in hundreds of illustrations that reveal a true harmony of art and technique — and formed the basis for modern scientific illustration. Each drawing combined artistic appreciation of the human body with new discoveries of vital human functions in unsurpassed detail — and boasted the triumph of knowledge by hands-on experience over the authority of classic authors. In this chapter, I show you the ins and outs of Leonardo's sketches and what they meant in a society where experimentation was slowly becoming all the rage.

Anatomical Progress in Leonardo's Day

Very little progress in anatomy took place before and during Leonardo's time. People lived, died, and decomposed . . . but that was about it. Although some philosophers and scientists had already paved the way for Leonardo's thinking, the human body and how it functioned remained largely a guessing game.

Following are some of the rather famous figures whose ideas and theories influenced Leonardo:

- **Aristotle (384–322 BC):** Leonardo adopted this Greek philosopher's diagrams of genitalia in *History of Animals.*

- **Plato (c. 427–347 BC):** Leonardo's illustrations of the sex act come from Plato's *Timaeus;* in his early illustrations, Leonardo also used Plato's arrangement of the internal organs and vessels, until he decided he knew better.

- **Hippocrates (460–377 BC), the founder of medicine:** For a time, Leonardo accepted Hippocrates's idea that semen (thought of as the force of life) derives from the spinal cord.

- **Galen (AD 129–c. 200):** Galen of Pergamum was an ancient Greek physician whose text, *On the Usefulness of the Parts,* dominated anatomical teachings in Europe through the 16th century. Through public *vivisection* (the live dissection of animals; he received partial training in a gladiator school!), Galen produced new research on the kidneys and spinal cord. Many of his ideas (for example, that blood originates in the liver and that human spirits originate in the nervous system) were partially correct — fetal livers are a large part of blood stem cells! His other findings, such as the location of the soul, were purely bogus. Nonetheless, his treatise on the human body dominated medicine in Europe for the next millennium.

- **Ibn Sina (980–1037):** Leonardo also looked to the "Prince of Physicians" (known as *Avicenna* in the West) as a general medical Bible. A philosopher-scientist during the golden age of Islam, Ibn Sina's famous medical text, *Al-Qanun fi al-Tibb (The Canon of Medicine)* became the predominant textbook used in European medical schools until the 17th century. It discussed many aspects of modern medicine: sickness, health, therapeutics, pharmacology of herbs, pathology, tumors (cancer), tuberculosis, and emotional health, to name a few.

- **Mondino de Liucci (de' Luzzi) (c. 1275–1326):** Leonardo studied *Anatomia,* the first text to offer lessons in anatomical practice and dissection. Although considered the most important precursor to modern human anatomy, de Liucci still relied heavily on many of Galen's observations.

During the 15th century, few anatomists carried their predecessors' work very far. Still, this era marked a shift toward practice, though Hippocrates's and Galen's theories still held strong sway. In the grand scheme of things, however, anatomy was still a low priority, and dissection was almost unheard of. But Leonardo worked with (or at least heard of) a few solid practitioners:

- **Niccolo Massa (1485–1569):** Massa's treatise on the human body, combined with his dissection experiments, remained the best short textbook on the subject through the century.

- **Marcantonio della Torre (d. 1511):** Della Torre was Leonardo's greatest influence. Leonardo worked with him on dissecting corpses and gained a good understanding of the interplay of bones, tendons, and muscles. (Della Torre, incidentally, died of the plague in 1511, ending what could've been a monumental partnership that may even have produced the definitive anatomical text.)

- **Andreas Vesalius (1514–64):** Vesalius, known as the father of modern anatomy, was the first person to seriously challenge Galen's ideas by showing that Galen's animal dissections didn't always apply to the human body. He published the first complete textbook on anatomy, *De Humanis Corporis Fabrica (On the Fabric of the Human Body)*. For the first time, good illustrations suggested ideas about disease, humanist medicine, the layering of muscles, the human heart, and so much more.

Leo's Magical, Mechanical Anatomical Methods

Although the writings of the ancient Greeks and Romans influenced him, Leonardo saw the limitations of the written word. "Those who study the ancients and not the works of Nature," he wrote in his notebooks, "are step-sons and not sons of Nature, the mother of all good authors." He turned, instead, to actual observation and questioning of nature — in this case, he observed the parts of the human body and questioned how they worked. And then he drew what he saw.

Dissection: Getting to the heart of the matter

Although Leonardo drew on standards in the medical profession for knowledge, he gained most of it through the actual dissection of people and animals — a rather revolutionary activity at the time. Because the Catholic Church viewed the human body as a vessel of God, it didn't permit post mortem dissection — though many people challenged these rulings and went ahead anyway.

Leonardo supposedly worked at night by candlelight in the crypt (or basement) of a church, which was often used as a morgue. Dissection was a dangerous proposition — the Church generally didn't permit it, because it viewed dissection as a desecration of God's creation. But it made a few exceptions. Because criminals clearly lacked God in them, they were fair game for the knife. So were a few saints, whose bodies could prove (maybe) the existence of God in them! Doctors also sometimes performed autopsies on plague victims to try to determine the direct cause of death.

I, Robot

Leonardo's anatomical drawings and experiments led to many drawings of a humanoid robot around 1495, probably for a court festival or to impress visiting dignitaries. The robot, dressed in medieval armor, was anatomically correct (based on his *Vitruvian Man;* see the later section "Divining proportion: Vitruvian Man") and could mimic many human movements, including sitting, moving its neck, waving its arms, and opening its jaws. Inside, the robot operated on two systems and had three-degrees-of-freedom legs, ankles, knees, and hips, and four-degrees-of-freedom arms, elbows, wrists, and hands. An external crank arrangement drove a cable that powered the legs, and a mechanical controller powered the arms. Probably, water or weights would've activated the robot. No one knows if Leonardo ever attempted to build it — but it was the first known design for a robot.

Generally, however, people caught in the act of cutting up a cadaver could be executed. But onward; Leonardo defied most rules, and authorities cast a blind eye his way. Leonardo received bodies from hospitals, like the Hospital of Santa Maria Nuova in Florence. In general, though, bodies were difficult to come by. For all these reasons, Leonardo sometimes chopped up pigs instead of people.

In order to study individual organs, Leonardo removed them from the body, washed them in a solution of water and lime, and injected them with liquid wax in order to preserve their shape. Then he held his nose and drew . . . and drew . . . and drew. . . .

Dissecting cadavers is a gruesome task, even in these modern times, when cadavers are pickled in formaldehyde and refrigerated. Consider how it must have been in Leo's day. In Renaissance Italy (read: no refrigeration), dissections took place under rather revolting conditions. Leonardo didn't like dead bodies to begin with, and he had no way to preserve them while he picked away at them. So he essentially cut up bodies (mostly cadavers of criminals) that had already begun to rot. And some body parts, particularly the digestive system, rotted remarkably quickly. Still, he pushed on quite admirably.

When Leonardo couldn't find human cadavers, he dissected animals, thinking (wrongly) that human and animal parts were pretty much alike. Many of his most famous anatomical illustrations feature pigs, cats, monkeys, cows, and horses. Horses in particular interested him, and he worked diligently (for a while, anyway) on figuring out both human and horse proportions for the Sforza equestrian monument in the early 1490s. In fact, he may even have completed a treatise on the anatomy of the horse during these years, but any evidence of that has disappeared.

Nuts and bolts: Leo's view of the human body

Leonardo applied physical and mechanical laws to what he saw as the macro-cosm of the universe and the microcosm of the human body. In his physics and engineering studies, he described four physical laws of nature: movement, weight, force, and percussion. He believed that these four powers behave in a pyramidal fashion (I discuss this idea in Chapter 6). He applied these physical laws to the human body and, in some sense, created biomechanical drawings.

As proof of his thinking, Leonardo used mechanical words, diagrams, and schematic representations to describe the human body. For example:

- He referred to muscles as *springs* and *wires*.

- He studied the human leg side by side with a drawing of gears.

- He thought of the bones in the arms and legs as levers.

- He understood a muscle's movement as the result of the force applied to it.

- He drew gondolas to explain the rowing motion of a wing, which he hoped would eventually help people fly (an idea that I discuss in Chapter 9).

- His drawing of the human shoulder was a *cord diagram,* showing how muscles were layered.

Many of Leonardo's biographers think that his obsession with mechanics — and his fascination with applying mechanical and physical laws to the human body — suggested that he was planning to create something much bigger, greater, and momentous — perhaps a human robot.

Leonardo's Discoveries and Theories

Leonardo's understanding of the human body and its functions didn't come to him fully formed. He studied human (and animal) anatomy for nearly two decades, and his studies fall roughly into three periods:

- **1487–95:** Leonardo, in Milan, drew heavily on Galenic thought about blood circulation, the nervous system, and the brain. (Galen of Pergamum was the court physician to Roman Emperor Marcus Aurelius.) Leonardo's ini-tial efforts were more speculative and descriptive, and many drawings, some having to do with the brain and female anatomy, were wrong. He focused on studies of the skull and proportion (and applied them to Francesco Sforza's doomed equestrian statue and figures from *The Last Supper*) during this time. He probably did a few dissections as well.

✔ **1504–9:** Leonardo still relied on many of Galen's concepts, but his direct observation of death and subsequent dissections of human cadavers marked a turning point in his thinking. Historians consider this time his period of synthesis, where he began to comprehend the workings of organs by applying his skills as a sculptor, for example, to model the ventricular system. He illustrated this understanding of the human form in the figures he painted for *The Battle of Anghiari* (see Chapter 3).

✔ **1510–13:** Leonardo moved away from Galen's concepts and formulated his own ideas about the inner workings of the human body. During this time, he did the majority of his 30 or so dissections. This period, one of analysis, reflected Leonardo's new methodology: He recorded his observations and then investigated the functions of his objects. He also collaborated with Marcantonio della Torre, a professional anatomist, during these years.

Unfortunately, Leonardo's study of anatomy ended in 1513 when he moved to Rome, which, because of stringent Church practices, wasn't so keen on his dissection practices. A few years later, a German mirror maker reputedly accused him of sacrilegious practices. As a result, Pope Leo X banned Leonardo from conducting further anatomical investigations, and his 20-something-year-long career as an anatomist came to a rather disappointing end.

Throughout his 20-something-odd years of anatomical study, Leonardo examined every inch of the human body. He came to many conclusions, some right, some wrong — but all, in some ways, pathbreaking for his time. The following sections examine some of his more interesting observations.

Divining proportion: Vitruvian Man

One of Leonardo's most famous illustrations, *Vitruvian Man,* which he drew around 1490, illustrates how he applied physical, mathematical, and mechanical principles to the human body (see Figure 5-1).

Vitruvian Man has become a pop-culture icon, featured in everything from the logo of a human research protection committee at the University of California in San Francisco to a major clue in Dan Brown's thriller, *The Da Vinci Code* (I dive into his novel in Chapter 15).

Leonardo based his drawing on ideas from the ancient Roman architect Vitruvius and his ten-volume treatise *De Architectura: The Planning of Temples,* compiled at the close of the first century BC:

✔ The planning of temples depends on symmetry.

✔ This symmetry must be based on the perfect proportions of the human body.

✔ The human body has certain fixed proportions. For example:

- Four fingers make one palm.

- The face from the chin to the top of the forehead is a tenth of a person's height.

- The foot is a sixth of the height of the body.

- The palm of the hand from the wrist to the top of the middle finger is also a tenth part.

- The greatest width of the shoulders is a fourth of the body's height.

- The navel is the exact center of the body.

- The length of a person's outspread arms is equal to his or her height.

✔ If a person lies on his back with outspread hands and feet, and the center of a circle is placed on his navel, his fingers and toes will touch the circumference of the circle.

Basically, Vitruvius believed that the perfect proportion of a temple must correspond to the perfect proportion of a man: a man fitting his body into both a circle *and* a square.

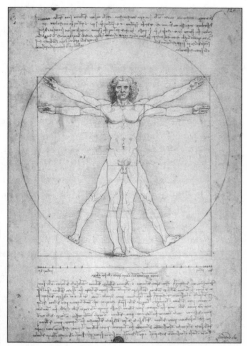

Figure 5-1:
Vitruvian Man, Gallerie dell'Accademia, Venice.

Cameraphoto / Art Resource, NY

FAST FORWARD

Testing your own little mug

Everyone can recognize a beautiful face.

True, beauty changes across time and cultures. However, studies have shown that beautiful people are more symmetrical and proportional than the average Joe. Physical symmetry generally reflects a person's youth, health, and fertility. And it all ties to evolution: In the past (like, 2,000 years ago), symmetrically shaped people had more babies.

To complicate the whole notion of beauty, researches have found a certain ratio that repeats in attractive things, from seashells and faces to the Great Pyramids, the Parthenon, and Leonardo's paintings. This *golden ratio* (also known as the *Fibonacci ratio,* the *divine ratio,* and the *golden mean*) is 1:1.61803399 . . . , with the 1.618 . . . known as *phi.* Studies have shown, for example, that the most attractive people have an ideal ratio between the width of the nose and mouth of 1:1.618.

Nothing definitively suggests that Leonardo was aware of *phi* per se, but he certainly knew about divine proportion and the beautifully proportioned human figure.

You can test out this symmetry idea yourself with a mirror and measuring tape:

✔ Your eyes should lie halfway between the top of your head and your chin.

✔ The bottom of your nose should be halfway between your eyes and chin.

✔ Your mouth should be halfway between your nose and chin, and the corners of your mouth should line up with the centers of your eyes.

✔ The tops of your ears should line up with your eyebrows, and the bottoms of your ears should line up with the bottom of your nose.

Hey, if you don't get the desired results, don't despair. There's always plastic surgery.

Not surprisingly, Leonardo — despite the attempts of others before him — found this divine relationship of the rational (and geometrical) relationship of body parts to the whole person, which he illustrated in *Vitruvian Man.* He started with a perfectly proportioned man (using two young men as models) and then found the circle and the square within the figure. By correcting inconsistencies in previous drawings, he showed the triumph of *empiricism* (relying on observation and experimentation) over taking old belief systems for granted, without testing them firsthand.

Leonardo, however, took this idea of divine proportion a few steps further, applying his understanding of the structure of the human body to other patterns in nature. After all, as he put it, "Man is the model of the world." He established, for example, a relationship between the movements of the eye and the mind and the rays of the sun — though he wasn't always correct, he always had something interesting to say. Basically, *Vitruvian Man* represented Leonardo's larger attempt to relate the human form to the workings of the larger universe.

Boning up and muscling in

Perhaps because he needed to understand the workings of the human body in order to draw and paint convincing figures, or maybe because, in the classical Greek spirit, nude bodies were all the rage back then, Leonardo became an expert at observing, then illustrating, human muscles and bones. He drew detailed illustrations of the jaw, neck, shoulders, arms, hands, torso, legs, and feet — basically, every single body part from head to toe.

Once again, in his notebooks Leonardo described the setup of muscles, tendons, joints, and bones with a mechanistic analogy: "The nerves with their muscles serve the tendons even as soldiers serve their leaders, and the tendons serve the common sense as the leaders their captain. . . . So therefore the articulation of the bones obeys the nerve, and the nerve the muscle, and the muscle the tendon, and the tendon the common sense, and the common sense is the seat of the soul. . . ."

Leonardo was interested in relationships, so he drew bare bones, bones covered by muscle, and perhaps bones in relationship to their joints. He invented the *exploded view* of a body part, where he drew parts of a joint separately in order to explain their relationship.

Leonardo had a few firsts in these studies. Comparing the human hand to that of a monkey and the wings of birds and bats, he was the first to correctly depict our hand bones. He also demonstrated the double curvature of the human spine, the tilt of the human pelvis, and the correct number of vertebrae (33).

One of Leonardo's most astounding conclusions had to do with how muscles move; after all, he couldn't catch his painted subjects as they stood still, could he? As he conducted more dissections, his drawings became more and more precise. His younger colleague, Michelangelo (yes, that one), modeled individual muscles in wax. But Leonardo used his illustrations to create a sculptural effect on paper, thus grasping the notion of antagonistic groups. That is, he realized that the action of a muscle corresponds to a reciprocal action by another muscle, a phenomenon not recognized until the early 20th century, when Nobel Prize–winning neurophysiologist Sir Charles Sherrington put it down on paper.

Leonardo got most of the muscle groups and bones correct, although he erred in depicting the angle of the ribs, the arch of the foot, and a few other things. He may have tripped up in these areas because the poor nutrition of the day (at least, for many individuals) favored delayed closure of some bones. Or perhaps the bones he studied came from different cadavers, so he never drew a complete skeleton. However, toward the end of his anatomy career, around 1511–13, Leonardo drew never-before-equaled — and never-since-surpassed — drawings of human bones and muscles (see Figure 5-2).

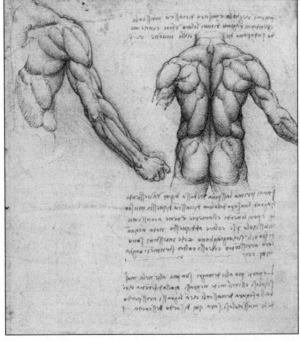

Figure 5-2:
Study for
Human
Muscu-
lature, Royal
Library,
Windsor.

Scala / Art Resource, NY

Pondering matters of the heart

Perhaps the muscle that interested Leonardo most was the heart. In his dissections and subsequent illustrations of the heart, most of which he conducted starting around 1508, Leonardo discarded many of Galen's principles, which had prevailed for 13 centuries.

Some of Leonardo's significant accomplishments included

- Identifying the heart as a muscle; Galen had concluded that it wasn't.

- Understanding that the heart has four chambers (not two, like his predecessors thought) — a left and right ventricle and a left and right atrium; Leonardo called the chambers *auricles.*

- Identifying the coronary arteries.

- Identifying and understanding the function of the three pouches at the origin of the aorta, in the heart's left ventricle (later named the *sinuses of Valsalva,* after the future discoverer of these bumps).

- Explaining the aortic root's structure and impact on the blood flow through the heart area.

Leonardo was able to explain this relationship by basing his study of the aortic valve on his knowledge of hydrodynamics. He devised a glass model to replicate the aortic root and the opening and closing of the leaflets of the aortic valve. Studies that reached the same conclusions as he did — that the closure of the aortic leaflets is gradual — didn't occur until 1969!

✔ Describing how the heart expands and contracts as it beats.

✔ Understanding how the valves function.

✔ Identifying *atherosclerosis* (hardening) of the aorta, nearly 450 years earlier than anyone else.

✔ Using comparative anatomy to identify and describe the importance of veins and arteries.

Leonardo combined his observations of the human heart into a larger study of the irrigation systems of the human body: the circulatory system, the urino-genital system, the alimentary (or digestive) system, the nervous system, and the respiratory system.

Leonardo's great discoveries: The leading cause of death in the U.S. and other stuff

Everyone has an "a-ha!" moment at some point. Leonardo had one of his while visiting Florence in the winter of 1507. At the hospital of Santa Maria Nuova, which he and others used as a storehouse for their books and drawings, he witnessed the death of an old man, probably older than 100. Leonardo wasn't about to let this man get away, dead or alive. In his subsequent dissection, Leonardo set out to find what he called "the cause of so sweet a death." Because the centenarian was all skin and bones, Leonardo was able to pen his clearest drawings of a single cadaver. He also made an original discovery: a weakness of the heart caused by the hardening of the vessels (or coronary arteries) carrying oxygen-rich blood to the heart (today, called *atherosclerosis* and *ischemic cardiomyopathy*), coronary artery obstruction, and failure of blood to reach the heart. And the

cause of the hardened vessels? The absorption of too much nourishment from the blood (*cholesterol* wasn't in the vocabulary at the time).

Leonardo probably didn't order a supersize milkshake and fries with his burger (actually, he was a vegetarian), but he did identify the link between what we eat and what we are.

At about the same time that he dissected the elderly gentleman, Leonardo also performed a dissection on the body of a 2-year-old child. When he compared his two cadavers, he found that they differed considerably, leading him to some firsts in medical bombshells: the first records of cirrhosis of the liver, calcification of vessels, atherosclerosis, and changes with age in the appearance of veins. These findings may seem obvious today, but few people at the time would've reached Leonardo's same conclusions.

Although Leonardo made some great finds about the human heart and circulatory system, he also made some mistakes:

- He was working with some old scientific theories and accepted one of Galen's ideas that the inner walls of the heart had invisible pores.

- Because he based many of his understandings of the human heart on the bovine heart, he wasn't always correct. For example, he incorrectly showed that the right pulmonary vein entered the superior vena cava, rather than the left atrium. Details, details.

Although he came very, very close to discovering the circulation of the blood, Leonardo wasn't the first to fully describe the human circulatory system in print. That honor went to the English doctor William Harvey in 1628.

Gulping down dinner

Although Leonardo made some astounding discoveries in anatomy, his observations of the human digestive system were less breathtaking. He did, however (as was his natural tendency), achieve some firsts:

- He was the first to correctly observe the relationship between the small and large intestines.

- With models created by injecting warm wax into the vessels, he accurately drew the arteries to the liver, spleen, and stomach, distinguishing them from the bile passages (ducts).

- He accurately described the act of swallowing and the movement of food through the esophagus.

Yet, his study of the human digestive apparatus wasn't his strong suit, and he made a few mistakes:

- He identified the muscles around the anal sphincter, but was wrong about their relationship and functions.

- Because of his regard for life (he was a vegetarian), he rarely performed *vivisection* (surgery on living beings) and thus never observed *peristalsis* (the wavelike contractions of intestinal smooth muscles that push food through the digestive tract). He instead attributed the passage of food down the guts to the propulsive force of intestinal gas and the stomach muscles.

- He was the first to accurately identify the appendix, but guessed (incorrectly) that it relieved gas pressure within the colon.

Thinking hard about the noggin

Leonardo began to study the human skull around 1489, when he was in Milan. In part, he was motivated by his desire to draw the human anatomy correctly; in part, he simply had an insatiable appetite for knowledge. Overall, he grasped the brain in a very modern way, understanding it as the command center for the rest of the body's activities.

You bonehead! Leonardo's take on the skull

Leonardo's earliest skulls correctly show

- The anterior and middle meningeal arteries (the arteries that supply blood to the membranes that surround the brain and spinal cord)

- The anterior, middle, and posterior cranial fossae (essentially the depressions in the floor of the skull that hold the brain)

- The frontal vein (which surgeons of that era used for bloodletting to treat head pain and psychological conditions)

- The proportions of the skull

- The optic, auditory, and other cranial nerves

- A skull from the side with the skullcap bisected (his inclusion of the *frontal sinus,* the two air spaces that lie above the eye sockets, posed a new discovery)

If I only had a (human) brain

Leonardo again dissected corpses in order to formulate his theories about the human brain. He also based his conclusions on some of his bovine friends.

Around 1506, Leonardo used his expertise and ingenuity as a sculptor to perform an original experiment to define the shape of the *cerebral ventricles* (the fluid-filled cavities). He injected hot wax into the brain of an ox and obtained a cast of the ventricles, which, as everyone knew since the fourth century, are the parts of the brain responsible for its major functions. But his technique of using a solid mass to determine an object's structure was new and wasn't widespread until about 100 years later.

Using this casting method, Leonardo visualized the cerebral ventricles. Based on ancient Greek thought, he (and some medieval thinkers) decided that the ventricles contained the

- ***Imprensiva:*** The anterior cerebral structure (basically the front part of the brain) that mediated between the sense organs (such as the eyes) and the *senso comune,* which houses the soul. (***Note:*** No one has used the term *imprensiva* since before or after Leonardo — he made it up to

express the idea of a receptor of impressions. However, the concept of an "animal spirit" existed in ancient thought.)

✔ *Senso comune:* "Common sense," or union of the senses, where the senses are judged and where the soul resides. Leonardo was especially interested in finding out more about humans' conscious experiences of the world and believed, as thinkers had since the fourth century, that it resides in the brain.

✔ *Memoria:* Memory, which monitored the *senso comune.*

In some of his drawings of the brain, Leonardo was incorrect. (Figure 5-3 shows a general proportioning of the skull.) For example, in one of his earliest existing anatomical drawings, made in 1487, when he still relied on ancient and medieval thought, he compared the human head and brain layers to an onion, focusing on the eye as the substance of the brain. Of course, he was wrong on this count, but he seems to have changed his mind in other drawings, which show a more correct correlation between the eye and brain. After all, it was all about observation and experimentation.

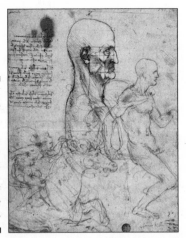

Figure 5-3:
*Study of
Human
Physiog-
nomy and
Horseback
Riders,*
Accademia,
Venice.

Scala / Art Resource, NY

Seeing through the window to the soul

Leonardo was always interested in exploring optics, perspective, light, and color in his painting. The eye was a key factor in this endeavor. Not surprisingly, Leonardo applied geometric and mathematical laws to his understanding of it. Leonardo went through three phases in his study of vision:

✔ In the late 1480s, he studied vision and perspective to improve his painting.

✔ In 1489, he focused on the anatomy of the eye and optic nerves.

✔ From 1508 until his death, he was mostly concerned with the region above the optic chiasma in the third ventricle (the place where the optic nerves meet the brain).

Leonardo was aware of binocular vision and the effect of overlapping visual fields (see Chapter 9). But in his view, the eye also provided the window to the soul, the chief organ that allowed the conscious mind to have the most complete sensory experience. "The eye," he wrote, "which is called the window of the soul, is the principal means by which the central sense can most completely and abundantly appreciate the infinite works of Nature."

Many doctors today would agree with Leonardo, which is why they wave their flashlights and look into your eyes. The eye and its optic nerve provide a convenient path in which to assess, if not the soul, at least the central nervous system.

Leonardo devoted entire notebooks to the physiology of the eye, but it seems as if he never quite reached full understanding of its structure. Also, his way of applying his theories about perspective in regard to painting (which I explain in Chapter 10) to the physiology of vision resulted in some errors with regard to pupil variations. Some of his other conclusions seem quite reasonable for the time; for example, he believed that people don't see upside down because a double inversion occurs at the pupil and lens. Oh well. He was right about double inversion, but wrong about where it occurs (first in the lens, then at the optic chiasma, for what it's worth!). However, for his time, he saw quite clearly indeed.

Boiling eyeballs, for real?

To study the human eye, Leonardo made an ingenious suggestion around 1508, when he resumed his anatomical studies. He suggested removing the eye from the eye socket (from a cadaver, of course!), placing it in an egg white, and boiling the entire contraption. This method would aid in the sectioning process (severing the eye from the optic nerve, or cutting the eye open to look at the parts within), making the eye more solid and hence easier to splice. It seems, however, that Leonardo never actually tried the technique. Had he actually boiled an eyeball, he wouldn't have drawn a round lens, but a more spherical one. (Similar techniques are used today to dissect fragile parts.) Nor would he have been able to enjoy a perfectly prepared three-minute breakfast egg.

Pithing a frog: The nervous system

Leonardo's respect for animal life was legendary. As a result, he was a vegetarian all his life. Still, in one instance his curiosity about the location of the *senso comune* — the area of the brain where he believed the soul resides — may have trumped his principles.

Leonardo was the first scientist to pith a live frog — a common experiment in biology labs (or high-school labs) today. The method entails piercing the poor amphibian's brain with a sharp object to destroy it and, if double-pithing is in the works, inserting the sharp object into its spinal column as well.

Leonardo observed that the pithed frog died instantly when he punctured its spine, but that the animal twitched around for a good while without its head, heart, skin, or internal organs. Leonardo concluded that the spine is responsible for life and labeled the spinal cord the *generative power*. (Despite this discovery that the spinal cord mediates between life and death, he still believed that the soul resides in the *senso comune*. He did, however, later abandon the ancients' view that semen derives from the spinal marrow.) Based on his pithing experiments, Leonardo also discovered that the spinal cord is responsible for the sense of touch, movement, and the origin of nerves.

Of course, Leonardo drew the spinal cord. He almost totally accurately drew it as curved, thereby correcting centuries of confusion; until Leonardo, people assumed the spine was ramrod straight. He also got most of the vertebrae — except for the placement of a few. And he correctly understood (though he used different words) that some nerves are sensory, some motor, some both, and accurately described the idea of a reflex.

Depicting the babe in the womb (and some odd lessons in sex)

I'll just say it quickly: Leonardo, perhaps because of his own search for sexual identity or suppression of it, was obsessed — to the point of disgust, really — with procreation and every body part involved in it.

Imagining the human embryo

One of Leonardo's most fascinating drawings features a fetus (a series of fetuses, sketches, and notes, actually, drawn on a single page), called *The Fetus within the Womb*. He drew this cut-open drawing of a fetus around 1510, during the last stage of his fruitful anatomy career, when he was at the height of his analytical abilities.

The Fetus within the Womb was one of the first known drawings of a fetus in the uterus, and its influence remained unsurpassed for two centuries. Through it,

Leonardo offered a new interpretation of the relationship between a part and the whole — not only the connection between mother and child, but between humankind and nature. Just as he compared the rules regulating blood vessels to the branches of trees, so, too, did he liken the fetus's amniotic fluid to the Earth's seas. He was also the first to comment on the fetal membranes: the chorion, amnion, and allantois.

In fact, he intended his fetus studies to form the first part of a book with della Torre, but plague struck his unlucky colleague before they got their act together. (If della Torre *hadn't* died, their book would've been *the* definitive book on anatomy for centuries.)

Nevertheless, Leonardo's drawing had some fatal mistakes:

✔ Leonardo based his drawing on a fetus of about five to seven months gestation, but he apparently never got his hands on a pregnant cadaver. Leonardo believed that the uteri of all animals were essentially the same, so after dissecting a cow and calf, he mistakenly applied this arrangement to a human mother and fetus. But humans have a single uterus, and cattle have two uterine horns. (Leonardo seems to have drawn on his predecessor Mondino's two-horned uterus here.) The placentas of cows and human fetuses differ, too.

✔ As far as the growth of the fetus was concerned, Leonardo drew on Ibn Sina's (and Aristotle's) idea that its growth depended on both the nature and the soul of the mother.

People today still consider *The Fetus within the Womb,* flaws and all, to be a masterpiece of anatomical drawing — one that intelligently corrected some misconceptions and still graces the pages of medical and anatomy textbooks in the here and now.

Getting it on, kind of: Leonardo's theories on sex

Leonardo's studies of the sex act itself were also rather interesting. As far as the penis is concerned, he speculated (by using castrated bulls, boars, rams, and cocks as subjects) that the testicles produce a manly hormone. And though he briefly considered the possibility that wind is responsible for an erection, the examination of hanged men with erections suggested to him that blood flowing through a large vein causes this phenomenon. Despite his general revulsion for sex, Leonardo seems to have regarded the penis with no small amount of pride.

As far as how babies actually come about: That doozy remained a bit of a mystery. In one of his most famous drawings, the so-called coitus drawing of about 1497, Leonardo shows a couple having sex. He evidently drew on some Middle Age misapprehensions about the sexual act and its organs. Here, the semen originates in the brain, travels along the spinal cord, and reaches the penis through some unidentified tube. The penis itself (which, incidentally, penetrates the woman's womb) shows two channels: one to release sperm,

the other for the mental powers that travel from the brain. On the woman's end, a tubelike channel connects her breasts and womb. And a blood vessel connects the womb to the nipple.

Leonardo questioned (and corrected) some of these ideas in later drawings (for example, he later realized that the womb had one, not seven, chambers). Still, he marched bravely on with other misconceptions. In his so-called Great Lady drawing of about 1510, a drawing of the inside of a woman (see Figure 5-4), Leonardo suggested that women and men contribute equal parts of seeds in making a baby. (Not surprisingly, he viewed the fit between a man and woman's sexual organs as more of a mechanical problem than a biological one, that is, in terms of hose-pipes.)

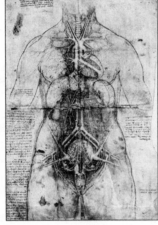

Figure 5-4:
Drawing of a Woman's Torso,
Biblioteca Ambrosiana, Milan.

Alinari / Art Resource, NY

Overall, sex seems to have greatly offended Leonardo. He viewed sex — and the body parts involved in this dirty act — as so ugly that if it weren't for people's beautiful faces, human beings would become extinct! And you know what makes faces beautiful (if you read the "Divining proportion: Vitruvian Man" section, that is).

Contributing to Modern Science: Leonardo's Anatomy Studies

During and after his lifetime, Leonardo's contributions to anatomy raised two questions: Was he a pivotal figure to early modern science? Or was he an eccentric dabbler with little or no influence?

His contemporaries were divided in their response. Many praised him for his inventiveness and beautiful anatomical writings. Others argued, however, that he wasted his time on strange speculations, was too much of a perfectionist, and — the clincher — because he didn't publish, his musings were worthless to others.

Today, the answer is undoubtedly that he was a pivotal figure. True, he didn't publish, but Leonardo clearly planned a book on anatomy (along with one on painting, one on engineering, one on hydrology, one on . . . you name it), though he never organized his theories and observations into a coherent treatise on the subject. What's more, some scholars argue that physicians entered his studio to look at his anatomical drawings, even though they weren't published until after his death.

As in most — no, *every* — discipline in which he dabbled, Leonardo became a master. His anatomical work represents an understanding of science far more advanced than that of his contemporaries. It's not surprising, then, that about 500 years later scholars have drawn — in name, theory, and practice — from Leonardo's anatomical drawings and musings and even his observational methods.

Experimenting the scientific way

In anatomy, as in his other areas of study, Leonardo proved that he was a man ahead of his time. As a scientist, he bridged the gap between shockingly unscientific medieval methods and today's modern scientific approach, which came of age during the so-called scientific revolution of the 17th century.

Leonardo wasn't called the quintessential Renaissance man for nothing. He relied on actual observation and his questions about nature when many of his contemporaries still depended on outdated medieval thought and descriptive text alone. Although he wouldn't have called it by the name that people today do, Leonardo was using the *modern scientific method,* a method taught in high school biology class:

1. **Observe.**

 Leonardo didn't simply look at the human body and its parts. He *studied* them. And then he drew what he saw, in detail and from multiple perspectives. Take his illustrations on everything from muscles to the skull.

2. **Ask questions.**

 Leonardo's dissection of a really old guy (I'm talking in his 100s), for example, raised all sorts of questions about why and how arteries harden.

3. **Formulate a hypothesis.**

 In the centenarian dissection, Leonardo formed a hypothesis about atherosclerosis by comparing the old man's heart to that of a toddler's.

4. **Test by means of experiments.**

 To test his hypothesis about the functioning of heart valves, for example, Leonardo experimented with a glass model (refer to the section "Pondering matters of the heart" for details). His frog-pithing experiments, for example, also gave him new insight into the location of the life force.

5. **Formulate a theory.**

 Leonardo less successfully developed overarching theories than studied the parts, but he did compare the workings of the human body to the larger functions of the earth (see "Depicting the babe in the womb (and some odd lessons in sex)" for some of these analogies). More specifically, his experiments led to theories (some correct, some not) about everything from sight to sex.

In many ways, Leonardo heralded the birth of a new descriptive, systematic scientific method before it was fashionable. Congratulations, Leo, for being among the first rational scientific thinkers! His methods of deduction and experimentation remain highly relevant today in all fields of science.

But — there's a big but. Leonardo, who declined to publish his findings during his lifetime, became a blip on the anatomical radar for some time. Though he probably influenced his close contemporaries, like Marcantonio della Torre and Andreas Vesalius (and vice versa), most of his findings weren't discovered until centuries after his death. Therefore, anatomical progress moved on without him.

Illustrating anatomical beauty

Leonardo pioneered modern anatomical illustration. Before Leonardo, researchers explained anatomy primarily through written description. Physicians and philosophers (many of whom dabbled in anatomy) *told* what the heart looked like or *explained* how a muscle flexed. What drawings existed were two-dimensional, single-perspective illustrations. Leonardo, however, changed that dilemma by focusing on firsthand experience. In his artistic endeavors, he revealed the truths that the human eye uncovers through sight. He believed that illustrations — an extension of these truths — far more effectively convey reality than analytical descriptions alone. To Leonardo, the goal was to show, not tell. So he drew and drew and drew, filling page after page with what he saw. And he sometimes supplemented his drawings with explanatory notes, just in case others didn't get the idea.

To illustrate the science of the human body, Leonardo pioneered some new methods based (usually always) on dissection:

✔ He presented several views of a bone, muscle, or organ to show all angles of it.

✔ He introduced the idea of cross-sectional representation to display the human insides, including veins, nerves, arteries, and skulls. (For example, he divided a leg at midcalf, showing the open end of it to illustrate the muscles there, and sawed a bone in half to show its internal structure.)

✔ Sometimes, he superimposed layers of a body part like a transparency to visualize each part together with the whole.

✔ To show movement (he listed 18 human movements, from standing and kneeling to carrying and lifting), he showed all parts of an arm, for example, including the skin, muscles, arteries, and bones. Then he illustrated how, in different combinations, they move. He also modeled human movements by attaching copper wires at muscles' origins on a skeleton to understand how they contract and relax.

Although none of Leonardo's discoveries were officially published in his lifetime, his methods became more widespread, and Vesalius, the father of modern anatomy, unofficially incorporated them in his book *De Humani Corporis Fabrica* (1543). Leo's technique has become the standard by which even modern-day anatomical illustrations are judged.

Challenging common knowledge

Leonardo was both a man of his time and a man ahead of it. His anatomical observations and theories about the human body were often at odds with the prevailing Renaissance ideas, as were his views about the repetition of patterns throughout nature and what people could discover by studying this natural design.

Leonardo's deductive reason linked structure to function. This reasoning, called *teleology,* relates design in nature to its final purpose. In other words, you can understand the purpose of any natural phenomenon by studying its design. This kind of thinking set Leonardo's work apart from his contemporaries, especially those who adhered to the church doctrine that human beings serve a higher purpose for God, and hence shouldn't be dissected to reveal the laws of nature at work. (Although it didn't become an issue for a few more centuries, Darwin's controversial theory of evolution put up a strong case for teleology.)

Leonardo also believed in the interconnectedness of the small and large patterns in nature. Consider his comparison of man (he didn't, needless to say, use politically correct language back then) to the larger universe:

> *The water which rises in the mountains is the blood which keeps the mountain in life. If one of its veins be open either internally or at the side, Nature, which assists its organisms . . . is prodigal there in diligent aid, as also happens with the place at which a man has received a blow. For one sees then how as help comes the blood increases under the skin in the form of swelling. . . .*

This idea of this interconnectedness was at odds with mainstream 15th-century philosophy, when people saw a distinction between the higher, generative (creative) principles of nature (such as procreation and the spiritual element) and nature's more basic, material parts. Leon Battista Alberti (the most important art theorist of the Renaissance), for example, believed in a larger female personification of nature. Leonardo contradicted these ideas in favor of more mathematical and mechanical understandings of the human body. Remember the comparison of muscles to springs and legs to gears? (If not, head back to the section, "Nuts and bolts: Leo's view of the human body.") Just as a spring didn't make a machine, nor did a muscle or leg make a body. These theories, together with his divine gift for drawing, led Leonardo to embrace important ideas that few doctors or scientists — if anyone, for that matter — recognized in Renaissance Italy, including the workings of the heart and brain. Prevailing wisdom still relied on ancient and Galenic thought and was only inching into a more modern era. Leonardo challenged the status quo with his dissections, detailed illustrations, and models, which contributed new knowledge to the study of the heart, brain, spinal cord, muscles, bone structure, facial expressions, and much more. (He was even the first to correctly count the number of adult human teeth: 32.)

Still, like many of his other musings on, well, just about everything, Leonardo's anatomical studies had only minor influence during the Renaissance. Part of the reason may have been that he never published a scientific treatise on anatomy — as was the case with many of his nuggets of brilliance — although he intended to write at least one complete text, probably more.

More importantly, during his lifetime, Leonardo's individualistic approach (not to mention his controversial dissections) may have alienated other practitioners during his lifetime. Certainly, he went against the church — which only the very brave did. Only "if you are alone you will be all your own," he noted, and that motto prevented him both from conforming to ideas of the time and sharing them with others.

Establishing a reputation and making an impact

Sadly, most of Leonardo's ideas, which influenced only a few of his contemporaries, lay dormant for a few hundred years. Historians only rediscovered his anatomical notes, sketches, and drawings, cast far and wide after his death, in the 19th century, marking Leonardo as a precursor to — and not the father of — modern human anatomy. Yet, some of his contemporaries *were* aware of his work. Leonardo made some prints of his earliest drawings; they appeared in contemporary publications like Albrecht Dürer's *Dresden Sketchbook* (1517) and a few other tracts. Overall, however, his drawings didn't circulate that well. Woodcuts, the standard technique for book illustration, didn't always capture fine details. And copper engravings were expensive and time consuming. After his death (and then Francesco Melzi's, his favorite student to whom he left the task of compiling his notes and sketches), all was lost for him. Vesalius's *De Humani Corporis Fabrica* (1543), an illustrated book on human dissection and critical anatomical knowledge, influenced the course of European anatomy for the next few generations. And the Venetian painter Titian and his students, no less, illustrated most of it! Vesalius, not Leo, thus became known as the father of modern anatomy. That is, until *Gray's Anatomy* (the most famous — and used — medical book, first published in Britain by Henry Gray in 1858, and now in its 39th edition!) came along.

Since the discovery of Leo's notebooks, physicians and medical historians have evaluated every aspect of his studies. In 1921, a Norwegian historian, H. Hopstock, made a compilation of Leonardo's anatomical feats, calling attention to his amazing illustrations, dissections, and correct depictions of the human form. Since then, books and museum exhibits have displayed and analyzed Leonardo's illustrations, charting his contributions to an anatomy that progressed largely without his contributions. Some of Leonardo's drawings even grace the pages of modern anatomy textbooks as evidence of near-perfect illustration techniques. And researchers have tested out his models. In 1970, for example, British scientist B. J. Bellhouse confirmed Leonardo's findings about the movement of the aorta's valves.

There's no doubt that if Leonardo's anatomical illustrations (many of which now take up residence at the Royal Library in Windsor) had been widely distributed in his day, they would've formed the foundation of modern anatomical studies. Right or wrong, they represented a new sophistication in exploring and understanding the human form. Given hindsight and circumstance, some consider Leonardo's anatomical studies to be revolutionary; others view them as just one gigantic leap forward in progress.

Chapter 6

An Inquiring Mind: Leonardo and the Natural World

*I*f you immediately think of a whimsical dabbler when you hear Leonardo's name, or if you assume that he simply studied other subjects as side interests to his art, stop right there. He didn't study trees because he was commissioned to paint them, or detail each human feature because he had to sculpt them. Far from it.

Leonardo studied objects and concepts independently, for their own sakes, but also for the sake of understanding how each tree (okay, maybe the forest), for example, relates to the world as a whole. It seems improbable that he would've related human anatomy to church architecture or botanical principles, but that's exactly what he did. He tried to understand each branch of knowledge as an organic part of a larger, unified whole. Aristotle and some of Leonardo's contemporaries, including the English philosopher Roger Bacon, had articulated this idea of a universal science. But Leonardo carried it to unprecedented heights.

Despite his best intentions to publish a treatise or book on almost every scientific subject he studied, Leonardo left nothing for posterity but a lot of sketches, scribbles, and notes (in mirror writing, at that). To make matters worse, he wasn't the most synthetic of thinkers to begin with, so he never postulated a grand theory of science or nature. Despite these shortcomings, Leonardo was, in most of his work, a scientist ahead of his time. In this chapter, I put Leo in his place, showing you how he (and his studies) fit in the grand scheme of a changing world.

Hitting Pay Dirt: Leo's Botanical Studies

Like everything in which he dabbled (and usually mastered), Leonardo's botanical drawings and notes form only a small part of what he probably produced. But he approached trees, plants, and flowers as he did everything around him. Not only was he interested in understanding and replicating the exact shape of each leaf in painting; he also wanted to understand each plant's function and larger relationships to earth, water, and sunlight. Once again, he tried to relate the micro- and macrocosm, the theory that said the structure of humankind reflects (in miniature, of course) the larger structure of the universe.

He wrote that a seed generates roots, for example, like the human heart generates arteries and veins (called the "tree of veins"). The seed even had an umbilical cord like a human. Despite some obvious limitations to these analogies, they perhaps helped Leonardo think about the structure and function of different plants, thereby distinguishing his thought from the ancients and his contemporaries.

Many books and thinkers inspired Leonardo's botanical interests. He read, for example, Pliny the Elder's *Natural History*. This encyclopedic compilation of ancient scientific thought included discussion of nearly 1,000 plants and some concept of their reproductive habits — but lacked any scientific methodology. Despite this generous background material, Leonardo probably started his serious inquiries with Leon Battista Alberti's *De re aedificatoria* (Ten Books on Architecture), published in Florence in 1485, because garden architecture may have inspired his early botanical interests.

Lounging around in the Italian garden

Although Leonardo wasn't a landscape architect per se, he had a helping hand in designing some ornate Italian gardens, mostly as a hydraulic engineer. (For more about his landscape designs, go to Chapter 12.) Now, don't misconstrue "hydraulic engineer" as a glorified water sprinkler. Italian gardens were elaborate. They encompassed large areas; integrated orchards, walkways, meadows, hedges, and more; and provided people with a way to enjoy the natural world, enhanced through human planning and design.

The gardens of the great

For upper-crust Italians, the suburban, country, villa, or palace garden offered a place of relaxation, refuge, or even escape — from the plague, political upheavals, or persistent tax collectors, to name a few rather unpleasant intruders.

Pliny's *Natural History* was one of the first books to articulate the idea of the famous Italian garden; Pliny imagined rooms of a villa with lush gardens and

landscapes. His Tuscany villa seems to have greatly influenced Renaissance gardens and their architects. Pliny the Younger, the Elder's nephew, also had a lot to say about the subject, including the formal U-shaped gardens known as *hippodromes* (which also meant racetracks). Of more profound influence on Renaissance gardens were the great villas of Emperor Hadrian, built in the second century AD at the base of the Tivoli hills. For Renaissance artists, Tivoli Gardens became a great place of pilgrimage, where they could examine the remains of ancient architecture, mosaics, statues, paintings, walkways, canals, fountains, and pools — and pillage its treasures along with past admirers.

Around the 14th century, Italians began to rethink their garden designs. Pietro de Crescenzi (c. 1233–1320) described the ideal villa garden in *Il Libro della agricultura* (1478). He envisioned gardens enclosed by high walls, built on 20 acres, and containing trees, geometric paths with arched trellises, and flowering hedges. A large, meadowlike lawn would boast a variety of small flowering herbs, and a pavilion would feature a large fountain. A more distant orchard would be arranged according to the seasons.

The Medicis, the Florentine ruling family, led this flowering of villas and villa gardens around Florence. Cosimo de Medici assembled the students of his Platonic Academy to discuss philosophy and prune vines at his faux Roman villa, Villa Careggi, built according to Pliny's descriptions and boasting an impressive botanical garden. Lorenzo de Medici wrote poetry at another Medici villa, Poggio a Caiano. The Medici gardens were elaborate affairs, with grand gardens, orchards, pools, and even aqueduct systems.

Leo's contributions

Leonardo, though he never served as the main landscape architect for any of the Medici gardens, worked on some of their hydraulic systems. He also helped Florentine merchant Giovanni Rucellai, whose garden, Quaracchi, was one of the most exquisite gardens of the era and one that he allowed the local peasantry to enjoy. Leonardo designed hydraulic works for the massive garden, preserving its herbs, exotics, and box trees clipped into dragons, centaurs, philosophers, and cardinals.

Leonardo also took his hydraulic engineering skills to Ludovico Sforza's court in Milan. In the *Codex Atlanticus,* he writes of the garden he designed for Ludovico and touches on the importance of building reservoirs behind the gardens and — of all things — manuring. Yet, historians have found no proof that Leonardo carried out any of his ideas. Instead, he seems to have been more of a spectator in the field of garden design. He recorded, for example, his observations of Ludovico's Paradise, the immense country villa/model farm called La Sforzesca. Leonardo seemed particularly fascinated by the villa's extensive hydraulic system, with its systems of stepped cascades and waterfalls. He concocted some theories of erosion and instructions for improving the operation of La Sforzesca's mills and canals — but who knows whose ears they reached.

Hearing colors, tasting music

When Leonardo wrote about mixing sounds, smells, and sight in his ideal garden, he may have been speaking from a synesthete's point of view. *Synesthesia* (Greek *syn*, which means "together," and *aisthesis,* which means "perceive") occurs when a person's neurons involuntarily cross-wire two or more senses, creating a perceptual richness; people with synesthesia often hear colors, taste tactile sensations, or see sounds. Many artists, scientists, and inventors claim synesthesia as the wellspring of their creative genius and ability to create artistic or logical unity in their works. Although there's some

dispute, John Locke is generally credited with being the first to reference synesthesia, though Aristotle may have as well, and Pythagoras considered it a great philosophical gift. Famous synesthetes include author Vladimir Nabokov, inventor Nikola Tesla, abstract artist Wassily Kandinsky, painter David Hockney, and physicist Richard Feynman. And possibly Leonardo, who supposedly saw different colors when he played and heard music and wrote about merging the senses for a richer perceptive experience.

Years later, around 1508, he also studied Charles d'Amboise's villa and offered integrated suggestions for improving it. He described how to grow citrus without using fires to heat orange trees in the winter and how to build hydraulic mills to evenly distribute heat given off by the spring. But Leonardo went much further in a way some scholars have called *synesthetic* (see the sidebar "Hearing colors, tasting music"): He wanted to merge all scents, sights, and sounds to please the senses. He thus proposed planting fragrant flowers to mirror the chirps of birds and music from a mill and to complement the harmonious, fountain-laden architecture.

Leonardo also designed a garden for François I's planned palace at Romorantin (which I discuss in Chapter 12). Despite Leonardo's grand plans, no evidence attests that he ever carried out his ideas in the gardens of Italy or France. Instead, he channeled his energies into other things having to do with nature, like botanical illustration.

The flowering of botanical illustration

Botanical illustration was hardly a science when Leonardo started drawing landscapes for his paintings. Italian painters generally traced manuscript paintings of plants instead of observing and copying nature with their own two eyes. A wonderfully illustrated manuscript known as the *Codex Juliana Aniciana* appeared in 512, giving artists more or less convincing models of plants. In the millennium that followed, however, little new transpired in the way of botanical illustration.

The Italian Renaissance ushered in a new form of naturalism. Around 1390, a monk named Cybo completed an amazingly realistic manuscript on plants and animals. Other manuscripts around 1400 started to capture the details of the natural world, but most depictions of plants were still highly stylized. Notable Italian artists during this period include some intermediary botanical artists, like Benedeto Rinio, Pisanello (Antonio Pisano), Giovanni Bellini, and even Leonardo's colleague, Sandro Botticelli. Botticelli's *Primavera* contains 30 (out of 40) identifiable plant species. And Flanders had its own realists in Jan van Eyck (c. 1395–1441) and Albrecht Dürer (1471–1528), both great botanical illustrators. Van Eyck in particular set a new standard for the naturalism genre, as a detail from his *Ghent Altarpiece* (see Figure 6-1) shows. Van Eyck's shrubbery, trees, and lawn were extraordinarily detailed and realistic for his time. Both artists, however, lacked Leonardo's thorough knowledge of plants.

Figure 6-1: *The Ghent Altarpiece,* by Jan van Eyck, 1425–29, oil on wood, 26 centimeters (10.2 inches) high, Cathedral of St. Bavo, Ghent.

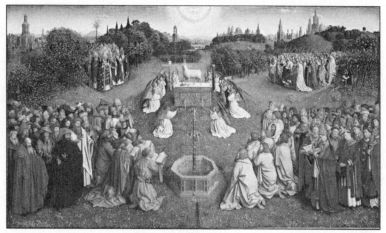

Scala / Art Resource, NY

For the most part, Leonardo drew directly from nature. Lorenzo de' Medici, for example, appointed him to study and paint in the Medici garden in Florence, which harbored many exotic plants. Leonardo sketched most of his plant drawings as studies for paintings, notably *Leda and the Swan* (see Chapter 10). All his botanical drawings, however, were virtually unknown until they were first exhibited in London in 1878.

Overall, Leonardo's botanical illustrations show a vitality in their details and overall unity that his colleagues' depictions of the same subjects lack. As the following examples from his body of work suggest, they also reveal his evolution as a painter and observer of nature, from the early *Annunciation* to the more naturalistic *Virgin of the Rocks.* Despite their realism, Leonardo's plants, flowers, and ecological settings also served an iconographic purpose, usually pointing out some religious symbol or meaning (see Chapter 13 for details on Leonardo's iconography).

✔ ***Annunciation*, c. 1472–75:** Leonardo (or Andrea del Verrocchio's studio workers, which included Leo) painted decorative, stylized plants in this painting, such as the meadow carpeted with flowers. The Madonna lily is more realistic — a flower, Leonardo claimed, copied from nature. But the painting contains a cypress tree, which didn't exist in Italy and was probably gleaned from a manuscript. See the painting for yourself in Chapter 13.

Although Leonardo evoked real landscapes in his paintings, he probably didn't visit all the places he painted. Like other artists, he either imagined them, painted them from local areas, or portrayed them from literary accounts, many based on those by 14th-century English armchair travel writer Sir John Mandeville.

✔ ***Ginevra de' Benci*, c. 1474:** Leonardo's juniper foliage, with a possible poplar living on the riverbank, is very botanically accurate. (See Chapter 11.)

✔ ***Virgin of the Rocks* (Louvre version, c. 1483–86):** Leonardo chose each plant in this painting for its iconographic value:

- To the right of the Virgin is the *Aquilegia vulgaris* (columbine or "dove plant"); doves symbolize the Holy Ghost.

- At the base of baby Jesus's foot is the *Cyclamen repandum*, emblematic of love and devotion.

- Above the baby's left knee lies a basal rosette of leaves from *Primula vulgaris*, the emblem of virtue.

- The infant St. John kneels over a plant of *Acanthus mollis*, a symbol of the resurrection of Christ.

- A palm leaf, symbolic of both victory and virtue, hovers above the Virgin's hand. In the London version of the painting, it's clear that other artists (not Leonardo) had a hand with the plants, for the fewer species are less precisely painted.

Despite the symbolic meaning of his selections, Leonardo also placed each in its proper ecological setting. For example, in the left corner lies *Iris pseudo-acorus*, which is usually found in aquatic areas at the foot of mountains. Here, the plant has long, spiky leaves, with spiraled lower leaves for a spatial effect, a trend Leonardo saw in nature but was probably uncharacteristic of the plant itself. Check out the painting in Chapter 13.

✔ ***Sala delle Asse* (c. 1495-1498):** Leonardo painted this geometrical tree motif for the north tower of the Sforza castle in Milan. The trunks replace columns, their branches imply Gothic vaulting, and their roots are anchored in rocks. The trees' branches weave together, with a single knotted ribbon running throughout — suggesting a conjugal motif, perhaps the marriage of Ludovico Sforza and Beatrice d'Este. Despite some overpainting and attempts at restoration, Leonardo painted each leaf with the precision of a botanist. And a mathematical order to the tangle of leaves and branches ties everything together.

✔ ***Leda and the Swan* (c.1505–10):** Although different copies of Leonardo's *Leda and the Swan* abound, featuring Leda in different poses, each shows a fertile, lush landscape (flip to Chapter 10 for one version). Some versions contain *Iris Pseudoacorus,* the aquatic iris, and the spiraling *Ornithogalum,* or Star of Bethlehem, about her feet. Leonardo deliberately contorted the plant to serve as an extension of her curvy figure and swan's outstretched neck. The drawing in Figure 6-2, possibly a study for the plants in *Leda,* reveals Leonardo's obsession with detail and the swirling patterns of nature.

Figure 6-2:
Star of Bethlehem and Other Plants, c. 1505–7, pen and ink over red chalk on paper, 19.8 x 16 centimeters (7.8 x 6.3 inches), Royal Library, Windsor.

Scala / Art Resource, NY

Focusing on the trees of the forest

Leonardo saw far beyond the paintbrush and canvas when it came to plants, though everything related back to his painterly vocation. He included a section on botanical principles called "Of Trees and Verdures" in his *Treatise on Painting,* though most abridged editions, following the one published in 1651, didn't include this text.

Plant physiology — the circulation of saps, water uptake, and transformation of soil compounds — didn't become a topic until the 16th century, though certain knowledge (for example, roots exist to anchor plants in the soil and take up nutrients) had been around since ancient times. Leonardo built on such knowledge, but went further. Some of his botanical observations and conclusions are remarkable for their time. Others are less original; some are even wrong. Leonardo falsely concluded, for example, that the leaf is the

nipple or the breast for the branch or fruit that grows the following year. But taken together, his relatively modern observations left most other botanists in the dust. Take a few of his ideas, for example:

- **Plants rely on water for nutrition.** Leonardo acknowledged that the earth nourishes plants with water. He explained the various shapes of roots in terms of the varying capacity of soils to hold water. And he tested his theory about water by leaving the smallest roots of a squash plant in the ground and watering it; it eventually produced about 60 large gourds!

- **Plants reach for the sun.** Leonardo realized that sun gives life to plants. Extremities of plants, unless pulled down by the weight of fruit, turn upward toward the sun as much as possible. Leonardo didn't say as much, but this principle is called phototropism, and Charles Darwin outlined it in the late 1800s.

- **Plants are drinkers.** Night dew penetrates the stems of large leaves with humidity, nourishing the vascular system. Leonardo thus arrived at the idea that plants draw in water from hydrostatic pressure.

- **The branches toward the top are the runts.** Leonardo also guessed at a process called *geotropism* (gravitational effects) and geotropic hormonal response. He observed that the part of the bough facing the earth produces the largest branches, and the smaller ones grow from it above the largest branch. The lower branch grows this way because the sap falls to the lower part of the branch, nourishes it more, and causes the bark to grow thicker — which is why the twigs of branches are much larger below than above. Like phototropism, Darwin more thoroughly articulated the principles of this process.

- **Trees have their own wrinkles.** He observed the presence of growth rings in *xylem* (part of the tree trunk tissue) as showing the number of years, including wetter (wide growth rings) or drier (narrower growth rings) years.

- **Trees have their own life-giving fluids.** Leonardo experimented with grafting on trees, a practice mentioned in Pliny's *Natural History* and Renaissance treatises. He observed that if a branch of a tree is cut and a twig grafted on, the twig will grow much larger than the branch that nourishes it because the vital saps rush to the injured graft location. He also showed that when a tree has part of its bark stripped off, a thick new bark grows in its place, showing the nutritive moisture at the wound, like scar tissue in humans. Basically, Leonardo arrived at the idea that hormones in a tree encourage the regeneration of tissues. But not until 1860 did Robert Hartig, a German professor of botany, "discover" that when a sharp blade cuts a tree deeply, sap pours forth — just as Leonardo pointed out around 1510!

Taken together, Leonardo's observations about the relationship of sun, water, and soil to plants and trees were revolutionary for their time.

Digging Deep inside the Earth: Leo's Geology and Paleontology Studies

Bet you didn't know that Leonardo was a rock (no, not *rocket*) scientist too, did you? He observed earth processes and probably even intended to publish a treatise on geology, just like the one he started to write on trees, water, you name it. But he never did. And because his notebooks scattered after his death, most of his prescient observations about geological processes disappeared deep inside the bowels of the earth. Nonetheless, his observations foreshadow later breakthroughs in *geology* (the science and study of the earth and its history) and *paleontology* (the study of fossil plant and animal remains).

The earth — 4.5 billion years and counting

Geology has been around for — well, for as long as humans have lived on earth. Leonardo was up-to-date on all the geological literature, including that of the ancients. Aristotle (384–322 BC) had observed many things: erosion and deposition of surface material; the idea that fossil seashells from rocks resemble those found on the beach, indicating they were once alive; and that the positions of land and sea had changed over long periods of time. Of course, way back then, people had no way to *prove* these things.

Scientists made few significant advances in geology (besides mineralogy and mining) during medieval times. The Renaissance once again brought geology to the forefront of scientific interest. French philosopher Jean Buridan (c. 1295–1358) questioned and examined many of Aristotle's ideas about the earth, influencing natural philosopher Albert of Saxony (1316–90). Albert studied the equilibrium of the earth and seas, erosion, and terrestrial mass and center of gravity, among other earth processes. And these ideas, particularly about erosion and the earth as a mass in continuous motion, in turn influenced Leonardo.

Leonardo, ever the man about town, was also the man about nature. Who knew that when cities hired him to move water and earth he'd make some pretty uncanny observations about the nature and age of the earth? In designing canals and other objects to harness nature, he came up with some quite modern conclusions, including the following:

✔ **Rivers carve mountains.** Leonardo realized that various river floods had produced different stratified layers in the mountains. One could even follow these distinct layers of different-aged rocks and clay over great distances. Basically, Leonardo prefigured the law of *superposition* (where the oldest sedimentary rocks lie at the base, and the youngest at the top).

This concept wasn't fully articulated until the Danish scientist Nicolaus Steno (1638–86) — who, incidentally, worked in Florence — put it in writing.

✔ **Rocks didn't appear out of nowhere.** Using Albert of Saxony's ideas as a jumping off point, Leonardo tried to make sense of the process of erosion. He realized that rivers erode rocks and carry the sediments to the ocean. He also understood that the deposition of sediments slowly produced new rocks — and, together, these steps form one big cycle.

✔ **The earth was one big pool — at one point, anyway.** He theorized that water had once covered the earth, which had emerged from the sea to form new landmasses.

Many of Leonardo's pathbreaking ideas weren't rediscovered for more than 100 years after his death, when Scottish geologist James Hutton (1726–97) presented a paper titled *Theory of the Earth* to the Royal Society of Edinburgh in 1785. Hutton posited ideas about the earth's age, arguing that it was older than people had supposed. After all, the earth needed some time to allow for mountains to erode and sediment to form new rocks at the bottom of the sea, which then rose as new land.

Dead again: Fossils

Theorizing the age of the earth was one thing; looking at specimens of former life to approach its exact age was another. Leonardo may have dug up his first fossils, mostly Cenozoic mollusks found in Italy, while excavating some earth for Duke Ludovico Sforza in Milan in the 1480s. Rumor also has it that peasants, knowing of Leonardo's interest, presented him with fossils at Ludovico's court. No doubt he came upon many of these entombed geezers while working on various projects, including, as Giorgio Vasari wrote in *The Lives of the Artists,* "plans to remove mountains or to pierce them with tunnels from plain to plain" (Oxford University Press, 1998).

Leonardo was neither the first nor the last scientist to study old life remains; once again, the ancients had beat Renaissance scientists to the punch. Around 540 BC, Xenophanes, a Greek philosopher, described fossils of fish and shells in deposits on mountains. In 490 BC, the Greek historian Herodotus noted similar fishes interred in stone. He concluded that the area of Egypt lying between mountain ranges up the Nile had, in fact, been a gulf that eventually filled with river deposits. Aristotle, in the fourth century BC, also noted the presence of fossils. And around 200 BC, the Greek geographer Eratosthenes asked why shells were found hundreds of miles away from the sea or nearest salt marshes. (Greeks, citing bizarre near-petrified giants along with the more harmless fish and shells, also may have found isolated fossil bones of creatures like the southern mammoth, a relative of the woolly mammoth.)

Leonardo was undoubtedly aware of these ancient and more contemporary writings. He agreed with Aristotle that fossils were the ancient remains of life.

During the 14th century, a Frenchman introduced the concept of the uplifting of land as a possible reason for fossils, but this concept didn't become popular in 15th-century Italy. Instead, Leonardo had to field some rather unscientific theories:

- ✔ Rocks had spontaneously sprouted fossils.

- ✔ The biblical Great Flood had carried them to strange places, high and low.

- ✔ An occult force produced fossils, or strange astral conjunctions created an inanimate plant or animal form in rocks. They were perhaps even the work of Satan himself!

- ✔ God had tried to create a little something special, but failed.

Leonardo had some compelling starting points for his own inquiries. Needless to say, he didn't buy into any of these popular (and erroneous) myths.

Dispelling the Great Flood story

Leonardo didn't wholeheartedly buy into orthodox Catholicism to begin with, but he did believe that a larger, godly force had something to do with the designs he observed in nature and humankind (see Chapter 13 for his views on religion). It's not surprising that he challenged the biblical story of Noah and the Ark (when a ticked-off God sent down rain for 40 days and 40 nights, flooding the earth), becoming one of the first scientists to dispel biblical stories on scientific grounds. And yet he was obsessed with violent floods, to which his *Deluge* series, discussed in Chapter 12, attests.

Leonardo saw every sign that fossils, from corals to oysters, had once been living, breathing organisms. In his examinations of these dead things, he doubted that a single worldwide deluge could've happened. His reasoning?

- ✔ After the flood peaked, the water would've had nowhere to go.

- ✔ A flood would've left fossils in quite a mixed-up state, not in the regular layers that geologists generally find. These successive strata, in fact, indicated that more than one great flood, maybe even a whole series of them, had occurred.

- ✔ Because falling rain travels downhill, any major flood would've carried fossils away from large mountains, rather than up them.

People who disagreed, Leonardo wrote in his notebooks, were only wracked by "silliness and stupidity," like that "other sect of ignoramuses who declared that Nature or the heavens had created them by celestial influence." Now, now.

If the Great Flood didn't carry fossils to the tops of mountains, though, how did they get there? Leonardo had a shockingly modern answer. He speculated that the sun, moon, or other terrestrial "machines" induced the ebb and flow of the waters. Fossils, far from being Satan's spawn, had been buried (alive) at a time before the mountains were raised. And the rivers, doing their thing called erosion, wore away the sides of the mountains, exposing the strata and

carrying sediment into the rivers and seas. Leonardo thought that the surface of the earth was continually raised, and the ancient seabeds became new chains of mountains. Where land now was, ocean had been.

Although Leonardo rejected the Great Flood theory, he acknowledged, after observing floods of the Arno River, that smaller, regular floods buried fossils as well.

Anticipating Darwin?

For all his advanced thinking, Leonardo had some limitations. Some people have called him the evolutionary ancestor to Charles Darwin (1809–82), but the two scientists' ideas showed more differences than Darwin's own finches.

For the most part, Renaissance men and women believed that God had created the world according to the exact specifications laid out in the book of Genesis: "In the beginning, God created the heavens and the earth. . . ." And if God said he put creatures on the earth on the fourth day, who was to disagree?

Well, some of the ancients, to start. (Remember, these guys were around before the advent of Christianity, and hence the Bible, and sought logical explanations for natural phenomena.) Early evolutionary theories appeared in some ancient Greek writing, including Aristotle. But they weren't exactly correct; the Roman philosopher Lucretius (99–55 BC), for example, denied that land dwellers could've emerged from the sea, though he realized that nature stamped out some of the more monstrous species. Yet, during the centuries in which the church reigned, few writings on evolutionary thinking emerged — that, or else the church squelched them. But the Renaissance, with its focus on humanism and scientific inquiry and discovery, opened the doors for such heretical thought.

"Necessity is the mistress and guardian of Nature," Leonardo wrote. "Necessity is the theme and artificer of Nature — the bridle, the law, and the theme." He thereby suggested that nothing superfluous in nature survived. As his questioning of the Great Flood showed, Leonardo challenged church doctrine as well. He also suspected that the earth was much older than his contemporaries thought and the church taught — centuries before studies by James Hutton, Sir Charles Lyell (1797–1875), and Darwin proved him right.

Sure, Leonardo considered some of the same ideas as Darwin, who, 300 years later, articulated his controversial theory of evolution in *On the Origin of Species* (1859). Boiling it down to the basics, Darwin believed that existing plants and animals had developed through a process of slow, continuous change. He subscribed to the idea of the survival of the fittest and natural selection — that favorable variations in an animal (from a beak to a tail) allowed it to survive in a dog-eat-dog world. This theory shook the foundations of Victorian England and posed unheard-of challenges to church lore.

But considering what people know today about the earth's epochal timeline, Leonardo's thinking fell a little short. He didn't have any sort of evolutionary

framework in mind when he wrote about nature and necessity, nor did he believe that species changed over time. Nature, he believed, did not change species by itself. The idea of nature's immutability thus remained an intellectual conceit through the Renaissance and beyond — leaving the monkey ancestors with some serious things to ponder.

Staying Afloat in Hydrological Science

For all I know, Leonardo couldn't swim a lick. He may have drowned had he dipped even his little toe in water. Whether he would've floated or sunk, plenty of evidence suggests that water — its behavior, motion, and the use of technology to control it — fascinated him. Once again, Leonardo intended to write a treatise on water's properties and uses, starting with pure hydrodynamics and ending with irrigation and hydraulic engineering. He seems to have gotten only as far as the table of contents.

In his queries about the nature of water, Leonardo took on classical scientists, from Aristotle to Pliny, as well as medieval scientific texts. Although he offered painstakingly detailed observations on all aspects of water, Leonardo nowhere offered a comprehensive framework for understanding the force and energy behind water. Taken together, his studies on H_2O — I present only a few of them here — seem to have bordered on the obsessive.

The lifeblood of the universe

Leonardo's fascination with water extended far beyond mere science and technology. In fact, he had a rather primal reaction to it. Comparing it to human anatomy, the macro to the micro, he saw water as the lifeblood of the earth, "the vehicle of Nature," the circulatory system for the entire world. This idea of water as the vital lifeblood of the earth came from Pliny, but Leonardo went to town with it. The rivers resembled veins, and mountain springs, the blood of animals.

Although water has properties like human blood — more powerful, even, as it fueled the entire earth — Leonardo never quite reconciled the substance's seemingly contradictory properties.

✔ It smells and feels different depending on the water source and quality, from sharp to steamy to bitter to sweet, from thick to thin, from health-giving to poisonous, from warm to cold.

✔ People, plants, and animals need water to live — yet, water can also kill them in great floods or storms. Leonardo depicted water's great regenerative force in paintings including *Virgin of the Rocks* and *Leda and the Swan,* and its capability for great destruction in his *Deluge* series (see Chapters 13, 10, and 12, respectively, for those paintings). Thus, water has to be tamed.

He also made other observations about earth's lifeblood, such as those in the following list, and came up with 64 terms to describe its movements, from rebound to circulation, revolution, turning, submerging, surging, depression, percussion, and destruction.

- ✔ **In time, water changes everything it touches.** In examining the motion of waves and currents, Leonardo developed a theory of erosion that postulated that water gnawed away at mountains and filled valleys. If it could, water would shape the earth into a perfect sphere.

- ✔ **Water moves around according to fixed rules.** It falls as rain or snow, springs up from the ground, rises as vapor, and runs in rivers to the oceans.

Around 1508, when he started to dissect the human heart in earnest, doubts began to plague Leonardo about whether earth's circulatory processes were, indeed, similar to blood in animals (and, for that matter, saps in plants). Think of what these doubts hinted at: Leonardo's macrocosm had no governing force. That idea must have scared the daylights out of him.

The nature of waves

Contemplating the entire ocean would've been impractical per se, but Leonardo studied the motion of waves by experimenting with water in a large, circular tub filled with water. He used seeds and colored inks to detect movement in these vats; along rivers, he used oils and designed floats to show surface movement. He concluded that

- ✔ Ripples caused by disturbance in the middle of the water move outwards, in widening circles, and then, when they hit the rim, contract back toward the center, which then starts a whole new ripple outward. (Interestingly, Leonardo compared these laws to percussion and music.)

- ✔ The shape of the object dropped into the water doesn't matter; all produce the same circular motion in the water.

- ✔ If two ripples or waves crash into each other, they overlap and then continue on in oblivion, without changing the other's shape.

- ✔ He comprehended the difference between the movement of water and that of a wave on the water's surface, theorizing that waves arise from vibrations in the water.

- ✔ Only moving water produces pressure at the bottom of a container or pond, for example. (He was wrong here; still water does the same.)

Although Leonardo never published his work on water movement and waves, his observations created the context for further study — and the technology to tame it all.

Bending nature to human will

Nothing frightened poor Leo more than the threat of a terrible flood or storm. For some reason, he had an abnormal fear of such forces. He was particularly paralyzed by and obsessed with violent, swirling waters, as his *Deluge* series shows (see Chapter 12). He even recounted a dream in which a giant sea monster was about to swallow him. Yet, Leonardo had ample reason for panic. When he was a child, he witnessed a devastating hurricane in the Arno Valley, which swept up people, animals, and houses in its wake. In 1466, ten years later, the Arno River burst its banks. Floods recurred in 1478, wreaking even more havoc. Thus, studies of hydrodynamic turbulence never failed to fascinate and frighten him.

What could Leonardo do to stop the madness that could wreak greater destruction than Italy's most powerful armies? Conquer nature, of course.

Throughout his life, Leonardo was obsessed with designing machines to harness water, alter its course with locks and canals, and control it to benefit humankind. Because Milan possessed the largest network of navigable canals in Italy, here is where Leonardo, working for Ludovico Sforza, developed many of his schemes for canals. Milan is also where, after countless experiments on the speed of currents, whirlpools, and silting up of canals, Leonardo intended to write a treatise on hydraulics. Not to make him feel bad or anything, but this treatise never submerged from the murky depths of his mind.

Leonardo brought his hydraulic expertise to Florence as well. Even though human power still provided the readiest form of power available, water power was growing in importance in certain industries, particularly textile manufacturing, the source of Florence's wealth. Leonardo designed what he called "gadgets of water," based on the Archimedes screw, to lift water for economic activities. And as Chapter 8 shows in greater detail, Leonardo dreamed of changing the course of the Arno River and creating a navigable waterway all the way from Florence to the sea. Had his plan come to fruition, it would've provided irrigation for dry farmland and brought greater prosperity to the farmers. It would've also, in these most unstable times, made Florence more independent of regional trade.

As it was, Leonardo realized none of his grand dreams of controlling waterways, digging canals, and draining marshes during his lifetime — though, as you see in Chapter 8, some were begun.

Gazing at the Heavens: Astronomy

Leonardo wasn't an astronomer per se, but hey, he showed a similar competence in this field as in others. (As for astrology — that topic was for the birds.) While in Florence in the 1470s, he surrounded himself with great intellectuals

and scientists, including (most likely) Paolo dal Pozzo Toscanelli (1397–1482), Florence's most famous astronomer and geographer. Leonardo also seems quite well read on the subject, possessing Ptolemy's *Cosmography;* a work by Albumasar, an Arabian astronomer; Goro Dati's *La Spera;* and a book on the quadrant, not to mention works by good old Aristotle and his medieval commentators.

Much of Leonardo's interest in astronomy stemmed from his study of mathematics, geometry, and optics. He made hundreds of drawings depicting the nature of light, reflections, and shadows and conducted many investigations about the relationship between art, science, and optics. He believed that astronomy could be understood by understanding perspective used in art, for example. He wasn't so concerned with how planets moved, but more with their appearance. After all, he strongly believed in the relationship between observation and knowledge. He studied science (at least through the 1490s) with the firm belief that the eye transmits accurate images to the mind, thereby relating the truth to anyone who will seek.

Leonardo later realized that the situation involving the eye, mind, and ultimate truth was more complicated than he initially thought. He made some mistakes about the anatomy of the eye, which affected his theory about perspective, vision, and the truths of nature (refer to Chapter 5). But no worries. Just take it one star at a time.

Twinkle, twinkle, little star . . .

Leonardo's greatest astronomical query concerned the transmission of light from one planetary body to another. The properties of the moon in particular, as well as the very subjective nature of the halo of the fixed stars, fascinated him to no end.

Leonardo obviously couldn't get his hands around the moon and stars as easily as fossils, but he could use optical principles to try to explain their shining light. In fact, Leonardo was one of the first Western thinkers to realize that moonlight is reflected light. "The moon is not luminous in itself," he wrote, because it fails to shine without the sun. Instead, he said it acts like a kind of bumpy spherical mirror that reflects the sun's rays earthwards. Somewhere along the way, probably from Aristotle or Albert of Saxony, Leonardo adopted the idea that the moon has different levels of transparency, from alabaster to crystal, and thus reflects the sun's light unevenly.

Leonardo made another fascinating observation about this reflected light. If the moon reflects the sun's rays, it logically follows that if you stood on the moon, the reverse should also be true. That is, the earth would also reflect the sun's rays. He thus reasoned the earth, like the moon, was a star, with all the planets being reflective masses of earth and water.

Did Leonardo invent the telescope? In a word: No.

All sorts of people will tell you that Leonardo invented the telescope. Leonardo invented other objects having to do with space, like the helicopter and parachute (which I discuss in Chapter 9), but he didn't have much of a clue when it came to telescopes.

Leonardo did, lest you think I'm undermining his abilities, conceptualize some of the principles behind the telescope. In his notebooks, he wrote about "making glasses to see the moon enlarged," as well as reflecting the image of a single planet onto the base of a concave mirror to enlarge the image. But the first practical refracting telescopes didn't appear until the early 17th century, with a Dutch lens maker named Hans Lippershey and Galileo Galilei at the forefront of invention.

This conclusion, of course, is wrong by precise scientific definitions. The earth isn't a star at all, but a planet. Yet Leonardo may have been using "star" in the larger sense, as a few people do today, to include the sun and all visible planets.

Earth is just another planet: The heliocentric theory

I'll say it really quickly: Leonardo was *not* an ancestor of Nicolaus Copernicus (1473–1543), despite some popular myths. With his heliocentric theory of the solar system, Copernicus tried once and for all to dethrone the earth from its astronomical position at the center of the universe. By contrast, Leonardo stuck to the geocentric model, although his musings suggest he almost changed his mind on a few occasions.

Geocentric model: For nearly 2,000 years, theories about the earth-centered universe as articulated by Aristotle, Plato, and Ptolemy dominated Western thought. This theory said that the earth was the center of the entire universe; for Plato, the universe consisted of ten spheres that rotated inside each other. Medieval astronomers, buying into this geocentric view, tried to figure out the relationship of these planets to each other based on their relative rotations. Through instruments including the ancient *astrolabe* (a tool to chart the position of a star), the *quadrant* (an instrument to measure the angle of a celestial object), and a map of the stars, medieval folk surveyed the universe.

Heliocentric model: In the 16th century, a few decades after Leonardo's death, the Polish astronomer Copernicus proposed a revolutionary new theory about the universe. In his pathbreaking *On the Revolutions of the Heavenly Bodies* (c. 1543), Copernicus came up with his heliocentric system theory: Perhaps

the sun, not the earth, was the center of the solar system. He even ordered most of the planets, sun, and fixed stars in a relatively modern way. In his new universe, the earth was just another planet, and the moon orbited around the earth, not the sun. The planets circled the sun (he didn't quite get the idea of ellipses), and the earth rotated once every 24 hours, causing the stars to only *appear* to be moving. Copernicus's heliocentric theory set the foundation of modern astronomy.

Bottom line? Leonardo likely didn't subscribe to the heliocentric doctrine developed by Copernicus, as nobody had yet posited it. In fact, Leonardo likely remained committed to the geocentric theory that had dominated classical and medieval astronomy, though in his notebooks he raised questions about it. Most of his drawings, sadly, feature the earth at the center of the universe.

Movin' and Groovin': The Science of Mechanics

Leonardo's contributions to mechanics were among his most original of the period. The chapters in Part III of this book examine his mechanical inventions in more detail, from his flying machines and hydraulic apparatus to his mere gadgets, like shoes for walking on water and a spit roaster. No matter their function, all his early designs for machines show certain trends. Leonardo had a special penchant for drawing relationships between machines and nature; both operated according to similar laws of mechanics. It wasn't atypical of him, for example, to sketch the swirling movement of eddies near a spiraling screw. Leonardo was so enchanted with mechanics, in fact, that he called it "The Paradise of the Sciences," in which mathematics turned empirical science into applied science.

In his projected (yes, you read right: *projected*) book on the "Elements of Machines," Leonardo intended to present what he called the anatomical elements of mechanical parts, from levers to pulleys, gears, and springs. (Instead, he left a morass of fragmentary musings about mechanics.) He combined these old parts in new ways and designed some pretty cool stuff. But while he was designing his machines, he also studied mechanics and physics for their own sake. He hoped that his analysis of cannon ballistics, for example, would help him figure out questions of power and motion. He also staged various experiments with balls, weights, levers, you name it.

Eventually, Leonardo came to realize that the relationship between mathematical theory and practice wasn't as straightforward as he'd have liked. Still, he touched on some very important principles of mechanics, and his technological designs are peerless for their time.

Buying into the pyramid scheme

Leonardo wasn't a gambler, yet he bought into a pyramid scheme. Not for money — for power. Literally. Leonardo constructed a general law in the *Madrid Codices* around 1495 that says, in effect, that a pyramid scheme governs all natural powers — what he called the "four powers" — movement, weight, force, and percussion. Leo's take says that movement is the most important, then weight, because it originates from movement. Then comes force, which arises from the previous two, and finally percussion, which springs from weight, movement, and force.

Leonardo applied his idea about the pyramidal nature of mechanics to science and art (mostly in his use of perspective), to the microcosm and macrocosm, as a few examples show:

- **Falling weights:** In his experiments with weights, Leonardo noted the pyramidal increase in the velocity of a falling weight.

- **Falling water:** The same principles apply to water. The farther it falls, the faster it drops.

- **Mirrors and reflection:** Leonardo observed how mirrors reflect images that recede with distance, in proportion to their distance within a larger perspectival scheme.

- **Light and color in painting:** Leonardo suggested that the power that brings images to the eye diminishes in pyramidal proportion according to distance. According to him, the same principle applies to the light that brings images of objects to the eye.

- **Machines (the spiral gear, spring, or pinion wheel in clocks):** All lose force in a geometric manner as they unwind.

This pyramid principle, in which energy is gained and lost in a geometric fashion, formed the foundation of mechanics. And the four powers informed all Leonardo's designs for machines, from the helicopter to the scythed chariot.

Action, reaction: Laws of motion

Leonardo, like those great thinkers before and after him, wondered what makes things move — and why they stop.

Well read in almost every subject under the sun, Leonardo initially relied on Aristotle's idea that abstract principles govern nature. After reading up on the medieval texts and staging a few experiments, he questioned Aristotle's assumptions, then ultimately backtracked and embraced the ancient's main truths:

✔ Nothing moves unless it's subject to force. (All motion requires some kind of mover.)

✔ Speed is proportional to force and inversely proportional to resistance.

✔ The most natural state is rest (or doing nothing, on earth at least).

✔ A vacuum can't exist for an object to move.

In his writings and drawings, Leonardo came up with both implicit and explicit laws of motion. Alongside some of his drawings, such as his spring equalization devices, he articulated some of these laws. He observed that weight increases as an object approaches the end of its motion, and force decreases. And the power of a spring is pyramidal — that is, it diminishes towards its end. Like Aristotle and all his followers, Leonardo thought that an object would only move as long as it was subject to force.

Yet, this idea didn't seem to explain things that moved *after* one had applied force, like a bouncing ball or a stone thrown across a river. To address this seeming contradiction, medieval philosophers, such as the 14th-century Jean Buridan, invented a theory of *impetus*. Simply put, they believed that a power is impressed in a moving body (such as a ball) and stays with it as an inherent force.

In the 1480s and 1490s, Leonardo bought into this belief and began to question some of Aristotle's ideas. But he wasn't satisfied. He finally concluded that *impetus* is derived movement and has a much weaker velocity than the primary movement. Thus the derived motion of the air (or water, or whatever) doesn't push the moving object when it's separated from the power of the moving force. Instead, these derived movements are only maintained by the air or water to prevent a vacuum — one of Aristotle's principles.

Despite being plagued with the problem of the universal laws of motion his entire life, Leonardo also studied other aspects of mechanics and physics.

✔ He used the idea of Aristotle's statics, or virtual velocities, to explain the behavior of simple machines like levers and pulleys.

✔ He adopted Aristotle's idea that the velocity of a moving object is proportional to the motive force and inversely proportional to the resistance the moving thing meets.

In this idea, Leonardo came close to discovering one of Isaac Newton's principles: An action is always countered by an equal reaction. He noted, for example, that in his studies of percussion, "everything striking against a resisting object leaps back from this object with equal force."

In many ways, Leonardo was ahead of his time when it came to studying mechanics, as his innovative gadgets show. But because he failed to formulate a comprehensive theory of motion, he was definitely behind Newton's times.

TECHNICAL STUFF

Where was Newton when Leo needed him?

It would've been helpful to Leonardo had Newton been around, wouldn't it? Perhaps then some of his machines may have actually worked. English physicist Sir Isaac Newton (1642–1727) was the first guy to describe universal gravitation via his laws of motion. In fact, people consider him the father of classical mechanics — how physics of forces affect bodies. He developed three laws that Leo may have found extraordinarily useful:

✔ **The law of inertia:** Everything wants to stay put, period. Every body continues in its state of rest, or moves in a straight line at a constant velocity, unless a force impressed upon it changes that situation.

✔ *F = ma.* Remember high-school physics? Force equals mass times acceleration. That is, the acceleration (or taking-off speed) of an object of constant mass is proportional to the resultant force acting upon it.

✔ **The conservation of momentum:** For every action, an equal and opposite reaction occurs (what Leonardo got at, kind of).

Had Leonardo understood these principles with certainty, he would've saved hours of reading up on the latest literature and experimenting endlessly with laws of motion. Newton's laws of motion explain many concepts: motions of pendulums and clocks, the tides, the orbits of the moon and planets, and the motion of spinning bodies, to name a few. They also explained why Leonardo's car slowed down after a while.

Son of Experience: Leonardo and His Scientific Impact

Leonardo relied, at least for the first two-thirds of his life, on the grand theme of the microcosm-macrocosm, which said that the structure of humankind reflects the larger structure of the universe. Parts of this metaphor extended as far back as Plato's *Timaeus* in the fourth century BC. But somewhere around 1508, when Leonardo started his human dissections in earnest, he realized that this pretty analogy didn't actually work for everything. Nothing substituted for empirical knowledge and experimentation. Understanding the human body only got you so far in understanding the universe; if you wanted to know what caused movement or how sunlight and moisture affected plant growth, you had to actually study objects in motion or dig up carrots in your neighbor's garden.

Indeed, what differentiated Leonardo from many of the scientific minds before him was his reliance on experimentation rather than speculation backed by abstract theory. Although Leonardo had some humanist leanings, he emphasized the value of sensory over abstract, intellectual knowledge. "All science

will be in vain and full of errors which is not born of experience, mother of certainty," he wrote. He applied this dictum to every field he explored, from botany to physics. He never stopped searching (and sometimes finding) underlying patterns of nature through direct examination. If he wasn't always correct, who is?

Ironically, what made Leonardo such a peerless artist gave him his greatest shortcoming as a scientist: his eyes. Time and time again, Leonardo insisted that the eye sees reality and tells the truth about the world. But when it came to explaining complex principles, like planetary motion, the eye didn't always see clearly.

Although Leonardo spun his wheels around in some areas and was obsessed sometimes to the point of unproductivity in others, you can generally say he bridged the gap between the shockingly unscientific medieval methods and today's modern scientific methods. Of particular importance was the growing empirical way of examining the world, which mushroomed during the Renaissance and affected the following generations of scientists, leading up to the Scientific Revolution.

Even though Leonardo didn't exactly come up with the same conclusions as some of the big men, like Copernicus, Galileo, or Newton, he certainly antici-pated some of their conclusions. Eventually, induction replaced Aristotelian deduction, and mechanical, mathematical understanding of the world replaced a qualitative, superstitious one. These changes, which occurred slowly over time, had vast implications for Leonardo's technological designs, which I discuss in the next few chapters.

Part III

Reinventing the Wheel: New Machines for a New World

The 5th Wave By Rich Tennant

During an intense period of scientific exploration of the ocean, Leonardo paints his famous...

THE VIRGIN OF THE CONNING TOWER

In this part . . .

If it moved, Leonardo studied it. And if it didn't, he wondered why. Leonardo is perhaps as famous for his inventions, from his flying machines to his canals to scythed chariots, as he is for the *Mona Lisa*. This part examines how Leonardo, at the behest of his patrons and his own curiosity, put together old machine parts in new ways. If most of his machines didn't work, no matter. It was the thought — the near-prophetic spirit of innovation that characterized Leonardo for his entire life — that counted.

Chapter 7

Machines for Home and Work

. .

. .

*N*o one knows when Leonardo's fascination with machines started. Like most boys, he probably played with toy cars and trains — oh, never mind, they didn't exist yet. He probably used a bunch of machines while apprenticing in Andrea del Verrocchio's studio, so he gained an understanding of mechanics there. He doodled with machines and their parts in many of his early drawings, but not until he landed a job with Duke Ludovico Sforza of Milan did he actually call himself an engineer — and despite his peaceful nature, a military one at that (you can read about his military machines in Chapter 8; if you're interested in his flying machines, go to Chapter 9).

By the time of his death, Leonardo left behind thousands of drawings of his mechanical designs. Of these, many were work machines: He created a machine for threading screws, a machine for making rope, a device for measuring the strength of iron wires, a mechanical drum to attach to a cart, a distiller with a continuous cooling system, an automated trench digger, a hammer to forge precious metals . . . well, you get the picture. Among the more than 15,000 drawings he left behind were also notes and illustrations of studies he conducted to figure out and show how machines operated and how he could improve them. This chapter highlights some of the more important, interesting, and extraordinary designs he created for use at work and home.

Tooling Around in Leonardo's Day

Leonardo didn't start from scratch with his mechanical engineering. Several machine parts already existed during the Renaissance, as did some sophisticated machines and their inventors. (Renaissance engineer Filippo Brunelleschi,

for example, achieved the major architectural feat of his time by constructing a dome on the Florence Cathedral without using scaffolding. Instead, he designed complicated hoisting machines.)

The following mechanical elements existed in old Renaissance Italy — and even before then — and Leonardo was familiar with them:

- **Wheel and axle:** The axle allows a wheel to move; water wheels, for example, turn millstones to grind grain.

- **Pulley system:** Enables a person to lift a heavy load.

- **Wedge:** Converts motion in one direction into a splitting motion; most cutting machines, and some lifting machines, use a wedge.

- **Screw:** A central core with a thread (or groove) wrapped around it to form a helix, which, while turning, creates forward or backward motion. In Renaissance Italy, people used Archimedes's screws to lift water from streams for washing, drinking, bathing, and irrigation.

- **Lever:** The rod, which rotates around a pivot point, creates downward motion at one end and upward motion at the other end, and can multiply the force being applied.

- **Gears:** Toothed wheels meshed together to create motion and force. In addition to regular gears, Renaissance Italy also had *bevel gears,* gears meshed together at an angle, which changes the rotation direction; and *worm gears,* a combination of gears combined with a screw, which changes the direction of motion.

- **Rack and pinion:** The pinion (a single gear) meshed with a sliding toothed rack, which, together, convert rotary motion to back-and-forth motion.

- **Cam:** A bumpy disk or wheel often connected to springs, levers, and rods.

- **Crank and rod:** When the *crank* (a wheel with a pivoting arm at its edge, attached to a rod) turns, the rod moves back and forth. And the crank turns when the rod is pushed back and forth.

- **Chains and belts:** Connect wheels to allow them to turn.

- **Ratchet:** A machine that allows a wheel to turn in only one direction.

Leonardo *did not invent* any of the tools that I mention in the preceding list. But he experimented with these devices, reasoning that if he understood how each separate device worked, he could improve upon existing machines and build new ones. So he spent his time improving the tools that were already at his disposal and combining them in new ways. He especially liked gears, which inspired about half of his inventions, from the automatic turnspit to the crane.

The Work Machines

As I mention in the preceding section, Leonardo was interested in fitting existing machine parts together (like the wheel and gear) to create new and improved machines. Many of his designs, not surprisingly, intended to make work easier and more efficient by creating machines that helped *other* machines.

Lifting requires more than muscle, baby

Lifting large, heavy objects posed as much of a problem in Renaissance Italy as it had elsewhere throughout history. Italians sure weren't building a new set of Egyptian pyramids, but they were designing high-ceilinged temples and excavating large canal sites that required more power than their scrawny arms could handle. Leonardo to the rescue!

- **A lifting jack:** Leonardo may or may not have invented the lifting jack, but he illustrated on different manuscript sheets a machine that resembles a rather modern version of the jacks used to lift cars to fix flat tires today. Leonardo's device had reducing gears, a rack, and a crank handle; it would've been useful back then for lifting heavy objects. But, of course, cars (except for Leonardo's model; see the section "Moving onward: Leonardo's car") didn't exist back then.

- **Cranes:** In the late 1480s or early 1490s, Leonardo designed a twin-armed revolving crane, probably for lifting immense blocks of stone near quarries, at excavation sites, or at canal sites. The crane had two arms; one loaded stone blocks from the quarry, and the other discharged the load. Then the two arms rotated, and the process reversed: The second crane unloaded, while the first reloaded. Magically, they could also tow the crane for short distances.

 Leonardo also drew a traveling crane, which lay on a small trolley and balanced with guide wires. Revolving on a pivot, it could (potentially) lift heavy weights for the construction of tall buildings.

- **Pillar lift:** A machine for lifting and transporting pillars and obelisks already existed when Leonardo started doodling, but he improved upon known machines around 1495. He designed one based on the side-sliding motion of a trolley, which held the pillar. A wheel operated by a winch set the trolley in motion.

Drilling deep inside nature

Leonardo illustrated designs for different types of drilling machines:

- ✔ **A vertical drill:** This drill was meant to drill a hole in a tree trunk to make wooden pipes and had mechanisms for deflecting the sawdust. Nearly 300 years later, an engineer from Dresden, Germany, invented a machine exactly like Leonardo's. (We know the truth about the *real* inventor.)

- ✔ **A horizontal drill:** Leonardo's horizontal drilling machine resembled the vertical one, but it used a screw system to shorten the distance between the drill and the log as the hole grew larger.

- ✔ **Double-movement drilling machine:** Leonardo also drew designs for a double-movement drilling machine, which allowed for deeper drilling and digging.

Like all of Leonardo's mechanical designs, these drills relied on human and animal muscle — a major limitation to many of his designs. (Leonardo also designed an auto-feed hydraulic saw to cut down those trees as quickly as possible so people could use them for building more tools, homes, or industry.)

Milling food and other goods

People had been feeding themselves for centuries before Leonardo got hold of a pen and paper. Way back in the day, cavemen crushed grain between flat stones and then invented slightly more sophisticated grinding machines. The Greeks used water power around 450 BC, and the Romans used gears to connect several millstones with a water wheel. Around the time of the Crusades, windmills replaced these machines until the steam-powered machines of the Industrial Revolution came along in the 18th century.

Perpetually perplexed about perpetual motion

In Renaissance Italy, some people believed that they could achieve *perpetual motion* (the theory that an ideal machine could operate continually without an external energy source); others didn't. Leonardo, of the latter camp, proved the impossibility of perpetual motion (on paper, at least) by showing a model comprising an unbalanced wheel with small bars that had weights attached to their ends. He also drew a model of a device made up of six semicircular grooves for small iron balls to slide through. Neither, of course, proved the existence of perpetual motion, because the balls eventually came to a dead stop. Leonardo made the modern observation that as a weight (a ball, in this case) moves farther from the rotation axis, its inertia increases. (No one had yet, however — not even Leonardo — articulated the idea of the conservation of energy. But Leonardo understood that energy wasn't exactly free.)

Leonardo designed a multiple-cylinder mill. Half of its millstones lay on one side of a canal, and the rest on the other. Paddle wheels, turned by the fall of water, operated a set of cylinder millstones via a shaft-gear system. Theoretically, this design improved upon contemporary designs because the wheels controlled the start-stop mechanisms of the mill.

Leonardo, who probably drew his pictures of the water mill around 1493, noted many uses for mills, including the manufacture of gunpowder and silk spinning. These represented some new possible (if as of yet untested) applications. Manufacturing gunpowder in a mill, for example, didn't happen until around 1675, in Milton (Mill Town), Massachusetts. But it seems as if water mills *were* starting to weave silk during Leonardo's time, though this practice didn't become common until the Industrial Revolution.

Spinning faster . . . and faster . . .

Few people — perhaps no one — at the time knew that Leonardo designed some machines for making cloth, but it's not surprising, given that Milan was one of the centers of the cloth industry. In general, four steps determine the manufacture of cloth: harvesting and cleaning the wool or fiber; spinning it into threads; weaving the threads into cloth; and, finally, creating new fashions! Leonardo designed machines to aid in all these steps:

- Automatic spindles, shearing machines, clipping machines, and rope-twisting machines. The most sophisticated twisted 15 strands at the same time!

- A *teaseling* machine that processed the cloth by untangling knots of wool and smoothing them out. The cloth, connected at the ends to both cylinders on a triangular stand, unwound from the upper roller onto the lower one. During this motion, the cloth was processed.

- A machine that performed the stretching, twisting, and winding functions simultaneously, using three threads. This *winged spindle,* which Leonardo probably drew between 1497 and 1500, inspired the later development of the continuous spinning machine.

- Improvements on a silk-doubling machine that featured an automatic stop mechanism when a few threads broke.

- A fabric stretcher that exerted true industrial output when several machines worked together. A wooden frame stretched the fabric, which two large shears cut automatically. This design reappeared in England in the 1700s.

Because his ideas remained unpublished and his machines unbuilt, alas, most of Leonardo's ideas weren't "invented" until the 18th century. Only then did John Key invent the flying shuttle (1738), James Hargreaves, the spinning jenny (1764), Richard Arkwright, the water frame (1769), Samuel Crompton, the mule (1779), and Edmund Cartwright, the self-acting loom (1787).

Other Improvements and Inventions

Leonardo invented and improved upon some machines that helped people when they were *at* work. He probably realized, like some of us procrastinators, however, that actually *getting* to work could involve all sorts of problems. Although he probably didn't view the inventions that I discuss in this section (such as the clock or car) in exactly this light, he did design some machines that are now indispensable to how people experience everyday life.

It's about *#&@% time!

In Renaissance Italy, people were late for everything. Okay, maybe not everything, but they probably never knew the exact time. Sure, they had some models for telling time; in ancient Egypt, people told time from the position of the moon. Water clocks, where raising waters would keep the time and eventually hit a mechanism that triggered a whistle, had been around in ancient Greece. Equally inexact sundials had also evolved. Mechanical clocks, with both hours *and* minutes, had been developed in the 1300s, and graced the towers in many Italian cities. But because heavy weights (which succumbed to varying degrees of force and friction) were driving them, sometimes they told the correct time, and sometimes they didn't.

Leonardo, noting this problem, experimented with springs rather than weights to power clocks. Inventors before him had explored this possibility. But springs lose force as they unwind, even with a gut or chain (which stretches over time), so they don't work as a permanent solution to keeping time. Leonardo tried to solve these problems, but no one knows if his inventions would've worked. In one drawing, he depicted a clock-spring equalizer (which no one has ever tested), and in another, he showed a large key winding up a clock spring — a plausible idea, given the popularity of windup watches.

Around 1510, other inventors, notably Peter Heinlein from Germany, began to successfully experiment with spring-powered clocks, which — after heavy weights disappeared — allowed for smaller clocks (like watches). Still, as the spring wound down, the clock came to a stop, and someone had to rewind it. Not until 1656 did a Dutchman, Christian Huygens, design the first pendulum clock and, about 20 years later, a much more accurate balance wheel and spring clock.

Leonardo also experimented with something called the *verge balance,* an idea already a century old, which alternately engages and releases two toothed gears creating a ticking sound caused by the rhythmic movement. The use of the pendulum eventually achieved the same effect, a concept that Leonardo understood, if didn't exactly apply, at the time. The use of the pendulum to regulate movement in clocks became popular a century after his death.

Leonardo also invented an alarm clock based on the flow of water. When a thin stream of water flowed from one container and filled another, a system of gears (Leonardo's favorite toy) lifted his feet into the air, waking him up and telling him to go back to work. No word on whether the sound of trickling water sent him flying to the yet-to-be-invented flushing toilet.

Hold the presses!

While Leonardo was experimenting with all his gadgets, Johannes Gutenberg had already invented his moveable-type printing press, which actually got real play time. Around 1450 (a few years before Leonardo's birth), his printing press spewed out copies of the first book ever published in bulk: the Bible.

So the printing press was already around by the time Leonardo came along. (Too bad he didn't use it. If he had, he may have been able to circulate his ideas more widely and actually complete one of his planned treatises.) Leo being Leo, he tried to improve on Gutenberg's design. He suggested a time-saving mechanism: a double thread that would increase the travel of the press each time someone turned the lever. He also tried to mechanically connect the printing frame, which holds the type, and the screw, which exerts the pressure necessary for printing, to increase the automation. But, in the end, it looks like he didn't make any significant improvements on Gutenberg's design. Amazingly, a few inventors adopted Leonardo's "improvements" over the next century, greatly bettering the ease, speed, and control of the printing press.

Moving onward: Leonardo's car

Leonardo was only in his 20s — a few years past getting a driver's license! — when he designed a horseless carriage (see Figure 7-1). It didn't sell over 18 million models like Ford's Model T did, but historians see Leonardo's car as the precursor to the modern automobile and mobile automaton.

Leonardo's car was basic yet revolutionary. Resembling a boxy, open-top three-wheeler (kind of like an ice cream cart), it was meant to spring forward about 40 yards after a person wound up a pair of back wheels. In many drawings dating from around 1478, Leonardo depicted a platform on three wheels, with a few coiled springs driving a set of gears. The car consumed no fuel, and the driver steered with the small, rudderlike third wheel.

Leonardo probably built his rather awkward-looking car to impress someone very important, like a visiting dignitary, at the royal court. He obviously didn't intend it as the family car, because it lacked a driver's seat.

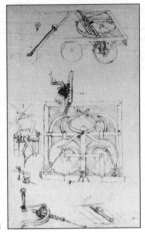

Figure 7-1:
Sketch of
Leonardo's
car, 1478,
*Codex
Atlanticus,*
Biblioteca
Ambrosiana,
Milan.

Art Resource, NY

From his drawings, it looks as if Leonardo didn't exactly master the spring system; how the springs were supposed to transmit driving power to the wheels is unclear. The drawing of the carriage's transmission, however, was right on the mark: It contained a differential that transmitted power to individual wheels, allowing each wheel to turn at slightly different speeds. Many early motorcars lacked this important detail, now known as variable speed drive (a key part of the transmission system of modern cars).

Da Vinci, da Vinci, give me your answer true: Leonardo's bicycle

In the 1960s, a group of monks in an abbey near Rome restored the *Codex Atlanticus* (the largest collection of Leonardo's papers, assembled in the 16th century). In 1974, a monk announced that he found a drawing of a bicycle on the back of a sketch of military fortifications.

The drawing, dated around 1493 (400 years before the invention of the bicycle!), resembled a modern two-wheeler. It had handlebars, pedals, a wooden frame, a rear sprocket, and a chain drive. The steering system looked a little odd, but no problem. The drawing looked almost identical in size and ratio to a modern bike's transmission system — which took many, many years to perfect.

Despite its remarkable resemblance to racers today, the question remains: Did Leonardo invent the bicycle? Or did someone else — perhaps one of his students — pen this famous drawing? Or was the entire drawing one big hoax?

Historians have written entire treatises on whether or not Leonardo invented the bicycle, and some evidence (though increasingly thin) supports Leonardo as the bike's designer, but more goes against the idea:

> ✔ **Evidence *for* Leonardo as the inventor of the bicycle:** The *Madrid Manuscript I,* located in the National Library, Madrid, contains a sketch of a chain with cubic teeth (here, used for lifting buckets out of wells), the same design shown in the bicycle in the *Codex Atlanticus.*
>
> ✔ **Evidence *against* Leonardo as the bike's creator:**
>
> - The translucent backside of the paper showed geometrical circles and lines. But it has no trace of an original bicycle sketch (Leonardo's thick brown markings would've shown through on the other side, like these original circles and lines).
>
> - It's a bad, childlike drawing, not up to Leonardo's usual par.
>
> - Many people looked at the manuscript before its final restoration, so anybody could've forged a design on it.
>
> - The bicycle was drawn with pencil, but pencil lead (graphite) wasn't discovered until a few decades after Leonardo's death.

A chemical or age test has never been performed on the sketch because of the manuscript's fragility, so no one has determined when it was actually drawn. That test alone would help establish the bike's authenticity — or not.

Road testing Leo's rod

For more than a century, Leonardo's car blew the minds of nearly everyone who tried to build it. As it turns out, would-be drivers misinterpreted Leonardo's designs. They all believed that Leonardo had designated two leaf springs on top of the cart as the motor apparatus. But the car kept failing its road tests and wouldn't budge. As it turns out, the leaf springs were really part of the steering design. About 1975, an Italian professor, Carlo Pedretti, discovered that the propulsion mechanism came from two completely *different* springs inside two closed drums beneath the surface of the wagon. When wound, the springs transmitted energy to the wheels via wooden gears and steel plates.

Over the following years, Pedretti worked with an American robotic scientist, Mark Rosheim, to create digital models — and commission a life-sized model — of Leonardo's car. The result? A 5-x-5½-foot box-frame wagon with gears, barrels, and metal plates mounted on three wheels that can move all by its lonesome. The barrels at the bottom have coil springs and gears, which store power to move the car. When wound, *Leonardo's Fiat,* as Pedretti called it, moves about 100 feet before you have to rewind it. ***Warning:*** Not for freeway driving.

Because the restoration of the manuscripts was totally chaotic, and abrasive cleaning techniques already destroyed some of the pages of the *Codex Atlanticus,* no one will probably ever know who really drew the bicycle. The mystery remains as puzzling as the *Mona Lisa*'s smile.

Modernizing the Household

You thought that the modern kitchen and household came about in the 1950s, didn't you? Think again — Leonardo made a few contributions to your domestic life, too.

- ✔ **Roasting that chicken:** Leonardo didn't invent the automated roasting spit, but he experimented with it in drawings. His objective was to know how different-sized fires produced meats of varying "doneness." He found that a hot fire, not surprisingly, roasted meats more evenly.

- ✔ **Mirror, mirror, on the wall:** Leonardo designed many machines for making mirrors. His mirrors were not, as you may suspect, used for vanity purposes. Rather, he used them to study painting, perspective, shadow, and light, though no evidence shows the link between his mirrors and his studies on optics (see Chapter 5). One machine, dating from around 1513, supposedly made concave mirrors with a short focal distance; another made spherical and parabolic mirrors with a long curvature radius. Although these sound pretty complicated, Leonardo experimented with these different kinds of mirrors in order to understand the nature of light, reflection, refraction, and vision.

 Leonardo also hoped to use mirrors to exploit solar energy for industrial purposes — once again, an idea that people today have successfully revived (think swimming pools, windmills, power plants, electricity, water heating, and a whole host of other things).

- ✔ **Cooling down the house:** Leonardo devised a rather unusual-looking machine, with a wooden drum that had propulsion fins. It served as a fan, and Leo intended it to keep a room cool, or, more likely, to drive air into a furnace. Human or water power operated this fan, which contained water circulating through different compartments in the drum. It compressed the air, forcing it out.

Back to the Future: The Impact of Leonardo's Mechanical Designs

Sadly, Leonardo's mechanical designs had very little — if any — impact on machinery at the time. His notebooks, scattered throughout Europe at his

FAST FORWARD

That's one determined man

Leonardo sketched about 15,000 drawings and models over the course of his lifetime — and one man, Carlo Niccolai, intends to build them all. Niccolai attended the Leonardo da Vinci technical industrial school in Florence and started to reconstruct Leonardo's models. In 1955 he set up a decorative arts firm (Niccolai), and a few years later started to reconstruct Leonardo's models — from his gears to his gliders — in his workshop. He first showed his models (made with 15th-century materials like wood and brass) in 1996 at trade fairs, which led to collaboration with the Engineering Museum in Milan. His models now reside in the Leonardo Museum in Vinci.

death, weren't rediscovered until the 19th century. So nobody besides his students and patrons realized what was going on inside Leonardo's little head for quite some time.

Despite his constant innovation, many of Leonardo's drawings (translated into working models, of course) would've been impractical or even unworkable, given the limitations posed by human and animal power. Furthermore, even with his pioneer thinking, Leonardo never *fully* grasped the nature of force, energy, and momentum and the behavior of certain power sources, including water. Thus, he imagined the future — but the future didn't always work. Nonetheless, his ideas were ahead of his time.

Guiding principles

Tellingly, Leonardo drew many machines that people have only recently built. Unfortunately, Leonardo's contemporaries (those who knew of or commissioned his plans, at least) stamped out most of his ideas before he could implement them. His plans for creating a dry route across the Gulf of Istanbul, for instance (which I discuss in Chapter 8), required so much material and manpower that the Turks nipped it in the bud. (Contemporary engineers have determined that the bridge would've been totally sound.) And his designs' reliance on human or animal power also posed a problem. His submarine and helicopter, for example (which I cover in Chapters 8 and 9, respectively), may have worked 500 years ago if they had a more reliable and lasting power source. (Well, the bike — *if* Leonardo actually invented it — may have worked then.)

Yet, despite some minor (and major) flaws, Leonardo's drawings contain a few guiding principles of machines that revolutionized society nearly four centuries later:

✔ He applied theory to his drawings, testing them out on paper.

✔ He studied the connectedness of parts — and integrated these parts in new ways. Think about how he combined wheels, gears, and springs to produce his car, for example.

✔ He applied scientific principles, including optics and hydraulics, to his machines, including the mirror and mill.

Anticipating the Industrial Revolution

Among Leonardo's thousands of drawings are mechanical designs anticipating machines that brought people out of the metaphorical (and literal) Middle Ages and into the modern era. Leonardo's spinning designs, lifting devices, drilling machines, and more foreshadowed the invention of machines that would come later. The Industrial Revolution, which used steam power–driven machinery rather than brute human or animal strength, transformed agricultural societies into factory-oriented ones. This so-called revolution also enacted large-scale changes in how people viewed time, nature, industry, and work.

More importantly, Leonardo's ideas — more than the similarities between his designs and inventions, like the spinning jenny or the flying shuttle that came later — foreshadowed larger ideological and economic changes to come. Leonardo was convinced that the use of machines could accomplish human endeavors more efficiently and economically, and that people could improve or invent machines to realize this purpose. These ideas were the fundamentals that gave birth to the Industrial Revolution 200 years later.

Colonizing Mars with Leonardo's robot

Some robots are toys; others have real-world — or in this case, universal — application. Around 1495, Leonardo designed his mechanical, anatomically correct robot, probably for court festivities. Five hundred years later, Mark Rosheim, an American robotics expert, designed a robot for outer space.

The link? Rosheim needed the best human model available, so he drew from Leonardo's anatomical studies and mechanical robot for his *own* robot design. Rosheim studied Leonardo's drawings, created computer animation that pieced the Renaissance man's robot together,

and then built a model by using electrical linear motors (instead of cables) that operated the robot's muscles to mimic Leonardo's robot's flexibility. Rosheim then delivered his robot to NASA's International Space Station, possibly to colonize Mars before astronauts arrive. Rosheim's work produced the electric 43-axis Robotic Surrogate built for NASA Johnson Space Service, intended to service Space Station Freedom.

Who knew that one of Leonardo's designs would one day travel to outer space?

Chapter 8

Leo the Defense Contractor: His Water Works and War Machines

*T*hroughout history, the engineer has been a medium for pushing discovery and conquest. In Renaissance Italy, as city-states fought and princes duked it out, military engineers' new technologies expanded the boundaries of conquest. And warfare became an art in and of itself.

Leonardo, a self-proclaimed engineer, designed more than machines for just work and home (see Chapter 7). Being the Renaissance guy, he of course addressed questions such as "If you were stranded on a desert island, how could you swim back to shore?" Or "if an enemy were to attack, how could you save your sorry little self?" The questions weren't totally unrelated; the functions of many of Leonardo's machines, from canals to scythed chariots, overlapped. Leonardo, who advertised himself as a military engineer to Ludovico Sforza (the duke of Milan and Leo's patron) in 1483, designed many of these technologies for imminent war. When Sforza's reign dissolved, Leonardo took a brief trip to Venice, where he worked on naval warfare issues. Then, in the early 1500s, he contributed a few ideas to General Cesare Borgia's deadly campaigns.

Though Leonardo was a pacifist, he may have seen his war efforts as actually promoting peace. "When besieged by ambitious tyrants," he wrote, "I find a means of offense and defense in order to preserve the chief gift of nature, which is liberty." Perhaps Leonardo's military career (which, as you probably suspect, didn't see too much of the light of day) is justified on the grounds that his designs intended to save a greater humanity from this "bestial madness." Not to mention, he needed a job.

In this chapter, I show you both his hydraulic and wartime designs, in which he again examined the relationship of individual parts to the whole, combining old tools in new ways to improve upon existing designs or invent new ones. He also read up on the literature; military and technical texts provided Leonardo with new knowledge, methods, and ideas. Discussion of electronics, however, probably would've left him perplexed! Nevertheless, I finish off by considering whether Leonardo was a true visionary.

Leonardo's Amazing Human-Powered Water Feats

Hydraulic engineering was a bona fide trade back in Renaissance Italy. Leonardo's master, Andrea del Verrocchio, for example, was an experienced hydraulic engineer (among many other professions) and probably taught Leonardo a thing or two about the movement and control of water. And water, it seems, fascinated Leonardo his entire life. After all, Italy *is* surrounded by water on three sides.

Around 1490, Leonardo planned to write a treatise on water, which he saw as the first step toward understanding — and solving — hydraulic engineering problems. He never wrote the work, but continued to dream. And he continued to design. Most of the water designs he pioneered (or at least improved upon) were intended to fight from sea to shining sea. He drew most for Duke Ludovico Sforza in Milan; as his engineer, Leonardo was responsible for maintaining and expanding the city's canal system. His notebooks are thus filled with drawings of locks, sluice gates, weirs, dikes, and pumps. But Leonardo also undertook other waterworks projects, including some for Cesare Borgia in Romagna and Pope Leo X, for whom he designed drainage systems for the Pontine Marshes that have been realized only relatively recently.

Diving into the deep blue seas

Well before Jacques-Yves Cousteau and Emile Gagnan invented the *scuba* (self-contained underwater breathing apparatus) in 1943, diving and its associated apparatus had long fascinated inventors. Diving (without the equipment) had already been around for a few thousand years; Homer mentions military divers in the Trojan Wars in the *Iliad*. These guys dived in the nude, using only a rope and a stone weight for positioning. Sponge-diving also brought great wealth to some of the Greek islands in ancient times. Skipping ahead, in the mid-1400s, divers (not in modern-day diving apparatus, of course) raised sunken Roman galleys. These existing diving suits served their function but had some severe limitations.

✔ Around 1430, a form of a diving suit appeared in a German drawing, with a waterproof leather garment and a breathing tube that reached the surface of the water. Unfortunately, these tubes often broke or failed if the surrounding water pressure collapsed the tube.

✔ Diving bells had been around since ancient times, but saw very little improvement until the mid-1500s. These bells held air for the diver. A diver would take a deep breath, go down, come up to the bell for another breath, and continue until all the air in the bell was unbreathable because of carbon dioxide. But they were insufficient to sustain divers for long periods of time.

Leonardo, basing his ideas on several existing diving suits, sketched a few possibilities for his deep-sea diving outfits, though none made it into *Skin Diver Magazine*. The purpose? He designed the outfits as a secret weapon for the Venetians to use against the invading Turks. Here are a few characteristics of his diving suits:

✔ Most of Leonardo's suits required a diver to breathe air from the surface of the water through a long cane hose (tubes joined by leather, with steel rings to prevent them from being crushed by the pressure of the water). The tubes attached to a face mask and, at the other end, a bell float (made of cork, for flotation) to keep the breathing opening above water. Jacquie Cozens, a modern-day diver and underwater filmmaker, tested this ensemble (though probably no one used it in Leonardo's day) — and it passed the test in the baby pool!

✔ Most were also made of pig leather and had masks with a glass lens.

✔ One design shows a crush-proof air chamber attached to the diver's chest, which would allow him or her to swim freely underwater.

✔ Another design, which Leonardo clearly made for war and holding enemy ships, features a coiled armor plate that attached to a sealed tunic and would prevent compression of the chest.

✔ Still others show coats with sealed wineskins to store air and, should the diver need it, a urination bottle. (This wineskin idea didn't reappear until 1825, when an English engineer designed an aqualung. But as a working mechanism, it didn't come to fruition until Jacques Cousteau.)

✔ Leonardo also designed some webbed gloves resembling web-footed birds or flippers to facilitate underwater movement.

No one knows if anyone tested any of these designs during Leonardo's day, though supposedly a diver recovered two of Caligula's sunken galleys in 1531 by using a diving bell that our man designed.

Leonardo may have improved upon existing technologies, but the major diving innovations came later. In 1535, for example (oh, so close to Leonardo's time —

only 15 years after his death!), Guglielmo de Loreno developed what is considered to be the first true diving bell. Only in the late 16th and 17th centuries did technology, from the diving bell to the air pump and secure face mask, make diving a significantly safer experience.

Walking on water

Throughout history (or myth), many people have claimed to be able to walk on water, including the Buddha, Hindu mystics, and Jesus (and his sidekick, Peter). Well, Leonardo wanted to walk on water, too — or more accurately, he wanted *someone,* beyond the folks already mentioned, to be able to. For Leonardo, doing so wasn't a matter of faith; it was a matter of practicality. During wartime, soldiers would perhaps need to cross streams and rivers quickly. And in peacetime, farmers had to cross rivers and lakes daily to transport their goods (boats were very expensive to operate in those days). So he turned his mind to solving how to make such a feat possible.

Yet walking on water is a complex technical problem. It involves stability, control, and efficient movement of the legs to set forth forward motion. He had to figure out a way to overcome these challenges. Around 1475, he did — theoretically, anyway.

Walking on water

Some pretty sound evidence explains why people *can't* walk on water:

- The perimeter of your feet would have to be enormous, about the size of open umbrellas.

- You'd have to raise your feet up to your ears to acquire the right speed, which would require you to exert an unreasonable amount of power.

Despite these problems, some creatures (and according to biblical accounts, one man) in this world really *do* (and did) walk on water:

- Water striders

- Lizards: The Jesus Christ lizard *(Basiliscus basiliscus)* actually runs across the water at about 6 miles per hour.

- Water spiders: Different species (including the fisher spider, *Dolomedes triton*) "walk" on water as a result of *surface tension* (the force between liquids and solids).

- Jesus: In ancient languages, the sea symbolizes power, the triumph of good over evil. For example, Peter's early attempts to walk on water with Jesus (he more or less sank) represented his lack of faith.

In the past 150 years, Americans have patented more than 100 water-walking inventions, all iterations of a similar idea. None, to date, have worked satisfactorily. So until then, you'll have to be content with water skis.

Leonardo's water-walking system relied on elongated floats strapped to a person's feet (these floats resembled modern-day water skis). For stability, he added two balancing arm poles (also on floats). If his design had worked — if Leonardo had really built it, rather — his water floats would've operated on principles similar to cross-country skiing.

Just paddling around: Watercraft

Leonardo didn't exactly design a solid system for walking on water, but he did draw a wide range of watercraft, some of which may have actually worked. Again, he intended many of his watercraft designs for times of war (head to the section "Designing More Weapons for War" for more info on those). Others simply operated as vehicles to aid in building and dredging.

Just as he designed his flying machines on the flight of birds (an idea that I discuss in Chapter 9), Leonardo based his watercraft designs on the shapes and movements of fish. He hoped that by imitating natural design he could improve the speed and ease of navigation; paddles shaped like fins moved boats faster than traditional oars, for example.

A design that he created around 1482 shows a crank-operated paddleboat with shovel-shaped paddles. Leonardo planned a gearing system that would turn the paddles faster, but this system still relied on muscle (or wind or water) power, which he didn't find so efficient. If only Leonardo had modern power sources back then!

Another design imagined a boat with driving paddle wheels, which would increase the rowers' strength. But once again, men (suffering below deck) had to provide all the energy.

Dredging the ocean (or lagoon) floor

Renaissance Italy was, like today's society, obsessed with improving the landscape — making rivers more navigable for commerce, defense, and war. Leonardo designed a number of dredges to facilitate this process. Most illustrate his inclination to use mechanical power instead of muscle power.

✔ **The shallow dredge:** Used to remove sludge and silt from canals, waterways, and the bottoms of lagoons, this design features a large-toothed wheel between two barges (like a modern-day catamaran). A crank turns the wheel, and four scoops take turns dredging the sludge and discharging it into another barge, moored between the other two. Obviously, this model works only to a certain depth. Check it out in Figure 8-1.

✔ **The deep dredge:** This drawing features a barge anchored in many places to the bottom of a deep lagoon, with a large bucket beneath it that has spikes and perforations at the open end to take in water. Basically, it resembles a plough system that moves suspiciously along the seabed.

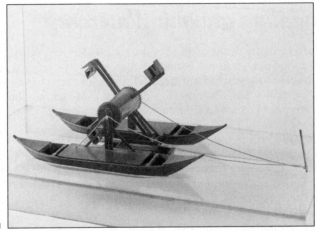

Figure 8-1: Model of the lagoon dredge, c. 1480–90, part of Leonardo's *Codices of the Institute de France,* Paris.

Scala / Art Resource, NY

One of his other designs, intended for excavating a canal, has flaps that drop open on the bottom in order to allow the earth to fall out (of course, human and animal power operated these flaps).

Connecting water and land: Canals

Leonardo prepared many plans for canals and canal systems while in Ludovico Sforza's employment. Just as in the here and now, canals diverted rivers, flooded valleys, transported boats and goods, and drowned out undesirable things, like opposing armies and *their* supplies. Leonardo thus imagined canals as the preferred method of transportation and as an offensive weapon.

The higher-ups frequently consulted Leonardo regarding canal engineering, and he designed a canal that would've linked Milan to the sea. Perhaps his greatest plan involved ending the war between Florence and Pisa by changing the course of the Arno, thus depriving Pisa of the river. He devised this plan in 1503, and though it was adopted, it was never completed. (See the section "Changing the course of the river: The Arno project" for more.) Nonetheless, Leonardo was as ambitious as usual when it came to canal design; he intended (at least, according to his drawings) to dig some relatively large canals — some nearly 18 meters (60 feet) wide and 6 meters (21 feet) deep.

An excellent drawing of a canal system, dating around 1480–85, displays the canal complete with two sets of locks built alongside *weirs* (dams). Houses for the lock operators stand alongside the canal as boats make their way through it. Another area of this manuscript sheet shows the gates in detail.

- ✔ **Sluice gate hatch:** Milan's canal and weir system predated Leonardo's arrival in the city by two centuries, but Leonardo, ever the tinkerer, knew how to improve it. One of his improvements involved designing an opening and closing mechanism for the sluice gates. A hatch allows a controlled amount of water to enter the gate. Leonardo designed this system for the larger San Marco canal system, which connected Milan's inner waterways. Around 1497, six of Leonardo's locks were in place . . . and the system is still widespread today.

- ✔ **Canal reinforcement structure:** As part of the San Marco canal system, Leonardo also designed a series of rows of poles sticking into the ground. Connected by horizontal beams, these poles would ensure that the lock's walls and the canal floor could resist the pressure of the water that resulted from the different levels between the locks.

- ✔ **Canal bridge with sluice gates:** Leonardo seems to have mastered canal improvements on rivers with regular water flow. Where watercourses had irregular flows, Leonardo designed a double-gated sluice system, which made it possible for boats to go up and down more easily.

Building bridges over troubled waters

Leonardo had advertised his services as a military engineer and touted his military credentials first to Ludovico Sforza in Milan, and then to the infamous General Cesare Borgia. Thus, he intended many of his bridge designs as fortifications or offensive measures.

Assembling the quickie

Leonardo studied makeshift military bridges constructed of wood trunks tied together with ropes — basically, a trestle bridge (or in some drawings, two rows of trestles). In 1482, he drew a plan for arranging and tying the trunks in the fastest amount of time in order to escape the enemy. He also wrote directions for how to construct these bridges.

Revolving around and around

Leonardo also had an idea for a light, strong revolving bridge (which he mentioned in his letter to Ludovico). This one, in a parabolic shape with one span, moved with ropes, hoists, wheels, and metal rollers. Soldiers could move it (and remove it) easily, especially when trying to escape from the enemy.

Crossing the Bosphorous: The Galata Bridge

Leonardo probably designed a bridge when he was traveling for Cesare Borgia in Romagna. During this time, ambassadors of the Ottoman Empire came to Rome to solicit the expertise of Italian engineers to replace the old boat bridge on the Golden Horn.

Around 1502, Leonardo drew a sketch of a dry route (a bridge) across the Gulf of Constantinople (Istanbul) to connect the Golden Horn and the Bosphorous, probably with the intention of offering his design to Sultan Bayezid II of Constantinople.

His drawing shows a single-span, three-arch stone pressed-bow bridge about 240 meters (787 feet) long, 23 meters (75 feet) wide, and about 40 meters (131 feet) above the water. Leonardo calculated that a flared pier could stretch and support the classic keystone arch. The bridge's enormity (it would've been the longest bridge in the world) and detailed calculations (nobody really knew if it would stand or fall) must have scared everybody around him, because no one built it in his lifetime. Interestingly, modern engineers have shown that Leonardo's Galata Bridge would've been completely sound.

Leonardo's Galata Bridge may not have been built during his lifetime, but it was during *mine*. In 1995, a Norwegian artist designed a smaller-scale model of Leonardo's bridge. He convinced the Norwegian highway department to commission a 100-meter-long (328-foot), 8-meter-high (26-foot) wooden version of Leonardo's design at Aas, a small township near Oslo. Leonardo's bridge (I can call it that, right?) opened in 2001 to grand celebration. The bridge is actually a pedestrian crossing and is 2,414 kilometers (1,500 miles) away from where Leonardo intended. No matter. It represents the first major civil engineering achievement built from Leonardo's drawings. And it proves Leonardo's impeccable credentials.

In the 20th century, engineers *did* build a bridge at Galata, but it looked nothing like Leonardo's original drawing.

Changing the course of the river: The Arno project

For many years, Leonardo toiled at one of his grandest projects: actually redirecting the course of the Arno River away from Pisa. He hatched his plan with Niccolò Machiavelli, whom he befriended while working with warlord Cesare Borgia in the early 1500s. Machiavelli, an Italian political philosopher, contributed greatly to modern-day political theory; *The Prince,* published in 1532, is still a classic. The plan of Leonardo and Machiavelli involved a Florentine effort to build canals and dams in strategic locations and dredge soil as necessary to fill in the river's many twists and turns as well as construct embankments. Such a project offered multiple benefits, at least on

paper: It would make the river easier to navigate, give all major towns in Tuscany access to it, and ensure adequate irrigation throughout the land. It would also serve a military purpose: The newly diverted waterway would reduce the risk of invasion from Pisa (Florence's enemy) and allow the blockade of supplies en route to Pisa.

Well, you could hear the Florentine tax collectors and naysayers well into northern Europe, so the Arno River project was never completed. But Leonardo's idea was still a good one. Antiflooding measures taken during the 20th century look quite a bit like his original plans.

Designing More Weapons for War

Separating Leonardo the peacenik from Leonardo the warmonger is difficult, but there you have it: Many of Leonardo's machines were, in fact, intended to defend his patron and duke of Milan Ludovico Sforza's honor (not to mention Milan itself). Leonardo designed weapons for war during two periods of his life: the first while working for Ludovico, and the second while following General Cesare Borgia around Italy. He designed both offensive equipment and, in case the enemy hatched the same idea, fortifications and defense machines.

In many cases, Leonardo built on the arsenal of weapons and theoretical body of knowledge that Renaissance Italy inherited from ancient times and the Middle Ages. Soldiers in the Roman Empire had used siege towers, battering rams, and mining operations to collapse thick castle walls or sneak troops into an enemy stronghold. In ancient times, offensive weapons were based on the ballistic principle — the use of the recoil resulting from twisting cables wound around a windlass, or cylinder. The recoil released a trigger, which then shot stones, fireballs, and sometimes even captured comrades into enemy lines!

In the Middle Ages, the widespread use of the lever led to the development of gigantic slings, which hurled stones, fireballs, and *Greek Fire* (a vicious mix of naphtha, quick lime, and crude oil that exploded everything it touched). The crossbow came into being around the 12th century, adding to the havoc, as did gunpowder, the most revolutionary innovation of the era (though the Chinese had used it a few centuries earlier). Firearms that mixed gunpowder with Greek Fire (Leonardo even had his own recipe) to attack armies on land and ships in water were widespread by the 1300s.

By Leonardo's time, military engineering was the highest of arts. Leonardo looked to many of his contemporaries, including Francesco di Giorgio of Siena and Robert Valturio of Verona. Thus, many of his offensive weapons weren't original per se, but were improvements designed to increase the firepower and speed of some of these more deadly toys.

Moving across enemy lines: Armored tanks

In his 1482 job letter, Leonardo wrote the following to Ludovico Sforza, the duke of Milan:

> *I can make armoured cars, safe and unassailable, which will enter the serried ranks of the enemy with their artillery, and there is no company of men at arms so great that they will break it. And behind these the infantry will be able to follow quite unharmed and without any opposition.*

This boast wasn't exactly an idle one: Leonardo's armored tank (shown in Figure 8-2) was, indeed, formidable. Had it not been too heavy to move, it surely would've wiped out enemy troops. Incidentally, Leonardo imagined this tank as a replacement for the elephant!

Figure 8-2: Study for an armored tank, 1487, *Codex Arundel,* British Library, London.

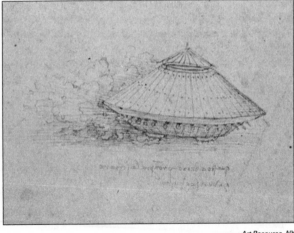

Art Resource, NY

Leonardo wasn't the first to work on the idea of a tank; some inventors before him had designed several sail-powered tanks, none of which ever saw the light of day. But around 1487, Leonardo invented a new kind of tank. His model showed a four-wheeled vehicle powered by animals or humans (it required eight men!) turning cranks attached to different kinds of wheels. The tank had holes at the base for firing cannons and a turret at the top for observation and more shooting. The body itself was turtle-shaped, reinforced with metal plates and armed with guns. But the design had a fatal flaw. The front and rear wheels were geared to turn in opposite directions — perhaps to prevent plagiarism, or perhaps in line with Leonardo's pacifist nature.

Despite its flaws, Leonardo's design (which no one built during his lifetime) served as a model 400 years later for tanks that saw action during World War I.

Storming walls

During the entire Renaissance, much of Europe — and almost all of Italy, with its belligerent city-states — was at war. Remember the battle scenes in *Lord of the Rings*? In some respects, warfare during the Renaissance resembled just that, without the vicious flying beasts. During the Middle Ages, people built fortified castles to protect villagers. At the first sign of danger, folks would hightail it up the hill to the castle and hide out in its confines. Then, after first trampling or burning the village below, the enemy would arrive at the fortress, ask for surrender, and if the answer was no, storm its walls with a battering ram, light it on fire, shoot at it, or tunnel underneath it — and either make it in, or not.

By the time of the Renaissance, armies were more orderly, tactical entities that, in turn, required more effective weapons. Besides the obvious (such as simple rope ladders for attacking walls), Leonardo developed some innovations for storming walls:

- **A battering ram:** A wheel-mounted frame fitted with a bridge that could span a moat and lean up against enemy walls.

- **Scaling ladders:** By Leonardo's time, scaling ladders (kind of like today's hook-and-ladder, which allows people to climb over high walls or knock down an enemy's ladders while firing missiles at them!) were in full use. Some were mounted on mobile platforms, making them more difficult to knock over. Others used baskets to lift men over the walls. Leonardo added a few new elements to these models. He designed rigid ladders, some with grappling hooks to attach to the wall, and others with spikes to hook into the ground. He based many of these designs on the scaling ladders presented in Roberto Valturio's treatise *On Things Military* (1472).

But what if the enemy used the same type of equipment? Leonardo took a few precautions and designed some countermeasures, including a large cog that unbalanced attackers from the wall and toppled them over the side. He also had some advanced notions on mining and sapping (ways that men, armed with picks, could chip away at the castle's foundation without direct assault). Leonardo recommended using a drum above the area in question, which detected the sound of the sappers at work when you placed a pair of dice on top if it.

Diving 20,000 leagues under the sea: The submarine

Around 1515, Leonardo drew a submarine. He described it as a "ship to sink another ship." Leo's sub was a shell with room for one person inside, but it

couldn't — like modern submarines — submerge completely. Had he built it, it may have worked with the proper power source. It sunk (or, *may have sunk*) other ships by ramming into them.

Leonardo's model of a submarine differed just a tad from the submarine that Jules Verne depicted in *20,000 Leagues Under the Sea.* No gigantic sea monsters threatened it, either. But it was still more or less a submarine — one that predated the real submarine by more than 100 years. (That honor went to a Dutch inventor, Cornelius van Drebbel, in 1624. However, no one used a sub in combat until 1776, three years after an American, David Bushnell, invented his wood-and-propeller sub.)

Although Leonardo's submarine never made it off paper, Leo was commemorated during World War II, when Italy named one of its hero subs (it sunk 17 Allied ships) the *Leonardo da Vinci.*

One of Leonardo's defenses against the submarine, should someone use it against his own kind, was a double-hulled boat that could reduce the damage in case an enemy vessel rammed into it. He also designed air-filled tanks that divers could then attach to the hulls of sunken ships to refloat them, as well as a machine that would pump water out of sinking ships.

Battleship down! Leonardo's hull rammer

In the age of naval warfare, Leonardo wasn't going to be left behind. Called *Great Ships* in 15th-century Europe, battleships, the most heavily armored warships in the seas, were born in rudimentary form in the 1400s. (The Spanish galleon was yet to come.) The 20th-century aircraft carrier made them obsolete, but they enjoyed a destructive life while the era of the Great Ships lasted.

Leonardo didn't invent a new battleship, only a part to sink one. Still, his design of a *hull rammer* (the tool used to sink the ship) is amazing for its features: a large scythe that revolves and aims at its target, and the crank-and-gear mechanism that lifts and drops the scythe. Made of iron, the U-shaped scythe was designed to sink enemy ships by ripping wooden planks from the other ship's hull. Leonardo offered, of course, some tips on how to use this mobile-ram boat to attack an enemy vessel — as well as how to release it quickly.

Not exactly Robin Hood: Catapults and crossbows

Although military technology was changing, Leonardo didn't abandon the old tried-and-true weapons of generations past. He improved on designs for a

wide range of slingshots, crossbows, and catapults. After all, these traditional weapons were still major — and greatly effective — weapons of war. Leonardo designed the following:

- ✔ The rapid-firing crossbow, the distance weapon. A huge treadmill (pedaled by people) powered this rotating, four-crossbow machine; see Figure 8-3.

- ✔ A giant slingshot that relied on multiple springs.

- ✔ A huge crossbow called a *ballista,* which rested on six wheels and absorbed its own recoil.

- ✔ The 76-foot bow, Leonardo's most sophisticated (and perhaps too technologically advanced for the time) bow relied on gears; the shooter released it by striking a pin.

- ✔ The quick-load catapult, which relied on a rope and winder mechanism, was useful in case of a surprise attack.

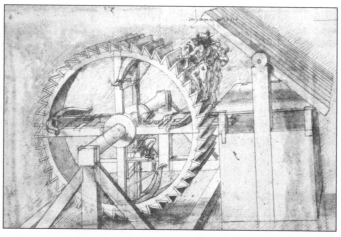

Figure 8-3:
Leonardo's crossbow machine, 1480–82, *Codex Atlanticus,* Biblioteca Ambrosiana, Milan.

Art Resource, NY

All of Leonardo's catapults used two-finned missiles with warheads, which resemble modern-day designs.

Improving cannons and prefiguring the machine gun

Cannons weren't all that practical on the battlefield in Leonardo's day, mostly because of their weight and lengthy loading time. They were cast iron or bronze, with a short barrel and a short range. So Leonardo experimented

with already existing models to find ways to improve upon them. Thus he designed a breech-loading cannon and a three-barreled cannon, measured the power of a missile, and even reportedly launched a rocket-powered cannonball 10,000 feet into the air! He even may have tested one of his more innovative designs — a steam-powered cannon. Ever thoughtful, Leonardo also invented a hoist for lifting cannons and a model to improve the ignition of firearms. Historians generally agree that Leonardo's ideas (never tested, of course) were as sophisticated as those of an artillerist in the mid-1800s!

In his letter to the duke of Milan, Ludovico Sforza, Leonardo boasted of his skills in making fast, light, and accurate firearms — should the use of cannons become impractical in emergency situations. A few of his designs prefigured the modern machine guns:

- A front-loading firearm that had an adjustable gear with a peg-blocking system, intended to be used by soldiers

- An adjustable and relatively light eight-barreled gun made up of small muzzles mounted on a two-wheeled carriage

- A 33-barreled machine gun, mounted on a revolving framework, that could fire 11 shots simultaneously

- A split-trail gun carriage, with a mechanism that allowed for greater angles of rotation and elevation

As far as gunpowder goes, Leonardo designed shells that exploded immediately and others that coughed out large balls that then coughed out smaller explosives. Leonardo also invented the wheel-lock, a better system than the flintlock, for igniting the gunpowder.

Slicing soldiers, the old-fashioned way: Leonardo's scythed chariots

What better way to kill the enemies than to slice them in half? Leonardo sketched several designs for horse-drawn scythed chariots, though probably none were ever built. Scythed chariots, which featured a horse-drawn war chariot with blades mounted on the axle, had been around since Persian times. They were still good to go in Renaissance Italy; Leonardo only made them more vicious, more deadly.

One of his sketches depicted scythed chariots plowing through enemy lines and beheading (and slicing off the arms and legs of) its men.

His most impressive model, capable of wreaking the most destruction, showed four large *scythes* (long and curved single blades) that rotated like helicopter blades, placed in front of the horse-drawn chariot with screws and gears. At the rear of the chariot, smaller scythes did a similar job. Beware, oh enemy!

Battling His Way through History: Leonardo's Impact

Leonardo may have planned to slice his foes in half, but it's quite unlikely he actually did. Like so many of his other grand designs, from the helicopter to the submarine, his scythed chariot met a terrible fate. For a few hundred years, it entered the dustbins of history with the rest of his notebooks, erasing the accomplishments of previous centuries. Of course, some of his colleagues — Duke Ludovico Sforza and General Cesare Borgia, to name two — must have been aware of Leonardo's wartime schemes. Despite Leo's purported pacifism, they commissioned his expertise in fighting their wars in the first place. And other designs, such as the plans of Leonardo and Machiavelli to redirect the Arno River (see the section "Changing the course of the river: The Arno project," earlier in this chapter), were quite public, if controversial. But most of Leonardo's sketches for war machines never saw the light of day during his lifetime.

Had someone actually built Leonardo's designs for water works and war machines, some, like the Galata Bridge, would've worked marvelously. Others, including the water floats that may have enabled people to walk on water, probably would've failed miserably, because Leonardo never clearly articulated the principles of hydrodynamics. (Nor, apparently, has anyone fully mastered walking on water today!) Leonardo also fell prey to idealism in much of his work. He invented some machines that, given the technology of the day, were simply too advanced for simple mechanical, human, or animal power. Having running men power a machine that shot crossbows at the enemy just wasn't practical!

Finally, in exploring Leonardo's contributions to both the Renaissance and modern technology, you should consider whether he was a peerless inventor who may have revolutionized Renaissance Italy, or whether he simply worked along a historical continuum of technical development. Clearly he was, and did, both. In some of his designs, such as his diving get-up, he improved on existing knowledge and technology. But in other areas, like his scheme to alter the course of the Arno River, he was centuries ahead of his time. As a result of the cost and time involved in such projects, most of his visionary plans never came to fruition.

Despite some failures, Leonardo persevered in his attempts to use machines to overcome both human boundaries and the limitations of history. After all, might not humans have use for some wings?

Chapter 9

Leonardo's Flying Machines

*S*ince antiquity, people have flapped their arms and spun their feet in attempts to lift off into the air — but sadly, they've flown unaided only in their dreams. For 2,000 years, this fascination with flight has taken many forms. Kites, gliders, attachable wings, lighter-than-air airplanes, and even half-birds, half-humans have graced art, literature, religion, and mythology. Despite a persistent desire to outfit the human body with wings like Greek mythology's tragic figure, Icarus, or jump aboard a motorized aircraft, people didn't actually begin to fly until two centuries ago.

What took so long? Well, nobody knew about the laws of aerodynamics until the 18th century. And aeronautics? Forget about it. In eras that seesawed between mysticism and reason, only one object gave people an obvious model for flight: the bird. So for a long time, mortals tried to navigate through the air like birds — an approach that was, in the end, more or less for the birds.

Leonardo da Vinci (considered by some to be the father of aviation) led these efforts — some successful, most not — during the High Renaissance period of late 15th-century Italy, and I take you back through them here.

Introducing Leonardo and His Feathered Friends

Leonardo saw the world and everything in it — birds, towns, people, and machines, for example — as operating according to universal laws of dynamics. So as he pondered the possibility of human beings flying, Leonardo looked to the most logical models of flight: birds and bats. He especially admired the force that birds were able to exploit by flapping their wings in the air. For that matter, he also liked their attitude toward gravity and free fall.

Interpreting Leonardo's dream

One of Sigmund Freud's more lasting contributions to psychotherapy was the idea that dreams uncover emotions and desires buried deep inside the unconscious mind. Freud, one of the most influential figures of the 20th century, claimed to know what caused Leonardo's obsession with flight.

In his 1910 study "A Child-hood Memory of Leonardo da Vinci," Freud recounted a child-hood dream or memory, originally recorded by Leonardo, in which a *nibbio* (a kite, which is a predatory bird) flew down, opened the baby Leonardo's mouth with its tail, and struck him several times. Freud suggested that the dream represented Leonardo's mother kissing him passionately on the lips, an image that seemed to offer proof of Leonardo's homosexuality (see Chapter 3). But Freud misread the German translation of Leonardo's dream, substituting the word *vulture* (the Egyptian symbol for mother) for *kite*. Whether or not Freud's interpretation held any kernel of truth is anyone's guess. But Leonardo's dream supposedly did inspire his lifelong flying aspirations.

Leonardo started with the premise that birds fly, and humans don't. No surprise there. So if birds could fly, why couldn't people fly? Still, that question didn't address why humans couldn't *imitate* the flight of birds and soar up high, too.

The answer was obvious to nearly everyone in Renaissance Italy: People lack wings — a fact that even the great Leonardo couldn't refute. But this point is where Leonardo's ideas differed from the dominant ideas of his time. He believed that similar physical and mathematical principles (gravity and wing design, for example) governed both nature *and* machines. If natural principles controlled machines, what would stop a person from flying? Nothing, apparently. "The bird," Leonardo wrote in the *Codex Atlanticus,* "is an instrument working according to mathematical law, which instrument it is within the capacity of man to reproduce with all its movements." In other words, people could create a machine by using the natural principles of flight. Such a machine would enable humans to fly.

Theorizing . . . and facing reality

Because he so admired birds and bats, Leonardo called his flying inventions *uccellos* (birds). After watching these animals in action through the 1480s, he came up with some general geometric principles of flight that may ring a bell from high-school physics: flight mechanics, air resistance, winds, and currents (see Table 9-1). As you can see, he wasn't always correct.

Table 9-1	Leonardo's Theories about Bird (And Bat) Flight
Leonardo's Theories	*What People Know Today*
The bird adjusts its wings, tail, and center of gravity in response to air currents and moves with the whirlwinds.	The bird adjusts its wings and tail, but uses its breastbone muscles to control its wings.
A bird's wings, by moving down and back, provide the force of upward movement, while the bird's "elbow" creates a necessary wedge of air for movement.	Tricky! In reality, the bird does *not* move its wings down and back for upward movement, as Leonardo thought. Rather, the wings move upward *(lift)* and *thrust* forward to counteract *drag*. And the bat's stroke resembles that of a rower (they move their wings down and up, and back and up).
The bird's tail acts as a balancing lever against air currents and prevents the bird from capsizing.	Bingo! The tails of birds (and bats, for that matter) act as rudders.
The bird can manipulate its center of gravity to fly up or down and can shift it to align either in front of or behind what Leonardo called the *center of resistance* that its wings make with the air. If the bird shifts its center of gravity forward, the bird moves downward; a backward shift allows the bird to descend.	Leonardo correctly observed that in order to fly efficiently, most birds must carry the bulk of their weight in their center of gravity — the balance point between their wings, head, and tail.

Remembering Newton's apple

Leonardo was a smart guy. Not surprisingly, some of his ideas about weight, mass, and gravity prefigured those of Sir Isaac Newton (1642–1727), one of the most famous scientists of all time. Newton was the first to realize that gravity is the force that draws two objects together. (Remember the story about the apple falling on his head? Apple + head = unpleasant collision.) The greater an object's mass, the more it pulls another object toward it. Leonardo understood the problem of weight — and because the earth is the heaviest thing around, it'll naturally pull everything (birds, people, flight machines, you, me) toward it. But how could a person overcome the force of gravity with human power alone? Well, that answer is one our genius *didn't* know.

Pinpointing problems

In the spirit of most inventors, Leonardo was partially right, partially wrong. But he gets credit for identifying four major problems associated with human flight:

- ✔ **The obvious:** Because people lacked wings, they couldn't fly exactly like birds.

- ✔ **The less obvious:** Humans just aren't strong enough! Leonardo knew that people could never supply a power-to-weight ratio that matched the breast muscles of a bird or bat. Instead, people would have to make do with artificial wings and tails.

- ✔ **The not-so-obvious:** Leonardo never determined a fixed rule for the relationship between wing area and weight in birds and bats. It didn't help matters that the pelican, for example, has very short wings, while the smaller bat has relatively long ones. And to Leonardo, both seemed to work just fine.

- ✔ **The unsolvable:** Leonardo never solved the greatest challenge — producing the sustained force necessary for human flight, which is what the Wright brothers accomplished 400 years later.

It's a Bird, It's a Plane, It's . . . Leonardo's Flying Machines!

Leonardo experimented with many different types of flying machines, from human-powered models based on bird and bat anatomy to machines that relied more on mechanical principles. Yet, they sure weren't lifting off anytime soon. Most of Leonardo's inventions never left his notebooks, but no matter: Genius is 1 percent inspiration and 99 percent perspiration. But you knew that, right?

Although he pioneered the basic principles of flight, Leonardo perhaps never rigged himself with wings and flew for one simple reason: He never really worked out the kinks in his designs!

For a good two decades, Leonardo assumed that people have the coordination and muscle power to imitate bird flight. His drawings and experiments proved him wrong time and time again. But as he started to understand people's physical limitations, he developed more sophisticated, mechanical prototypes of flight machines. The problem was, the more complicated they

were, the heavier they became — and the more difficult to launch without a real motor.

Leonardo's brilliance may have led to his undoing when it came to birds and airplanes. He touted empirical methods throughout his life, yet the biggest mistake he made came from his powers of observation. Leonardo never fully wrapped his brain around the crucial concepts of *lift* and *drag* (refer to Table 9-1). More important, he misinterpreted how wings actually work. He thus spent 25 years building wings that had little hope of liftoff.

Designing the human uccello (Bird)

Leonardo experimented with a variety of factors in his human-bird designs: materials, human pilot positions, arm-and-leg power ratio, and, of course, wings.

- ✔ **Wing structure:** Leonardo's most important design, the articulated wing, allowed a flexed wing to move in different directions. Leonardo used springs, joints, and wire to connect various parts of the wing, and a pulley system to move it. Figure 9-1 shows drawings of a batlike wing with a flexible construction, along with some sketches for his ornithopter (wings attached directly to a flier's body). I discuss the ornithopter in the section titled "Fred Flintstone meets George Jetson: The mechanical models," later in this chapter.

- ✔ **Testing wings:** Many of Leonardo's sketches feature a device for testing beating wings. If a person pushed down quickly on a long lever, a batlike wing lifted a 200-pound weight, around the average weight of a man. But the wing, Leonardo calculated, would have to be 12 meters (39 feet) square to sustain a man in midair.

- ✔ **Materials:** Leonardo used some rather outdated, if effective, materials. (Today, designers would use carbon, aluminum, and steel.) He constructed webbed wings of the lightest, strongest, and most flexible materials he could find: pinewood strengthened with lime for the skeleton, raw silk and starched taffeta for the membranes, and canvas covered with feathers for the wings. He also used leather smeared with grease for the lanyards and straps (the tendons), young pines or reeds for the frame, and steel and horn for the springs.

- ✔ **Methods:** Leonardo's drawings feature different methods of lifting. Some show a system of strings and pulleys that could bend, stretch, and beat wings in both vertical and horizontal directions. Other sketches depict pedals, stirrups, sails, handles, harnesses, steering cables, and platforms. Leonardo even designed a flight machine with a retractable ladder, kind of like a UFO.

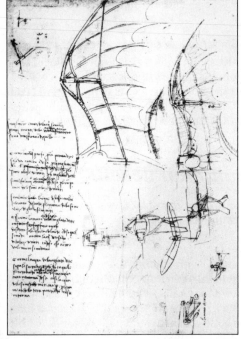

HIP / Art Resource, NY

Figure 9-1:
*Fixed-Wing
Aircraft
with
Ornithopter
Extension,* c.
1490,
Science
Museum,
London.

Because Leonardo used some wacky materials and designs for his *uccellos,* he produced some rather strange results. But people today would still more or less guess at the function of most of his flying machines. They resembled

- A canoe with a balancing mechanism
- A large, four-winged butterfly
- A windmill (or a double-pronged bat!)
- An indoor rowing machine
- A dragonfly (in this drawing, a stooped man pumped a piston with his head while operating four 24-meter-long/80-foot-long wings with his four limbs)
- An upright man (a man stood upright, operating two stirrups that moved the wing with ropes and pulleys)
- A human slider (a man used his legs to slide up and down to control upstrokes and downstrokes)

Because he changed his plans and drawings so many times, Leonardo possibly ended up with a primitive hang glider with fixed wings rather than a human-propelled flight machine.

So you fly, do you?

Ever wake up from a dream where you're jetting through the sky just by flapping your arms, legs, and little noggin? You feel a little powerful, don't you? More than one-third of the dreaming population reports experiencing Superman-like qualities. According to the dream experts, here's what those dreams may suggest:

✔ Confidence and high self-esteem

✔ Creativity, joy, and spontaneity

✔ Freedom

✔ Domination (to look down from above)

✔ Spirituality (an out-of-body experience)

✔ Peace of mind

✔ Prophecy (of death, good luck, life change)

✔ Sexual desires, freedom, and repression (Freud's theory)

✔ Fear (especially if you're falling to the earth)

Of course, if you're flying through the air in only your underwear, the dream probably means something else entirely.

Calling Earth to Leonardo, Earth to Leonardo: The gadgets

Leonardo understood that life's all about the gear and gadgets. He also knew that he could never even *hope* to lift off without flight controls. He thus designed many small machines to chart and control air movement and flight. The three most important, which created very simple templates for modern-day flight controls, were the following:

✔ **The *inclinometer:*** This glass bell jar holding a small ball inside controlled the air position of Leonardo's flying machines. Today, an inclinometer measures the relative angle of an aircraft with the horizon. Or, you may hear people refer to it as "a unidirectional sensor with a capacitive transducer" — in which case it belongs to a robot's sensor!

✔ **The *anemometer:*** Leonardo built a wooden vane that allowed him to study wind speed, a telling sign of weather conditions. (The first anemometer appeared around 1450, designed by the Italian architect Leon Battista Alberti.)

✔ **The *anemoscope:*** This machine, which indicated the direction of the wind, looks exactly like today's weather vanes. (Did it differ from the anemometer? Not very much; Leonardo seemed to have doubled up on his efforts here.)

Fred Flintstone meets George Jetson: The mechanical models

As you probably guessed by now, Leonardo's *uccellos* neither rocketed to the future nor romped on Neptune, because they relied exclusively on human power. But Leonardo also experimented with more sophisticated models that combined wing structure and human strength with mechanical parts.

The aerial screw and helicopter design

Leonardo didn't exactly hover over Renaissance Italy in a helicopter. In an attempt to study propeller forces, however, he experimented with a rudimentary machine that resembled a primitive helicopter (see Figure 9-2).

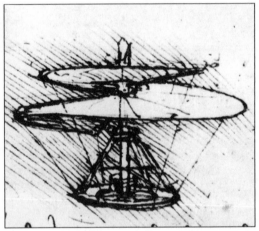

Figure 9-2:
Leonardo's aerial screw, c. 1483–86, part of Leonardo's *Codices of the Institute de France,* Paris.

Snark / Art Resource, NY

In theory and design, Leonardo's helicopter resembled an aerial, or ancient Archimedean, screw. He adopted the design of a children's toy that arrived in Europe from China, where the aerial screw was invented. When Leonardo drew his flying machine, he wrote: "A small model can be made of paper with a spring-like metal shaft that after having been released, after having been twisted, causes the screw to spin up into the air" *(Madrid Manuscript).* In one of his large-scale drawings, the aerial screw spanned 13 feet. Four men turned the shaft, causing the spiral to turn and rise through the air like a giant corkscrew.

Leonardo was the first inventor to apply the screw's use to aviation. Although he understood that the vehicle needed a power source much lighter than people to lift off the ground, he didn't realize that the forward action of the four men would push the floor backwards (read that: the darn thing was *heavy!*). So in the end, his craft stood still.

Did he, or did he not jump?

What's a theory without proof? Around 1500, during his second Florentine period, Leonardo may have put some of his models to the test. Then again, he may have bowed out at the last minute, or put a cat in his place. Rumors abound that he perhaps used the roof of the Corte Vecchia in Florence, where he had his workshop, to launch his various flight devices. Intending his experiments to remain secret, he wrote in his notebooks: "Barricade the top room!" He also tried to detract bystanders from witnessing a potentially devastating fall: "If you stand upon the roof at the side of the tower the men at work upon the cupola will not see you." (May I add: "Hope an inflatable mattress is waiting at the bottom for you, Leonardo!")

Most historians believe that Leonardo never actually took the Big Jump from his roof into the cathedral square below. Nor did the inventor, who must have sensed some legitimate danger, instill confidence in his would-be subjects. He recommended that anyone wanting to test his machines do so over water, lest they crash. And under no circumstance should they forget to wear their long wineskins, which served as buoys (see Chapter 8 for info on this Leonardo-designed device). Other historians suggest that Leonardo may have attempted to fly. Girolamo Cardano, whose father, Fazio Cardano, was friendly with Leonardo, indicates that Leonardo did take the plunge, but to no avail: "*Vincius tentavit et frustra*," he wrote. "Vinci tried in vain."

Today's helicopters, by contrast, rise and descend vertically by means of the power-driven rotation of overhead blades.

The spaceship

One of the most creative flying machines Leonardo ever designed on paper was a small flying ship, a prehistoric Jetson mobile, with flapping wings and a helm. In his drawing, the two-man crew sits inside a shell-shaped vessel, which controls two large, batlike wings operated by a screw and nut-screw device. The tail adjusts the flying position and direction of the ship. Leonardo's idea was ahead of his time, of course; no evidence suggests that anyone ever tried to replicate this design.

The airplane

One of Leonardo's most sophisticated drawings that combined human and mechanical power was an *ornithopter* (an airplane that flaps its wings to fly), which was only rediscovered when another would-be inventor sketched a similar design in 1799. It had a complicated flight control system and relied on a head harness that operated a combination rudder and elevator. In many similar drawings, Leonardo adapted the *leaf-spring* (flat blades of metal used in suspension systems today) that he used in his land machines. The leaf-spring offered a substitute for human strength. At the same time, it attested to Leonardo's slow, sad, and final realization that human strength alone would never catapult people into the air.

Yet, Leonardo was on to something: Ornithopters based loosely on his design have survived flight. The first to do so was Vladimir Toporov's *Giordano* ornithopter, flown in 1995. In December 2004, Professor James DeLaurier at the University of Toronto's Institute for Aerospace Studies created a prototype of Leonardo's ornithopter as well.

If you can't fly, then float: A primitive parachute

In 1483, just as he began to study birds and bats, Leonardo designed a parachute (see Figure 9-3). It resembled an umbrella (when it rains, you can thank the Chinese for this invention). The linen tent, the pores stopped up with starch to make the linen stiffer for flight, spanned 6.5 meters (21 feet) across and 3.5 meters (12 feet) deep, holding rigid poles running down from the top of the canopy and a person suspended by his or her arms. Like most or perhaps even all of his flight machines, Leonardo never tested his design. (When landing, the heavy poles and weight of the contraption may have caused a nasty mishap.)

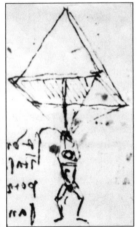

Figure 9-3:
Leonardo's
parachute
design,
*Codex
Atlanticus,*
Biblioteca
Ambrosiana,
Milan.

Snark / Art Resource, NY

As with Leonardo's other flight machines, nobody discovered this specific design until the 19th century. Leonardo can't claim, therefore, to have shaped the course of parachute history, which made its great leap around 1797 when the French aeronaut Jacques Garnerin descended from a 914-meter-high/3,000-foot-high balloon. Still, Leonardo was dead-on about its basic principle: The umbrella-like design creates drag, which permits a slow descent for the brave flyer.

It works! It actually works!

Because modern parachutes rely on a much lighter parasol design, modern-day aerodynamics experts believed that Leonardo's 15th-century design would never work. But in 2000, a British skydiver, Adrian Nicholas, proved these heretics wrong. Nicholas spent three months constructing the 187-pound parachute according to Leonardo's exact specifications. Using only materials that were available in the 15th century, he constructed a harness attached by four thick ropes to a 21-meter (70-foot) square frame built of nine wood poles and covered in canvas.

Nicholas strapped himself to the parachute and jumped over Mpumalanga's wide-open fields in South Africa, bravely embarking on what turned out to be a slow and peaceful 2,134-meter/7,000-foot descent. Though he lacked steering or navigation controls, he landed safely. (Things could've turned out very differently, I suppose. Lucky for him! And kudos to Leonardo!)

Although thousands of miles away and hundreds of years removed from Leonardo's time and place, Nicholas finally fulfilled, at least partly, Leonardo's grand dream of flight — and validated the inventor's original stroke of genius.

Connecting Leonardo's Theories and Inventions to Modern Times

Leonardo explored the art and science of flight in pages of at least two notebooks, *On the Flight of Birds* (1505) and the *Codex Atlanticus* (1480–1518), which I describe in Chapter 16. He applied his understanding of physics, mechanics, and bird and human anatomy to more than 500 flight designs and written explanations of flight. Unfortunately, nobody discovered his notebooks until the late 1800s. Not only did Leonardo keep all his theoretical and practical work on aviation secret at the time, but he also used mirror writing to conceal his musings and detract potential rivals. For a few hundred years, then, aviation history marched on without his contributions.

The birds and the bees (or bats)

Why do Leonardo's musings on birds and bats matter today? Because his observations of their anatomy and movement enabled him to develop some rudimentary principles of flight. Leonardo made three key contributions to this field:

> ✔ **He used natural design.** Instead of relying on some religious hogwash to explain scientific phenomena, Leonardo looked directly at nature (birds and bats) as models for flight. He used the modern scientific method known as the *empirical method,* which is based on inductive reasoning

and deductive logic (pull out the high-school biology book!) about 200 years before John Locke popularized the concept during the Enlightenment. (See Chapter 4.)

✔ **He got a few concepts right.** Based on his observations, Leonardo sketched some rather odd, but partially correct, theories about aerodynamics and aviation.

✔ **His inventions (well, at least one of them) did their jobs.** He drew models of flight machines that *actually worked* — well, the parachute would have, anyway. A few others, such as his glider, were more or less successfully tested after his lifetime. After a few crashes, British inventors in the late 1990s and early 2000s combined different (and workable) elements from his various drawings to test a Leonardo-inspired glider. (No motorized vehicles or intergalactic spaceships yet — sorry.)

Even your humble author has called Leonardo the *father of aviation,* but I must also share one caveat: Many of his musings wouldn't have aided the cause of modern-day flight even if someone *had* discovered them earlier. Although Leonardo made some good, educated guesses about the laws of aerodynamics, he was dead wrong about others. Simply put, most of his aircraft designs never would've lifted off the ground. They nonetheless reveal the creative, scientific, and mechanical mind of a genius and offer important insights into modern-day flight.

A few degrees of separation: The Wright Brothers connection

Leonardo may have been the first person to study birds and apply their principles to human-powered flight, but later inventors built on his findings, which created a kind of domino effect for aviation history. Supposedly, here's how the story goes as far as Leonardo, his birds, and his flying machines are concerned:

1. Leonardo studied birds and bats.

2. Inventors in the 19th century studied his notebooks.

3. Otto Lilienthal (1848–96), a German engineer who was inspired by Leonardo, observed birds in flight. As he experimented with lift, drag, and artificial wings, he helped transform aerodynamics into a serious field by the end of the 19th century.

4. Lilienthal died in a gliding accident (go figure), but his models of gliders and many writings, especially *Birdflight as the Basis for Aviation* (Markowski International, 2000), directly inspired the Wright brothers' invention of the airplane.

And *that* is how Leonardo directly and indirectly helped the cause of all your worldly travels!

Part IV
The Divinity of the Painter and Architect

The 5th Wave
By Rich Tennant

"It reminds me of da Vinci in its use of light and shadow, the luminous skin tones, the reverence for nature, and the way it covers a large crack in the wall."

In this part . . .

If you want to know why *Mona Lisa* is smiling at you (yes, *you*), this is the place to start. This part explores how Leonardo brought a new technical mastery to Renaissance painting, ushering in the period known as the High Renaissance. It also explains how he applied his new techniques to portraiture. Finally, it introduces a lesser-known side of him — Leonardo as architect and mapmaker. Yes, he donned a city planner's hat and applied many of his artistic principles to urban and landscape design.

Chapter 10

The Master of His (Artistic) Domain: Transforming Renaissance Art

*T*here was darkness, and then there was light.

Not exactly — but in many ways, Leonardo *did* epitomize all the advances that Renaissance artists made between the *quattrocento* (in Italian, this term literally means "400" and indicates Italian art and literature in the early and mid-1400s) and the High Renaissance of the late 1400s and early 1500s. During this time of artistic evolution, painters focused on a few thorny problems. The biggie? How to draw three-dimensional figures on a flat surface in order to convey greater realism and the illusion of depth and distance.

Like some of his colleagues and predecessors, Leonardo used mathematical and scientific rules to test his ideas about linear (and atmospheric) perspective, depth, distance, and form — but he brought these artistic principles to new heights. He also experimented with oil paints and perfected new techniques that contrast light and dark for fuller figures and backgrounds.

Overall, Leonardo's understanding of painting as a science set him apart from his contemporaries and transformed High Renaissance art. In this chapter, I give you the skinny on his techniques, influences, and inventive methods of painting that paved the way for a whole new line of artists.

A Hundred Years of Change

Throughout the 1400s, Renaissance artists broke with their predecessors and the limitations set by medieval art. They studied nature, improved their understanding of perspective, and brought together a new technical mastery of human expression, movement, and painting. Between the 1480s and 1525, these efforts resulted in the *High Renaissance,* the climax of Renaissance art.

Reviewing age-old techniques

During the early 1400s, Italians saw their splendid past in the distance and wanted to recapture the glory. Thus, the quattrocento saw the rebirth of models of classical antiquity, from suggestively nude statuary to Greek orders of architecture and depictions of Greek and Roman gods, goddesses, and mythology in paintings. Artists devoted their efforts toward understanding optical perspective and realism in painting, sculpture, and architecture. Masaccio (1401–28, born Tommaso Cassai), for example, whom historians and artists alike consider the first great painter of the Renaissance, used scientific perspective to create three-dimensional illusions. His play of light and shadow — though nowhere near as sophisticated as Leonardo's — added to this realism and contrasted sharply with flat, medieval art. Donatello (1386–1466, or Donato di Nicolo Bardi, the one *before* the Donatello of Ninja Turtles fame!) used soft, graceful lines to convey greater realism and movement in sculpture. And in architecture, Filippo Brunelleschi (1377–1446) used geometric principles and mathematical proportion to create perspective and focus on the relationship between form and function and inner and outer space.

However, quattrocento art still had a long way to go to reach the emotional height of the High Renaissance masters.

Coming to a head

A few decades before 1500, a new crop of talented artists entered the Italian art scene: Michelangelo, Raphael, and Leonardo. They drew on their quattrocento counterparts, but also displaced older artists by pioneering a new technical, scientific, and humanist mastery of painting, sculpture, and architecture. People today call this period the *High Renaissance.* This term refers to the artistic genius of early 16th-century art in Milan and Florence, but primarily Rome.

High Renaissance artists showed a new confidence in the use of classical themes and took those themes in new directions. To Giorgio Vasari (considered

the father of art history and a noted Leonardo biographer), writing in 1550, the key to the new artistic style was *razia,* meaning a refined grace and ease of manner. For example:

✔ Harmony and equilibrium of form, proportion, and perspective still prevailed, as it did during the quattrocento.

✔ Artists still looked at antique statues (nudes) but made their works more monumental, energetic, and purposeful. They depicted the gentlemen with more powerful muscles and the ladies with rounded torsos and broad hips.

✔ For High Renaissance artists, beauty was the sum of all its parts. So physical perfection possessed both spiritual *and* intellectual components, such as dignity and nobility. In short, physical beauty reflected spiritual beauty.

✔ Some High Renaissance artists (for a while, at least) combined elements of Christianity, classicism, and Oriental mysticism. For example, they used *both* the Virgin Mary and the goddess Venus to suggest the idea of love.

Florence, Flanders, and Germany: Renaissance hot spots

For 15th-century artists, Florence was the place to be. Artists and philosophers had already established it as their haven, and the city continued to attract kindred souls. The wealthy Medici family, who built up Florence in the 15th century, bankrolled most of the important Renaissance artists. They started with an ingenious plan to create a competition for the design of the doors on the Duomo Cathedral. From there, Florence's pivotal role in Renaissance art was a *fait accompli.* (I discuss Florence and its patrons and artists in more detail in Chapter 2.)

The Republic of Florence wasn't the *only* locale of artistic innovation, however. In northern Europe, Florence had its counterpart in Flanders (then a part of the duchy of Burgundy), a commercial center built up (like Florence) from banking, with quite generous patrons of the arts. (Florence had the Medicis; Burgundy had its dukes.)

At first, northern Renaissance art focused on *illuminated manuscripts* (books written by hand and adorned with pictures). A classic example is the Limbourg Brothers' religious-themed, calendar-like *Book of Hours* (a series of manuscripts drawn between 1413 and 1416), which you may — or may not — remember from Art History 101. Jan van Eyck (c. 1390–1441), a court painter to the duke of Burgundy, fooled around with oil paints, perfecting the idea of glazes to create light and dark. Then, northern Renaissance art became more whimsical. A generation later, Hieronymus Bosch (1450–1516), a painter in the late Gothic period, contributed some strangely unique and fanciful pieces, such as *The Garden of Earthly Delights* (1504); Peter Bruegel the Elder (c. 1525–69), considered the greatest Flemish painter of the 16th century, painted simple, often humorous scenes of daily life.

Eyeing the competition: Leonardo's major rivals

Leonardo had some competition, to be sure — mostly in the form of Michelangelo and Raphael, the two other giants working in Florence and Rome during the same era. Clearly, they all had some trouble sharing the spotlight, but each contributed distinct elements to High Renaissance art.

Not the teenage mutant ninja turtle: Michelangelo (1475–1564)

Michelangelo, considered perhaps *the* most important painter and sculptor of the High Renaissance (though not an inventor, like Leonardo), embodied the High Renaissance ideals. He looked at classical sculpture, endowing his hero-sized figures with noble qualities, pathos, and — of course — plenty of muscles and pent-up energy. His significant works include

- *Pietà* **(1498–1500, St. Peter's Basilica, the Vatican):** Michelangelo completed this Virgin-Christ marble statue when he was only about 25 years old. Many historians consider the *Pietà* — for the duo's muscles, countenances, and depiction of death — the greatest sculpture in history.

- *David* **(1501–4, Galleria dell'Accademia, Florence):** This marble statue represents the biblical David as an athlete, defined by his twisting pose (an example of *contrapposto,* which means that the form is more realistic than rigid), beauty, powerful expression, tension, and inner strength (see Figure 10-1).

- **Sistine Chapel ceiling and** *The Last Judgment* **(1508–41, Rome):** In 1508, Julius II commissioned Michelangelo to decorate the Sistine Chapel ceiling, which resulted in more than 400 larger-than-life-sized figures over a tortured four years. Perhaps the greatest of these frescoes (and the largest of the Renaissance) was *The Last Judgment,* which Michelangelo completed in 1541 at the rear of the Sistine Chapel. It depicts Christ on Judgment Day, separating the saved from the damned, while souls cross to hell via *Charon* (in Greek mythology, the ferryman of the dead).

- *Moses* **(c. 1515, San Pietro in Vincoli, Rome):** Part of the planned monument of Julius II, this muscular, horned figure, sporting a flowing beard and strong, powerful hands, holds the Ten Commandments.

Although more than 20 years separated Leonardo and Michelangelo, the hostility between them remains legendary. When Leonardo returned to Florence as a middle-aged (albeit respected) artist, Michelangelo was in his heyday, the cause celebre of the town, cavorting with Italy's popes and princes. Despite their open animosity (Michelangelo was known for his arrogance and difficult nature), Leonardo and Michelangelo worked together on frescoes in the *Palazzo Vecchio,* the seat of government in Florence. Neither completed his work.

Figure 10-1:
David, by Michel-angelo, c. 1501–4, marble, 4.1 meters (13.5 feet) tall, Galleria dell'-Accademia, Florence.

Alinari / Art Resource, NY

Minus the sai: Raphael (1483–1520)

Although Michelangelo offered Leonardo more run for his money, Raphael was a leading contender in 16th-century Florence and Rome. Unlike Leonardo and Michelangelo, his sheer artistic output shamed his colleagues (he left completed works, whereas Leonardo and Michelangelo left mostly sketches and scraps). Overall, Raphael synthesized elements of classical antiquity (harmony, clarity, order, and balance) into graceful, monumental works.

Leonardo's work, perhaps more than anyone else's, even Michelangelo's, inspired Raphael. (Raphael seems to have viewed Leonardo as a sort of elder statesman.) In particular, Raphael looked to Leonardo's *The Virgin and Child with St. Anne* (which I discuss in Chapter 13) for inspiration for his own paintings. Some of Raphael's most famous Florentine Madonnas, including *The Madonna of the Meadow* (c. 1506), *Madonna of the Golfinch* (c. 1507), and *La Belle Jardinière* (c. 1506), mimic Leonardo's simple pyramidal structure (the reason St. John has to be in the picture is to complete a triangular structure!), *chiaroscuro* (use of contrasting light and dark to create the illusion of three dimensions), and *sfumato* (blurring of lines) techniques. Yet, in many ways, Raphael went *beyond* Leonardo in his figures' calm, harmonious radiance that just oozed divinity.

Raphael's *The School of Athens* (1510–11), one of several frescoes he painted for the room called the Stanza della Segnatura in Pope Julius II's papal apartments in the Vatican, marks his mature style (see Figure 10-2). Considered his masterpiece, it depicts Plato, Aristotle, and other ancient Greek scholars and uses perfect perspective and harmony to achieve the High Renaissance ideals. Raphael also paid tribute to his humanly inspirations, modeling his philosophers' faces on those of Leonardo and Michelangelo.

Figure 10-2:
The School of Athens, fresco, 7.7 meters (25.3 feet) wide at the base, Stanza della Segnatura, Rome.

Outside Rome: The Venetian competition

Italy dominated the art scene in Renaissance Europe; the High Renaissance masters in Rome had Venetian counterparts. Titian (Tiziano Vecellio, 1485–1576) was the undisputed master. His colorful expression, dramatic brush strokes, and depiction of sensual beauty, inner expression, and raw emotion gave new voice to the High Renaissance, as shown in his *Venus of Urbino* of 1538.

Rejecting the High Renaissance style

An artistic style called *Mannerism* became popular immediately following the High Renaissance and lasted through the late 16th century. Generally, Mannerist artists looked at the work of Michelangelo and Raphael for inspiration — but distorted the human form and its harmonious principles into overly stylized work. Famed artists of this period include a few in the Florentine school, such as Rosso Fiorentino (1494–1540); Jacopo Pontormo (1494–1557); a Greek-born Spaniard, El Greco (1541–1614, born as Domenikos Theotocopoulus); and another Italian, Parmigianino (1503–40, whose birth name was Girolamo Francesco Mazzola). Giorgio Vasari, more famous for his gossipy biography than for his works, was also an Italian

Mannerist. Even Michelangelo segued into Mannerism for a bit with *The Last Judgment*.

By the late 16th century, many artists rebelled against this theatrical but technically intricate style. Around 1600, they developed a new style (encouraged, in fact, by the Catholic Church as a return to spirituality) that relied more on realism, emotional tension, and deep shadows than Mannerist paintings. Well-known artists of the *Baroque* period, which extended through the 17th century, include an Italian, Caravaggio (1571–1610, born Michelangelo Merisi), the Flemish Peter Paul Rubens (1577–1640), the Dutch Rembrandt van Rijn (1606–69), the Spanish Diego Velázquez (1599–1660), and Jan Vermeer (1632–75), another Dutchman.

Ideas That Informed Leonardo's Art

The 15th century saw the growth of a secular intellectual movement called *humanism* (which I discuss in greater depth in Chapter 2). In Renaissance Italy, the predominant strain was Neoplatonist philosophy, a love of the pagan world — that is, the study of people and nature *outside* of religious authority.

Humanism turned the clock back to classical Greece and Rome, emphasizing the idea that people who embraced ancient texts would learn how to live the moral life. At the same time, humanism emphasized many qualities of the individual. One of the important revelations was that people were *rational* — and that they could wield this rationality whenever, wherever, and to whatever end they wanted! Essentially, people, although created in the image of a Judeo-Christian God, were autonomous beings. This idea, considering that most Florentines were Christians, in many ways contradicted the teachings of the Church.

To what extent humanist thought influenced Leonardo is still up for debate. He wasn't a man of letters (as an illegitimate child, he lacked higher education) and was self-taught in languages, though he never mastered Latin. Although at some point in his life he worked for the Medici family in Florence, big humanists themselves, he never entered their very special literary and philosophical circle. Still, some sort of humanist philosophy must have infiltrated Leonardo's brain. Although he expressed disdain for humanism's methods at various times, he applied many of these general humanist principles to his own life, from his study of anatomy to his paintings.

Seeing the larger truths

Leonardo always searched for larger truths. As far as painting was concerned, the human eye was of utmost importance in ferreting out reality. To Leonardo, the eye *was* truth; sight supplied descriptive, analytical, and fantastical understanding of the world. "The eye," he wrote in his notebooks, ". . . is the chief means whereby the understanding may most fully and abundantly appreciate the infinite works of Nature." This idea is one of the reasons that Leonardo considered illustration more important and effective than words — the eye was the supreme instrument by which to acquire the knowledge to move *beyond* the written tradition, to produce new artistic (and other useful) inventions. In fact, Leonardo considered painting superior to poetry and even sculpture. Although poetry, for example, "attempts to represent forms, actions, and scenes with words, the painter employs the exact images of these forms in order to reproduce them," he mused in his notebooks.

Leonardo argued that through human sight, and hence true experience, people could fill their lives with purpose *not* dictated by God. In his notebooks, he referred to the eye as lord of the universe, which could interpret the world and create art in its image. Sight, in fact, made all people "disciple[s] of experience" rather than products of pure logic or superstition. At the same time, the eye wasn't faultless; it also needed a sound mind: "The painter who draws by practice and judgment of the eye without the use of reason is like the mirror that reproduces within itself all the objects which are set opposite to it without knowledge of the same," Leonardo wrote.

Basically, people could see (and understand) the entire universe! The eye's truth was Leonardo's truth, and that was that.

Naturally, then, he saw painters as the arbiters of truth. So he took his claim a step further. He scribbled in his notebooks that

> The mind of the painter should be like a mirror . . . which is filled by as many images as there are things placed before it. Knowing therefore that you cannot be a good master unless you have a universal power of representing by your art all the varieties of the forms which Nature produces. . . .

The painter relied on sight, mind, and imagination to portray buffoonish, pitiable, or beautiful characters; drawing "present[ed] to the eye in visible form the purpose and invention created originally in your imagination."

Applying mathematics to art

"No human investigation can be called true science without passing through mathematical tests," Leonardo wrote in his *Treatise on Painting* (see Chapter 16). In his notebooks, he also wrote, "There is no certainty where one can neither apply any of the mathematical sciences nor any of those which are based upon the mathematical sciences." So mathematical tests he did, focusing on geometry, proportion, and perspective for his studies, drawings, and paintings.

Leonardo applied math to perspective and proportion and used geometry in many of his paintings, from *Adoration of the Magi* to *The Virgin and Child with St. Anne* (both paintings are featured in Chapter 13). Leonardo loved mathematical puzzles and worked on a number of projects with the great mathematician Luca Pacioli. Pacioli, an authority on Euclidean geometry, taught Leonardo a thing or two about this science. For example, Leonardo used forms suggested by the triangle to create pyramid-shaped compositions of grouped figures that not only provide harmonious balance, but also draw viewers' eyes to the main emotion of the painting. (See the section "Applying proportion

to painting.") Leonardo also measured, remeasured, and measured again — everything from the length of arms to the circumference of the ideal human skull, as outlined in the ideal (if unrealistic) man, *Vitruvian Man* (see Chapter 5). Finally, perspective was a science, a mathematical relationship showing the relative distance of things to each other and the viewer.

For Leonardo, a mathematical understanding of art was a means to achieving clarity and balance — both in his outer *and* inner depiction of his subjects, which suggests an inherent order to creation.

Learning from Luca Pacioli

Leonardo's greatest math teacher was the Franciscan monk Luca Pacioli (1445–1517), called "the father of accounting" for pioneering the method of double-entry bookkeeping. He wrote a few books on mathematics and taught some classes at different universities around Italy.

Pacioli's most famous work is the *Summa de arithmetica, geometria, proportioni et proportionalita* (1494), which summarizes everything known about mathematics at that time — arithmetic, algebra, geometry, and trigonometry. Although Pacioli didn't make any astounding new contributions (in fact, he based much of his work on that of artist and mathematician Piero della Francesca), he was an authority on Euclidean geometry.

By a fortuitous turn of events, Leonardo made Pacioli's acquaintance in the Court of Milan. In 1482, Leonardo entered into Duke Ludovico Sforza's service as a court painter and engineer. More than a decade later, Ludovico invited Pacioli, perhaps at Leonardo's prompting, to come to Milan to teach mathematics at his court. Pacioli and Leonardo soon became friends, based on their mutual interest in mathematics and art. Shortly thereafter, Pacioli began *Divina proportione (Divine Proportion),* which marked a shift away from faith in divine reason;

Leonardo drew amazing geometric figures of Platonic solids for the text; an example is his *Polyhedra,* which you can see below. Begun in 1497 and published in 1509, the book discusses divine proportion, or the *golden ratio,* an important aspect of architectural design.

When French armies entered Milan in 1499 and captured Ludovico, Leonardo and Pacioli fled to Mantua and then to Venice. They eventually returned to Florence, sharing a house for a while and continuing to influence each other despite their divergent life paths.

Putting things in perspective

Artists use *perspective* to structure an ordered space in which they place objects in systematic relation to each other. Perspective maps the relationship and distance between small and large objects. In Renaissance Italy, it was revolutionary not only because it formed these relationships, but also because it formed these relationships *dispassionately* — signifying a more modern relationship between mind and matter. Perspective represented one of the first steps in the modern scientific outlook.

Linear perspective, which greatly occupied Renaissance painters, is the mathematical tool artists use to create the illusion of distance and space on a two-dimensional surface. To create linear perspective, an artist must imagine the painting surface as an open window, then draw straight, parallel lines to represent the *horizon line* (where the sky appears to meet the ground) and *orthogonals* (visual rays) connecting the viewer's eyes to a distant point, where all the parallel lines that run from the viewer to the horizon line appear to come together (at the *vanishing point*).

Although Leonardo didn't invent perspective (that honor goes to Filippo Brunelleschi, 1377–1446), he perfected it. As he wrote in his *Treatise on Painting,* perspective is "to painting what the bridle is to a horse, and the rudder to a ship." That is, basic indeed.

Historical perspective and Leonardo

Leo drew his own ideas about perspective from others. The architect Brunelleschi had already demonstrated many of the principles of perspective (you can say he invented linear perspective) in his work, and Leon Battista Alberti (c. 1406–72), considered the first theorist of humanist art, was the first to write down these rules for others to follow.

In *On Painting* (1435), Alberti laid a visual foundation for painters. He drew from ancient Greek and Roman texts, intertwining these ideas with those of his colleagues, including Brunelleschi, as well as Florentine sculptor Donatello and his predecessor, the painter Masaccio.

- ✔ Alberti defined a painting as the world seen through a window. He viewed a picture's surface as an invisible plane cut through a visual pyramid that separated the real space from the imaginary space.

- ✔ He described how the eyes see by means of a visual pyramid, a converging system of rays that measures the shape and position of objects.

- ✔ He saw mathematics as a means, not an end, and the source of Renaissance painting.

- ✔ He touted the artist's ability to acquire perfect skill in painting, including perspective, light, color, anatomical form, movement, and space.

> ✔ He introduced the humanist idea that painting should impress with its dramatic content (emotional expressions and dignity), not its size. (He called this idea, which specifically referred to the power of representing historical events through painting, *istoria*.)

This treatise, read widely in Florence, carried considerable weight among many humanist thinkers and artists — including Leonardo.

From the horse's mouth: Perspective in Leonardo's Treatise on Painting

Like Alberti, Leonardo saw the eye as an investigative instrument for depicting perspective. His *Treatise on Painting* justified linear perspective and showed how it was possible — although he didn't use it in all of his own paintings.

The idea that linear perspective was much more than a tool for painting — indeed, that it showed the importance of *human* over *divine* perspective — was quite revolutionary and probably raised a few eyebrows. All of a sudden, people could re-create the world they saw through their very own eyes on a flat surface. Like some of his predecessors (Masaccio, for one), Leonardo forged a new relationship between the painting and viewer by creating a more realistic, convincing scene that involved the viewer in its spiritual or emotional subject matter. He also revolutionized Renaissance art by allowing artists to compress miles of landscape onto a two-dimensional surface.

A brief history and short list of other stuff in Leo's *Treatise on Painting*

Leonardo left his notebooks — approximately 15,000 pages of them — in somewhat of a mess. Scattered throughout them he downloaded his thoughts on painting. He probably intended these musings to be a complete text, but he never got around to compiling it.

After his death, Leonardo's student Francesco Melzi, following specific instructions left by the master himself, began to compile this rather chaotic legacy. Melzi cobbled together the document now known as Leonardo's *Tratatto della Pittura,* or *Treatise on Painting,* considered one of the most important documents in all of art history. Leonardo's *Treatise* revolutionized his era, transforming and modernizing Renaissance art.

In it, he discussed many important principles of art, touching on the following areas:

✔ **The human body:** Proportions, anatomy, motion, posture, expression, decorum, and drapery (that would be clothing)

✔ **Nature:** Light, distances, atmosphere, smoke, water, horizons, and plants

✔ **Painters' practices:** Ethics, advice, instructions on how to judge works, studio etiquette, wall painting, allegories, and composition

✔ **Science of vision:** The eye, color, light, shadow, and perspective

Experimenting with the camera obscura, the pinhole camera

Leonardo experimented with the camera obscura (in Latin, *camera* means "room" or "chamber," and *obscura* means "dark") to prove some concepts about images and objects. *Camera obscura* literally means "dark chamber," and the earliest versions of it were small, dark rooms with light coming through a tiny hole. Through this hole an inverted image of the outside world projected on the opposite wall, which was usually whitened for effect. Glass lenses improved the sharpness and brightness of the image.

Leonardo didn't *invent* or *discover* this phenomenon. A Chinese philosopher in the fifth century BC noted (if he didn't correctly explain) it, and then other luminaries like Aristotle experimented with it. Leonardo only helped *explain* its principles. He suggested testing it out by either setting up shop in a dark room, or going out into a brightly lit piazza or field with a dark dwelling nearby. All objects lit by the sun would transmit their images through a hole to a white wall in this dark space.

You can try this trick at home by going into a dark room on a bright day. Make a small hole in a window covering and look at the opposite wall (hopefully white, or a light color). You should see (in full technicolor!) the world outside the window, but *upside down*. The smaller the hole, the more precise the image will be. Using mirrors will turn it right side up again.

Leonardo repeated this experiment many times starting around 1490 and was amazed, once again, at the power of human sight. "Who would believe that so small a space could contain the image of all the universe?" he wrote. "This it is that guides the human discourse to the considering of divine things." Using the camera obscura, Leonardo also tried to explain the structure of sight. Basically, he contradicted older theories of vision that said people see objects by means of rays of light coming from their eyes. Instead, he turned it around. He wrongly believed that the rays of light originate in the object of vision, not in the eye, and that the object sends its image to the eye due to the luminous nature of the air, which attracts images and objects like magnets.

Why was Leonardo so concerned with a camera that didn't even *work?* Because it could aid in drawing and perspective — so an artist could see all images on a wall! No one knows how much Leonardo used this phenomenon to aid his drawing, if at all. But as later artists did, he could've placed paper on the surface to sketch or trace the image. Or he even could've used a mirror (not unlikely, given his interest in mirrors!) to reinvert the upside-down image and then trace it. (There's no proof for this either way; actually, the principles of camera obscura have been more associated, right or wrong, with the 17th-century Dutch artist Jan Vermeer.)

Leonardo supplemented Alberti's theories in many ways. He focused on the human eye and *optics,* the science of sight, and noted some important characteristics of perspective after experimenting with his eye, an object, and a pane

of glass. By moving each of these variables independently to different distances and angles, he was able to systematically explore perspective and resolve a few things that Alberti hadn't. Leonardo also thought that Alberti's idea of the pyramid (which terminates in a point on the eye) was too simple. Leonardo came up with some new, tried-and-true ideas:

- **Diminishing (linear) perspective:** Objects appear smaller as they recede from the eye. The study for *Adoration of the Magi* (c. 1481) reveals Leonardo's early use of linear perspective (see Figure 10-3). He constructed the background ruins correctly, and the space between the foreground and background achieves a convincing three-dimensional effect. The high horizon allows viewers to focus on Mary and her pals. But Leonardo wasn't perfect. The horses on the right look too large compared to the ruins and front horses, and the study as a whole lacks cohesion. Still, compared to other artists' use of perspective at this time, *Adoration* was simply revolutionary.

 Leonardo's *The Last Supper* (c. 1495), painted when Leonardo was fully acquainted with its theory and practice, in many ways perfected linear perspective; it draws your eyes straight to the man himself. (Leonardo played some tricks on his viewers' eyes, too — I discuss them more in Chapter 14). Leonardo seems to have stopped using linear perspective after 1500, choosing to focus more on optics and perception as he did in *St. John the Baptist* (c. 1513), which you can find out more about in Chapter 13.

- **The perspective of color:** Colors also vary (and grow fainter) as they get farther from the eye. In the *Mona Lisa,* Leonardo painted the ground and hills behind Lisa a warm reddish-brown. But as the landscape recedes, the mountains become bluer. Leonardo attributed this difference to variations in the air. And because the air closer to the earth is denser, he painted the bases of hills lighter than the summits. (Go to Chapter 11 for more information about the *Mona Lisa*.)

- **The perspective of disappearance:** Objects in a picture should appear hazier and less complete in relation to their distance. In the *Mona Lisa,* images recede until they almost disappear. Leonardo also referred to this phenomenon as *atmospheric perspective.* To show distance in paintings, in particular landscapes and backgrounds, he used the blurring of outlines, decreasing of color, hazy detail, and value contrast.

Although Leonardo generally privileged observation and practice over theory, he warned that the painter who relied *only* on his eye, and not on his brain, was no better than a mirror with no consciousness. Ha!

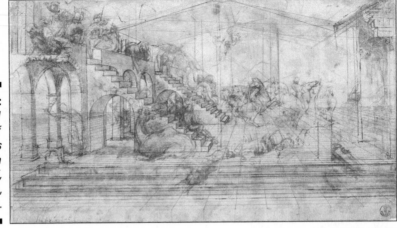

Figure 10-3:
Perspectival Study of Leonardo's Adoration of the Magi, Uffizi, Florence.

Pioneering a New Realism in Painting

Leonardo was among the first to pioneer some key techniques in High Renaissance art — never before perfected, never again perfectly replicated. He greatly influenced his colleagues (including Raphael), as well as future generations of painters, including Rembrandt.

Solving the problem of lighting: Chiaroscuro

Human eyes take in an enormous range of brightness, from the sun to dark shadows. But unlike eyes, paints have a much more limited range of bright colors that don't reflect the normal range.

During the late Middle Ages and early Renaissance, artists tried to replicate the natural range of light by overlaying light colors (like gold, which indicated grandeur) over dark objects (such as robes). The lighter color indicated the folds and depth of the cloth, which the artists had difficulty otherwise contrasting. As a result, many of the early Madonnas seem dark and stuck to their surface, rather than light and three-dimensional.

Leonardo understood how light and shadow help create perspective, three-dimensional forms, and the perception of distance. He used a technique called *chiaroscuro,* an Italian word meaning "light" *(chiaro)* and "dark" *(oscuro),* to achieve these aspects. The technique is the distribution and contrast of light

and shade in a painting, no matter how many colors the artist uses. Painters use it to model and define forms — figures seem to emerge from dense shadows into lit areas and, in this way, without contour lines, become defined. In the *Mona Lisa,* for example, Leonardo used shadow in the lowest areas of the portrait, at the edges, and in the landscape to blur detail and focus on Lisa's face.

Leonardo used chiaroscuro in many of his paintings, including the *Mona Lisa* and *Virgin of the Rocks* (you can see the paintings for yourself in Chapter 13). In *The Lives of the Artists* (Oxford University Press, 1998), Vasari noted,

> *One of the remarkable aspects of Leonardo's talent was the extremes he went to, in his anxiety to achieve solidity of modelling, in the use of inky shadows. . . . He eventually succeeded so well that his paintings were wholly devoid of light and the subjects looked as if they were being seen by night rather than clearly defined by daylight.*

Leonardo shed light on, well, light. He brought Renaissance artists out of the dark, so to speak — and it's still a big deal. Which other Renaissance artist has been distinguished with a ten-volume comic book series, *Chiaroscuro: The Private Lives of Leonardo da Vinci* (DC Comics, 1995–96)?

Reviving Flat Stanley: Sfumato

In medieval and early Renaissance paintings, people looked like Flat Stanley (who, once squashed by a bulletin board, packed his svelte self into an envelope to travel cross-country). Why were these figures so flat? Many reasons. The fact that artists outlined them against a two-dimensional background didn't help. Leonardo realized that viewers, with a little guesswork and mystery — if they just could *imagine* figures a bit more instead of seeing them so sharply outlined — would experience a more realistic figure.

The other chiaroscuro

Leonardo was neither the first nor the last to use chiaroscuro. He just more or less perfected it. In Renaissance times, the term *chiaroscuro* also referred to a whole other type of art — woodcuts. Sixteenth-century German and Italian artists, using different wood blocks for different tones of a single color (each, obviously, with defined edges), used colored woodcuts to suggest tonal drawings. They created a sense of depth without labor-intensive hatchings. The most famous artists of this medium included German painters Lucas Cranach (1472–1553) and Hans Burgkmair (1473–1531).

Leonardo used a technique called *sfumato* (Italian for "smoky"), which uses blurred lines and merged colors between different parts of a painting to create a smoky effect. He coated the objects in his paintings with very thin layers of paint, which helped soften and blur edges and shadows. In some paintings, including the *Mona Lisa,* his sfumato looks like gauze or haze, which creates qualities both of dreaminess and reality (see Chapter 11). In others, Leonardo's sfumato (and chiaroscuro) highlights religious and emotional depth; in *St. John the Baptist,* the holy one emerges from the dark, with God's light shining on him (see Chapter 13).

Applying proportion to painting

What was a painting without people — and what were people if they didn't look human? Making them look human entailed applying mathematical and geometric principles to the human body, again tying together Leonardo's idea about the human machine (a concept that I explain more in Chapter 5).

The golden mean, redux

Like other Renaissance artists, Leonardo drew on the ideal of the *golden mean* — the idea that natural objects are divinely, or perfectly, proportioned — extensively in his paintings to achieve harmony, balance, and beauty, classical Renaissance principles. (See Chapter 5 for more about this idea and how it relates specifically to the human body.) Of course, he didn't get it perfect — no one did.

If the golden mean was an ideal, and hardly practical in all matters of art and architecture, it still offered some guiding principles for achieving that Barbie body and dream house in which to place him or her, affecting almost everything Leonardo did:

- Measuring and drawing the human head and skull

- Charting the dimensions of a horse for his paintings and planned equestrian monuments

- Figuring out human proportions (*Vitruvian Man* — the man inside the square inside the circle; see Chapter 5)

- Painting *The Last Supper,* which uses proportion in everything, from the large table where Christ and his buddies sit to the windows in the background (head to Chapter 14 for details)

Pyramids and other fun shapes

Geometry was a tool that helped organize figures and space to create a cohesive painting. In most of his paintings, Leonardo also experimented with

pyramidal compositions, the broadening of a triangular composition into three dimensions. This geometrical ordering of people and space marked a vast improvement from the unnatural, geometrical groups of saints and biblical figures in works from the Middle Ages, and was a technical hallmark of the Renaissance style. Leonardo first used it in *Adoration of the Magi* (see Chapter 13), which draws viewers' eyes to the people grouped in a pyramid, namely the mom and child. In *Virgin of the Rocks* (see Chapter 13), Leonardo drew four figures that form a three-dimensional triangle, with the Virgin as the apex. *The Virgin and Child with St. Anne,* as well as the *Burlington House Cartoon* (see Chapter 13), also uses a pyramidal composition. Leonardo also messed around with different shapes, including triangles and ovals, as ways to achieve proportion and harmony.

Twisting this way and that: Contrapposto

There's no denying that Leonardo's mature figures (that is, those painted later in his career) had some sass. Just look at the way Leda (of *Leda and the Swan*) twists (see Figure 10-4)!

Figure 10-4:
Leda and the Swan, c. 1505-10, oil on panel, 112 x 86 centimeters (44 x 34 inches), Galleria Borghese, Rome.

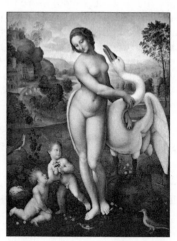

Scala / Art Resource, NY

This modeling and posing of human figures is called *contrapposto,* or counterpoise. In a painting or sculpture, the hips and legs turn in different directions from the shoulders and the head. The weight of the body resides on one foot (pretty easy, isn't it? It's called the slouch.) Contrapposto gives figures a more natural pose while they remain balanced on a vertical axis.

Leonardo's Class(ical) Act: Leda and the Swan

While working in Milan, Leonardo seems to have been slightly obsessed with the Greek myth of Leda and the Swan. According to one version of the story, the god Zeus, disguised as a swan, seduced Leda, the queen of Sparta. Their union produced four illustrious offspring: Castor, Polydeuces (Pollux), Helen (of Troy), and Clytemnestra, double sets of twins born from eggs.

Leonardo sketched this theme many times, using the moat around the castle as a model, then painted *Leda and the Swan*. In the painting,

Leonardo included many erotic and sexual symbols: the toad (death), daisy (love), columbine (concealed love), jasmine (tribute to love), and Leda (fertility *and* modesty — imagine those ideas going together!). (I discuss plants and their allegorical meanings more in Chapter 6.)

Unfortunately, Leonardo's original painting disappeared somewhere around the 18th century; people know about it only through copies of the painting, written descriptions of it, and Leonardo's two cartoons of it and his drawing of Leda's head and bust.

Contrapposto marked a vast improvement from days of yore (ancient Egypt, for example), where symmetrical poses made figures even more flat and unrealistic than they had to be. By the fifth century BC, Greek sculptors had invented contrapposto as a way to animate a figure in a nonsymmetrical, more relaxed stance. For some reason, this technique disappeared into the dusky abyss of the Dark Ages, only to reappear during the Italian Renaissance in Donatello's many sculptures and Masaccio's paintings. Leonardo followed this trend, with some pretty good results.

Using and Sticking With Oil Paints

One of the big transitions from the quattrocento to the High Renaissance was in the paint itself, which allowed artists to control their style and technique. Leonardo had his own recipe for paint, of course. But unlike most of his other inventions, he actually put this one to diligent use.

Egg versus oil: A brief comparison of paint

Paint has many components. The *activator* (or coloring agent) is called a *pigment*, a solid particle that determines the paint's color, opacity, and consistency. The pigment floats around in a liquid *vehicle* (like oil, wax, sap, egg, or water). Painters always use the same pigments; they change only the specific *vehicle* of the pigment to create distinct types of paint, from egg tempera to watercolors to acrylics.

Retaining the brilliant splendor: Tempera painting

Although tempera paint had been around since ancient times (like Pompeii, for example), early Renaissance artists developed new forms of tempera — paint with ground pigment mixed with a water-soluble material, such as egg yolk (for egg tempera) or milk proteins (casein). Leonardo's colleagues, including his master Andrea del Verrocchio, painted primarily with egg tempera.

Egg tempera, which artists applied in short strokes to wood panels coated with *gesso,* a thin layer of plaster of Paris and glue, has specific qualities that made it a highly desirable medium:

- ✔ It allows a great range and clarity of light, shade, and color.
- ✔ It binds well to many surfaces.
- ✔ It dries relatively quickly (faster than oil paint, for sure) and becomes insoluble, which allows artists to paint over it without wrecking previous layers of paint.
- ✔ It lightens as it dries, so artists can use it for bright pigments, and dries to a matte finish (unlike oil paint's gloss and shine).
- ✔ Tempera is durable and less subject to oxidation than oils — hence the brilliant appearances of many 500-year-old Renaissance paintings.

Adding shine and depth: Oil painting

In the 16th century, oil paint came into vogue. Artists in northern Europe had experimented with oils as early as the 12th century. The big change came 300 years later, around 1410 (according to the famous biographer Giorgio Vasari, anyway), when Jan van Eyck, Dutch master of realism and color, invented this medium by using linseed oil and mineral pigments.

Reviving tempera painting

Tempera painting may have gone the way of the dodo during the High Renaissance (after all, oils *were* superior for the kinds of effects Leonardo and company tried to achieve). Some artists, like Mexican painter Diego Rivera, used it in the early 1900s. But between 1930 and 1950, tempera experienced its own little renaissance. Well-known artists, wanting to learn from medieval and Renaissance artists, began to experiment with tempera on large canvases (no altarpieces this time!). Even the New Deal's Works Project Administration's (WPA) Federal Art Project caught on, hiring artists to paint different themed tempera murals in different cities. The most noted of these tempera artists? N. C. Wyeth, his son Andrew Wyeth (who made egg tempera his main medium), Thomas Hart Benton, Paul Cadmus, and Jackson Pollock. An exhibit called *Milk and Eggs: The American Revival of Tempera Painting, 1930–1950,* at the Brandywine River Museum in Pennsylvania, commemorated this rebirth in 2002.

Oil painting (whose *vehicle* is oil, by the way) differs from tempera painting in the following ways:

- ✔ Because oil dries more slowly than tempera, artists can manipulate it for a longer time. They can also dilute it with turpentine and work on a wet painting, which greatly helped Leonardo's sfumato technique.

- ✔ It's versatile and flexible: Artists can use all types of brush strokes, from very fine details to large, broad strokes.

- ✔ Oil is easy to blend; Leonardo, for example, painted blended shadows that created the illusion of three dimensions.

- ✔ Oil makes pigments look translucent, which allows painters to apply thin layers *(glazes)* and create rich colors.

- ✔ Oil creates brilliant, glossy colors (think of the jewels, velvet, metal, and glass highlights in Leonardo's paintings).

Overall, oil paint created an unprecedented form of realism in painting.

Experimenting with oil

Leonardo first experimented with oil paints while apprenticing with Andrea del Verrocchio in Florence. According to biographer Giorgio Vasari, he assisted in Verrocchio's *Baptism of Christ* (c. 1472), adding in the left-hand angel and making the rest of the painting, by comparison, look quite dull. Leonardo also decided to diverge from his master's use of tempera and use oil, thus asserting his independence when he was only about 20 years old. It seems that this experience sold him on the value of oil over tempera, for most things, anyway.

He even invented his own recipe for oil paint. Leonardo's concoction greatly improved the state of oil painting at the time. It required cooking the oil paint at a low temperature after adding 5 to 10 percent beeswax, which kept the paint from becoming too dark. Titian (Tiziano Vecellio, 1485–1576) and Tintoretto (Jacopo Robusti, 1518–94), a Venetian High Renaissance/Mannerist painter, altered this recipe slightly, but overall, kept this recipe secret in Italy for about three centuries.

Leonardo's oil paint, of course, represented only one miniscule contribution to his larger one — changing the face, literally and figuratively, of Renaissance painting.

Chapter 11

Mona Lisa's Smile and Other Mysterious Mugs: Leonardo's Portraits

Leonardo da Vinci is best known for his paintings, but if I'm *really* generous, I can say that he left somewhere between 15 and 20 paintings and portraits. *Only 15 or 20* — hardly an impressive number. And those 15 or 20 pieces include collaborations (mainly with students who worked in Leonardo's studio in Milan), unfinished panels, and paintings with disputed authorship — that is, they may be by Leonardo . . . or may not be (unlike many other portraitists of the time, Leonardo didn't sign or date his paintings). Add to this the facts that the dates of the works aren't guaranteed and that other artists have tried to alter and improve upon most of the pieces.

Some of the portraits that I introduce in this chapter are definite Leonardos, and some are collaborations. Yet, each is a masterpiece in its own right. These works illustrate Leonardo's trademark use of *sfumato* (blurring of lines), *contrapposto* (the positioning of a pose so the effect is more realistic than rigid), *chiaroscuro* (the play of light and shadow), and *composition* (the arrangement of the elements), even if the sitters and subjects pose something of a mystery.

To understand Leonardo's work and to see how in the world art historians can determine which works are actually his — or which element of a piece, like a single angel in a whole choir, they can attribute to him — you need to know Leo's trademark moves. Recognizing these techniques can also give you a greater appreciation of his artwork. For fuller definitions of these terms and explanations of Leonardo's technique, head to Chapter 10. By the time

you finish this chapter, you'll be able to rush to the nearest art museum, point at your favorite Leonardo portrait, and intelligently tout the who, when, why, and how (or lack of answers thereof) behind it.

Sitting for Leonardo: The Portraits

Experts consider some of Leonardo's portraits to be his masterpieces (then again, everything was a masterpiece, wasn't it?). The portraits show his evolution from a young painter to a seasoned artist with his own following. They also reveal his beliefs: He wanted his portraits to reveal what he described as "the motions of the mind" — that is, the beauty and psychological power within a person — through heightened expression. This heightened emotion represented one of the transitions from *quattrocento* (15th-century) painting to High Renaissance painting. Although Michelangelo, Raphael, and the later Mannerists also dug out their sitters' inner psychology, no painter before Leonardo or since has produced portraits with such power, intrigue, and inner expression. And his mastery of technique — from sfumato to perspective to applying oil paints — allowed him to paint unparalleled portraits.

Ginevra de' Benci (c. 1474)

The *Portrait of Ginevra de' Benci* is perhaps Leonardo's best preserved early portrait. He completed this painting while still working with Andrea del Verrocchio, the master Florentine artist in whose studio Leonardo studied. Although by this time Leonardo was an independent painter, he still continued to work with Verrocchio for a few years. This bust portrait is typical of the quattrocento and, compared to his later paintings, looks relatively wooden — that is, stiff and kind of waxy — and less expressive. But, when shown next to paintings of his contemporaries, the portrait is a wonder in facial modeling and light-dark contrast.

In this portrait (shown in Figure 11-1) Leonardo connects beauty, nature, and female virtue: Ginevra sits in front of a detailed juniper bush, a symbol of chastity and virtue. (*Ginepro,* which sounds like "Ginevra," means "juniper" in Italian; for the first time, Leonardo meshed a meaningful symbol with the sitter's name.) Her ringlets seem to blend right in with the bush. On the back of the portrait, Leonardo painted a motif of a wreath of laurel and palm encircling a sprig of juniper, with the inscription, "Beauty adorns virtue" (in Latin, *Vertutem forma decorat*).

As the juniper motif suggests, Leonardo probably intended this portrait to celebrate the 16-year-old Ginevra's forthcoming marriage to 34-year-old Luigi Niccolini. In this portrait, Ginevra, considered one of the great intellectuals of her time (at least for a lady), looks rather proud, sulky, and withdrawn; her shaved eyebrows don't help. Perhaps she dreaded her marriage, or maybe

she was sick. (Some historians think that the Venetian ambassador to Florence in the 1470s, Bernardo Bembo, with whom Ginevra was probably having an affair, commissioned the portrait — this idea may explain her rather aloof expression.) In any case, she has *personality*.

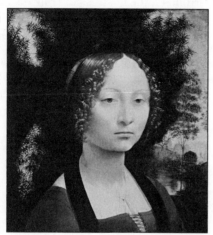

Figure 11-1: *Portrait of Ginevra de' Benci,* oil and tempera on wood, 38.1 x 37 centimeters (15 x 14.6 inches), National Gallery, Washington.

Erich Lessing / Art Resource, NY

Overall, the bust pose and harsh light make the *Portrait of Ginevra de' Benci* a typical quattrocento portrait, though Leonardo used his *sfumato* technique in the background (that is, he blurred the lines of objects to give them a more realistic appearance). And although the face has relatively little shadow (compared, say, with the *Mona Lisa*), it shows a painterly sensitivity — note the delicate eyelids. This portrait also shows the influence that the Dutch masters like Jan van Eyck (c. 1390–1441) exerted on Leonardo's style, particularly his detailed, careful depiction of even the smallest parts of nature, like leaves. Leo's meticulously portrayed juniper bush, for example, surrounds Ginevra's head like a wreath, casting a delicate shadow on her cheek.

Somewhere along the line, somebody chopped off the bottom of the portrait, which is why Ginevra has no hands. But Leonardo perhaps did a sketch of this painting, now at the Royal Library at Windsor, which shows her hands. Their grace and beauty possibly inspired M.C. Escher's famous drawing of a hand drawing another hand, *Drawing Hands* (1948).

Lady with an Ermine (Cecilia Gallerani) (c. 1482–83)

Leonardo (if the painter was, indeed, him) probably created the *Lady with an Ermine,* shown in Figure 11-2, during his early years in Milan. Although not

certain, some believe the subject to be Cecilia Gallerani, the Duke of Milan Ludovico Sforza's most important mistress, who, despite her aged appearance, was probably only 17 at the time. Others think that the portrait dates from a later time (around 1490) and speculate that the sitter is *not* Ludovico's mistress, but his wife, Beatrice d'Este. Oh, what sad confusion. Then again, the sitter might *really* be La Belle Ferronière, the mistress of François I of France, though this theory is the least probable.

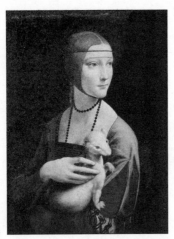

Figure 11-2:
Lady with an Ermine (Cecilia Gallerani), oil on wood, 54.8 x 40.3 centimeters (21.6 x 15.9 inches), Czartoryski Museum, Cracow.

Nimatallah / Art Resource, NY

Despite the number of mistresses or betrayed wives this mysterious woman could be, evidence points to Cecilia as the sitter: In 1498, the great patron of the arts Isabella d'Este, born into the ruling family of Ferrara, asked for a sample of Leonardo's work from Cecilia, after the death of her husband, the ruler of Mantua. Cecilia replied that the portrait she was sending could've resembled her just a wee bit more, because she'd changed over the years.

The ermine (or weasel), which sits comfortably in its white winter coat in Cecilia's arms, is a symbol of virtue and purity. Again, Leonardo linked a symbol with the sitter's identity. The Greek word for ermine is *galée,* and historians link *Gallerani* to *galée.* Ludovico used the ermine — also a symbol of nobility — as one of the emblems on his coat of arms. Ironically, Cecilia (typical for other women of her stature) wasn't exactly chaste, as she bore a son with Ludovico.

The portrait went far beyond conventional portraiture at the time. The composition is classic Leonardo:

 ✔ **Shape:** The portrait boasts his typical pyramidal base and geometric proportions, softened by curved lines (refer to Chapter 10 for a discussion of these elements).

- ✔ **Color:** He also used trademark colors, believing that subjects placed in front of dark backgrounds should wear lighter colors in order to stand out. Cecilia wears a midrange blue-gray gown with tomato-red and mustard accents, all with a similar range of *values* (meaning, lightness and darkness).

- ✔ **Light:** The lighting, which comes from above, also shows Leonardo's evolution as a painter. The chiaroscuro contrasts Ermine Lady's milky face and attentive expression further with the dark background (which, incidentally, has been repainted, showing sharper contours than Leo probably would've liked). Here, Leonardo shows his understanding of how the contrast of both lighting and color enhance the perception of three-dimensionality, creating a new degree of realism.

Both Cecilia's hand and the alert position of the ermine, which mirrors his lady's pose, also show an understanding of anatomical structure that was uncommon at the time.

Portrait of a Musician (c. 1482–90)

If Leonardo *did* author this portrait (once again, historians are besieged by uncertainty), it would've been the only portrait he did of a man. Unfortunately for men, art gurus consider this work his least important (if best preserved) portrait.

When the painting hung in the Louvre between 1796 and 1815, historians attributed it to the artist Bernadino Luini, after they had disproved cries of Leonardo. Some others consider the real painter to be Giovanni Antonio Boltraffio or Ambrogio de Predis, one of Leonardo's students. The reason for the controversy is that the portrait isn't typical Leonardo.

- ✔ The musician sits in an uncharacteristically rigid pose. Most of Leonardo's figures appear in more relaxed, lifelike poses. Consider the woman's pose in the *Mona Lisa,* her body turned slightly to the left but her face turned to the observer (see the later section "Mona Lisa (1503)" for more on Leonardo's most famous portrait).

- ✔ The shadows are harsher and more definite than in Leonardo's other portraits; he typically used a strong chiaroscuro to blend light and shadow.

- ✔ No record exists of the portrait's commission. More than half of Leo's other portraits possess some written reference to its commission, even if the paintings are undated and unsigned.

Still, the portrait has some trademark Leonardo characteristics, including shadowy backgrounds, an anatomically correct bone structure, and detailed hair and fingers.

TECHNICAL STUFF

Will the real sitter please stand up?

Researchers have long sought to identify the man in the *Portrait of a Musician*. (Although Leonardo was considered a very fine musician, he didn't sit for himself.) One possibility includes Ludovico Sforza. The Biblioteca Ambrosiana, a great library in Milan, listed this painting as *Portrait of Ludovico il Moro* in the 19th century. But in 1905, experts cleaned the portrait and uncovered the sheet music that the portrait's subject clutches, which meant that the subject was probably *not* Ludovico. That being the case, historians then identified three musicians: Franchino Gaffario, choirmaster of the Milan cathedral; Angelo Testagrossa, a singer; or Atalante Miglioretti, Leonardo's friend and singer, artist, and maker of musical instruments. But the mystery (and the music) plays on. . . .

Portrait of an Unknown Woman (La Belle Ferronière) (c. 1490–95)

If you read the preceding sections, this may come as no surprise: Leonardo may or may not have painted the *Portrait of an Unknown Woman* (see Figure 11-3). The stiff, unnatural pose and thick, relatively cumbersome facial features suggest that he didn't, although the hair and part of the face were also painted over by someone trying to improve (or perhaps finish?) Leo's original. One possibility is that Leonardo outlined the figure, and some of his apprentices, like Giovanni Antonio Boltraffio, filled it in — kind of like an advanced coloring book. The hair, face, and relatively wooden pose suggest that Leo didn't paint this portrait . . . perhaps no one will ever know.

Yet, other aspects target this portrait as a Leonardo. The fashion accessories (including the cords around the sitter's neck, the knotted ribbons on her shoulder — Leonardo was ever fascinated by complicated knots — and the band around her forehead, called a *ferronière*) imply that he's responsible. Other female sitters, like Cecilia, are similarly decked out (refer to the section "Lady with an Ermine (Cecilia Gallerani) (c. 1482–83)," earlier in this chapter).

This mysterious woman's penetrating gaze and the gentle turn of her head also suggest Leonardo's hand. Like some of his other subjects, her face bears a mysterious, intelligent expression that reveals her inner psychology. In fact, in overall composition — a three-quarters bust pose, head turned slightly, and midtone clothing (hers is, once again, a tomato-red, highly decorative garb) — the portrait resembles *Lady with an Ermine (Cecilia Gallerani)*.

Tragically for the beautiful Cecilia Gallerani, Ludovico Sforza's first mistress, the duke took a second lover, named Lucrezia Crivellia. She's the possible sitter here, though the name Isabella of Aragon has come up in certain circles as well. Then again, historians speculate that this portrait could be a second take of Cecilia, which would make her doubly important. One thing is certain: The sitter is *not* the mistress of King François I, as the title of the portrait implies; this name comes from a mistake in the catalogue in the French Royal Collection!

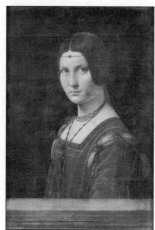

Figure 11-3:
Portrait of an Unknown Woman (La Belle Ferronière), oil on wood, 63 x 45 centimeters (24.8 x 17.7 inches), Louvre, Paris.

Erich Lessing / Art Resource, NY

Isabella d'Este (c. 1499)

Leonardo never completed this portrait of Isabella d'Este (shown in Figure 11-4), one of the leading ladies of the Renaissance (Isabella ruled Mantua after her husband's death), because he left for Venice in March 1500 and then moved on to Florence a month later. Isabella was reputedly peeved but could do little to make Leonardo finish her portrait. Despite its sad state, the half-finished portrait — actually a sketch — reveals her inner composure.

This sketch has been pricked, or perforated, by the artist, a pretty ingenious way to make a tracing. Essentially, the artist punches small holes along the outline of the sketch, places the perforated sketch over whatever medium he wants to transfer it to, and then blows powdered pigment through the holes.

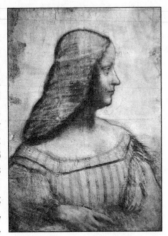

Figure 11-4:
Portrait of Isabella d'Este; charcoal, black chalk and pastel on paper, pricked for transfer; 63 x 46 centimeters (24.8 x 18.1 inches); Louvre, Paris.

Mona Lisa (1503)

If you know only one painting in the entire world, it's probably the *Mona Lisa* (see Figure 11-5). This painting is the most famous portrait — perhaps even work of art — in history. People everywhere have copied, analyzed, idolized, fetishized, and stolen (only once!) this lady, and her mysterious, intimate smile draws an estimated 6 million visitors to the Louvre Museum in Paris every year.

Leonardo painted the *Mona Lisa* over a period of about four years, starting in 1503. He worked slowly, and the sitter posed for him on more than a few occasions. According to Leonardo's biographer, Giorgio Vasari, Leonardo hired jesters or musicians to keep her happy. The portrait immediately brought him fame within Italy. Leonardo himself loved this small portrait so much that he carried it with him wherever he went, until it fell into the hands of France's King François I (see the "Touring the world" sidebar).

Unlike many other portraitists of the time, Leonardo didn't sign or date the portrait or reveal the identity of the sitter, though Vasari mentions that Leonardo undertook the portrait as a commission from one Francesco del Giocondo (see the following section). This anonymity applies to many of his paintings but confounds both our understanding of them and his evolution as a painter. So, a few persistent mysteries surround the painting: Can you say for sure *who* Mona was and why she's smiling? What's her story, and what makes her so fascinating today?

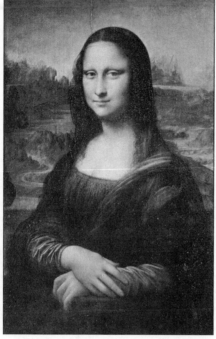

Figure 11-5:
Mona Lisa,
oil on wood
panel,
77 x 53
centimeters
(30.3 x 20.9
inches),
Louvre,
Paris.

Scala / Art Resource, NY

Identifying the sitter

Art historians have long debated the identity of the mysterious woman in the *Mona Lisa.* Was it

✔ Leonardo's mother?

✔ A society figure (like Isabella d'Este, Isabella Gualanda, or Cecilia Gallerani)?

✔ Lisa Gherardini, the wife of a family friend of the da Vincis?

✔ A Florentine prostitute?

✔ A disguised self-portrait of Leonardo?

The winning ticket most likely goes to Lisa Gherardini, the lovely wife of a Florentine silk merchant, prominent politician, and two-time widower, Ser Francesco del Giocondo. (The *Mona Lisa* has also been called *La Gioconda* in Italy and *La Joconde* in France.) Leonardo's family was closely connected to this man, who married Lisa in 1495, when she was 16 years old and he was 30.

Leonardo painted Lisa when she was 24 years old; she went on to become a virtuous wife and the mother of five kids. (Just in case you're wondering: Mona Lisa's first name wasn't Mona. *Mona* is short for *Monna,* or *Madonna,* which means, in this context, "Italian lady.") Vasari guessed Lisa's identity in 1550, but his opinion — though it came down through the ages — was pooh-poohed for hundreds of years.

Setting the standard for portraiture

The *Mona Lisa* set the standard for all future portraits (so the experts say, anyway) for many reasons:

- ✔ **Technique:** When Leonardo began painting in oil directly onto the wood, he added weak turpentine, which allowed him to paint many layers of glaze and remodel the face as many times as he liked. The layers of glaze heightened the effect of light and shade *(chiaroscuro).* The light casts soft, heavy shadows on Lisa's face, which lacks eyebrows; ladies of the time considered shaved eyebrows very attractive. (But the copy of the *Mona Lisa* in Madrid has eyebrows added!) Leonardo's use of *sfumato* (the deliberate blurring of lines) both defines and incorporates Lisa into the rolling valleys, rivers, and icy mountains behind her, connecting her with nature.

- ✔ **Composition:** Leonardo relied on a pyramidal design, which gives the painting a great sense of harmony between the sitter and the landscape. For the first time, he adopted the half- to three-quarters length, instead of the bust-size pose, with her sitting sideways. This *contrapposto* (the twisting of one part of the body away from another part) was a modern development (here Mona Lisa sits sideways but she faces front) and helped establish three-dimensional space.

- ✔ **Landscape:** The *Mona Lisa* was one of the first portraits to show its subject posed before an imaginary landscape. Lisa (and her hair, which blends into the rock outcroppings) interacts with the landscape in a new way. This landscape, with its rocks and pinnacles, is quintessential Leonardo. Although imagined, it reveals Leonardo's studies of watersheds, plants, and maps. It also stresses his interest in a wild nature that contrasts with orderly human life — both, incidentally, part of a larger (mechanistic) whole. Leonardo considered rocks, for example, not only as decoration, as other artists did, but as part of the earth's bones and caused by the earth's geology. The *Mona Lisa* thus brings together Leonardo's artistic interest in unifying people and nature.

Note that the landscape is uneven. If you look carefully at the water and rocky outcrops, you'll notice that not everything seems to connect at the proper places (behind Lisa's head, which you can only imagine). This flaw is minor — perhaps intentional — in a portrait that otherwise set the standard for portraiture. (Some people, including Vasari, believed that Leonardo may never have finished the painting, thus accounting for this error.)

✔ **The smile:** Who can turn it down? Seriously, it embodies how Leonardo captured the complex inner life — and all of Lisa's mysteries — without offering solid proof, or overt symbols, of her inner self. The following sections outline these possible complexities and mysteries in more detail.

Smiling or mocking? Some explanations

Around 1550, in *The Lives of the Artists,* Vasari described *Mona Lisa*'s smile as "more divine than human" (Oxford University Press, 1998). Since then, people have come up with different theories about her mysterious mug:

✔ She was pregnant (and kind of smug about it, too; her swollen fingers, resting on her stomach, give her condition away).

✔ She had some sort of facial paralysis, wore away her teeth by grinding them, or suffered from asthma.

✔ She was an unhappy wife, subject to an impotent, alcoholic, and abusive husband. (According to Vasari, Leonardo hired jesters to entertain her while she sat for him, so she remained merry instead of melancholy.)

✔ She's really playing a joke on you — the *real* subject is Leonardo himself (in drag!), and he's trying not to laugh. (If this theory is true, then her smile, in Sigmund Freud's view, signifies an old memory that plagued Leonardo his entire life — his erotic attraction to his mother!)

Of course, not everybody buys these theories. So scientists have come up with a few more reasons for Lisa's smile.

If you stare long and hard at Leonardo's portrait of the *Mona Lisa,* you'll notice how she smiles at you — and how quickly her smile flickers and disappears. Why is she so fickle? Don't worry. It's not you; it's her. Or, rather, it's *you,* but not in the way you think.

Touring the world

The *Mona Lisa* has had quite a journey the last 500 years. Leonardo lugged her around with him for a decade. Then, when King François I invited Leonardo to France around 1515, the king bought the painting. Lisa first resided in Fontainebleau, then in Versailles. She moved to the Louvre after the French Revolution, and Napoleon supposedly gazed at her from his bed in the Tuileries before returning her to the Louvre in 1804. In the early 1870s, during the Franco-Prussian War, Lisa went into hiding, but returned shortly to the Louvre. In 1912, Lisa was stolen but recovered two years later, only to go into hiding once again during both world wars. In 1963, she traveled to New York and Washington, D.C., and, in 1974, exhibited herself to over 2 million people in Tokyo and Moscow. Since then, she's led a rather staid existence (despite some minor assaults, like stone and acid attacks by hoodlums) in the Louvre, in a bulletproof glass case.

The famous *Mona Lisa* caper

How do you steal a famous painting? It's possible, and it's been done. In August 1912, a thief strolled out of the Louvre with the *Mona Lisa* hidden under his coat. For a while, police got nowhere with their investigations, though they brought in some big-shot suspects, including the French poet Guillaume Apollinaire and the painter Pablo Picasso. Ironically, visitation to the Louvre actually *increased* after the theft — people wanted to see Lisa's empty space! Two years later, an Italian housepainter named Vincenzo Peruggia (a Louvre employee!) tried to sell Lisa to a Florentine art dealer. Authorities quickly arrested Peruggia (who cited patriotism as his motive — he thought the painting belonged back in Italy) and returned the painting to its home in the Louvre.

Until a few years ago, art historians described Lisa's smile by using the word *sfumato:* blurry, mysterious, elusive. But now, they have a more scientific explanation. Dr. Margaret Livingstone, a Harvard neuroscientist, attributes Lisa's changing expression to the way your eyes and brain process information. Your eyes have two different regions for seeing. The central part (the *fovea centralis*) picks out details. The peripheral area, which picks up low spatial frequencies, focuses on motion and shadows. When you look at Lisa's eyes, you have less accurate peripheral vision of her mouth. But you still pick up the shadows from her cheekbones, which suggest that she's smiling. When you focus on her mouth, her cheerful disposition seems to disappear. Other artists who (knowingly or unknowingly) have used this optical illusion include Claude Monet, Chuck Close, and Robert Silvers.

Scientists have another theory for *Mona Lisa*'s mysterious smile, and it has to do with lighting. As Christopher Tyler and Leonid Kontsevich of the Smith-Kettlewell Eye Research Institute in San Francisco claim, variable levels of human noise determine how you interpret her smile. After experimenting with *visual noise* (the equivalent of white specks, or snow, on TV sets) on an image of the painting, they concluded that noise lifting the edges of Lisa's lips gave her a more cheerful countenance, and noise flattening her lips made her look sadder. The flecks of grayish light also made people change their perception of Lisa as they viewed her. Scientists think this phenomenon has to do with how the brain interprets the flow of light signals in the retina. But research in this area continues.

Restoring the masterpiece

Leonardo painted the *Mona Lisa* in oil on a thin, poplar panel. Over 500 years, the panel has warped and deteriorated, and multiple layers of varnish have yellowed the original colors.

Leonardo executed this drawing in silverpoint, which required a very steady hand. *Silverpoint,* which has been around since classical times, is a sharpened metal rod used for drawing with lead, copper, or gold on paper or parchment. Leonardo used silverpoint to create hard, distinct lines and hatchings that, after time, turned into a warm brown tone.

✔ **Old Man with Ivy Wreath and Lion's Head** (c. 1503–5): This sketch shows just how well Leonardo, once convinced of his beliefs about the relationship between facial features and character, stuck to them. Here, he shows a man with leonine features (he must be very brave!) wearing a lion skin flung across his shoulders — man or beast? For a comparison of facial expressions, Leonardo added a lion's head in the corner of the drawing. The wreath symbolizes the Greek god Bacchus, god of the vine.

✔ **Study of Five Grotesque Heads** (c. 1494): This sketch of five heads (see Figure 11-7) shows Leonardo's interest in modeling different facial features, including eyes, eyebrows, and mouth. By rearranging these expressions, Leonardo portrays different emotions, from anger to laughter. According to his *Treatise on Painting,* he used similar motions of the mouth, cheeks, and eyebrows to portray both laughing and crying; only people's outward motions (such as the tearing of clothes or shedding of tears) distinguished these emotions. As for this group of old men: Some scholars think they were meant to be satirical — gullible cuckholds, fools, or pathetic men. After all, there *is* a fine line between laughter and sorrow, right?

Debunking the ties between physique and personality

Leonardo wasn't alone in his belief that facial characteristics revealed a person's temperament or character. Through the end of the 19th century, many scientists believed that facial traits revealed a person's personality. For a few hundred years, especially during the 19th century, imperialists used *physiognomy* (the science of evaluating someone's character and personality by his or her facial features) to support their racial theories. Many British, for example, saw blackness as barbaric (and thus weak) as they conquered parts of Africa and

white as purer and superior. Fortunately, history has entirely disproved this link between facial characteristics and personality.

Although scientists finally chucked the physiognomy theory once and for all about 100 years ago, crackpot scientists and propagandists used this theory (along with *phrenology,* the examination of the shape of a person's skull, to reveal character traits) even as recently as the middle of the 20th century to support Aryan supremacy (and eugenics) during World War II.

Museum curators inspect the painting every few years and have restored it many times, removing age spots and shining her up. (X-ray examinations, incidentally, show that three versions of the *Mona Lisa* exist under the present one.) They've also taken the precaution of controlling humidity and temperature in her air-conditioned triplex glass case (a gift from the Japanese after her visit to Tokyo in 1974).

The *Mona Lisa*'s dirty, dark, and faded appearance — not to mention its warped panel — has Louvre officials worried. Tests to determine the cause of her deterioration start in 2005.

Funny Face (s): The Grotesques

People greatly interested Leonardo, who was ever fascinated by the study of *physiognomy,* the science of evaluating a person's character and personality by his or her facial features. Leonardo believed (incorrectly) that the human face directly reflected an individual's underlying character. Take the nose as an example:

- A downturned, slopelike nose indicated a person with a reserved character.

- A straight, delicate nose suggested a stoic, unsentimental person.

- A flattened nose indicated a passionate, unreserved character.

- A small, upturned nose meant cleverness, intelligence, and rapid emotional responses.

The series of drawings Leonardo produced on facial expressions are now known as the *grotesque* drawings for their subjects' strange, immediate, and rather horrible expressions. In his grotesques, for some reason, Leonardo almost always depicted older rather than younger faces. (He even may have had some stalking tendencies: Word has it that he followed older men on the streets, mentally recorded their expressions, and then returned to the drawing board.) Three notable grotesque portraits are Leonardo's *Antique Warrior, Old Man with Ivy Wreath and Lion's Head,* and *Study of Five Grotesque Heads.*

- **Antique Warrior** (c. 1472–75): Leonardo probably learned how to draw this old warrior type (also called *Portrait of a Warrior* or *The Condottiere;* see Figure 11-6) from one of Verrocchio's bronze studio models. From his expression and facial characteristics, including that bumpy, downturned nose, you can guess that he may have been serious, as befitting his occupation.

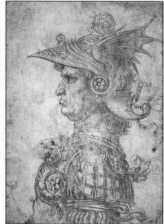

Figure 11-6:
Antique Warrior, silverpoint on prepared paper, 28.5 x 20.7 centimeters (11.2 x 8.2 inches), British Museum, London.

Scala / Art Resource, NY

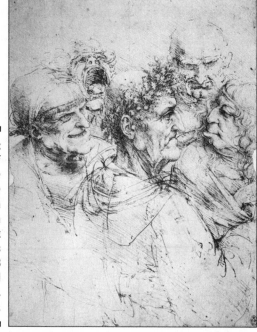

Figure 11-7:
Study of Five Grotesque Heads, pen and ink on paper, 2.6 x 2.1 meters (8.6 x 6.8 feet), Royal Library, Windsor.

Scala / Art Resource, NY

Setting the Standard for Portraiture

Never before, and never after, has anyone mastered portraiture like Leonardo. Before Leonardo, figures were flat, unrealistic, and highly stylized (go to Chapter 4 to see what early Renaissance paintings looked like). After him — let's just say it was a whole different story.

Simply put, Leonardo pioneered a new realism and naturalism. He was among the first of his generation to use oil paints, which enhanced his techniques of sfumato and chiaroscuro. He discarded the traditional sideways or straight-on pose for a half-turn pose, creating fuller, grander subjects than his quattrocento predecessors. He stalked people on the streets to capture different facial expressions and ably portrayed inner psychologies, complexities, and emotions. In his *Treatise on Painting,* he noted,

> *A painter ought to aim at universal excellence. . . . A man may be well proportioned, and yet be tall or short, large or lean, or of a middle size; and whoever does not make great use of these varieties, which are all existing in Nature in its most perfect state, will produce figures as if cast in one and the same mould, which is highly reprehensible. . . . In temper size, complexion, actions, plumpness, leanness, thick, thin, large, small, rough, smooth, old age and youth, strong and muscular, weak . . . some short, some long, some quick in their motions, and some slow, with a variety of dresses and colours. . . .*

Leonardo's study of anatomy also gave him precious insight into how to draw the human form, from head to toe, from hair to fingernail. Finally, no other artist in the course of history has influenced modern-day art practices in quite the same way. In his *Treatise on Painting,* he insisted on the rigor of art — both its physical and intellectual demands (even though Leonardo did seem a little remiss in the "how to complete a painting" department).

For all these reasons, Leonardo reshaped European painting and inspired generations of artists. (A 2004 exhibit at New York's Metropolitan Museum of Art featured an exhibit titled, "Painters of Reality: The Legacy of Leonardo and Caravaggio in Lombardy.") Leonardo's use of contrapposto and three-quarters poses, for example, created the standard for future painters and photographers. And his naturalism inspired a whole host of landscapes and still-life paintings. Yet, no one since Leonardo has ever quite captured his masterful technique and spirit, which set him apart from all others. Rembrandt's students, for instance, imitated Rembrandt, making his and his pupils' work hard to distinguish. But try as Leonardo's heirs may to imitate his smiles, his mistiness, his gauzy effect, his penetrating gazes, and his intimacy, they simply could not. But they could certainly try, couldn't they?

Chapter 12

Town and Country: Leo's Landscapes, Maps, and City Designs

● ●

● ●

The ancient Egyptians had their pyramids. The Babylonians had their tower (maybe). The Romans had their aqueducts. India, Mesopotamia, and China had their grand hydraulic works. These architectural and engineering feats, far from merely decorating the landscape, symbolized the complex power, labor, and social relations of each society.

Renaissance Italy was no different. Its architecture, city-planning efforts, and landscapes reflected the city-states' inner makeup as well as their relationship to surrounding seats of power. What *was* different, however, was the extent to which Renaissance planners looked back in time to the symmetrical, harmonious buildings of ancient Rome and Greece. And with new mathematical and theoretical tools (like perspective), Italian architects could apply new principles to old designs and build ever-grander monuments to commemorate their achievements. Renaissance Italy, then, had its Greco-Roman classical revival.

Leonardo, the consummate dabbler, donned a hat as architect and city planner more than a few times — when he was working at Duke Ludovico Sforza's court in Milan, working with General Cesare Borgia, and living with French king François I, for example. His notebooks contain many references to architecture and city plans, from rebuilding Milan to designing cathedrals, experimenting with the strengths of certain shapes and materials, and answering

questions such as how to decorate a platform for a celebratory shindig. Much of his work was theoretical; all was innovative; and most never saw the light of day. In this chapter, I cover all you need to know.

Depicting Nature's Forces: Leo's Landscapes

Landscape paintings — the portrayal of natural scenes as the main subject of the work — had been around in Asian art since the eighth century and had flourished during the T'ang, Sung, and Ming dynasties (spanning collectively from around AD 620 to 1640). But in Renaissance Europe, landscapes formed only the background for the painting's main subject. Painters, although they tried to draw naturalistic landscapes, always subordinated nature to the main (usually religious) subject. Most artists viewed landscapes not as a *holistic* environment, in which the parts are related to the whole, but as made up of individual, separate components.

Leonardo, however, viewed nature as parts constituting a larger macrocosm, the small and large intertwined. In some of his early paintings, including the *Annunciation* (see Chapter 13), individual elements don't add up to the whole; he placed the angel and Virgin in a crisp, lush garden that nonetheless fails to draw them in. But in later portraits like the *Mona Lisa,* Leonardo connected his subjects to their landscapes, doing more than plopping them down against some rivers and mountains. (Go to Chapter 10 to see how he accomplished this feat.)

Landscape drawing for Santa Maria della Neve

When Leonardo was only 21, he drew a Tuscan landscape that few (or more likely, no one) could achieve in a lifetime; see Figure 12-1. *Landscape Drawing for Santa Maria della Neve* (Santa Maria della Neve means "Day of Holy Mary of the Snows," and the painting is also known as *Study of a Tuscan Landscape*) depicts a gorge and valley near Leonardo's hometown, possibly views from the town of Montalbano, and it remains extremely faithful to what he saw possibly during a walk up a hill to escape the summer heat. On the left of the drawing lies the castle of the town of Montelupo or Larciano; the Arno River valley lies in the distance. Some art gurus have called this piece the first true landscape drawing in Western art, although the Sienese painter Ambrogio Lorenzetti painted two landscapes on wood panels 150 years earlier.

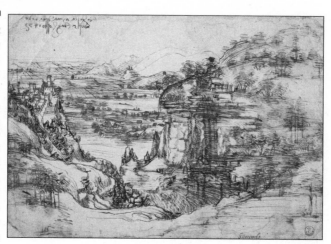

Figure 12-1:
Landscape Drawing for Santa Maria della Neve, 1473, pen and ink, 19 x 28.5 centimeters (7.5 x 11.2 inches), Galleria degli Uffizi, Florence.

Scala / Art Resource, NY

This landscape drawing is unique for a couple of reasons:

- **It's the first of Leonardo's drawings for which historians know the date.** The date of composition is August 5, 1473, to be exact — the feast day of the Virgin of the Snows, celebrated in Leonardo's town and other local villages. Recording the date, which marks a certain time, stands out because in other forms of Renaissance art, time wasn't important — the timeless subject, usually religious, was. Thus, the drawing reveals Leonardo's power to faithfully re-create what he saw on a certain day. In fact, this is probably the first Renaissance landscape to do so.

- **It reveals Leonardo's early concerns with space, emotion, perspective, and naturalism.** These concerns were all attempts to penetrate and understand the natural world. With pen and ink, he used dynamic lines to draw mists, shadows, and the volumes of objects, like hills. He captured more than trees and rocks, however. He also depicted natural phenomena like atmosphere and wind, creating an impressionistic atmosphere that later artists tried to re-create.

Rain, rain, go away: The Deluge series

Leonardo drew about 16 small landscapes, called the *Deluge* (or *End of the World*) series, toward the end of his life (see Figure 12-2 for one of the drawings from the series). These drawings offer an interesting contrast to his first landscape drawing, which I discuss in the preceding section. The early drawing is more traditional and foreshadows Leonardo's later stylistic concerns with chiaroscuro, sfumato, and receding colors (or atmospheric perspective; refer to Chapter 10 for a discussion of these techniques). His *Deluge* series, drawn nearly 50 years later, shows how Leonardo abandoned traditional

compositions for a forceful examination of the natural landscapes around the Arno River. Indeed, in these drawings, he was wearing his hat as geologist and hydraulic engineer, not traditional landscape painter.

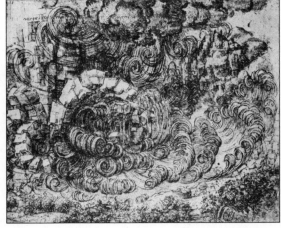

Figure 12-2:
Cataclysm,
c. 1517–18,
black chalk
on paper,
Royal
Library,
Windsor.

Scala / Art Resource, NY

Cataclysm (refer to Figure 12-2), drawn with coarse swirls of black chalk, depicts nature at its most violent — the fury of the winds, rains, and floods carrying away everything human and nonhuman in its path, a horrifying apocalyptic vision. Why the dramatic representation of nature? For any of these reasons:

- ✔ The drawing has various allegorical and symbolic references, none of which art historians have fully uncovered or understood. For example, Leonardo may have been referencing the biblical flood, though no such evidence exists. Certainly, Leonardo, like other Renaissance men, believed that something larger than nature, some kind of mysterious power, was at work in the physical processes he observed.

- ✔ The series may also show how Leonardo wished to differentiate his skill from that of Michelangelo, whose relatively placid flood scene on the Sistine Chapel ceiling depicted the biblical story of Noah and the Ark.

- ✔ Then again, Leonardo's *Deluge* drawings may attest exclusively to his passionate interest in the motion of nature — fire, water, or whatever. He noted the optical effects of falling rain in some detail, observing the swollen waters swirling around within a lake, eddying waters striking everything in their sight, and mountains falling into vast lakes. Basically, he posited scientific reasons for these appalling catastrophes.

As he did in his *Deluge* series, Leonardo used descriptive and analytical language to connect mechanical movements in the larger world, sometimes correctly, other times incorrectly (see Chapter 6 for more information on Leo's

scientific theories). Here he focused on the properties of the swiftly moving flood, based, perhaps, on the catastrophe that destroyed Bellinzona, Switzerland, in 1515, when a mountain slid down a valley, creating a massive mudslide and flooding the entire region. It's also interesting to see how Leonardo's depictions of nature evolved from his measured, ordered, if atmospheric landscape of 1473 into more chaotic, forceful drawings. Leonardo's ideas about the natural world evolved over time (see Chapter 6 for more insight into his scientific views), and he began to discern certain principles that he thought governed the world. At the same time, he acknowledged the great, unpredictable force of nature — and people's inability to stop it.

Leonardo's *Deluge* series has so fascinated viewers that in 1989, historians, filmmakers, and even museums, such as the Metropolitan Museum of Art (New York) and the Getty Museum (Los Angeles), got together and created *Leonardo's Deluge*. Directed and produced by Mark Whitney, narrated by Anjelica Huston, and written by Leonardo expert Carlo Pedretti and others, this 14-minute video blends Leonardo's scanned drawings with computer animation techniques to understand the significance of his work. Leonardo's *Deluge* series has also greatly influenced the work of 21st-century American sculptor Alice Aycock (1946–), who studies transition and movement in her art.

Designing the Ideal City

Renaissance cities were almost entirely sealed entities. High walls prevented outsider attacks, but along with narrow streets and crowded quarters, they also shut in filth and disease. When a plague swept through Milan in 1484, it claimed about 5,000 to 10,000 lives, necessitating action against future scourges. Leonardo, working under the duke of Milan, Ludovico Sforza, had the idea to rebuild the city and avoid future problems. Once again, he drew on ancient and contemporary ideas about ideal city planning.

Taking from existing architectural principles and styles, Leonardo tied the relationship of building parts to the whole and linked people to a larger rational cosmos. In this way, his architectural designs and city-planning models exemplify the long and short of his life's thought.

Laying the groundwork: Renaissance architecture 101

During the Middle Ages' gothic period, Italy developed architecturally less than its neighbors did. France and England, for example, boasted immense cathedrals and grand architecture. But a new focus on Italian architecture emerged in the 15th and 16th centuries. This Italian revival had some unifying themes that appealed to both reason and emotion.

- ✔ It looked back to ancient Greek and Roman examples, like the Coliseum and Pantheon. Rome didn't fall; it merely tripped, coming back in quite spectacular 15th-century form.

- ✔ It relied on mathematical proportion, symmetry, and geometrical balance to create harmonious structures and spaces, ideas that came from the Roman architect Vitruvius. Columns, arches, domes, pediments, and pilasters reappeared.

- ✔ A new concept of public space reflected civic pride and organization.

These principles became manifested in new types of buildings. More churches and cathedrals cropped up, of course. Two new types of buildings included the *villa* (a country house for the likes of the wealthy and powerful Medicis) and the *palazzo* (a town house within city confines, also for the rich and powerful). By the 15th century, these affairs were impressive inside and out, showing the importance of private and public space.

The big issues

By the 11th century, Milan, Genoa, Venice, Florence, and Pisa had become powerful, rival city-states, each with quasi-independent forms of power. Italy, in fact, wouldn't be unified until 1861. Until then, each city-state needed its own form of government. What *type* of government was a hot topic of the day, and many scholars took up the issue. Leonardo Bruni, the Florentine chancellor who wrote the 12-volume *History of the Florentine People* (published between 1415 and 1444), advocated the small state. Dante Alighieri had disagreed in *On Monarchy* (c. 1313) and then went on to write the more popular *Divine Comedy*. And Leonardo's acquaintance, Niccolo Machiavelli, wrote about political unification in *The Prince,* published in 1515.

Philosophical questions aside, city planners had practical matters to consider.

- ✔ How should one design a city that conformed to the ideals set out by its rulers (the Sforza dynasty in Milan or the Medicis in Florence, for example)?

- ✔ How would it be fortified?

- ✔ What would it look like in terms of civic buildings, productive zones, and housing?

- ✔ How would it reflect the power and wealth of its rulers?

- ✔ Would it impose social divisions?

Designing an ideal city was, as you can see, a complicated affair.

The main men

Architecture back then didn't require years of specialized training, as it does today, so anybody and his mother could submit a drawing for a structure and maybe even build it. Many architects outlined ideal cities in their treatises,

but a few men in particular (one would think women didn't exist!) influenced Leonardo's thoughts:

- **Vitruvius** (first century BC): Considered the first architect and author of the ten-volume *De Architectura* (c. 33–14 BC), the only surviving treatise on architecture, human proportions, town planning, and civil engineering from antiquity. Vitruvius proposed polygonal towns developed from a circle with square or rectangular buildings inside (for optimal ventilation, based on his studies of the human form). His design was so influential that variations of it even found their way into modern American cities, from Savannah, Georgia, to New Haven, Connecticut!

- **Filippo Brunelleschi** (1377–1466): Considered the first Renaissance architect, this Florentine studied ancient Roman buildings. His greatest accomplishment was engineering the dome of the Florence Cathedral (the Duomo, or Santa Maria del Fiore), which historians now consider the start of Renaissance architecture. He embraced proportion, linear perspective, and the classical Doric, Ionic, and Corinthian orders, revolutionizing architecture and creating internal and external visual centers for Florentine civic life.

- **Filarete** (Antonio di Pietro Averlino; c. 1400–69): In his 25-volume *Treatise on Architecture* (1461–64), Filarete envisioned an ideal city, Sforzinda (named after his patron, Francesco Sforza), and a port, Plusiapolis. The city, a circular plan with star-shaped fortified walls surrounding a central tower (like Vitruvius's idea) was a hub for a community with eight streets leading out radially from the center. Its buildings would embrace reason, symmetry, and extravagance, but would have organic forms to ease movement. In *The Lives of the Artists,* the famed biographer Giorgio Vasari called Filarete's treatise "perhaps the most stupid books ever written" (Oxford University Press, 1998). Others, like Leonardo, apparently thought otherwise.

- **Leon Battista Alberti** (1404–72): Drawing on Vitruvius's writings, Alberti touted simplicity as a central virtue, but praised the majestic elegance of ancient Roman architecture. He offered up an ideal city that used walls to divide a city into two separate neighborhoods, according to class and occupation. Wealthier peasants would live in the outer, more spacious circle, while lower-class workers would reside in an inner circle. (Beggars would go bye-bye.) He also designated spaces for men and women and for public and private use. Of course, he was anal about applying exact mathematical and geometric principles to monumental, balanced buildings and rooms.

- **Francesco di Giorgio** (c. 1439–1501): A Sienese painter, architect, and military theoretician, he worked for Lorenzo de' Medici, the duke of Urbino, and wrote an influential treatise on civil and military architecture. Leonardo owned Francesco di Giorgio's book, *Trattato di architettura civile e militare.*

- **Donato Bramante** (1444–1514): Bramante, like Leonardo, worked for Ludovico Sforza in Milan, directed the construction of a major church at

Pavia, and then moved to Rome to work for Pope Alexander VI and the succeeding Pope Julius II to make Rome the empire it had been. His design for the Vatican's Belvedere Court influenced garden design for the next couple of centuries; he also designed (though never completed) St. Peter's Basilica. Again, he embraced classical ideas of unity throughout all his designs.

✔ **Andrea Palladio** (1508–80): The Venetian Republic's head architect, Palladio designed two Venetian churches but specialized in domestic structures, like centrally planned villas inspired by Roman models. He also wrote a highly influential treatise, *I quattro libri dell'architettura (Four Books on Architecture)*. His villa designs, and the idea that structures for the wealthy should rival public buildings and churches, became widespread and are now visible, in various permutations, around the world.

So you see, Leonardo had a good start to his city-planning studies, and not surprisingly, he added a few of his own twists.

Rebuilding Milan: Leonardo's ambitious plan

After a plague devastated Milan from 1484 to 1485, hygiene and sanitation should've been pressing issues. Unfortunately, they weren't; not until the mid-18th century did cities even enact public health laws relating to the disposal of feces! The Italian cities probably weren't proud of their sewage, rotting carcasses, and other disease-spreading waste. Leonardo, in his city-planner's garb, realized that organized planning; better circulation of people, animals, and goods; and the separation of classes (to increase cleanliness — nevermind that even upper-crust Milanese women probably never washed their hair) would improve a city's overall health. He focused on function and practical considerations, often at the residents' behest.

Formulating ideas

Leonardo, who'd already begun his anatomical studies, applied his theories about the blood's circulation through the human body to Milan's reconstruction of its roadways and other transportation routes, once again relating the micro- to the macrocosm. (You can explore Leonardo's ideas about the human body in Chapter 5.) He viewed the city as a living entity, in which the circulation of air and water sparked life. Roads were arteries, the aristocracy the brain, and domes the skulls, for example. And buildings, with their hollows and entrances, doors, and light, resembled the structure of the human body.

Leonardo also picked his colleagues' brains. He applied Alberti's unifying mathematical principles to his plan. He drew from Filarete's dream of Sforzinda and the organic city. He also looked back to Vitruvius, borrowing simple, geometrically harmonious shapes divided even further into simpler shapes. Above all, Leonardo stressed that form should follow function.

Laying out the ideal city

Something old, something new, something borrowed, something blue . . . what, blue? No. Here's how Leonardo outlined his ideal city plan for Milan:

- ✔ **He separated the poor from the middle class and the middle class from the wealthy.** Leonardo imagined a three-tiered city, with the three levels corresponding to the different social classes, just as Alberti had imagined. (Leonardo wasn't a proponent of segregation, per se, just efficiency and function.) The top level would contain opulent homes, spacious walkways, and hanging gardens. Upper classes would live in porticoed palazzi. The middle level would contain mass-produced homes for workers, broad roadways, and canals. And the lowest would have underground waterways for sewage and garbage disposal.

- ✔ **He went straight for the beachfront property.** This ideal city would put down stakes near the sea or large river, such as the nearby Ticino, in order to supply a source of fresh water to the city, transport goods, connect Milan with other cities, regularly flush out the canals leaving the city, and remove waste. Here, Leonardo expressed a newfound interest in hygiene. Waterfront property owners, in an innovative twist, would help maintain the canals. (Milan, incidentally, already had the largest networks of navigable waterways in Italy. Leonardo surely looked at different schemes, including the Martesana Canal, locks at the Naviglio Bereguardo, dams near Pavia, and irrigation works at the Sforzesca.)

- ✔ **He upped the ante for road construction.** As far as movement was concerned, Leonardo called for a double system of wide roads. The upper level would serve pedestrians, and the lower one, vehicles. Staircases would connect the levels, each of which would be flanked by arcades. These stairs would ensure an efficient delivery of goods by boat to the shops at the lower arcade's level.

- ✔ **He gave people their space.** Leonardo, relying on mathematical principles, ordained that buildings should be spaced farther apart than current Milan structures to prevent crowding. In fact, the width of the streets would equal the average height of the houses to create a large enough area for the movement of people. He also noted that the palazzos should have porticoes and large windows on all floors. (Just think of his studies of the veins and arteries of the human body; when they thickened, they blocked circulation, and the patient died. So, too, could some cities suffocate.)

Leonardo's ideal city may have risen like a phoenix, but for some obstacles. His plans would've entailed leveling Milan to the ground and rebuilding it from scratch, a very expensive proposition. So naysayers had their way. On the other hand, Leonardo's city-planning efforts resulted in one of the first major attempts to survey and organize a region for human ends. Had they succeeded, his ideal city would've served as a model for other European cities.

Dreamers, dream on

Leonardo was neither the first nor the last to dream up an ideal city. Some, in fact, actually sprouted during Renaissance times, such as the city of Palmanova, outside of Venice.

Leonardo's plan for Milan was both practical and utopian, just one in a long string of other visionary plans. Some of the most famous utopian philosophers and their experimental towns or colonies include

✔ Robert Owen (1771–1858) and New Harmony, a communal experiment in Indiana that became a cultural and scientific haven.

✔ The Shakers, founded in 1772 as an outgrowth of Quaker religion, built communities in New England.

✔ George Ripley (1802–80) and Brook Farm, an experimental communal farm in Massachusetts in the 1840s (members included Ralph Waldo Emerson, Nathaniel Hawthorne, Margaret Fuller, among others, and most embraced transcendentalism).

✔ John Humphrey Noyes (1811–86) and Oneida, a religious, communal society of Perfectionists in central New York from 1848 to 1881.

Sadly, most, if not all, of the utopian societies have disappeared, though the Shakers have some remnants. But these societies live on in fiction and literature, including in the following texts:

✔ Plato, *Republic* (c. 360 BC)

✔ Sir Thomas More, *Utopia* (AD 1516)

✔ Karl Marx and Friedrich Engels, *The Communist Manifesto* (1848)

✔ Edward Bellamy, *Looking Backward* (1888)

✔ Aldoux Huxley, *Brave New World* (1932)

✔ George Orwell, *Animal Farm* (1946) and his famous dystopic society in *1984* (published in 1949)

Mapmaker, Mapmaker, Make Me a Map

Leonardo drew *maps* as well as landscapes and ideal cities? Yep. He produced most of his cartographic exercises while traipsing through central Italy, the Romagna, with that scoundrel General Cesare Borgia, as his mapmaker and chief military engineer. In some of his maps, Leonardo wasn't an innovator. He followed the tried-and-true style of drawing cities, rivers, and mountains as he saw them; without proper perspective or scale, most fall into the landscape drawing category (see the earlier section "Depicting Nature's Forces: Leo's Landscapes").

Others, however, such as the map of Imola, show revolutionary techniques for the time. The Renaissance revolution in cartography entailed new ideas about perspective and scale; tools such as new surveying discs; the rediscovery (around 1500) of Ptolemy's *Geographi*, written in the second century AD, the first work to attempt to describe the world through maps; and the voyages of discovery.

Don't worry; Leonardo *didn't* invent the first modern world atlas or anything even close to it; that advent didn't happen until a few decades after his death.

Mapping out Imola

By the summer of 1502, after spending a few years in Florence, Leonardo was firmly ensconced as a salaried servant in Borgia's entourage. He first traveled the Tuscan coast, surveying fortifications, draining marshes, and recording his observations and plans in his notebooks. Then he ended up in the Romagna and at the strategic town of Imola, where Borgia set up his winter quarters that included, of all people, Niccolò Machiavelli (author of *The Prince,* which theorized about how to gain and keep power and offered a blueprint for despots).

Leonardo probably drew the map of Imola from scratch, though the possibility exists that he modified it from a map of unknown origin. Either way, the map is certainly one of the most impressive survivors of Renaissance cartography due to its perspective and detail (see Figure 12-3). It may even be one of the first geometric plans and overhead maps of a town.

Figure 12-3:
Town Plan of Imola; c. 1502; pencil, chalk, pen, and wash on paper; 44 x 60.2 centimeters (17.3 x 23.7 inches); Royal Library, Windsor.

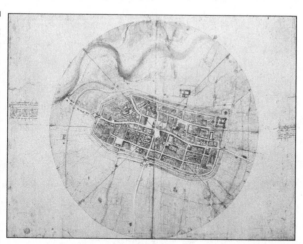

Scala / Art Resource, NY

Leonardo probably drew on Alberti's revolutionary cartography work of the early 1430s. Alberti used a horizontal surveying disc to map out Rome and explained his technique in writings with which Leonardo was familiar. Basically, Alberti mounted a bronze surveying disc at a central vantage point and measured the radial angles of specific landscape features, like a cathedral or mountain. Then he coordinated these bearings with other measured distances in order to produce an accurate plan. (Recording more than one vantage point would establish a network of triangulation, which would then eliminate the need to painstakingly measure more distances on the ground.)

Leonardo apparently took the harder route and measured all the distances of roads, landmarks, and other points in Imola. From the center of his map — a town inscribed in a circle; look familiar? — he radiated 64 evenly spaced lines. Using these lines as guides, he penned in the town's walls, gates, fortifications, homes, roads, villas, and churches. He color-coded these distinct structures in different shades, from dark pink to pale yellow and blue. The precision of the overall surveying, compared, say, to his more impressionistic 1473 landscape of his home (refer to Figure 12-1), makes the *Town Plan of Imola* a truly modern achievement.

Under the Tuscan sun

Leonardo's more-traditional bird's-eye *Map of Tuscany and the Chiana Valley* (also called *Bird's-Eye View of a Landscape*) dates from Leonardo's service with Borgia. Its place and river names — Perugia in the top-right corner, Arezzo in the top left, and Siena at the bottom — suggest its use as a strategic map (see Figure 12-4). Then again, Leonardo may have drawn it as part of his plans to redo the plumbing in the countryside by constructing a canal from Florence to the ocean. In his ambitious mind, a canal would increase the value of the land through irrigation and bring prosperity to the surrounding countryside.

Figure 12-4:
Map of Tuscany and the Chiana Valley, c. 1502, pen, ink, and watercolor on paper, 33.8 x 48.8 centimeters (13.3 x 19.2 inches), Royal Library, Windsor.

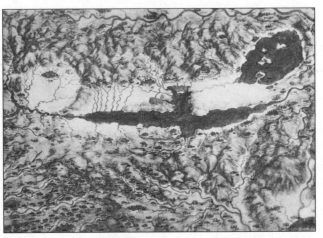

Scala / Art Resource, NY

Dam the lake!

Chiana Valley is the most extensive of all the valleys in the Apennine chain, and people in the olden days considered it the granary of Etruria. When Leonardo surveyed the valley more than 15 centuries later, it again appeared as a lake. (After the fall of the Western Roman Empire, the brutal Gothic Wars depopulated the productive countryside, and the Chiana Valley succumbed to encroaching waters.) In Leonardo's humble opinion, damming Lake Chiana would provide a reliable source of water for a canal all times of year. He also had plans for draining the disease-ridden marshes in the Chiana Valley. But again, Leonardo's plans fell to naught. Land reclamation only started again in the 19th century; today, farm complexes dominate the region.

Looking down on the Italian Coast

Leonardo drew *Bird's Eye View of Italian Coast by Terracina* (shown in Figure 12-5) around 1515 when, in the service of Pope Leo X, he designed plans to drain the Pontini marshes south of Rome.

Figure 12-5:
Bird's Eye View of Italian Coast by Terracina; pen, ink, and watercolor; 27.2 x 40 centimeters (10.7 x 15.8 inches); Windsor Castle.

Alinari / Art Resource, NY

Like his map of Tuscany and the Chiana Valley (see the preceding sections), Leonardo's map of the Italian Coast offers an aerial view of the region's marshes. But in its treatment of the trees, hills, and the foamy coast, it more closely resembles his *Deluge* series, which he penned around this time (refer to the section "Rain, rain, go away: The Deluge series"). Just look at those waves lapping up against the southern tip of coast, ready to spill into the mountains. Here, however, Leonardo was probably more concerned with mapping out locations and topography than depicting the forces of nature.

Place names, written by one of Leonardo's pupils, mark strategic sites and points of interest near the Pontine Marshes. Circeo, a coastal region south of Rome, is now part of a national park set up in 1934 to protect the wildlife in the mostly reclaimed Pontine Marshes. Terracina, an ancient Roman garrison, is now a resort on the West Coast of Italy, between Rome and Naples. The last place, Sermoneta, is an ancient Roman town overlooking the Pontine Marshes, briefly owned and defended by Cesare Borgia.

Imagining Castles, Cathedrals, Churches, and Châteaux

Leonardo, though you can't call him *the* great planner of the day, was involved in many civic improvement projects. On different occasions, he possibly worked with architectural head honchos including Bramante and di Giorgio. Unfortunately, most of his plans never left his notebooks — had they been realized, Leonardo's designs for castles, temples, cathedrals, and chateaux certainly would've changed the Italian skyline.

The domes on the church go 'round and 'round . . .

Renowned architects of the time, such as Alberti, Filarete, and di Giorgio, instilled in their gracious public that a centralized design — a square, circle, or polygon, preferably ensconced in a circle — constituted the most perfect design. This total harmony of design reflected Vitruvius's definition of beauty and ancient Roman temples.

Leonardo followed this trend. He devised all sorts of structures based on a centralized plan, in which all (symmetrical) parts are developed around radii passing through their centers, as in Vitruvian man (see Chapter 5). As Leonardo believed, human geometry and architectural symmetry represent the perfection of the universe.

Modeling the dome of the Milan Cathedral

The question of how to fit a dome onto a square base occupied many of the era's brilliant minds. And Leonardo designed his own sets of domed churches. The dome (a circle) represented the heavens and humans' relationship to God. Around 1488, Leonardo and his carpenter assistant (what, you think he worked alone?) prepared a wooden model for the *tiburio* (a domed crossing tower) to enter the competition for the Milan Cathedral's dome. As he said in his introductory letter to those in charge of the competition, he saw himself as a physician-architect ready to devise a cure for the sick cathedral. He drew an ingenious arch and peppered his plans with drawings

of human legs and skulls to prove his point about the relationship between people and their surroundings.

Rivalry for this commission, which included Bramante and di Giorgio, was ugly. Apparently, however, Leonardo saved himself some possible embarrassment by withdrawing his model before a decision was made. Still, the final design by Giovanni Antonio Amadeo and Gian Giacomo Dolcebuono probably incorporated many of Leonardo and other contestants' ideas — with their permission, of course. Most historians think that the final design was an amalgam of all competitors' plans. And though Leonardo was invited to submit a new design, he never did. Nonetheless, this experience, including his contact with Bramante and other masters, shaped his ideas about the relation of architecture, nature, and humankind. A dome, for example, represented the human skull and hence the key to understanding the heavens.

Examining Leonardo's centrally planned churches

What was a city without a church? Today, that scenario would be like a suburb without a mall. Both in practice and in theory, Leonardo experimented with centrally planned designs for churches. Few were actually built, as these centralized designs met fierce opposition from the more popular *basilical* church (oblong with a large, long central hall), which was already firmly engrained in Renaissance culture.

Although Leonardo experimented with these more traditional basilica-like schemes in his notebooks, he spent more of his energy on a series of centralized designs; see Figure 12-6 for an example of one of his centrally planned churches. These designs envisioned churches with a centralized plan, with apses and chapels radiating outward from the center. Towering domes, reminiscent of Brunelleschi's Florentine architecture (see Chapter 4), cap his symmetrical plans. Leonardo aimed for symmetries obtained by intricate structures of apses, niches, chapels, porticoes, pillars, beams, and arches. Some of his sketches show how ambition overruled reality; a few show enormous domes, double-spiral staircases, and multilevel walkways and roads. In all, he moved shapes around in new ways to build on ancient and contemporary design. Some of these shapes included

- **A circle and a star:** Around 1490, di Giorgio employed Leonardo as a consulting engineer on the restoration of the cathedral at Pavia. In their design, a large circle girdles the polygonal, star-shaped ground plan.

- **Straight lines and a half-moon:** Leonardo designed many variations on the theme of the centrally planned church between 1487 and 1490. He drew most with four equal axes that intersected in the middle and then radiated outward to accommodate varying numbers of chapels. A large hemispherical dome rests on the central drum and smaller ones lie on the radiating chapels. Leonardo drew the decorations, such as the oculus windows, from Brunelleschi's Florentine architecture.

- **Everything in between:** One drawing of a "gemmated" plan shows an octagon as the center church space with eight octagonal chapels

radiating outwards, again connected by passages — all resembling a cut gem or jewel.

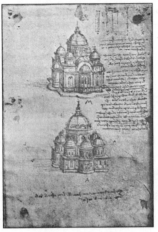

Scala / Art Resource, NY

In his designs for centrally planned churches, Leonardo again applied his understanding of the human body to architecture. His *tiburio* design for the Milan Cathedral, as well as the domes of these churches, resembled the structure of the skulls he so painstakingly drew during these years. He sectioned off his pen-and-paper cranium, for example, along main axes like some of his church designs (refer to Chapter 5 to find out more about Leonardo's anatomical drawings). Proportion, after all, governed everything in life.

Palaces in the air

Leonardo spent the last happy years of his life in the arms (or at least on the grounds) of French king François I at the Clos Luce, a stately manor near the royal castle of Amboise, in France's Loire Valley. Leonardo doesn't seem to have done a whole lot in his final days except construct the amazing mechanical lion with flowers in its chest. But he did, upon François's request in 1517, draw plans for a royal palace on the shores of the Sauldre River, at Romorantin in the Loire Valley.

Leonardo rose above and beyond the occasion. He designed not only a palace, but also what looked like a 16th-century version of a 1950s suburban town. Reviving plans for the ideal city that he developed for Milan in the mid-1480s (refer to "Rebuilding Milan: Leonardo's ambitious plan," earlier), he adapted them to new circumstances. Had Romorantin actually been built, it would've constituted the most revolutionary town-planning concepts in Europe at the time.

✔ Leonardo planned to raise the level of the river so that it descended into Romorantin, supplying water for mills and irrigation.

✔ He designed an early form of prefabricated housing, made of wood and easily transportable (no Tupperware or Frigidaire here).

✔ He planned a complex, star-shaped network of canals that would link the river to the Mediterranean and crisscross the town. Canals would supply water for irrigation, flush out dirty streets, and remove garbage. A large basin for aquatic tournaments and garden fountains would grace palace grounds.

✔ The palace grounds contained an octagonal pavilion for the park, other moveable pavilions when the court wished to move, and an immense stable.

✔ Leonardo planned the palace itself by fusing Italian Renaissance motifs with the French château style. The palace had a rectangular structure, round towers, and classical elements. Leonardo also added what has become his famous double, triple, and quadruple spiraled staircases, returning to the idea of circulation (arteries, for example) as the key to movement and life. In the end, the palace may have resembled Louis XIV's Versailles.

✔ What's a town without people? Leonardo planned to bodily transport people to the new town. All desirable citizens, of course!

Unraveling the double helix

Leonardo based his magnificent double-spiral staircases on a double-helix pattern. A single circular helix is the shape taken when a plane with a straight line (neither vertical nor horizontal) is wrapped around a cylinder, creating a spiral like a corkscrew, wire spring, or twisted ladder. The double helix is — well, two of those corkscrew designs, parallel to each other. Leonardo didn't invent this design; just like the golden mean/ratio, it had been around in architecture for a very long time. (Again, it ties into the symmetry-equals-beauty concept.) It had also been around the block in nature, too.

Take DNA, for example. In 1953 (more than 400 years after Leonardo designed his stairs!),

James Watson and Francis Crick "discovered" the molecular structure of DNA. They also pointed out its double-helix construct (it twists to the right, in case you were wondering, with two polynucleotide strands wound around each other). They won the Nobel Prize for their efforts. Watson's *The Double Helix,* first published in 1968 and now a standard text, popularized these scientific concepts for lay readers. The double helix has also entered pop culture. Star Trek appropriated this name for its series. Designers have adapted this concept to logos, business designs, a pedestrian bridge in Seattle, staircases (duh), and jewelry — a double-helix bracelet, anyone?

Influencing the design of the Château de Chambord?

François I ultimately rejected Leonardo's plans for Romorantin, but he didn't throw the baby out with the bath water. Leonardo's designs indirectly influenced untold numbers of châteaux throughout France. They probably even inspired the architects of the Château de Chambord, although no documentation proves if, or to what extent, Leonardo contributed to its design. Possibly, Leonardo drafted the blueprints, then turned them over to architect Domenico Barnabei da Cortona.

Under François, architects and laborers started to build Château de Chambord in 1519 — as Leonardo gasped for his last breaths. Completed in 1547, it's now one of the most visited châteaux in the Loire Valley. Intended as a retreat for French kings, the grounds contain a château, park, and village. The château, more like a palace, combined medieval and Renaissance features, including a four-towered square *donjon* (the main tower, which also usually contained the dungeon) inside a rectangular four-towered *enceinte* (the fortified area of the building). Four rectangular vaulted halls on each floor form a cross, meeting in the center with a double-helix staircase. It bears striking similarities to Leonardo's Romorantin plans, with its staircase, floor layout, minaret-type turrets, and other elements.

Today, the château contains 440 rooms, 365 fireplaces, 84 staircases, 13 great staircases, and stables for 1,200 horses — all in a park surrounded by a 22-mile wall.

Leonardo possibly submitted his plans to François's architects or contractors, including fellow resident architect Domenico Barnabei da Cortona (Il Boccador), who designed Chambord and Paris's Hôtel de Ville. Yet, like so many of his other projects, Leonardo's ideal town of Romorantin came to naught, nada, nothing. Malaria swept through the region, and the epidemic killed off much of the labor force. Not to mention, Leonardo himself was growing weaker every day, soon to write his last will and declare his faith in God and the church. So François halted the Romorantin plan in 1518 and turned his attention to Chambord, near Amboise.

Rapunzel, Rapunzel: Leonardo's castles

Last, but not least, throughout his life Leonardo designed different castles. I'll just call a spade a spade — they were really fortresses. Again, none saw the light of day. A few of his designs include

> ✔ **A castle with a triple defense system:** This design, dated around 1490, only *looked* like a typical castle. Leonardo added a few innovative elements, including a row of cannons on the jutting stronghold, which defenders could use to attack prospective intruders. He thoughtfully included these grazing fires at points where enemy troops advanced with difficulty, such as the embankment, moat, and path along the top of the wall.

Winding up, winding down, but never shall they meet: Leonardo's famous staircases

Rhett wouldn't have swept Scarlett off her feet on one of Leonardo's staircases. Instead, they literally would've dodged their tormented union. Why? Because Leonardo's specialty was the ingenious double-helix (or double-spiral) staircase, which contains two separate stairways that never meet, although they're technically part of one staircase. The purpose? So that you (as king, of course) wouldn't have to meet the lowly servants on your way up or down. Although no specific proof exists, Leonardo's work possibly inspired the design of France's most famous Renaissance flight: the ingenious double-spiral staircase that winds around a hollow center at Chambord.

To Leonardo, staircases posed the thorny problem of circulation, as well as kept his geometrical and mathematical modeling skills in tune. In addition to his double-spiral staircase, Leonardo also may have designed the unispiraled staircase at the Château de Blois. And speculation exists that he drew plans for the wall of the courtyard stair tower, with an outside staircase that gave users extraspecial exterior views,

much like the escalator tubes do at the Pompidou Center in Paris today. He even added a double-ramp staircase in one of his paintings, the unfinished *Adoration of the Magi* (c. 1481–82; check it out in Chapter 13).

Historically, the stair's traditional clockwise rise related to defense. It gave defending swordsmen an advantage, as the inner wall handicapped a right-hand attacker. These spiral staircases reached their height in 16th-century England and France, so Leonardo was right in the game.

During his day, many architects adapted Leonardo's ideas for emergency situations, as his double-spiral staircase allowed the evacuation of double the number of people on one staircase. But because of their unsafe construction (after all, people tend to take the shortest path up a staircase, often stepping up the narrowest angled steps that have less of a foothold), building-code prohibitions now abound. What a sad sacrifice of beauty for utility!

> ✔ **A mountain castle with two defense *enceintes* (the fortified areas):** This type of mountain castle probably existed in Leonardo's time. But, he upgraded different parts of it, from the ravelin at the base of the castle to the thick *masonry curtains* (the wall enclosing the entire castle or courtyard), to withstand attack.

Leonardo also drew sketches in which he tried to improve on various parts of these fortresses. His ideas include

> ✔ An angular tower with *corbels* (or brackets to support an arch or other large, jutting feature). Again, not much is new here. Leonardo's design contains elements from the Middle Ages (like a *battlement,* a wall inside the castle wall) and the Renaissance (like a massive *tower scarp,* or steep slope in front of the tower). Leonardo hoped his design would repel all enemy aggression.

✔ A curtain with semicircular salients, which embodies Leonardo's work with bricks and arch structures. Old buildings buried arches in the vertical walls; Leonardo tried to apply this same technique to a horizontal plane of projection.

✔ A moat with a submerged defense system, drawn when Leonardo was traveling with Borgia in Romagna.

✔ A ravelin or triangular bastion. Again drawn during his Borgia days, this depiction of a military defense to the entrance to a fortress drew on old designs.

Circulating Classical Ideas Today

Many of the concepts that Renaissance architects pioneered or built upon persist to this very day. Some historians called Renaissance buildings samples of the first modern architecture. Their open, harmonious spaces and focus on internal and external appearance forged a new relationship between people and space. Just look at Thomas Jefferson's Virginia state capitol (1785), based on Greco-Roman architecture, or the neoclassical U.S. Capitol, one of the finest specimens of the continuing classical revival! Certainly, Renaissance architects invented compelling new ideas about the relationship between public space and civic — even national — pride.

Renaissance architects also emphasized the concept of circulation within a city. In their day, architects like Leonardo were dead serious when they compared a city's circulation to a person's heart and lung system. People in this generation may laugh at the seriousness of it all, but modern city planners still use the ideas of circulation, arteries, and choking as apt metaphors for today's uncontrollable megalopolises. (Freeways and city streets offer just one example.)

Although city planners from Alberti to Leonardo theorized about segregation, separating the wheat from the chaff, so to speak, the tradition of social, racial, and economic segregation in cities today still prevails. The Venetian Jewish ghetto of the 16th century offers but one sad example of the increase of separation by race, class, or creed in Renaissance Europe.

But back to Leonardo. Sad to say, this architect left little lasting impact on Renaissance architecture, despite his close association with some of the best architects of the day, including Bramante and di Giorgio. His designs, from Milan's ideal city to his castles, never got their moment of glory. Being a "practicing" architect meant sketching, rather than implementing, his projects. Nor did anyone find his other plans until the rediscovery of his notebooks centuries after his death. Still, in some fields — cartography or landscape painting, perhaps? — he left small but indelible marks. Not as great, perhaps, as with his portraits and religious paintings (which I explain in Chapters 11 and 13, respectively) — but then again, Leonardo was merely an architect and landscape planner on the side. And for that, he wasn't too shabby.

Part V
Leonardo, His Religious Artwork, and *The Da Vinci Code*

"I read *The Da Vinci Code* a few months ago. I'll never look at the *Mona Lisa* again without thinking about the *New York Times* Best Seller List."

In this part . . .

This part explores how Leonardo transferred his ideas about Catholicism to his religious scenes, from *Adoration of the Magi* to his famed *Last Supper*. Then it corrects the fallacies about Leonardo, Renaissance art, and Catholicism posed by Dan Brown's bestseller, *The Da Vinci Code*. If you believed every word of it, it's time to turn the page!

Chapter 13

Getting Religion: Leonardo's Religious Beliefs and Paintings

Most Renaissance painting was religious in nature, even if artists had begun to incorporate pagan and allegorical elements. Like his counterparts, Leonardo seems to have favored some rather elusive sitters: Madonna and her relatives (like St. Anne), Jesus, St. John, St. Jerome, other saints, and a host of unearthly angels. He produced many paintings, sketches, and drawings on Christian themes such as the Annunciation, striving to capture a heartfelt, emotional story rather than simply depict its main cast.

Ranging from simple pyramidal figures to elaborate allegorical scenes (and still centuries away from photography!), Leonardo above all tried to naturalize his subjects and show the tender emotions among his sitters, if you will, unlike some of his contemporaries' highly figurative paintings. As a result, most of Leonardo's religious paintings have an emotional sensibility that far surpassed his colleagues' same renderings. Not to mention, of course, that Leonardo used his pioneering techniques (including chiaroscuro, sfumato, contrapposto, oil paints, and so on; see Chapter 10) to enhance this realism. Although many of his religious paintings were way ahead of their time in terms of both style and substance, many still incorporate traditional Christian motifs and symbols.

In this chapter, I paint Leonardo's role in the grand scheme of religious and scientific Italy.

Goin' to the Chapel . . . or Maybe Not: Leonardo's Views on Religion

Leonardo experienced the unfortunate challenge of being a man of reason in an age of religious fervor. Science was heresy in some parts; Catholicism meant towing the line. Leonardo didn't like either option. Unfortunately, though he left plenty of thoughts on other subjects, like flight, scythed chariots, and mathematical perspective, he left fewer musings on religion, leading to an incomplete portrait of his religious beliefs and practices.

Bucking church practices and Christian norms

Assuming, like most historians, that Leonardo was Catholic, people are still in the dark about how much Leo embraced the religion. According to Giorgio Vasari, Leonardo's biographer, Leonardo was a heretic who elevated scientific knowledge and reason over Christian faith. Point taken. After all, didn't Leonardo's dissections contradict the teachings of the church? Didn't his experiments with flight intend to elevate humankind to God's level, or even higher? And didn't his studies on the eye, vision, and perspective *prove* that people are masters of their observations, experiences, and hence their individual fates?

As far as church practices went, Leonardo clearly disdained many elements of traditional Catholicism. He believed that priests were corrupt charlatans who hoodwinked the True Believers. Many priests, he wrote, were hypocrites who "will abandon work and labor and poverty of life and possessions, and will go to dwell among riches and in splendid buildings, pretending that this is a means of becoming acceptable to God." Furthermore, Leonardo protested against many church practices, which he considered only symbols of this stunt: the sale of indulgences and emphasis on money, mandatory confession, the cult of saints (and sainthood), and the pomp and circumstance of praying before God and a few sordid statues of a dying Christ. (For a complete look at the role of religion and the Catholic Church during the Italian Renaissance, refer to Chapter 2.)

Leonardo was just a few years too early to reap the full benefits of the Reformation's major Church cleanup, but he may have caught some whiffs of the changing tide. After all, the Renaissance *was* the time when humanism, emphasis on the individual, and new reliance on classical texts challenged the power of the church. (The widespread introduction of printing during Leonardo's day hastened these sentiments.) At the same time, the religious and political reformer Girolamo Savonarola's fanatical reign over Florence in the late 1490s — and his condemnation of paganism and the corrupt papal court — probably planted more seeds of religious doubt in Leonardo's head.

Sporting the yarmulke: Was Leonardo Jewish?

Rumor has it that Leonardo's mother, a possible Caterina, was Jewish (a slave, even, from a Middle Eastern country). In Jewish law, Leonardo would've been Jewish as well. According to this theory (which a few scholars have articulated), Leonardo, raised in his father's household, embraced a Jewish-inspired humanism (the concept of free will in particular) and possibly turned to Christian dogma later in life.

Of course, according to the Catholic Church, being Jewish would've made him a heretic — not a good idea, given the deadly practices of the Inquisition. As proof of their charges, they could point to the fact that Leonardo never did draw or paint the bloody Crucifixion scene, as all good little artists of the time did, now did he?

Piecing together his philosophy

Leonardo's opposition to the church's reach into secular affairs didn't mean that he was agnostic or atheist. He just viewed God differently, and he embraced religion as a nature-combo mix, mutually inspiring and transforming.

Leonardo called God the *primo motore,* the first mover, the main creator, the head honcho, "the Light of all things," who designed everything more perfectly than any human, our man included, ever could. Instead of seeing God up there and people down here, as Catholicism would have it, he saw God in everything around him. Donning the hats of an artist, anatomist, architect, and more, Leonardo discovered God's presence everywhere — in the beauty of light and shadow, in the rushing wind and rain, in the human body's complex bone and muscle structure, in harmonious architecture, and most of all, in the human soul.

Although Leonardo saw God as the *primo motore,* he assigned the world's functioning to natural law. He attributed the birth (and death) of everything he saw to nature, including human souls. In fact, he believed that the greatest function of the human world is to understand the natural world. In this respect, he differed from some of the great Florentine humanist scholars of the day, including Marsilio Ficino. These guys believed that the human mind and soul occupy a divine realm, and that the truth resides in this mystical, abstract sphere. (See Chapter 3 for the scoop on humanism.) Leonardo criticized this rather hazy view of truth, because it lacked any shred of objectivity.

Clearly, though, Leonardo wasn't 100 percent sure about the soul, even though he tried to work it out in his anatomical drawings. He left some of the soul's workings "to the imagination of friars, those fathers of the people who know all secrets by inspiration," and called the Bible the "supreme truth."

Returning to the faith?

No evidence shows whether or not Leonardo was a practicing Catholic. From the limited information available, people today can assume he wasn't. But at the end of life, as he lay dying in the lap of luxury in the home of French king François I, Leonardo turned to religion one more time. Soliciting advice about how to die as a good Catholic, he apparently confessed and received the holy sacrament at his death (according to his biographer, Vasari, anyway). Yet, it's possible that Leonardo was, in this instance, bowing to convention. For he called death the "supreme evil" and nowhere expressed a belief in life after death. In fact, it seems that he had no clue as to where the soul went after death — so there you have it. He probably *was* a damned man, after all.

Leonardo thus pieced together a religious philosophy that relied more on respect for all life than on constant supplication before God. He practiced vegetarianism, after all, released caged birds from the market, and spoke out against war. Less specifically, he embraced a holistic view of the universe, forging a personal cosmology that placed himself within a larger relationship to spirituality and nature — leading him, of course, to defy the church with his vast scientific studies in order to find this larger relationship. A Catch-22, no?

Universalizing the Language of Religion: Christian Iconography

Christian *iconography* — the representation of a religious theme, event, or idea in art — has been around almost forever. At least since the Roman catacomb frescoes painted in the early years of the Christian era, anyway. In iconographic art, all scenes, from the Madonna and Child to Abraham and Isaac to St. Jerome in the wilderness, serve distinct functions. As a universal language, icons intend to direct you (yes, *you*) to the moral aims of the Christian religion, educate you if you've forgotten some key concepts since Sunday school, and establish a relationship between yourself and God. Look at a painting, keep up the faith! It's that simple — especially if, like many Renaissance residents, you couldn't read.

Understanding Renaissance iconography

The Renaissance marked a shift in the use of traditional religious iconography. Neoplatonist and humanist ideas were translated into *allegorical images* (images that underscore some hidden spiritual or moral meaning) drawn from ancient Greek or Roman mythology. Examples include Leonardo's *Leda*

and the Swan, which I discuss in Chapter 10, and Sandro Botticelli's *Birth of Venus,* reproduced in Chapter 4. Even without the heavy dose of religion, these allegorical paintings had straightforward moral messages: Be good, be kind, be virtuous, blah, blah, blah. They were also big among the Neoplatonists because allegorical paintings could safely depict nudes (a taboo subject in religious Church art); nudes (the goddess Venus, for example) offered links to the classical past. Renaissance artists, dying to show off their knowledge of the human form, jumped at the chance to paint nude figures — hence one of the reasons for the popularity of allegorical paintings.

In part, this shift in iconography stemmed from the new demands that Renaissance patrons put on their artists. Religious art, previously commissioned by the church, was now a commodity for wealthy homes. Not all patrons were religious, so secular themes (in this case, classical, pagan themes, including nudes) began to sneak back into art. What a run for a patron's money — moral allegory *and* naked women, all wrapped up in one!

Comparing Leonardo's iconography

Leonardo, unlike some of his contemporaries, stuck more closely to more traditional religious themes at his patrons' requests. At the same time, he dumped some conventional icons and styles for new ones, which reflected his questioning of Catholic practices *and* his belief in the sublime creations of God. Scholars who believe that Leonardo was Jewish (see the corresponding sidebar, earlier in this chapter) chart his rejection of Christian credo through his changing use of icons in his religious paintings. Consider these points:

- His art did away with the flashy gold paint that marked many earlier Renaissance paintings.

- In many instances, he eliminated halos, showing, perhaps, some Reformation tendencies.

Leonardo nonetheless incorporated many tried-and-true symbols — listed in Table 13-1 — into these works.

Table 13-1	Religious Symbols in Leonardo's Work
This Object	*Symbolizes This Idea*
Halo	Divinity for the person wearing it; originally a pagan, Buddhist, and Hindu (basically, not a Christian) image; also called a *nimbus.*
Cross	Pain and suffering; initially not an early church symbol; by the third century, it had become a symbol of conquest and death.

(continued)

Table 13-1 *(continued)*

This Object	Symbolizes This Idea
Vine	Christ, youth, and eternal life; birds flying in and out of vine leaves symbolize souls.
Lily	As a symbol of Mary, the lily (sometimes represented by the fleur-de-lis) represents her virginity (and purity in general). As a symbol of Christ's death and resurrection, it represents death and rebirth (a lily comes from a bulb, which dies, decays, and then regenerates into a new flower).
Daisy	The naivete and innocence of the baby Jesus.
Rose	Hope, joy, beauty, and the coming of heaven and the return of Christ (the prophet Isaiah prophesied that roses would bloom in the desert).
Lion	Courage; supposedly, the lion sleeps with one eye open and uses his tail to destroy his tracks and escape hunters. So, too, did Christ hide his glory from his enemies.
Snake	Sin, temptation, and the Fall, often representing Satan.
Ox	Strength, patience, and sacrifice.
Fish	Christ; the fish played a major role in the Gospels.
Lamb	The lamb of God, Christ, representing humility, patience, and sacrifice.
Dove	Purity and peace; when depicted with a halo, the dove represents the Holy Spirit of the Trinity.
Other birds	St. Francis of Assisi's preaching to the birds.
Rocks	Permanence, safety, protection.
Triangle shape	The *Trinity* (God, Jesus Christ, and the Holy Spirit), in shape, composition, and form

Singing a New Tune: Leonardo's Angels

Everybody has to start somewhere, and Leonardo was no exception. He cut his teeth on a couple of angels while apprenticing in Andrea del Verrocchio's studio and while working as a more-or-less independent painter. Leonardo's early angels differentiated his artistic skills from those of his contemporaries.

Baptism of Christ (c. 1472–75)

Baptism of Christ is the quintessential example of workshop production. It reveals a notable difference in styles and methods, from the iconographic design and preliminary drawings to the painting and the corrections by other artists. The monastery church of San Salvi in Florence commissioned this painting around 1470 in Verrocchio's workshop. When it was completed, Leonardo, though independent, was probably still working with his former master.

The painting reveals traditional religious iconography. It depicts St. John the Baptist pouring water over Christ's head. (Get it? It's a baptism.) A dove (a form of the Holy Ghost) and the outstretched arms of God, shattering golden rays downward, form the upper part of the painting. Two small angels, holding Christ's clothing, kneel to his right. The rocky outcrops and the fluid motion of the streams and hills symbolize the cosmic synthesis of permanence and regeneration.

In Figure 13-1, note the angel kneeling in front, on the far left. That figure is the work of none other than Leo.

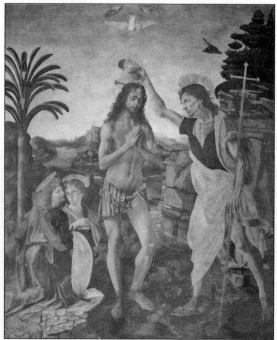

Figure 13-1: *Baptism of Christ,* oil and tempera on wood, 1.8 x 1.5 meters (5.8 x 4.9 feet), Uffizi, Florence.

Scala / Art Resource, NY

Vasari reported that Andrea del Verrocchio, the master artist under whom the young Leonardo worked, did most of the work on *Baptism of Christ*. He also noted that Leonardo, only around 20 years old at the time, painted a far superior angel to Verrocchio's. And Verrocchio's shame at being bested by a pupil, according to Vasari, explains why he never picked up a paintbrush again.

Compared to the angel on the right (possibly painted by Botticelli), Leonardo's angel looks natural and engages with his surroundings. In fact, Leo chose an extremely difficult pose: the three-quarters pose, which allowed him to depict a turning figure. X-rays of the painting reveal that Leonardo improved on the angel in Verrocchio's original sketch. Leonardo also painted his winged friend in oil, which allowed him to blend colors better than with the traditional egg tempera used throughout the rest of the painting. It also enabled Leonardo to apply thin, very fine layers of paint, which created a luminous effect. Even at a tender age, Leonardo was clearly charting his own path.

Annunciation (c. 1472–75)

Two versions of Leonardo's *Annunciation* exist. In the panel shown in Figure 13-2, the angel Gabriel (a common figure to Christianity, Judaism, *and* Islam) appears before Mary to inform her of her imminent motherhood. (Note Mary's three-quarters profile, which represents a new development in Renaissance art.) The Madonna lily symbolizes purity and virginity.

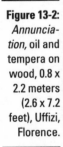

Figure 13-2: *Annunciation,* oil and tempera on wood, 0.8 x 2.2 meters (2.6 x 7.2 feet), Uffizi, Florence.

Scala / Art Resource, NY

Like most of Leonardo's paintings, historians don't know the definite authors of either of the two paintings. The one in the Uffizi (refer to Figure 13-2) is probably Leonardo's, though Domenico Ghirlandaio won the fame until the late 1860s. (It may also have been another example of studio production —

that is, produced by a workshop of painters rather than one particular artist.) After much debate, experts agree that Leonardo had a hand in this version, probably with the angel. Compared to the *Baptism* angel (refer to Figure 13-1), this one shows more thorough modeling and molding; Leonardo probably shaped the wings after a bird's wings. Although the quality may vary throughout the painting, the work nonetheless reveals a sweetness and unity of depth and light that were virtually unknown at the time.

One of Verrocchio's apprentices, Lorenzo di Credi, may have painted the Louvre version, though parts (the angels' wings, for example) resemble Leonardo's style. Still, experts disagree about if — or how much — Leonardo contributed to this work. Some elements, including the flowers and drapery, show di Credi's rather than Leonardo's hand.

Neither version of this painting receives the rave reviews that the *Mona Lisa* or *The Last Supper* do. Leonardo *was* young, perhaps a little over 20, and still inexperienced compared to the painter he later became. Experts consider both paintings comparatively amateurish in their figure placement and per- spectives. In the Uffizi version, shown in Figure 13-2, the Virgin's right arm is rather long and is placed on a lectern that sits closer to the viewer (you) than she does. If the background or overall perspective isn't quite convincing, you must remember that this painting — still considered a masterpiece — may have been Leonardo's first independent work. Bravo!

Multiplying Madonnas

As a whole, Leonardo's Madonna gals aren't as well known (or acclaimed) as, say, the more distinguished *Mona Lisa.* They nonetheless set a new standard for the genre, and artists copied them profusely back in the day. Most of Leonardo's Madonnas, like the beautiful (and perhaps not so beautiful?) women he painted in his day, reveal his trademark style:

- ✔ Their faces radiate inner emotions, from joy and tranquility to mystery.

- ✔ Both Madonna and Child are anatomically correct, from their hairlines down to their fingernails.

- ✔ They exhibit Leonardo's pioneering sfumato, chiaroscuro, and contrap- posto techniques (defined in Chapter 10).

Judging from his Baby Christ figures, which he painted over a few decades, Leonardo probably used only one baby model. For obvious reasons, the real one wasn't available. So Leonardo probably picked one baby, sketching him multiple times and from different angles and regurgitating his sketches as necessary.

Madonna with the Carnation (c. 1475–80)

Leonardo, if he really painted *Madonna with the Carnation* (also called *Madonna with the Vase* and *Munich Madonna*), probably did so while working with Verrocchio. Historians generally consider this work to be the earliest existing painting done by Leo's lonesome, even if others had a hand with the details. The figures' soft facial features, rich drapery, and mountain scenery suggest Leonardo's hand.

As he did in many of his early paintings, Leonardo looked to Flemish painters for inspiration, particularly in the detailed landscape and religious symbols. The flowers and crystal vase, for example, represent Mary's chastity; the carnation symbolizes both the passion and a mother's undying love for her child.

Madonna Benois (c. 1475–80)

Madonna Benois (also called *Madonna with a Flower* or *Benois Madonna*), shown in Figure 13-3, is *probably* an authentic Leonardo. It takes its name from a former owner, the 19th-century artist Léon Benois, who sold it to Tsar Nicholas II of Russia and the State Hermitage Museum (simply called the Hermitage) in 1914. But no record of a commission for it exists.

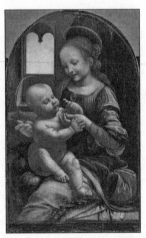

Figure 13-3: *Madonna Benois,* oil on canvas (transferred from panel), 48 x 31 centimeters (18.9 x 12.2 inches), Hermitage, St. Petersburg.

Scala / Art Resource, NY

Madonna Benois is one of Leonardo's less popular gals. Critics decry her bald forehead, puffy cheeks, bleary eyes, toothless smile (okay, she *has* teeth, but they're kind of dirty), girlish face, and the utter lack of landscape behind her. Only Mary's obvious affection for her rather indifferent-looking son shines

through — although the flower of the *Cruciferae* family suggests his ultimate fate. Leonardo simply may never have finished the painting. Still, it shows some of his hallmark style, including his contrapposto and chiaroscuro techniques (see Chapter 10). And by ditching the obvious halos (they're thin lines here), gold ornaments, and loud-mouthed angels, Leonardo depicted the divine mystery by rendering an emotional, heartfelt bond between mother and child. This Virgin and Child may look relatively immature compared to Leonardo's other paintings, but their tender gazes signified a new form of emotional expression in Renaissance art. In this respect, he was ahead of his time.

Madonna Litta (c. 1490)

Leonardo probably played at least some role in the *Madonna Litta*'s composition; see Figure 13-4. He possibly drew the heads and helped out his pupil Giovanni Antonio Boltraffio by smoothing over the awkward composition and harsh figures. The *foreshortened* composition (conveying a sense of depth and three-dimensionality by using receding lines or angles to make the nearest part of an object appear bigger than the rest, which then recede into the distance) also shows Leonardo's hand. Note the lack of a halo — a divine frame some critics say he omitted to suggest the secularization of the Jesus story and focus on its emotional impact.

Figure 13-4: *Madonna Litta,* tempera on canvas (transferred from panel), 42 x 33 centimeters (16.5 x 13 inches), Hermitage, St. Petersburg.

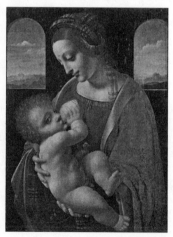

Scala / Art Resource, NY

Not a favorite among critics, *Madonna Litta* is considered one of Leonardo's more awkward ladies. Overall, this Madonna lacks his other girls' spark, though the painting was popular at the time. The Hermitage acquired this piece in 1865, after Russian Emperor Alexander II dispatched the director of the Hermitage to Milan to examine some of the paintings in Count Litta's gallery, including *Madonna Litta*. And then the emperor purchased it, of course.

Virgin of the Rocks

In 1483, Leonardo received a commission to paint an altarpiece for the chapel of the Immacolata at the church of San Francesco Grande in Milan. The painting would be a division of labor typical of workshops of the day: Leonardo planned to do the center panel; Evangelista de Predis would gild, color, and retouch; and Ambrogio de Predis would produce the side panels. The de Predis brothers worked in Ludovico Sforza's court in Milan, studied under Leonardo, and collaborated with him on occasion. Finally, woodworker Giacomo del Maino would build the framework and then assemble all the pieces into a tiny temple.

Leonardo had a tight deadline: the Feast Day of the Immaculate Conception on December 8, when church leaders would lower the painting mechanically for all to see. But when he failed to meet the deadline, two long and nasty lawsuits ensued. Leonardo eventually *did* finish the painting, but possibly gave it to French king Louis XII as a thank-you for settling the lawsuits. Leonardo didn't get any cash for the first painting, and he agreed to do a second and deliver it *on time*.

The end result? Leonardo painted two versions of *Virgin of the Rocks* (also called *Madonna of the Rocks*). Both depict the idea of the *Immaculate Conception* (the notion that Mary conceived Christ without having sex first!), an oft-debated topic in Leonardo's time, and stories concerning the young St. John the Baptist. Although both versions show essentially the same event — a young John the Baptist, who's running away from Herod's massacre of innocents, pays homage to the baby Jesus — the two paintings have some important differences.

The first go: Virgin #1

Leonardo imbued this religious allegory, featuring Mary, an infant St. John, an infant Christ, and an archangel, with many symbols. In fact, the subject was rather unusual to begin with; few paintings portrayed both Jesus and St. John as infants, and nowhere in the Bible do John and Christ appear together as children. In the first rendition (see Figure 13-5), a baby Jesus meets an infant St. John the Baptist, who blesses him.

Leonardo's technique and the symbols he used tell a story on their own:

- ✔ Leonardo's use of deep, contrasting shadows suggests that those people shrouded in the dark were rather unenlightened, while those cast in light possessed revelatory powers.

- ✔ The dark cave offers the painting a mysterious quality. It may represent knowledge, or, according to legend, it perhaps symbolizes how a mountain opened up to shelter the holy family. The distant rocks represent a spiritual world.

✔ The columbine beside the Virgin's face shows love for the Holy Spirit; Saint-John's-wort symbolizes martyr's blood, and the ivy represents chastity and fidelity. The palm in the foreground evokes peace, and the blood-red anemone, the flower of death, prophesies the Crucifixion. Leonardo also copied the plants directly from nature instead of from books, as most artists did at the time.

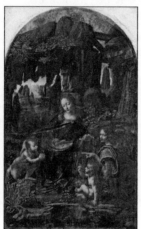

Figure 13-5: Leonardo's first version of *Virgin of the Rocks*, c. 1483–86, oil on wood, 2 x 1.2 meters (6.5 x 4 feet), Louvre, Paris.

Réunion des Musées Nationaux / Art Resource, NY

Despite relying on traditional symbols, Leonardo ditched the halos and gold leaf, which he saw as superfluous, as well as all the chubby cherubs that would've gleefully flown overhead. Overall, the painting succumbs to a rather chaotic landscape, deep contrast, and an air of mystery. Nonetheless, its balanced, triangular figures lend it great harmony.

Try, try again: Virgin #2

Unlike the first, Leonardo's second version of the Virgin, shown in Figure 13-6, may have been less Leonardo and more de Predis. Despite its questionable authorship, historians consider it a more-mature work. Note the different details from the earlier version, including the lack of color and the use of shadows and symbols.

This version differs considerably from its Louvre counterpart in the following ways:

✔ **Its depiction of the waters:** Here, they're flowing in the background, through the cave, more forceful and vibrant than in the original.

✔ **The inclusion of St. John's reed cross and the presence of halos:** An unknown artist probably added the cross and halos at a later date.

- ✔ **The angel's lack of sexuality:** In the first version, she's female; here, the angel is androgynous.

- ✔ **The lighter drapery:** Mary's medium-blue garb creates greater contrast with her dark, cavelike surroundings and reveals her girlish figure a bit more.

- ✔ **The quality of the children and background:** The relatively dull, flat children and the dark background are obvious indications that others besides Leonardo had a hand in painting.

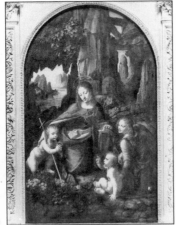

Figure 13-6: The second version of *Virgin of the Rocks,* c. 1495–1508, oil on wood, 1.9 x 1.2 meters (6.2 x 3.9 feet), National Gallery, London.

Alinari / Art Resource, NY

In 1508, this version made it to its destination, the chapel of the Immacolata at the church of San Francesco Grande in Milan. After some European sojourns, it entered the National Gallery in London in 1880, where the de Predis's two side panels of musician angels joined it in 1898.

Madonna with the Yarnwinder (c. 1500–10)

Leonardo painted *Madonna with the Yarnwinder* (also sometimes called *Madonna of the Spindle* or *Madonna with the Distaff*), shown in Figure 13-7, for Florimand Robertet, Secretary of State for Louis XII of France. The original is lost, though two slightly varying copies exist — probably in Leonardo's hand, or at least from his workshop.

The painting symbolizes the Passion of Christ. The baby Jesus grasps at a cross-shaped yarnwinder (used to wrap yarn), which represents his future death. His mother, meanwhile, tries to yank him away from this fate — but how unsuccessfully!

FAST FORWARD

All dressed up, but nowhere to go

On August 27, 2003, a thief (or group of thieves, last seen in a white Volkswagen; noticed them?) made out of the Drumlanrig Castle in Scotland with *Madonna with the Yarnwinder,* which had been in the Buccleuch family's possession for about 250 years. At first, the Scottish police thought that professional thieves had stolen the fine lady for a wealthy collector. Later, they believed that opportunist thieves (who may still have it) stored and ditched her somewhere — for the single reason that they have no clue what to do with her! Selling *any* stolen Leonardo, which could potentially fetch millions of dollars in the open market, is pretty much impossible.

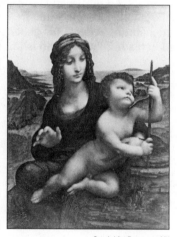

Figure 13-7:
Madonna with the Yarnwinder, oil on wood, 48.3 x 36.9 centimeters (19 x 14.5 inches), private collection.

Snark / Art Resource, NY

He created a pyramidal form of Jesus, his mother, and the rocks they sit on. If you look closely, you see contrasting triangles (such as the Madonna sitting against the V-shaped mountains, rocks, and water in the background). And, once again, both figures possess an inner beauty and tenderness that radiate from their faces.

Other Biblical Folks

You've seen the angels; you've seen the Madonnas (if you read the earlier parts of this chapter, of course). Pretty, aren't they? Unfortunately, many of Leonardo's other biblical folk lack their grace, their sweetness, and their charm. Still, like them, Leo's renderings of St. Jerome and St. John tell important stories through allegory and symbols — as well as, of course, confirm his own painterly expertise.

St. Jerome (c. 1480–83)

Remember St. Jerome's scandalous dreams about young Roman maidens, his lonely travels through the Syrian desert before returning to Bethlehem, his fasts, his friendship with a lion, and his loyalty to Christ? According to the most famous of these stories, a wild lion with a thorn caught in its paw approached St. Jerome. While everyone else ran away, St. Jerome healed the wound, and the now tame lion remained with him forever after — as a kind of spiritual pet.

The feeling is all here, rendered in a half-completed painting (see Figure 13-8). All this emotion, plus *St. Jerome* is the real thing, a Leonardo whose authorship historians have *never* questioned.

Leonardo probably painted the unfinished *St. Jerome* (also known as *St. Hieronymus*) for the altarpiece for the Badia in Florence, when he was just starting to establish his reputation. The painting reflects his general melancholy at the time, sentiments recorded in his notebooks, and is unequaled in its emotional expressiveness.

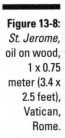

Figure 13-8:
St. Jerome,
oil on wood,
1 x 0.75
meter (3.4 x
2.5 feet),
Vatican,
Rome.

Scala / Art Resource, NY

Leonardo chose to represent the saint as an ageless, bare-boned, and generally sunken figure, beating his breast with a stone and gazing at an invisible Christ. Despite the sorry theme, Leonardo revealed his masterful knowledge of bones, tendons, muscles, and skin. His use of contrapposto, chiaroscuro, and foreshortening also suggests his mature (and scientific) style (see Chapter 10 for the details). The dark tones around the saint produce volume; a lighter background creates a sense of depth. And the lion? Probably drawn

Piecing it back together

It's amazing that *St. Jerome* is still in one piece. After it mysteriously disappeared, someone chopped it into two pieces: one for use as a tabletop, the second for a stool. In 1820, Joseph Cardinal Fesch (an uncle of Napoleon Bonaparte) recognized the table painting, bought it from a junk shop in Rome, and then, a few years later, found its counterpart. The two pieces were reunited, though if you look closely, you can still see the cutout section around St. Jerome's head.

from nature — just look at that tail! (Did they have zoos back then?) Above all, Leonardo showed how to use light and color to portray a scene's inner drama.

St. John the Baptist (c. 1513–16)

Leonardo had very few possessions when he died, but *St. John the Baptist*, shown in Figure 13-9, was supposedly one of them. It remains one of his most copied (if controversial) paintings. This painting, the last Leonardo probably ever produced, boasts his mysterious trademark smile.

Figure 13-9: *St. John the Baptist,* oil on wood, 69 x 57 centimeters (27.2 x 22.4 inches), Louvre, Paris.

Erich Lessing / Art Resource, NY

Once again, some historians debate about the authorship, though X-rays of the painting taken in the mid-20th century suggest Leonardo's artistry. Art gurus often criticize St. John's rather androgynous features (check out that soft arm, gentle face, and luscious curls!), but these features conform to the character type of the protégé that Leonardo set out in his *Treatise on Painting.* The painting has no real background, possibly in an attempt to

St. John as Bacchus

Leonardo (or one of his students, such as Cesare da Sesto or Franceso Melzi) painted another rendition of St. John in the form of Bacchus, the classical god of wine (c. 1510–15, Louvre). He (whomever) used *St. John the Baptist* as a model. Crowned with a laurel wreath and donning a panther cloak (added in by another artist), St. John holds a bunch of grapes and points to a spring. Here, Leonardo or Melzi or some Lombard painter meshed pagan elements and traditional religious themes; the consumption of wine may have led to greater contemplation of God's glory. Now that makes sense, doesn't it? Yet, despite the symbols, *Bacchus* evokes an emotional response rather than recounting a linear story — a theme that was fast becoming a Leonardo trademark.

focus on the spiritual side of the matter. St. John nonetheless emerges radiant from the darkness, with a pointed finger that denotes the coming of Christ. This contrast is typical for Leo, though the lack of background isn't. Regardless, someone else painted the reed cross and animal skin, as X-ray examinations later revealed.

The pointing finger in this painting has been copied ad nauseum; didn't they know back then how rude it is to point? But in his defense, St. John *does* boast that special *Mona Lisa* smile . . . and you know what that means. Another mystery waits right around the corner.

Other Religious Paintings

Leonardo's other religious paintings again range from simple human compositions to elaborate allegorical scenes. Spanning decades, they chart his evolution as a painter, showing his experimentation with perspective, composition, and religious and allegorical symbols. He didn't get everything right the first time around, as the perspective in *Adoration of the Magi* shows. But practice makes perfect — or near-perfect, anyway — and all show unsurpassed technical mastery for the era.

Adoration of the Magi (c. 1481–82)

In 1481, the monastery of San Donato a Scopeto, just outside of Florence, commissioned an adoration scene for its high altar. Historians consider *Adoration* Leonardo's most important early painting and, indeed, one of his (and the quattrocento's) greatest (see Figure 13-10). For the first time, he showed his hallmark method of organizing his subjects into a pyramidal

shape that draws viewers' eyes to the Virgin and Child. The painting also represents a bridge between his apprenticeship under Verrocchio and his artistic independence.

Figure 13-10:
Adoration of the Magi, oil on wood, 2.4 x 2.5 meters (7.9 x 8 feet), Uffizi, Florence.

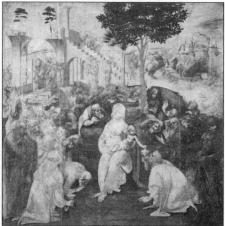

Scala / Art Resource, NY

The *Adoration* scene shows the moment when the second king (one of the three magi) offers his gift of frankincense (sap from the tree *Boswellia*), a symbol of the Eucharist, to the baby Christ. In its largest sense, the *Adoration* depicts the fall of the pagan world. In the background, for example, the stairs of a decrepit palace denote pagan ruins — and the downfall of paganism after Christ's birth.

In various sketches, Leonardo included traditional iconography (the palm symbolizes peace, the carob tree marks Judas's hanging), yet he seems to have slowly abandoned some of the more traditional elements in the final version:

✔ Balthasar, one of the magi, usually wears all black, and all three usually don oriental decorations, like colorful turbans and jeweled crowns. Instead, Leonardo painted three identical old men, weary and modestly clad.

✔ Leonardo sketched a huge group of people (and some animals, including oxen, horses, and a camel) approaching the Virgin and Child. He spent years working on their poses, drawing naked people first so he could get them anatomically correct in the final (albeit uncompleted) version. In the final, however, a lone shepherd boy stands to the far right; this figure is perhaps the only self-portrait Leonardo ever added in any of his works, as was common at the time.

✔ A sketch of a camel, which denotes patience and perseverance (and in ancient times, royalty), became men on horseback attacking each other.

Breaking the contract

Leonardo's contract with the monks of the San Donato a Scopeto monastery stipulated that he was to finish *Adoration of the Magi* within 30 months, with the monks offering Leonardo payment in the form of some land they inherited and a bit of money. He'd get nothing if he didn't deliver the altarpiece on time. But Leonardo departed for Milan before he completed the altarpiece — and didn't come through. (Years later, the monks called in Filippino Lippi to produce a new painting, which he finished in 1496.)

Although he completed many, many sketches of all parts of the scene, all that remains of Leonardo's original work today is a brown ink and yellow ochre groundwork.

Adoration of the Magi is by no means perfect; the Virgin and Child sit a little too close in the forefront, for example, and the crumbling stairs hunker too far back. Still, historians consider it a masterpiece for one reason or another: Leonardo distinguished himself from his colleagues with his pyramidal grouping of figures, contrast between light and dark, use of perspective, and depiction of emotionally wrought figures.

Burlington House Cartoon (c. 1499–1500)

For his wife's birthday, French king Louis XII wanted Leonardo to produce a large painting of the Virgin and Child with St. Anne and a young St. John. Leonardo apparently started the painting around 1508, but sad to say, never finished it. All that remains of his design is a *cartoon,* or preparatory study meant to be transferred to a canvas (see Figure 13-11), as well as some sketches. Leonardo was supposedly so intent on finishing the little Madonna portrait for Florimond Robertet, *Madonna with the Yarnwinder,* that he had time for little else. The *Burlington House Cartoon* covers eight sheets of paper and — despite its unfinished state — is considered one of Leonardo's most important works.

The cartoon depicts the infant Jesus blessing St. John in the desert, while St. Anne and the Virgin ponder secret theological matters (just look at their shadowy, tender expressions!). Despite a rather awkward pyramidal structure and smudged lines, historians praise the figures' great humanity and Leonardo's use of chiaroscuro and contrapposto. Although only a cartoon, this rendering of Mary, St. Anne, St. John, and Jesus reveals the portrayal of compassion, introspection, and enigma that made Leonardo famous.

Leonardo never painted this exact scene, but it provoked Bernardino Luini, one of his students, to create an oil painting based on the cartoon.

Figure 13-11:
Burlington House Cartoon, charcoal with white chalk heightening on paper, 1.4 x 1 meter (4.6 x 3.4 feet), National Gallery, London.

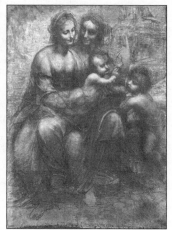

Art Resource, NY

The Virgin and Child with St. Anne (c. 1508–10)

Despite their common themes, the *Burlington House Cartoon* and *The Virgin and Child with St. Anne,* an unfinished painting possibly commissioned as an altarpiece by the Servites in Florence (see Figure 13-12), aren't related. Yet, depicting this trio was so common at the time that the idea had its own name, *Santa Anna Metterza* — St. Anne as the Third. Although never finished (you can see sketches beneath the thin layers of paint), Leonardo's portrayal of this generational trio is, once again, considered a masterpiece.

Figure 13-12:
The Virgin and Child with St. Anne, oil on wood, 1.7 x 1.3 meters (5.5 x 4.3 feet), Louvre, Paris.

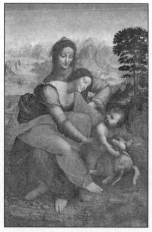

Scala / Art Resource, NY

Here, Leonardo shows three generations of life. The infant Christ holds a lamb, a symbol of — what else, himself (the "lamb of God"). At this time, Leonardo was supposedly experimenting with proportion, but the poses seem rather heavy — how, for instance, does St. Anne support the Virgin? The heads also lack the fine texture of the *Mona Lisa,* though they exude the mysterious sweetness typical of Leonardo's Madonnas.

Redux: Leonardo failed to deliver on time. He bounded off with that scoundrel General Cesare Borgia throughout central Italy, leaving Filippino Lippi and Pietro Perugino to finish the painting. Because Leonardo worked on the painting in intervals over many years, he never quite got around to completing the landscape or the robes, which his pupils finished as he embarked on his adventure with Borgia.

Rethinking Leo's Religious Pieces

Just as Leonardo set the standard for portraiture, so, too, did he carry religious paintings to a new height. He dumped some of the old motifs and symbols (like the halo) and adopted more natural, realistic renderings of his ethereal sitters. All his religious paintings, in fact, chart his evolution as a quintessential Renaissance painter. He used the techniques he employed in his portraits, from chiaroscuro to contrapposto and sfumato, to the same successful degree in his religious paintings. All captured the inner emotions of the mind, a new inner radiance and expression.

As a testament to their popularity, Leonardo's religious scenes inspired many copycat paintings. Workshop production not only lent the pieces an air of collaboration, but also invited students to copy directly from their master. Good thing they did, because without copies of some of Leonardo's drawings and paintings, people today would have scant evidence of his genius. In fact, some paintings, such as *Leda and the Swan* (see Chapter 10), are known only through students' duplicates. Others, like *Madonna of the Yarnwinder* (see that section earlier in this chapter), spawned numerous copies from Leonardo's workshop — a couple possibly completed by the master himself, but others finished by skilled students.

Some of Leo's religious paintings, including *St. John the Baptist,* gave universal symbols to artists: the pointing figure and the sly, enigmatic mug, for example. Consider, after all, the questionable iterations of this painting in the Palazzo Rossa in Genoa and the Municipal Museum in Basle (both disputed copies, of course), and renderings by Andrea Solario, Bernardino Luini, and Andrea Da Pontedera, three of Leonardo's students. Because Leonardo lugged *St. John the Baptist* around with him until his death, the painting's fame traveled far and wide. Spanish baroque painter Diego Velázquez, for example, copied St. John's pose in his own *St. John the Baptist* (c. 1620),

creating a brighter but rather bored-looking saint. Leonardo's *Bacchus* invited even more copycat artists and new interpretations of the same theme to accord with changing times.

That religion has somewhat diminished in importance, at least in Western art (what's with that modern stuff, anyway?), in no way undermines Leonardo's influence today. Leonardo and his subjects continue to fascinate. Sigmund Freud, for example, imagined the shape of a vulture hiding out in the Virgin's skirts in *The Virgin and Child with St. Anne*. To him, this odd shape suggested the psychoanalytical explanation for Leonardo's homosexuality (never proven, as Chapter 2 shows). Perhaps people today also have a greater appreciation of how Leonardo's religious outlook shaped his works of art, and how his art, in turn, continues to shed light on an extraordinary era.

Chapter 14

Leonardo's (Faux) Fresco: *The Last Supper*

*I*f the *Mona Lisa* is the most famous painting in the world, then *The Last Supper* is a close runner-up. But because the latter is attached to the wall of a *refectory* (a communal dining room in a convent or monastery), it's not exactly mobile. Therefore, it hasn't toured as widely as other Leonardo treasures. And because it was out of commission for 20 years while experts restored it, it hasn't been as widely viewed by the public.

Nonetheless, *The Last Supper* remains one of the most well-known and valued paintings in the world for its technical innovation, *istoria* (dramatic narration of one of Christianity's most important events), and beautiful, expressive figures. Historians consider *The Last Supper* to be Leonardo's most famous *fresco* (a painting technique using pigment on wet plaster) — perhaps the most important of the Renaissance. Though, as this chapter shows, it's not a true fresco at all, a fact that has presented some thorny problems about how to preserve and even restore it, if at all.

In this chapter, I introduce you to this masterpiece, telling you the story behind it and within it, pointing out the key techniques and symbols that Leonardo used, involving you in the drama over how historians are restoring the painting, and showing you the cultural waves it created.

Looking Closely at The Last Supper

In the 1490s, Leonardo's patron, Ludovico Sforza, despite his strange mix of Christian and pagan beliefs, decided to leave a religious monument to himself and his dynasty. He turned all his attention to Milan's Dominican Church and Convent, Santa Maria delle Grazie, which he saw as his family chapel and burial place. He hired artists to reconstruct the east end of the church. He also asked Leonardo, who was then working for him as court artist, to depict a gigantic biblical story, 4.6 by 8.8 meters (15 by 29 feet), on the north wall of the refectory. (In those days, monks were supposed to talk as little as possible while they ate and apparently needed something spiritual to contemplate as they chewed.)

The Last Supper, of course, is more than eye candy for dining monks. In this work, Leonardo portrayed subjects close to his heart. Matters of purity versus evil and loyalty versus betrayal occupied him in his personal relationships (think of the accusations against him for sodomy!) and work projects (such as designing war machines). But those ideas didn't make _The Last Supper_ famous. Rather, Leonardo pioneered an entirely new way of looking at a traditional subject, giving a well-worn scene new vitality.

Reviewing the biblical back story

The Last Supper — what Leon Batista Alberti, the most important art theorist of the Renaissance, would've called _istoria_ for its grand, historical theme and dramatic, emotional punch — reflects Leonardo's visual interpretation of an event told in all four of the Gospels, books in the Christian New Testament (as opposed to the Old Testament). Here's the short version.

Combing Milan's back streets for models

Leonardo was ever on the prowl for models, and _The Last Supper_ was no exception. Supposedly, Leonardo modeled all his figures after people he saw in Milan. He spent time in bathhouses, taverns, and the occasional brothel to find people with interesting qualities. He possibly based the head of St. John or another disciple on one Cristofano da Casti; one other, Count Giovanni, may have inspired his depiction of Christ.

By 1497, Leonardo had apparently completed 11 apostles and the body of Judas, but couldn't find an appropriate model for Judas's face. And Ludovico, who was paying Leonardo quite handsomely, was becoming impatient with his artist's slow progress. For over a year, Leonardo searched for Judas's evil head. He finally found it, though no one's sure where he got it — rumor has it that Leonardo spent time in jails, searching for an appropriate criminal on which to model Judas's face.

One evening, Christ invited his 12 disciples to an intimate gathering in Jerusalem (most likely the *seder,* the Jewish celebration of Passover — Christ *was* Jewish, after all). He knew that his number was up, so he washed his disciples' feet (which showed their equal weight before God) and started talking about love for God and fellow men and stuff like that.

Then Christ dropped the bombshell. "I tell you the truth, one of you is going to betray me" (John 13:21). Someone was, in fact, going to rat on Christ. Looking around the table, Christ announced that he would dip his bread into a dish — and the recipient of this bread would turn against him. He gave his bread to the greedy Judas and said, "What you do, do quickly" (John 13:27). Judas immediately left the table (after the devil entered him). Shortly after, he betrayed Christ for the payment of 30 silver coins by pointing him out to Roman soldiers.

During the meal, Christ also instructed his disciples how to eat and drink in ways that would commemorate him after his death — an act known as the *Eucharist.* This term literally means "gift" or "thanksgiving." The symbolic bread (Christ's body) and wine (his blood), which a person takes during *communion* services, represent the Christian doctrine of salvation.

Reworking a traditional scene

The Last Supper wasn't a new subject; many artists before (and after) Leonardo depicted this same scene. It was an especially popular fresco for monastery refectories because of the themes of food and sacrifice. By the time Leonardo started his painting, many Renaissance artists had established a sort of Last Supper template. Two notable examples include

- **Andrea del Castagno, 1450:** Castagno created the basic arrangement that other artists, except for Leo, followed. His *Last Supper* fresco featured haloed disciples sitting at a long table in front of a rear wall, with Christ in the center; his fave, John, leaning against him; and Peter to Christ's right. Only Judas (the bad guy) sits alone, in black and on the opposite side of the table, an arrangement that Leo later switched. The painting represents the moment of communion.

- **Domenico Ghirlandaio, c. 1476:** The first of his *Last Supper*s also shows a long, curved table with haloed disciples seated around it, John crying in Christ's lap, and Judas seated on the opposite side, his back to the viewer.

Leonardo thus inherited a scheme that had satisfied people for a long time: 11 apostles sit on the far side of a table. Christ sits in the middle with St. John playing the lap dog. Alone, on the near side of the picture, roosts Judas.

Experimenting with composition

Leonardo experimented with the composition of the final painting. You can see this experimentation in the famous *study* (sketch or preparatory drawing) for *The Last Supper* (see Figure 14-1), one of a bunch that Leonardo did. It looks as though Leonardo considered placing the apostles around the table and Judas opposite his more esteemed colleagues, as older Renaissance painters had. Leonardo also played around with their expressions and interactions — note John, doing a face plant. Given the overall stiffness of these figures, Leonardo had probably handed them off to his students, who based them on previous studies their master had drawn of each apostle.

Figure 14-1:
Study for *The Last Supper,* 1494–95, red chalk on paper, 26 x 39.2 centimeters (10.2 x 15.4 inches), Gallerie dell' Accademia, Venice.

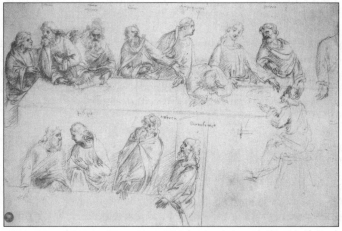

Alinari / Art Resource, NY

Switching things up a bit

In his final version of *The Last Supper* (see Figure 14-2), though, Leonardo went out on a limb. He departed from this traditional composition and created an entirely new drama:

- **He put a spotlight on the moment of revelation rather than the moment of communion.** Leonardo portrayed a more terrible moment than had previous artists, who depicted the communion. He painted the exact moment of truth: "One of you will betray me."

- **He lined up his characters and made them face the front.** Leonardo, who wanted to focus on the dramatic reactions of his characters to this statement, seated them next to each other, rather than *around* a circular or square table. Thus, you can see their looks of shock, dismay, disappointment, anger, and questioning.

✔ **He kept the bad guy in the mix.** Unlike previous artists, Leonardo didn't dispatch Judas to the other side of the table. Instead, he placed him in the same row as the 11 innocents (fourth from the left). Yet, he put Judas in deep shadow (an extension of his *sfumato;* see Chapter 10) and painted his hand hovering over a dish — both signs of his guilt. (Early sketches show that Leonardo originally seated Judas across from Christ, in the Renaissance tradition.)

✔ **He gave St. John a backbone.** Leonardo's St. John doesn't lie pathetically on Christ's breast. Instead, Leo chose to show St. John at Christ's right-hand side (or left from the viewers' perspective), showing the apostle in a bit of shock. Leonardo thus diverged from past artists in both narrative and style. (Interestingly, many people speculate that this figure isn't St. John at all, but Mary Magdalene — I won't get into that here, but you can flip ahead to Chapter 15 for the debate.)

✔ **He organized the players into teams.** To draw his viewers' eyes toward Christ (and to fit the disciples around the table!), Leonardo painted his subjects in four groups of three. From left to right you have Bartholomew, James (the Less or Little, the son of Alpheus and James, called "the Lord's brother"), and Andrew; Judas, Peter, and John; Christ; Thomas, James (Major, brother of St. John), and Philip; and Matthew, Thaddeus, and Simon.

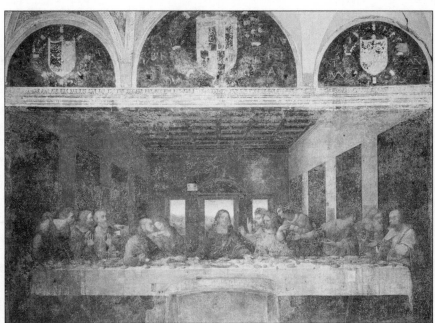

Figure 14-2:
The Last Supper, pre-restoration, c. 1495–98, oil and tempera on sealed stone wall, 4.6 x 8.8 meters (15.1 x 28.9 feet), Refectory of Santa Maria delle Grazie, Milan.

Scala / Art Resource, NY

In search of some grub?

Leonardo's _The Last Supper_ is in Milan, but you won't go hungry in Florence, either. Creating a Last Supper fresco was a popular Florentine hobby for the region's great painters. Convent refectories, in which the monks' earthly tables mirrored the apostles' (painted) sacred one, happily obliged. In the 1700s and 1800s, many monasteries, squelched by religious orders, were turned into museums. If you're headed to Florence, here's where you can still see some of the greatest feasts of all.

Artist	Date	Monastery	The (Interesting) Details
Taddeo Gaddi	c. 1340	Santa Croce	Originally attributed to Giotto; the first major Florentine representation of Christ's last meal.
Andrea di Cione (Orcagna)	c. 1360	Santo Spirito	Only a few fragments remain, but check out his Crucifixion scene above the fresco.
Andrea del Castagno	c. 1450	Santa Apollonia	More realistic in architecture and details than its 14th-century predecessors.
Domenico Ghirlandaio	c. 1476	Badia di Passignano	The first of Ghirlandaio's _Last Supper_s.
Ghirlandaio	c. 1480	Ognissanti	Highly decorative and iconographic.
Ghirlandaio	c. 1482	San Marco	A counterpart to the Ognissanti fresco.
Pietro Perugino	c. 1495	Foligno	One of his best landscapes of the Umbrian countryside.
Francesco di Cristofano (Franciabigio)	1514	Calza	Influenced by Leonardo's _The Last Supper_.
Andrea del Sarto	c. 1527	San Salvi (outskirts of Florence)	Dramatic and harmonious; considered his most spectacular masterpiece.

Synthesizing Style in The Last Supper

Leonardo started _The Last Supper_ around the same time he was collaborating with Luca Pacioli on _De divina proportione_ (a book about divine proportion, which demonstrated a shift away from faith in divine reason). As you may expect, he applied theories about mathematical perspective to his painting,

which created a more unified and dramatic piece in comparison to its earlier counterparts and contemporaries. At the same time, Leonardo omitted certain traditional symbols, included others, and fooled around with perspective to paint the most convincing and harmonious narrative he could.

Setting the scene and deciphering the symbols

Leonardo omitted some traditional iconography in favor of greater emotional depth and realism. He didn't clutter the painting with flying birds in the corners, halos around the disciples' heads, or fanciful ornaments and decorative architecture. (The *lunettes* above the painting, semicircular spaces formed by the triple-arched ceiling of the refectory, bear Ludovico's coat-of-arms. Leonardo painted these around the same time as *The Last Supper.*)

Instead, Leonardo focused on period details. He drew the trestle table, folded tablecloth, glassware, china, and utensils similar to the way that he saw them at the monastery in the mid-1490s. He used some traditional religious symbols as well; Christ points to the bread and wine, introducing the Eucharist. But not all's well; the objects on the table look ordered in between Christ's hands, but to his right and left the objects increasingly become messier, suggesting imminent chaos (and perhaps even foreshadowing Jesus's death).

Leonardo extended this realism to his apostles' faces (now only *palimpsests* — or surfaces that have been reworked numerous times, so only shadows of the original drawing remains — of the originals, due to restoration efforts). The apostles all display identifiable emotions — and in viewers' minds, seem like real actors on a stage set, spilling their guts for all to see. For example, Bartholomew (far left) is clearly agitated; James the Less and Andrew (second and third from the left) are more shocked. Judas (fourth from the left), looks shocked as he fingers the pouch with the money he received to betray Christ. Leonardo portrayed Judas in particular with a physiological realism that mirrored his psychology, thereby differentiating him from the rest of his pals. Peter (fifth from the left) is angry, but John (sixth from the left) looks contemplative, and Jesus (center stage), of course, remains serene. Above all, Leonardo tried to expel their inner thoughts through their postures and their expressions.

Experiencing (and imagining) perspective

Leonardo's use of space and perspective played a large part in his narration of the Last Supper. Without the figures, the space would collapse; without the space, the figures lack meaning in relation to each other. Form thus mirrors content.

Extending the refectory

Leonardo, who painted *The Last Supper* on the north wall of the refectory, intended to make the fictional space of the painting, a banquet hall, prolong the real space of the dining area. He supposedly did so by driving a nail into the northern end of the refectory, tying strings to the nail, then radiating them outward in different directions to see the perspective.

Playing with lighting

The gentle lighting, coming in from the windows on the left side of the refectory, also meshes the painting with the room by illuminating the scene of the painting. The right wall of *The Last Supper,* in turn, looks like it's reflecting the light coming in from the refectory's windows. But the painting's internal light comes in just behind Christ's head, forming a natural halo around him.

Drawing viewers' eyes to the head honcho

In *The Last Supper,* Leonardo combined his linear, one-point perspective with two of his other theories: the ideas that as objects recede into the distance, they lose their clarity as well as their bright colors (I go into more detail in Chapter 10). Note, for example, the progressively dark drapery in Figure 14-2.

Everything Leonardo did in this geometrically harmonious painting draws viewers' eyes toward its center, the vanishing point, the Savior, the Man: Christ (his right eye, to be exact). He's the focal point in perspective, helped by his rather triangular pose (a symbol of the Trinity), relatively larger form (compare his body size to Judas's, for example), the window behind his head (the understated halo), and the groups of figures that generally lean in toward him. Christ looks down at the bread and wine; his hands point in the same direction.

Around the serene Christ, however, everything's simply one terrible, but orchestrated, mess.

Making sense of Leonardo's optical puzzles

Leonardo relied on tried-and-true mathematical laws for his composition. He also played a few tricks on his viewers. Don't feel cheated, though; his optical illusions actually make *The Last Supper* all the more ingenious, and one of the most famous illusionistic spaces in all of Western art. It demonstrates sound perspective, but if you take it apart, it's quite illogical in construction. Leonardo compromised the elements of realism he worked so hard to define in the face of a few rather thorny issues.

First, you see the top of the table. Because it's not at eye level, you *shouldn't* be able to see it from where you'd stand in the refectory. But Leonardo twisted the table forward a bit to involve you more in the painting and allow you to see the apostles' bodies.

Harmonizing with Leonardo

Leonardo, besides being an inventor, engineer, and artist, was also a talented musician. Some historians think that he even applied his musical understanding to *The Last Supper*. Possibly, he was thinking about mathematical progressions of a musical kind (those involving twos, threes, fours, sixes, and octaves) in his preliminary studies and applied these ratios to parts of his painting. Leonardo had a concept of harmonic space; his rules of optical diminution related to a musician's musical intervals and arithmetic progressions. Everything he painted, from the width and height of the top and bottom of the table to the drapery, had geometrical harmonies that related, to a certain extent, back to music. The tapestries, for example, appear to diminish in size according to musical ratios. Of course, Leo's painted objects always referred back to larger mathematical proportions he observed in nature.

Second, Leonardo crowded 13 figures around one length of the table, even though, if you tried this at home with your family and pets, you wouldn't all fit. The table is simply way too small for all the figures seated; Bartholomew and Simon would probably be odd men out.

Leonardo, who usually didn't resort to such optical contrivances, probably used these illusions because of the problem of scale that he encountered. He wanted both narrative cohesion *and* a rationally scaled arrangement (form and function, again), but he couldn't have his cake and eat it, too. If he scaled his figures down, the effect wouldn't be realistic. Leonardo addressed this issue by grouping his figures together in threes (obviously not a crowd).

Damaging (And Restoring) the Painting: Techniques and Controversy

While Leonardo was working on *The Last Supper,* he was also planning the doomed equestrian statue for Ludovico Sforza, painting the ceiling and vault of the Sala delle Asse in the Sforza Castle, and feeling a little pressed for time. Not to mention, he wasn't the best at completing projects anyway — a quality that ultimately contributed to the fresco's rapid decline.

Leonardo's disappearing fresco

Artists have frescoed their homes, temples, and villas for thousands of years, since the ancient Greeks and Romans. The Italian Renaissance ushered in a new stage of fresco painting. It witnessed the likes of Giotto, Michelangelo, Raphael, and Andrea del Sarto, who combined this traditional medium with innovative techniques. Usually, frescos improve with age — but sometimes, if they're not *true* frescoes, they don't.

Although people refer to Leonardo's *Last Supper* as a fresco, it really isn't one. In Renaissance Italy, fresco (called *buon fresco*) involved applying pigments mixed with water to a damp, fresh lime plaster *(intonaco)* wall or ceiling. As the pigments mixed with the lime, a chemical reaction occurred, creating a new calcium carbonate that cemented the color onto the surface of the wall. The artist had to work quickly, in small batches (an artist couldn't modify a fresco as he worked), finishing each section before the lime plaster dried (about a day). Artists applied new sections of plaster the next day. Occasionally an artist would add a fresh layer of color to the fresco after the plaster had dried, a technique called *fresco secco*.

Leonardo probably realized that the traditional fresco, which most artists completed in a couple of weeks, just wasn't his medium. Instead of using the tried-and-true method of tempera on wet plaster, he decided to test out a new idea. He sealed the stone wall of the refectory with a layer of pitch, gesso, and *mastic* (a type of cement) and then painted onto the sealing layer with chromatic oil and tempera pigments. This mix gave him more varied colors — and a more leisurely pace, for he didn't need to finish a specific section in a day. Unfortunately, his method proved to be highly unstable.

Leonardo had barely finished *The Last Supper* when it started to deteriorate. (By contrast, the *Crucifixion* fresco that Donato Montorfano painted on the opposite refectory wall in 1495 has barely suffered over the centuries.) The plaster flaked off the wall by the handful, and by 1550, Giorgio Vasari described this formerly beautiful painting as quite ruined.

In addition to the flaking paint, *The Last Supper* has suffered a few other indignities:

- In 1652, some poor monk imagined a passageway through the painting and cut a door through Christ and two apostles' feet. The doorway was later bricked up, though it's still visible.

- French troops used the refectory as a prison in 1796; despite Napoleon's orders, some soldiers threw bricks at the apostles' heads — and the damage was done. A few years later, the refectory became a stable.

- On August 15, 1943, during World War II, Allied bombs struck the refectory, blowing off its roof. Sandbags somewhat protected the painting — but didn't prevent vibrations from knocking more paint off the wall.

Restoring (or, repainting) the masterpiece

The Last Supper experienced an unfortunate, if well-intentioned, chain of events as experts simultaneously tried to restore (or, as the case may be, repaint) it:

- ✔ **1726:** Michelangelo Bellotti, who painted missing sections in oil and then applied a coat of varnish to the whole shebang (thinking, mistakenly, that Leonardo had painted exclusively in oil), initiated the first restoration attempt. The consensus today: Bellotti did more harm than good.

- ✔ **1770:** When Bellotti's restoration failed to do the trick, Giuseppe Mazza stripped off Bellotti's coats and repainted the entire surface in oil. By the time the public realized what was going on, he had repainted all but three faces!

- ✔ **1821:** Around this year, an expert in detaching frescoes from their walls, Stefano Barezzi, started to remove *The Last Supper* (even though it wasn't a fresco!) to a safer location. He managed to damage the center section even more, but reattached the ripped-off sections with glue.

- ✔ **1901–8:** Restoration expert Luigi Cavenaghi started to clean the painting — for seven years! He also established that Leonardo had painted in tempera, *not* oil.

- ✔ **1924:** Oreste Silvestri cleaned it further and attempted to stabilize some of the more unstable edges with stucco.

- ✔ **1947–53:** In the first modern restoration, the much-acclaimed restorer Mauro Pellicioli cleaned and tried to stabilize the painting with a waxless shellac (a kind of fixative). At the same time, he removed all of the previous repainting. He brightened the heads of Bartholomew and Philip, Judas's body, and Christ's hands, showing that the latter's robes were once red, a sign of the Passion.

- ✔ **1978–99:** Dr. Pinin Brambilla Barcilon, under the auspices of Milan's Superintendent for Artistic and Historic Heritage, led a major — more than $7 million — restoration project. With surgical precision, she sought to redress the errors of the previously misguided restoration efforts. She made the refectory into a climate-controlled environment and removed all the previous layers of paint that were eating away at the original. Then she used new technologies, including infrared reflectoscopy (which enabled restorers to see Leonardo's original painting), miniature TV cameras (to see small cracks), and microscopic core samples, as well as Leonardo's original sketches of the painting, to help remove mold, glue, repaint, and smog from the original work. Given this painstaking process, sometimes only a square inch of the painting was restored each day. She also repainted the unrestorable parts with soft watercolors to indicate that they weren't part of the original work. (You can read more about Brambilla's restoration efforts in her memoir of the process, *Leonardo: The Last Supper,* translated into English from Italian in 2001 and published by the University of Chicago Press.)

The lingering controversy over restoration

In 1999, after 20 years of restoration efforts, the painting was put back on display, to the public's joy — and dismay. There's no denying that *The Last Supper* is brighter and shinier than ever before, even though its figures still remain, for the most part, despondent. So why isn't everyone happy?

Sprucing it up: The pros

Historians recognize that *The Last Supper* remains one of the most important paintings of the Renaissance. It's Leonardo's most literary painting — it tells an important story with heightened emotion while remaining mostly true to the mood (and principles) of classical art. Fans of Brambilla's restoration claim that *The Last Supper* bears witness to — and allows people to experience — Leonardo's genius in full splendor. And of course, the admission ticket into the refectory adds some revenue to Florence's economy!

Destroying it further: The cons

Admittedly, at this point you can't really call *The Last Supper* Leonardo's original work. For more than 400 years, in attempts to restore the painting, artists painted directly over Leonardo's hand. The exaggerated facial expressions of some of the apostles suggest the work of many artists, even the Mannerists of the 17th century. These coarsely painted heads would've absolutely *horrified* Leonardo, given his obsessive interest in facial expression (see Chapter 11).

Brambilla's approach, the extensive cleaning and the repainting with watercolors, has come under fire from Leonardo purists, who call her work destructive and unfaithful to the original. Columbia art history professor James Beck has been especially virulent in his attack, calling *The Last Supper* overcleaned and mostly Brambilla's, not Leonardo's, work. (In fact, he even went on CBS Television to crusade against the "madness" of uninformed, overzealous restorations like this one.) And Martin Kemp, a noted Leonardo biographer and professor of history at Oxford, has also questioned Brambilla's decision to fill in some of the painting with watercolors. Other critics have called Brambilla an amateur.

However you stand on the subject, one thing's for sure: Ludovico was lucky that he fled from Milan only a year after Leonardo completed *The Last Supper*. Not only did he get to see it — he witnessed it in its original glory. But as for you: Are *you* experiencing the *real Last Supper,* or a subjective 20th-century version? You decide.

Popularizing The Last Supper:
Its Cultural Impact

Let's face it; Leonardo's *The Last Supper* was pretty much the dinner that never was. But a strange thing happened: The minute it started to disappear, it began to reappear everywhere. More than 500 years of scholarship and art have emerged from this ephemeral, ethereal painting.

Despite changing attitudes toward religion, the Last Supper as a subject never went out of vogue. Artists influenced by Leonardo, from Tintoretto (c. 1592) to Peter Paul Rubens (1630), Rembrandt van Rijn (c. 1634), and Nicholas Poussin (c. 1640s), all produced their own final meal renditions. More recently, Salvador Dali (1955) and contemporary artists have taken the once-religious scene, warped it, and erased the fine lines between fine art, popular culture — and, dare I say it, kitsch.

But back to Leonardo. Testimonials to his *Last Supper* in particular run the gamut of artistic and literary responses. Giorgio Vasari, Rubens, Johann Wolfgang von Goethe (whose essay on the painting defined how generations of critics interpreted it), and Eugene Delacroix all praised the painting, focusing on Leonardo's intensity of expression.

Others have capitalized on Leonardo's specific drama and trauma for centuries. Like the *Mona Lisa,* Leonardo's *The Last Supper* has also gone pop — though not quite to Lisa's rather embarrassing extent. Copies exist in almost every artistic medium: tapestries, stained glass, carvings, paintings, dramatic performances, and even poetry. Take, for example, the life-sized mosaic copy in Vienna's Minorite Church, which Napoleon I ordered Roman artist Giacomo Raffaeli to produce around 1810.

Over time, the painting's meaning has also become more secular. The 20th century abounded in overt references, including Tomás Gutiérrez Alea's black comedy film, *The Last Supper* (1976). You can also find sly allusions, from Eugene O'Neill's play, *The Ice Man Cometh* (1946), to the film *Babette's Feast* (1987).

Some of the more illustrious examples of recent decades include the following:

- In 1986, Andy Warhol created a group of silkscreen collages based on *The Last Supper* — more than 100 variations on the theme, in fact.

- A famous *New Yorker* cartoon by artist Constantin Alajalov shows *The Last Supper* with the caption, "Separate checks."

✔ _The Last Supper_ is the model for the all-time best-selling paint-by-number kit produced by Crafts House about 50 years ago. (When it went off the market in 1993, the public demanded its comeback.)

✔ Dan Brown based his runaway bestseller, _The Da Vinci Code_ (Doubleday, 2003), on some of the mysteries of _The Last Supper_ (which I discuss in depth in Chapter 15).

✔ There's no shortage of essential household items with _The Last Supper_ image, from candles to hand-held fans, pillows, T-shirts, and refrigerator magnets. You name it, _The Last Supper_ has covered it.

Too bad that given the proliferation of _The Last Supper_ (not to mention the _Mona Lisa_) images, Leonardo isn't alive today to collect royalties. He'd be a rich man indeed.

Chapter 15

Breaking *The Da Vinci Code*

In This Chapter

▶ Telling it in 500 words or less: Dan Brown's *The Da Vinci Code*

▶ Drawing a line between where Brown is right and where he's wrong

▶ Clearing Leonardo's name

▶ Traipsing throughout the novel's settings

*J*esus sells. It's that simple.

How else can one explain the wild success of Dan Brown's novel, *The Da Vinci Code*? Published by Doubleday in 2003, it ranked number one on the *New York Times* bestseller list for more than a year. It has sold more than 10 million copies worldwide, been translated into more than 40 languages, and topped bestseller lists in France and England. Whatever you want to call the book — a conspiracy thriller, a murder mystery, a romance, a religious exposé or manifesto, historical fiction, or revisionist history — you can't deny the fact that religion, couched in a riveting, cliff-hanger story, sells.

Brown's thriller caused an uproar the second it came out. You name it — biblical scholars, art historians, clergy members, and religious historians — immediately jumped on the wagon. Debate over the novel spawned TV specials, church seminars, magazine articles, and many, many books decrying Brown's claims. *The Da Vinci Code* does, after all, seem to be causing a little confusion about the boundaries between fact and fiction in its depiction of Christianity.

What's all the hoopla about? Clearly, Brown touched a nerve somewhere. About 90 percent of Americans say they believe in some sort of God. But after reading Brown's thriller, you may find yourself, whatever mode of thinking you subscribe to, questioning some of your steadfast beliefs about religion, society, humankind, and even Leonardo. Just call *The Da Vinci Code* a *Satanic Verses* for the masses, if you will. And if you take Brown at his word, you'll discover secrets that, Brown says, would confront the Vatican with one major crisis of faith. Hopefully, the following pages will save you before it's too late. And, of course, help clear Leonardo's slandered name!

Summarizing The Da Vinci Code

Yes, I know. You've read it. I've read it. We've all read it. If your dog could read, he'd have read it. But a little refresher never hurts, does it? Just don't go hunting for another copy in a poorly lit library; an albino assassin just may be lurking behind the next stack.

The plot, when you take it apart, is quite simple.

A brilliant Harvard professor of religious symbology (whatever *that* is; Harvard doesn't have one), Robert Langdon, visits the scene of a crime at the Louvre Museum. He finds that one of the museum's curators, Jacques Saunière, an expert on goddess history, has been murdered in one of the galleries. But just before his death, Saunière plopped himself down on the floor, spread-eagle in the position of Leonardo's *Vitruvian Man* (see Chapter 5 for more insight into this famous drawing), and used his blood to draw all sorts of anagrams and symbols on his torso.

Sophie Neveu, a gorgeous Parisian cryptologist and Saunière's estranged granddaughter, joins Langdon at the scene of the crime. Luckily, she can interpret some of Saunière's strange last messages by finding some cleverly disguised signs in Leonardo's paintings. With her new sidekick Langdon, they traipse from clue to clue, place to place. When they become suspects in the case, they ally themselves with deceitful holy grail scholar Sir Leigh Teabing. With his help, they start to uncover some pretty juicy secrets about church history, the holy grail, and Leonardo.

In hot pursuit is a self-flagellating, albino monk-assassin from Opus Dei, a murderous organization seeking to suppress the truth. "What truth?" you may wonder.

[*Warning:* Plot spoiler ahead!]

Saunière possessed knowledge of the *keystone,* knowledge that would lead to the holy grail. As Grand Master of the Priory of Sion, a secret society, he guarded a terrible secret that could threaten to topple the Church.

How's that? Glad you asked. Throughout human history, people had practiced a kind of religion that balanced the masculine and feminine. Jesus, too, subscribed to the power of women and the goddess. While he preached about love, peace, and all that other stuff, he was really married to Mary Magdalene and planning to hand her the reigns of this religious movement. Peter, jealous of Mary's power, repressed Jesus's teachings after his crucifixion and removed her from power. She fled to France, finding refuge in a Jewish community, and gave birth to her and Jesus's daughter, who then became the head of the Merovingian royal life.

Here's the clincher: You know the holy grail? It wasn't the cup that Jesus used at the Last Supper *or* the vessel that caught his blood at the crucifixion. Instead, the *real* grail — the holder of his blood — is Mary Magdalene's "sacred feminine" self and womb — to find the grail, you must find her final resting place.

So, the secret's up. Are you in or out?

What matters is that Saunière guarded this 2,000-year-old history, which, at heart, represented a struggle between the Catholic Church and the goddess-friendly Priory of Sion. The Priory, in turn, had seen the likes of painter Sandro Botticelli, Leonardo, scientist and mathematician Isaac Newton, writer Victor Hugo, composer Claude Debussy, and filmmaker Jean Cocteau as Grand Masters. A rather shabby bunch overall, don't you think?

The reason no one knew about Jesus's real life as an ordinary rabbi who married his favorite disciple, fathered a child, and did *not* rise as Savior of the world was because the power-hungry, patriarchal Catholic Church had suppressed this truth and the sacred feminine through its canons. Some evil bishops and emperors turned Mary Magdalene into a prostitute, squelched writings they deemed heretical, and, in the worst lie to date, voted to transform Jesus from mere mortal into the Son of God at the Council of Nicaea in AD 325. But Jesus's intended religion survived underground in southern France, where different Gnostic teachings and cults (pre- and early-Christian groups believing they possessed secret knowledge) dedicated to its survival thrived, from the Order of the Knights Templar to the Freemasons.

But back to Saunière, Sophie, and Langdon: Pursued by some bad Church guys attempting to take them out at every turn, they scurry through France and England looking for clues to Saunière's death — and the secret that he guarded. All in the course of about a day, no less! Sophie eventually learns that she's of the Merovingian line, finds some promising romance with Langdon, and is reunited with some long-lost relatives. And everything, nearly everything, at least, ends up happily ever after.

Is Dan Brown in hot water?

Soon after *The Da Vinci Code* topped bestseller lists everywhere, one disgruntled author came forward with a complaint. Seems, it turns out, that Brown's book closely follows an already published but lesser-known book, *The Da Vinci Legacy*, published in 1983 by Tor. The author, Lewis Perdue, accused Brown of stealing his plot and tried to finagle a settlement. Brown insists that he never read Perdue's book and

that Perdue is piggybacking on his success. So Brown and his publisher, just in time for producer Ron Howard's *The Da Vinci Code* movie, sued back, citing Perdue's "escalating campaign" and "false claims." Stay tuned.

If you're curious about Perdue's claims, go to his Web site at www.davincilegacy.com/Infringement/.

Except for the holy grail, of course. But that's easy. It's buried beneath I. M. Pei's 21-meter-high (70-foot) pyramid, the entrance to the Louvre. Go on, don't be shy; why don't you join Brown's 10 million other fans in digging it up?

The Novel's Claims: Fact or Fiction?

If you devoured *The Da Vinci Code* and believed every word you read, you're not alone. But there's something you should know before you try to hunt down the grail or marry into the Merovingian line: *Not all of it is true.*

Responses to the novel fall into three general categories:

 ✔ **It's truth:** *The Da Vinci Code* explains the whole history of Western civilization, and wow — what a revelation! I'm never going to church again!

 ✔ **It's good movie stuff:** It's amusing and a little unbelievable, but entertaining.

 ✔ **It's all lies, lies, and more lies:** The novel is pure garbage, completely beyond all rational credibility.

Your views probably also depend, to a certain extent, on how you see Christianity.

The biggest backlash to *The Da Vinci Code* comes from many Christian writers and leaders, from Protestants to Catholics, theologians, and Bible scholars. Ultraconservative biblical scholars consider Brown's interpretations pure heresy. Moderates examine, consider, and question all aspects of Brown's claims, including the traditions or speculations reflected in the works he cites, like the Gnostic Gospels. Liberal scholars (like Brown) take such scholarship as reliable facts. If you're a nonbeliever, you may take all the rather nasty things *The Da Vinci Code* says about the Catholic Church at face value: The traditional Christian Gospels are trash. Only heretics follow Christ. And women really rule the world (an obvious point to begin with, no?).

In a preface titled, "Fact," Brown claims that "All descriptions of artwork, architecture, documents, and secret rituals in this novel are accurate." But as the following sections explain, he misrepresents many persons and events — some more than others. Brown has some pretty harsh things to say about the church. Much of his cause for slander has to do with the way he thinks the Catholic Church suppressed the *true* nature of Christianity — its feminine side, that is.

Revisiting the Council of Nicaea

First things first: During the first and second centuries AD, Jesus's apostles and their followers penned about 50 gospels about the life, death, and resurrection

of Jesus. (*Gospel* means "good news" in Greek.) The early Christian movement deemed four of these gospels — those written by Matthew, Mark, Luke, and John — as "official" and inspired by God. Along with more than 20 other books (letters, really), they became part of the New Testament canon in the fourth century. The rest of the canon developed more slowly as different letters, epistles, and stories were incorporated into Christianity over the next few centuries.

The Da Vinci Code introduces the idea that the fourth-century Roman emperor Constantine, when he highlighted the four "official" Gospels, suppressed others for political reasons and imposed the doctrine of the divinity of Christ at the Council of Nicaea in AD 325. History's winners write history, Brown says, and so Matthew, Mark, Luke, and John's accounts of Jesus prevailed over many others. In addition, no one, not even Jesus's loyal clan, believed in his immortal divinity until Constantine said so.

That idea is all good and well, but many Christian scholars accuse Brown of grossly distorting what, exactly, happened at the Council of Nicaea. They say that the truth of the matter is as follows:

- ✔ Writings about Jesus's divinity had formed part of the Church's established canons well before AD 325 and predate most of the newly found Gnostic and other gospels.

- ✔ According to many religious and biblical scholars, the church picked and chose writings for its canon, but suppressed far less than Brown claims. According to Teabing (the holy grail scholar in the novel), "More than 80 gospels were considered for the New Testament, and yet only a few were chosen for inclusion — Matthew, Mark, Luke, and John among them." By the mid-second century when the Council of Nicaea convened, the Church had already recognized the four "divinely inspired" gospels for inclusion in the New Testament, and only a few gospels were still up for debate.

Looking the Gnostic Gospels in the face

Teabing, that treacherous, two-faced scholar, tries to teach Brown's characters a thing or two about Christianity. Pooh-poohing the "official" Gospels, he touts the Gnostic Gospels (discovered for real in 1945, all 52 texts in an earthenware jar across the river from the town of Nag Hammadi, Egypt), in particular the Gospels of Philip and Mary Magdalene. Both of these real documents deal with Jesus speaking to the disciples, with Mary generously bestowing some of her precious knowledge on them. In fact, the entire premise of *The Da Vinci Code,* including the idea of the "sacred feminine," rests on buying into many ideas introduced in the Gnostic Gospels.

Challenging traditional Christian ideas

Although the Gnostic Gospels offer little in the way of cohesive narrative or chronology and tell precious little about the life (and death) of Jesus, they

still, nonetheless, threatened the foundation of the fledgling Christianity in the early centuries after Christ's life.

- ✔ Many Gnostic scholars more or less ignored Jesus's crucifixion and resurrection. In fact, most Gnostics were considered Christian heretics.

- ✔ Some Gnostic writings depict Jesus not as a carpenter and prophet, but as a shadowy, not-quite-solid creature. He's described in places as "the mother" and, at other times, he appears as a man. The texts introduce mysterious, secret descriptions of Jesus that only elite scholars would understand.

- ✔ The Gnostic Gospels have fueled debate about Mary Magdalene's relationship to Jesus, particularly among feminist historians and theologians. The Gospel of Philip, for example, suggests a carnal relationship between the two in describing Mary as Jesus's "companion" and bringing up the *L* word (love).

- ✔ Other Gnostic groups (no, there's no central station) also embrace the idea of God as an androgynous being, in touch with both his-her male-female sides or even male *or* female, depending on what the situation warrants — yin and yang, God in drag, whatever you want to call it.

Overall, Gnosticism offered a version of Christianity free of unnecessary dogma — quite attractive to the nonbelievers.

Gnosticism defined and discovered

Gnosticism isn't an organized movement, but a way of thinking that incorporates many different concepts: the spiritual source of goodness in life, freedom from authority, the evilness of the material and corporeal world, Jesus as a spiritual teacher rather than a Savior God, and the importance of knowledge in attaining salvation.

The word *gnostic*, in fact, comes from the Greek word *gnosis*, or a secret knowledge of God that only a few special people can possess. Part of the breakaway success of *The Da Vinci Code* rests on the premise that with a few clues here and there, you, too, can attain such knowledge — if you're one of the elite, that is.

The discovery of the Gnostic Gospels at Nag Hammadi, Egypt, in 1945 posed some thorny challenges to the underpinnings of early Christian thought. Archaeologists uncovered 13 different codices, with over 50 different titles, written in *Coptic* (the Egyptian language in Greek letters). Sealed in an earthenware jar, they dated from the mid- to late-fourth century. The texts were translations from Greek originals dating back around 100 or so years. These discoveries include the Gospels of Mary (Magdalene), Peter, Philip, Thomas, and Q (called the Lost Gospel or Synoptic Sayings Source; the Q derives from the German word *quelle,* or source) — along with other early Christian scriptures that didn't make it into the New Testament canon. Scholars view the Nag Hammadi discoveries as part of a library, probably hidden by monks when the Orthodox Church banned these writings.

Refuting The Da Vinci Code's Gnostic claims

The Da Vinci Code relies heavily on the Gnostic texts to make its claim about Christianity as a deliberate sham, Christians as mindless followers, and Church leaders as power hungry, deceptive, and misogynistic. After all, Emperor Constantine supposedly wiped out matriarchal paganism and cultivated male-oriented religion instead. Brown asserts that the Gnostic texts, along with the Dead Sea Scrolls discovered in the caves of Qumran near the Dead Sea a few years after those at Nag Hammadi, reveal the *true* holy grail story.

First, the Dead Sea Scrolls don't have anything to do with Christian texts. These writings, which date from between the middle of the second century BC and first century AD, probably belonged to a group of people who broke with (or were kicked out by) the Jewish leaders in Jerusalem and who independently developed their own religious worldview that had nothing to do with Christianity.

Second, Gnosticism celebrates many things, including God as both mother and father, a balance between female and male. It also depicts Jesus's relationship to Mary Magdalene as quite human. But Brown's critics claim that despite what these Gnostic texts say, the chance that the early Church was an egalitarian body, led by both male and female bishops and priests, is unlikely indeed. Even most feminist scholars will tell you that not all Gnostics saw women as equal. And despite what Brown says, Jesus most likely didn't intend to hand the reins over to Mary instead of to Peter. In fact, some of the Gnostic texts even belittle Mary (and women in general, for that matter). In the Gospel of Thomas, the most famous of these texts, the final verse reads, "Simon Peter said to them: 'Let Mary leave us, for women are not worthy of life.' Jesus said, 'I myself shall lead her in order to make her male, so that she too may become a living spirit resembling you males. For every woman who will make herself male will enter the kingdom of heaven.'" There you have it: All animals are equal, but some animals are more equal than others.

Other critics of Gnostic writings argue that Gnosticism took root many decades after Jesus and his apostles' life. Thus, Gnosticism must have arisen outside the mainframe of Christianity.

Shining the spotlight on Mary Magdalene

The Da Vinci Code puts Mary Magdalene smack center in a swirl of controversy. Brown (or his characters) makes many claims about this gal:

- ✔ Mary, a Jewish woman who came from the tribe of Benjamin, married Jesus and had his child. Jesus, who cared deeply about integrating the sacred feminine into daily life, left her in care of his church. She was, in fact, the first apostle. After Jesus's crucifixion, Peter took over, and Mary escaped to a Jewish community in southern France. The Knights Templar

and Priory of Sion (see those sections later in this chapter), worshipping her as the divine mother, protected her story — and thus the holy grail.

✔ The "repentant prostitute" label came from a vicious Church plot hatched to counter evidence of her identity and role in the early Christian church.

✔ Her name was banished from the Catholic Church because of the threats it posed.

Not surprisingly, biblical scholars demote many of Brown's claims to mere smoke:

✔ No factual basis exists for Mary Magdalene's life as a prostitute, but her being labeled as such is an error rather than a smear campaign. In the sixth century AD, Pope Gregory the Great mistakenly combined Mary Magdalene's story with Mary of Bethany and an unnamed sinner mentioned in the Gospel of Luke into one woman. Therefore, the Mary in question supposedly took on odd jobs she never had, like prostitution. Although the Roman Catholic Church cleared her reputation in 1969, Mary has yet to come clean in the public eye.

✔ Although the topic has been debated for centuries, Christian historians generally agree (with some dissenters) that Mary and Jesus never tied the knot.

✔ The Vatican did _not_ bury any mention of Mary Magdalene. In fact, she has her own feast day: July 22.

✔ No solid proof points to Mary's leadership role in the early Christian church. The canonical Gospels mention her only a few times: She accompanied Jesus in his ministry, witnessed the crucifixion, and after his resurrection, he appeared to her alone.

✔ She didn't come from the tribe of Benjamin, which, going back some ancestors, could claim the throne. (Quick Sunday school lesson: Saul, a Benjaminite, was the first king of Israel — but King David deposed him.) Mary Magdalene probably didn't come from royal blood.

Still, some people speculate that Mary Magdalene had the credentials to be an apostle, maybe even the first. According to the New Testament, when Jesus rose from the dead, he appeared to her first — even before Peter! But favorable references may have been excluded because of her possible rivalry with Peter.

Identifying the holy grail

In Christian lore, Jesus and his disciples sat around for Passover dinner just before his fateful demise. He broke and passed around some bread (identifying it as his body), then offered wine in a cup (calling it his blood). This moment initiated understanding of the Eucharist, or Holy Communion — symbolic as atonement for all of humanity's sins. Then this same cup may have caught Jesus's blood as it dripped down the cross.

Gnosticism goes pop

Gnosticism, alive and well today, picks and chooses from all sorts of belief systems, from Christianity to Judaism, Buddhism, Platonism, astrology, existentialism, paganism, oriental mythologies, and other philosophies. Its most famous iteration is New Age religion/philosophy, but it also has some rather famous (and infamous) proponents:

✔ In 1997, the mass suicide by members of the Heaven's Gate UFO cult acted on the Gnostic belief that people must escape their bodies to achieve true spirituality — and secret knowledge. The clues? Auspicious numerology and signs from the heavens.

✔ Joseph Campbell (1904–87), New Age guru and host of the popular TV special *The Power of Myth,* bought into the Gnostic idea of the *ultimate reality,* meaning, basically, that humans are divine in their everyday existence, and spread the love. (He also reputedly inspired George Lucas's *Star Wars.*)

✔ Carl Jung (1875–1961) applied his psychological approach to understanding Gnosticism and used Gnosticism as one starting point for understanding dreams, fantasies, and the unconscious.

✔ German political philosopher Eric Voegelin (1901–88) attributed all of modernity's evil, from Communism to Nazism, to Gnostic ideas.

✔ Science fiction author Philip K. Dick drew on Gnostic ideas for his fiction, as did science fiction writer Philip Pullman in the *His Dark Materials* trilogy.

✔ Other writers inspired, in part, by Gnosticism include Beat poet Allen Ginsberg, Umberto Eco, and Jorge Luis Borges.

✔ The Gnostic Society in Los Angeles, established in 1928 and led by Stephan Hoeller, promotes the individual experience of achieving *gnosis* (knowledge of spiritual things).

✔ Movies from *The Matrix* to *Toy Story* (it's not only for children, is it?) rely on some Gnostic themes, including people's illusory experiences.

This very special cup has become the stuff of legend, folklore, romance, and religious mythology. Remember when Monty Python lampooned King Arthur in the 1975 film *Monty Python and the Holy Grail,* or when that swashbuckling Harrison Ford sought the grail in *Indiana Jones and the Last Crusade*? Throughout history, the grail has assumed many shapes and sizes, from a silver goblet to a huge emerald. It's also reputedly buried (or on display) in places ranging from Byzantium and Genoa to Valencia, Spain. Rumor even has it that the Knights Templar possessed it in the Middle Ages; then, after some infighting, some Knights carried it to Scotland to reside in the Rosslyn Chapel (Collegiate Chapel of St. Matthew), just south of Edinburgh.

In legend, a woman often protects the grail. Thus, it does have some symbolism related to birth and life-giving. But no known tradition, as Brown claims, says that the grail symbolizes the "lost goddess" (Mary Magdalene) or Jesus's bloodline.

Nevertheless, a few scholars, like Carlo Pedretti, head of the Center for Leonardo Studies at the University of California, Los Angeles, support this view. Until someone finds the grail, however, and takes DNA samples, any connection between Mary and the grail is quite unlikely to be proven beyond the shadow of a doubt.

Secret sects: The Priory of Sion

Brown borrows liberally from some other books (like *The Templar Revelation* by Lynn Picknett and Clive Prince and *Holy Blood, Holy Grail* by Michael Baigent, Richard Leigh, and Henry Lincoln) to concoct his riveting story about the *Priory of Sion,* a good-looking breed of people who drive nice cars, invoke the wrath of Opus Dei, and cavort with the Knights Templar (see the sections that follow). According to Brown, the Priory emerged in Jerusalem in 1099 to protect Mary Magdalene's great secret — and her and Jesus's bloodline. Its members sure know how to keep a secret, "one that, if made public, would shake the foundation of both Church and State," says Brown. ("Why do members of the Priory of Sion keep such knowledge secret?" you may well ask. Well, in the novel, Saunière — the murdered museum curator — worships the divine feminine by engaging in some pretty raunchy sex acts. He guards the secret that Mary, as a symbol of this divine feminine, is the holy grail and carries her own bloodline. But he believes that the power of this divine feminine will emerge spontaneously when Rome becomes more liberal. Humph.)

The Priory of Sion was an elite organization with rather unusual grand masters. Most were of high rank, nobility, or fame; some were even female. They came from all over western Europe but had the same purpose: to restore the Merovingian bloodline to the throne of France. Now, to do so they had to sneak around and do all sorts of behind-the-scenes maneuvers, like manipulate the Church, the 16th-century religious wars, and other things — even through the 20th century!

But before you start seeing secret signs everywhere, keep this fact in mind: *The Priory of Sion never existed.*

Its legitimacy rests on a great big hoax devised by one conspiracy theorist, mythomaniac, anti-Semite, and petty criminal, Pierre Plantard. He believed he was the last descendant of the Merovingian bloodline, heir to the French throne, and grand master of the Priory, to which he gave a fictitious pedigree. (He was really descended from peasantry.) In the mid-20th century, he set up an association called the Priory of Sion — trouble was, it wasn't a secret society at all, but a very public tenants' association. The "Sion" referred to a location between Annecy and Geneva! Well, never mind. In the late 1950s, he and some other crazies forged some documents about the fictitious Priory, including the illustrious list of its grand masters and a fake genealogical history of the Merovingians, and planted them in the French National Library. A bunch of French books examining these documents, as well as a 1996 BBC documentary, debunked Plantard's scam. A few people still claim to represent

the Priory, but most scholars believe that the Priory of Sion was a fake society that never existed — except in Plantard's head. But it sure captured Brown's imagination, didn't it?

Still, evidence of two more or less unrelated Sions does seem to exist. First, crusaders built a medieval Church of St. Mary in Sion in 1099, over the ruins of an earlier Byzantine church called Hagia Sion. This church has absolutely no relation to the Knights Templar. Evidence also suggests that a Priory of Sion emerged in late 19th-century France, set up as a right-wing group that fought against representative government, but which then disappeared.

Evil societies: Opus Dei Dei Dei Dum

The Da Vinci Code portrays Opus Dei as a powerful group of sadistic extremists and brainwashers, stubbornly resorting to murder to get their way. Brown suggests that Opus Dei bailed out the Vatican bank in return for its establishment as a personal *prelature,* or office of the clergy. In the novel, an albino Opus Dei monk assassinates those who guard the secret about the union of Jesus and Mary Magdalene and tortures himself to atone for circumstances beyond his control.

Like many other groups and subjects, Brown casts Opus Dei in a negative light. In reality, the group is a conservative worldwide network of Catholic priests and laity. Some more liberal Catholics have targeted the group as elitist and overly influential in Church politics. But when Pope John Paul II canonized Opus Dei founder Jose Maria Escriva de Balaguer, a Spanish Catholic priest, in St. Peter's Square in 2002, dissenters quelled their complaints, as canonization further validated the organization. But then again, the situation could all be one big conspiracy, couldn't it?

For Opus Dei's own defense of itself in light of *The Da Vinci Code*'s claims, go to their official Web site: www.opusdei.org.

P. S. No one in Opus Dei is a monk, and nobody wears a habit.

If you're royalty, I'm definitely royalty: The Merovingian line

Brown ties the Priory of Sion directly into the Merovingian bloodline. I don't need to rehash the story once again — just know that Mary Magdalene ended up in what is now southern France with her daughter. In the fifth century, their holy blood entered into the Merovingian dynasty that took power in France after Rome's fall. The last Merovingian king was deposed in 751, but that fact didn't prevent the line from spawning in secret and threatening the Church — secrets well guarded by the Priory of Sion.

You should get one thing straight. The Merovingian line really *did* exist, but its offspring weren't quite as enlightened as Brown would have you think. They didn't have mystic healing powers, for example. Nor did they found Paris. This honor goes to the Celtic Gauls in the third century BC. But the Merovingians did name Paris as the Frankish Kingdom's capital in AD 508. Finally, after the Merovingians fell in 751, no new blood entered its lineage.

Onward Gnostic soldiers: The Knights Templar

Unlike the Priory of Sion, the Knights Templar really did exist, even if most historians agree that they had absolutely no connection whatsoever to Mary Magdalene or any of her secrets, including the holy grail, as Brown implies. As the story goes, the Priory and Knights Templar shared the same grand master until 1188, after a strange but insignificant fight.

In reality, the monastic order of the Knights Templar, more officially known as the Order of the Poor Knights of Christ and Temple of Solomon, was founded in the 12th century AD by French crusader knights to protect pilgrims traveling from Europe to the Holy Land. These warrior monks, stationed along the major trade routes, soon became independent local bishops, answerable only to the powerful papacy. As they expanded, they became rich through banking.

The Knights are rumored to have, in their journeys, uncovered many relics of Christendom, including the holy grail. (Brown incorrectly speculates that the source of their wealth derives from some valuable secret they held concerning the excavation of Christ from the site of the Jewish temple; perhaps the Knights blackmailed the Vatican, or the Vatican bought their silence.) In this view, supported by some 19th-century scholars, the holy grail wasn't a cup at all, but Gnostic knowledge. Back to that idea. Not surprisingly, no proof exists. Nor did the Knights, as Brown asserts, build Gothic cathedrals to record the sacred feminine.

As far as their grisly fate: The jealous French king Philip II imposed all sorts of rules on the Knights Templar, squelched their power, and seized their assets in 1307 — on Friday, October 13, to be exact, which is one theory about where the bad luck tag attached to Friday the 13th derives. Brown casts all the blame for the Knights' mass burnings on Pope Clement V, referring to the Vatican as the source of all papal decisions. But as you see in Chapter 2, at this time the pope lived in Avignon, France, not Rome, so the Vatican couldn't have made all the decisions! Once again, Brown gets his facts wrong about the source and location of power.

Back to the Main Man — Leonardo!

So where does Leo fit into the story? Well, his ghost, though it doesn't rise from the dead or anything like that, hovers over the entire novel. Brown cites Leonardo as the author of the "codes" because, as former grand master of the Priory of Sion (which never really existed; head to the section "Secret sects: The Priory of Sion), he supposedly placed secret clues, symbols, and hidden anti-Christian messages pointing to the truth about Christianity in his paintings. Thus, understanding his life and art is crucial to the quest of Langdon and Sophie.

Knowing what you know about Leonardo's life and work (that is, if you've read the rest of this book), you couldn't possibly reread *The Da Vinci Code* with a straight face. Some fast-paced writing and thrilling subplots will keep you turning the pages, but they mask many exaggerations and half-truths about the artist, inventor, what have you.

Fun — and fallacious — facts

Consider some simple facts about Leonardo's life (as compared to Dan Brown's claims in *The Da Vinci Code*).

- **Leonardo's art is on the skimpy side.** Brown refers to Leonardo's massive output of Christian art and "hundreds of lucrative Vatican commissions." No doubt people mourn the fact that for such a prolific sketcher, Leonardo could've shown a little more dedication to his craft and left more paintings for posterity. But as you well know by now if you've read just about any other chapter in this book, Leonardo was anything but a prolific artist. All told, he has a few shy of 30 existing, individual pieces of artwork (not including his drawings). In addition, Leonardo spent very little time in Rome. While he was there, he didn't receive hundreds of commissions from Pope Leo X, but conducted mostly scientific experiments.

- **Leo's sexual preferences are in the gray.** Brown calls Leonardo a "flamboyant" homosexual. No solid proof, even with his (dismissed) charges of sodomy and close friendships with male students, says that Leonardo was gay. His sexual orientation may forever remain a mystery.

- **Leonardo's religious beliefs aren't crystal clear.** No one's quite certain about Leonardo's exact religious beliefs (go to Chapter 13 for a little bit about that subject), but in Brown's hands, he comes off as a rebellious genius, obsessed with rejecting Christianity. Yet no evidence shows that Leonardo opposed the Catholic Church or was radical in his spiritual beliefs and slightly anticlerical sentiment. Brown writes that Leonardo lived "in an age when science was synonymous with heresy." Certainly, as a scientist, Leonardo experienced some tension with church officials over dissections, for example. However, the church often supported

scientific research during the Renaissance. And Leonardo kept an open mind about exploring the world around him, using his experience in nature as a starting point for comprehending a larger God or force behind nature's complexity.

Leonardo was more likely a product of his time. He included the typical religious and cultural iconography of the Italian Renaissance in his paintings (find out more about his religious-themed paintings in Chapter 13). He even added some of his own interpretations. But Leonardo's rather ambiguous religious beliefs in no way point to an embrace of the "darker arts," as Brown claims. In his notebooks, Leonardo instead expressed a sort of disdain for astrology, black magic, and alchemy (though he conceded that the latter was useful for chemistry). Leonardo's eccentricities (such as his interest in cadavers) by no means gave him "an admittedly demonic aura." By all accounts, he was a rather friendly, handsome dude.

✔ **Leo couldn't have been part of a group that didn't exist.** Brown claims that between 1510 and 1519, Leonardo served as grand master over the Priory of Sion, and that he was fascinated with goddess iconography, paganism, feminine goddesses, and disdain for the church. As the earlier sections make clear, Leonardo had nothing to do with any of these things associated with the Priory, because the entity is fictitious. Leonardo did, however, display some interest in pagan themes, as his painting *Leda and the Swan* shows (see Chapter 10).

Uncovering the hidden clues in his art

How accurately does Brown portray Leonardo's art? Did the artist, in fact, leave secret messages about Jesus and Mary Magdalene's marital life together? Or is Brown just leading one big campaign smear against poor Leo, finding arcane religious messages at every turn? Take a look at Leonardo's artwork to find out.

Virgin of the Rocks

Brown claims that the painting *Virgin of the Rocks* (the Louvre version, anyway — two versions exist, and the other one is in the National Gallery in London) contains "explosive and disturbing details" and anti-Church messages. As a result, he says, the Confraternity of the Immaculate Conception that commissioned it rejected it. Not true. Actually, Leonardo didn't finish the painting and ended up in a lengthy lawsuit over it (refer to Chapter 13). Here are some other fine details about the painting (from Brown's perspective) that don't hold water:

✔ **John the Baptist was the real CEO.** Brown misidentifies the sitters in the painting. He mixes up baby Jesus and John the Baptist, which allows him to claim that the baby John blessed Jesus. According to the author, this idea shows John's authority over Jesus, when, in fact, the reality is

the other way around! By mixing up his characters, Brown suggests that Leonardo thought that the Church of John, whatever that was, operated as a parallel church at the time of Christ. As a result, Jesus may have suffered from some sort of inferiority complex!

✔ **The hand that rocks the cradle. . . .** Brown attributes deep, menacing meanings to the angel Uriel's hand and the Virgin Mary's, which hovers over Jesus's head. How about protection?

Want more? Here are some other tidbits Brown got wrong about the *Virgin of the Rocks:*

✔ **The nuns did it.** Brown talks about nuns commissioning the painting (which he calls by its other name, *Madonna of the Rocks*). In fact, the Confraternity housed only men.

✔ **You can fold it up and put it in your pocket.** In one spicy scene, the character Sophie uses Leonardo's *Virgin of the Rocks* as a shield around her body. However, the tall painting, about 6½ feet high and in a wooden frame, would *never* have bent. Sophie would have to be an Amazon woman to wield it as a weapon — or even lift it up, for that matter.

The Mona Lisa

Brown goes on and on about the *Mona Lisa*'s true identity. He claims that Lisa is really Leonardo — in drag. According to him (and his characters like Langdon), this idea points to her androgynous nature and the true nature of Christianity and Mary Magdalene's early leadership.

What better way to fit into Brown's thesis about the *sacred feminine,* the divine fusion of both male and female (also the symbol of the womb, the wellspring of life, and a revitalized form of ancient goddess worship), than accusing poor Lisa of androgyny? To muddle the situation further, Langdon points out that the name *Mona Lisa* is an anagram of the names of Egyptian gods of fertility: Amon (male) and Isis (female), marking the divine union of the sexes. Hence the reason for that secretive smile, right?

Not quite. Although Leonardo lugged the portrait around with him until his death, he didn't name it *Mona Lisa.* Giorgio Vasari, Leonardo's first biographer, did. Scholars have also established that the *Mona Lisa* isn't a self-portrait, but most likely the wife of a Florentine man named Francesco del Giocondo. (For more insight into Lisa and her smile, turn back to Chapter 11).

The Last Supper

Brown takes liberties when discussing Leonardo's *The Last Supper.* He bases his misconceptions about the painting on those introduced in *The Templar Revelation* by Lynn Picknett and Clive Prince and in *Holy Blood, Holy Grail* by Michael Baigent, Richard Leigh, and Henry Lincoln — books that inform many of Brown's claims about Christianity and the sacred feminine in general.

Leonardo, maker of torture machines?

In Dan Brown's *The Da Vinci Code,* the main character, professor Robert Langdon, observes that Leonardo created "horrific, never-before-imagined weapons of war and torture." Yes, it's true; Leonardo did forsake his antiwar stance for jobs with Duke Ludovico Sforza and General Cesare Borgia. Although he drew hundreds of designs for battle, his notebooks don't have evidence of any torture designs — unless, of course, you consider making several men run on a treadmill to power a rapid-fire crossbow machine torture. (For a look at some of these designs, go to Chapters 7 and 8.)

Brown bases his analysis of *The Last Supper* on his assumption that Jesus and Mary Magdalene were hitched. Once again, this idea fits into his thesis about the Church's big coverup. Folks, here's the proof according to Brown:

✔ **Jesus's leading lady is at his right hand.** If you thought that blondish bombshell to Jesus's right (actually the left, when you're looking at the painting) is the Apostle John, think again. Brown argues that the figure seated to Jesus's right is *not* John, as is commonly thought, but Mary Magdalene. In this painting, Leonardo supposedly communicated his knowledge of their marriage and his belief that Mary, not Peter, was the true leader of the church. The clues? Langdon and Sophie find significance in the *M* shape seen in the composition of figures John, Jesus, and Peter. This *M*, of course, stands for Mary Magdalene. The *V* shape between St. John/Mary and Jesus represents the grail, the chalice, and the female womb, according to the character Teabing (the windbag), a scholar elucidating matters of religion to Langdon. The quest for the holy grail is, by extension, the quest for Mary's final resting place.

You can't deny that John does have some feminine traits, with his luscious long hair, soft face, and delicate paws. So what? Leonardo explains his decision to depict John as younger and less manly in his *Treatise on Painting,* where he discusses the different types of people. Each person should be painted according to his or her age and lot in life, he wrote. In typical Renaissance art, artists portrayed a protégé as very youthful, longhaired, and clean-shaven. Leonardo's John in *The Last Supper,* far from being a disguised Mary Magdalene, conforms to this type.

Besides, if John is really Mary, then where's John?

Oh, and P. S. According to Teabing, only special people — those possessing *gnosis,* or the "truth" — see Mary Magdalene in the painting.

✔ **Peter is one malicious man.** In the painting, Brown interprets Peter (the pointing man leaning in between Jesus and Judas; Judas's face is in shadow) as supposedly wielding a threatening knife, leaning in to Jesus (and by extension, his wife) with evil intent. Oh, stop the nonsense already and see for yourself. Peter's just trying to defend his main man, not kill him!

> ✔ **The grail isn't what you think it is.** Leonardo didn't include a chalice in the painting, which only reinforces Brown's claim that the holy grail wasn't a chalice, but Mary Magdalene's womb. Scholars ask why Leonardo *should* have included a chalice, a special cup for Jesus, which differed from the other apostles' cups. Brown apparently forgot that *The Last Supper* depicts the moment following Jesus's announcement that one of his fellas would betray him — *not* the moment of the Eucharist, though each apostle has a cup and some bread in front of him for further instruction. Still, Brown gets clever, pointing out that the French expression for the holy grail is *San gréal,* a play on *Sang réal,* which means "royal blood."

Adoration of the Magi

Langdon alludes to the preparatory drawing *Adoration of the Magi* and gets his facts about aspects of the work mixed up, just like he does with other Leonardo paintings.

Art historians agree that a layer of painting over Leonardo's original drawing may hide some of his original work. For years, the art world was in arms about removing this layer. Brown, in line with his argument that Italian museums are fearful of uncovering potentially antireligious or heretical art that could point to a devastating truth, cites this reason as the major controversy over restoration. But as ArtWatch International's successful efforts to halt restoration show, the real debate centered on whether to keep the painting in its "original" state. In the end, the Uffizi decided to abandon its plans to restore the masterpiece.

Hot on the Trail, from Paris to London

Join the herd. Follow in the footsteps of Langdon and Sophie as they race through France and Britain, passing cultural landmarks along the way. Better yet, take one of the many tours that have cropped up since *The Da Vinci Code* reached Europe. It'll cost you a pretty penny, but so what? You *do* know where the holy grail is by now, right?

Here's what you'll see along the way, starting in France.

The Louvre: The novel starts and ends at the Louvre. As Paris's largest museum, it houses one of the major art collections in the world. You'll find the *Mona Lisa* at the end of the Grand Gallery, a vaulted passageway 1,500 feet long (the painting is scheduled to move into its own room in 2005).

If you sign up for the "Cracking *The Da Vinci Code*" tour at the Louvre, the new hit tour, this is what you'll learn:

> ✔ The Grand Gallery, where Saunière is killed, does have a nice parquet floor.

> ✔ The gates, bathrooms, and some other rooms don't exist in locations that Brown described.

✔ You can't fold or rip Leonardo's *Virgin of the Rocks* (like Sophie does in the novel); it's wood.

✔ *Mona Lisa* is most likely a woman, not a man.

You can follow Langdon and Sophie as they escape capture at the Louvre by darting around the Place de la Concorde in Sophie's Smart Car.

The Tuileries Gardens: Why not take a leisurely walk through these gardens? Never mind that Brown describes Langdon's journey south from The Ritz to the Louvre past the Opera House, which lies north of The Ritz, and through the Tuileries — which means that he'd have had to drive up and down several flights of stairs!

Palace Vendome: See what Langdon saw! From this 44-meter-high (144-foot-high) column near the Ritz Hotel, Langdon darts off to follow his hunches regarding the location of the holy grail.

Saint Sulpice: Langdon and his sidekick never make it here, but Silas, the red-eyed albino villain and obedient Opus Dei assassin, does. He believes that a keystone leading to the holy grail is buried beneath the obelisk and brass strip. This strip is called the Rose Line, which traverses the width of the church. The Church of Saint Sulpice lies in between the Saint Germain–des Pres neighborhood (the perfect place to upgrade your wardrobe) and the Luxembourg Quarter. Started in 1646, Saint Sulpice is the largest and most ornate Jesuit-style church, offering a contrast to the Gothic Cathedral of Notre Dame.

Château de Villette: In the French countryside north of Paris lives Sir Leigh Teabing, a wealthy man who's built his career studying the holy grail's symbols and myths. Built in the 17th century and known as "Little Versailles," the château remains one of the most magnificent estates in France.

Now, cross the Chunnel to Britain and visit these places.

Temple Church: The Knights Templar supposedly built this temple, one of London's lesser-known churches off Fleet Street. The building is modeled after the Church of the Holy Sepulchre in Jerusalem.

Westminster Abbey: Pay homage to Sir Isaac Newton! You can also relive the scene where Teabing is arrested. Finally.

Rosslyn Chapel: The holy grail possibly rests in this 15th-century chapel, located near Edinburgh. Funny coincidences regarding Sophie and her long-lost family occur here as well (can't give away everything, can I?).

Part VI
The Part of Tens

In this part . . .

Want to know more about Leonardo's manuscripts, famous paintings (and their homes), where to go to find out more about him, and some zany trivia about the man? More fun awaits you in the following pages.

Chapter 16

Leonardo's Ten (Or So) Manuscripts

. .

. .

*L*eonardo left only a few completed paintings, but he was *not* a man of few words. He regularly downloaded everything from his brilliant head, from sketches to personal experiences and grand theories of art. In fact, more than 7,000 pieces of paper in different manuscript collections hold his ideas — though historians believe that only about one-fourth to one-third of Leonardo's manuscripts survive today. Taken together, these pages form a sort of portrait of the artist, engineer, and inventor — and offer the most complete look into one Renaissance mind.

On the downside, Leonardo's manuscripts are anything *but* a traditional, chronological biography. First, he wrote his musings in his characteristic mirror writing (he wrote from right to left instead of from left to right). On more than a few occasions, he scribbled over existing passages or drawings with new topics and sketches and added tiny notes in even tinier corners of space. This method explains why some of his manuscript pages sometimes range over the entire course of his career.

Then you have the organizational nightmare. When Leonardo died in France in 1519, he left all his manuscripts and drawings — supposedly in some sort of order — to his favorite student, Francesco Melzi. Melzi returned all his master's papers to Italy and started to reorganize them, but when *he* died around 1570, Leonardo was out of luck. His papers scattered far and wide to friends and collectors throughout Europe. Not only did most people have no idea of the manuscripts' importance, but some also took it into their hands to chop up Leonardo's original notebooks and cut and paste according to their whimsies, thus creating new notebooks. Given this utter chaos, many of Leonardo's manuscripts were rediscovered only in the 20th century.

In this chapter, I give you a quick rundown on the most well-known collections, from their travels since Leonardo's death to the sketches and notes they contain to where they sit today.

Codex Atlanticus

In the 16th century, Pompeo Leoni, a sculptor at the King of Spain's court, dissected a few of Leonardo's original manuscripts and separated out all the scientific and technical drawings. He then assembled them into a large-format book similar to an atlas *(atlanticus)*. Leoni effectively created the largest (and most important) collection of Leonardo's papers, spanning his entire career and marking his contributions in every area. After his death, Count Galeazzo Arconati purchased the manuscripts and donated them in the 1630s to the Biblioteca Ambrosiana, a major research library in Milan. In 1796, Napoleon Bonaparte whisked them away to Paris, but they returned to Italy in the 1850s. The 12 leather-bound volumes (totaling about 1,200 items) contain notes that Leonardo made between c. 1478 and 1518 and include the following:

- Studies of mathematics, geometry, astronomy, botany, zoology, and hydraulics
- Notes on the theoretical and practical aspects of painting, including perspective and light and shade
- Studies of paintings *(Adoration of the Magi, Leda and the Swan,* and *The Battle of Anghiari)* and the Sforza and Trivulzio equestrian monuments
- Sketches of military machines, work machines (including the self-moving car), vessels, and flying machines
- Architectural and urban plans, from the urban renewal of Milan to a new Medici Palace in Florence and the Romorantin residence in France

The *Codex Atlanticus* is located at the Biblioteca Ambrosiana in Milan.

Codex Arundel

After the *Codex Atlanticus,* the *Codex Arundel* (c. 1492–1516) is the most impressive manuscript collection. Like other notebooks, it was assembled after Leonardo's death from loose papers — but not according to chronology or subject matter. Art collector Thomas Howard, the Earl of Arundel, probably acquired the manuscript in Italy in the 17th century. In 1681, his grandson passed it on to the British Royal Society, which, in 1831, transferred it to the British Library in London.

This manuscript comprises 238 sheets of various sizes, including Leonardo's description of the prehistoric sea monster and cavern; his studies of weights, balances, friction, light, sound, mirrors, optics, and hydraulics (including some sketches of diving equipment); his drawings of war machines, including the armored car; a collection of allegories and popular proverbs; drawings and notes on the moon's reflection of light; and plans for the royal residence at Romorantin, France, for King François I.

Codex Ashburnham

The *Codex Ashburnham* (1489–92, Institute de France, Paris) includes two cardboard-bound manuscripts. Discovered in the 19th century as part of *Codex A* (which I discuss in the following section), from which they were torn, this codex includes pictorial studies and assorted drawings. The codex contains a few anatomical drawings, but consists mostly of architectural sketches, including Leonardo's domed churches and other church plans.

Codices of the Institute de France

The *Codices of the Institute de France* (c. 1492–1516, Institute de France, Paris) are actually a series of notebooks that go by the letters *A* through *M*. They're preserved in their original format (paper manuscripts, bound in parchment, leather, and cardboard) and contain over 2,000 pages of material, including studies and sketches of military machines (like the assault battleship), mechanics, optics, and geometry; musings on bird flight and drawings of bird wings; studies of hydraulics and some diving equipment (such as the webbed glove); and notes on painting and architecture (Leonardo's temples and ideal city).

Codex "On the Flight of Birds"

This codex, located in the Biblioteca Reale (Turin, Italy), reflects Leonardo's obsession with observing nature — in this case, birds — and then applying natural phenomena to human actions and abilities — in this case, flight. This codex, which was pulled together out of various sheets of Leonardo's notebooks and assembled by Carlo Alberto of Savoy around 1840, marks his second phase in studying flight. Reflecting Leonardo's observations and musings in 1505 and 1506, this codex contains notes and sketches on the flight of birds, including mechanics, air resistance, winds, currents, motion, anatomy, and comparisons between birds and machines. It also includes some notes on mechanics, botany, architecture, and water.

Trattato della Pittura (Treatise on Painting)

Leonardo probably wrote his *Trattato della Pittura* (also known as *Libro di Pittura*, or *Codex Urbinas Latinus 1270*) for his students in Milan, possibly at his patron (and duke of Milan) Ludovico Sforza's instructions. After his death, Francesco Melzi compiled these papers, which have become the most celebrated of all of Leonardo's notebooks and one of the most important studies in the history of art. In 1651, these papers came into the possession of Raphael du Fresne, who published them in Italian under the title *Trattato della Pintura;* the work was translated into French the same year. When the treatise was published in entirety in 1651, a series of engravings by French Baroque painter Nicolas Poussin (1594–1665) and a set of geometrical designs by Florentine painter and sculptor Leon Battista Alberti (1406–72) accompanied it.

The *Tratatto della Pittura* (published in 1651 in Paris; the original manuscript version, originally held in the duke of Urbino's collection, is now held in the Vatican Library in Rome) contains notes on perspective; elements of good composition; the human form; expression of various emotions; effects of light, shadow, and color; the art of inventiveness and artistic form; and the need for constant study and practice.

Madrid Manuscripts 1 and 11

The Madrid Manuscripts I and II, reflecting Leonardo's work during 1490–96 and 1503–5 respectively, are housed in the National Library, Madrid, and were discovered only in the 1960s due to an error in the library's catalogue. Although it's unclear how these papers ended up in the National Library, it's possible they were originally part of the larger collection of Pompeo Leoni, sculptor at the court of the king of Spain. The manuscripts remained in Spain while others (like the *Codex Atlanticus*) scattered elsewhere. The two paper manuscripts of about 700 pages are bound in leather and contain Leonardo's studies of mechanics (including the robot!), hydraulics, and geometry; architectural notes and sketches; notes on painting; and discussion of the casting of the Sforza equestrian monument.

Codex Trivulzianus

The 55 sheets that comprise *Codex Trivulzianus* (c. 1487–90, Trivulziana Library, Sforza Castle, Milan) include architectural drawings related to the construction of the Milan Cathedral; drawings of real and imaginary portraits;

notes on religious themes; notes on Leonardo's self-taught efforts in literature; and notes on how to organize (and standardize) the Italian language, including word lists for language and interpretations of classic Renaissance texts.

Codex Leicester

A painter discovered the *Codex Leicester* manuscript (which, for some reason, Melzi didn't inherit) in an old storage chest in Rome in 1690. He sold it to Thomas Coke, the Earl of Leicester (hence its lasting name), in 1717. The family held on to it until 1980 when American oil magnate Armand Hammer purchased the manuscript from Christie's (the famed auction house) and renamed it after himself. In 1994, Microsoft chairman Bill Gates bought it for $30.8 million, restored its original name, and displayed the manuscript around the world (it's still part of his private collection). The manuscript is a near-complete synthesis of Leonardo's views on nature, as shown in the backgrounds of his paintings.

The 18 leather-bound sheets, folded into 72 pages that comprise *Codex Leicester* (1506–10) contain Leonardo's studies of hydraulic engineering (including dams and submarines) and his observations on the nature of water in rivers and seas; astronomy (reflected light, cosmology, and celestial light); and geology (fossils, erosion, water, and natural disasters). They also hold a record of work on the Sforza equestrian monument and personal observations of travels through Tuscany and Lombardy.

The Forster Codices

The Forster Codices actually include three notebooks: *Forster I* (c. 1487–90, 1505), *Forster II* (c. 1495–97), and *Forster III* (c. 1493–96). Melzi inherited these three small notebooks, which, after his death, passed into the hands of Pompeo Leoni (the guy who organized the *Codex Atlanticus*). They somehow reached Vienna, and in the 19th century, Earl Edward George Lytton purchased them; after the earl's death, John Forster inherited them. In 1876, Forster bequeathed them to the Victoria and Albert Museum in London.

These parchment-bound paper manuscripts contain studies on Euclidean geometry learned under Luca Pacioli, the famed mathematician, and hydraulic machines; notes on physics (force, gravity, weight, and movement) and grammar; sketches of horses for the Sforza equestrian monument; designs for masquerades and ornamental knots and plaits; and jokes, fables, and parables. Interestingly, they also list the expenses for the burial of "Caterina," who may (or may not) have been Leonardo's mother (refer to Chapter 3).

Windsor Castle Royal Library Collection

The papers from the Windsor Castle collection — about 600 unbound draw-ings, produced anytime between 1478 and 1518 — entered the collection of Charles I of England around 1630. They contain the bulk of Leonardo's anatom-ical, animal, and plant studies. Anatomical drawings and proportion studies make up the lion's share, but the papers also include drawings of horses and other real and imaginary animals; studies for the Sforza horse, the *Anghiari* horses, and the Trivulzio horse (see Chapter 3); drawings of flowers, plants, water, and mountains (for the *Leda* series; see Chapter 6); and the blue chalk mountain series, Adda River series, and Deluge series (see Chapter 12).

This collection is currently part of the Royal Collection at the Windsor Castle.

Manuscripts in Other Collections

Other manuscripts and loose sheets reside in many public and private col-lections, including the Louvre in Paris, the Royal Academy and the British Museum in London, the Ashmolean Museum at Oxford University, the Galleria degli Uffizi in Florence, the Metropolitan Museum of Art and the Pierpont Morgan Library in New York, and the Gallerie dell'Accademia in Venice.

Chapter 17

Leonardo's Top Ten Masterpieces

When Leonardo died, he had only three of his paintings in tow: the *Mona Lisa, The Virgin and Child with St. Anne,* and *St. John the Baptist.* The rest of his paintings were already jet-setting throughout Europe, and as I explain in Chapter 16, only a fraction of them survived. If the adage that scarcity creates value is true, then each of Leonardo's existing paintings is priceless indeed, and the works that remain are surely masterpieces.

Ranking Leo's paintings would be pointless, as they're all masterpieces in their own right. Historians disagree about many ideas, including authorship and the relative ranking of a painting. Still, they've come to a general consensus about which paintings constitute Leonardo's greatest works. So here they are, presented in a rather indefinite order.

Mona Lisa

Date of Creation: Between 1503 and 1506

Eight-five percent of all Europeans think that the *Mona Lisa* is the most famous painting in the world — so I'll take them at their word. Leonardo must have liked her quite a bit as well, because he lugged her around until his death.

You can find the *Mona Lisa* at the Louvre Museum in Paris. The most common question visitors ask when they enter the museum is "Where is she? You know, *her,* the *Mona Lisa*." She's famous for her seductive, mysterious, and [add adjective] smile, Leonardo's mastery techniques, and her iconic status. By 2005, the *Mona Lisa* will be the only painting in the Louvre to have her own room. And by international agreement, she'll never leave her home again. Move over, siblings, and make room for grand dame. For detailed information about the *Mona Lisa,* go to Chapter 11.

The Last Supper

Date of Creation: Between 1495 and 1497

Duke Ludovico Sforza commissioned one of Leonardo's most famous, yet worst preserved, paintings for the north wall of the refectory at the Monastery of Santa Maria delle Grazie, Milan. The painting was an immediate success — and an even faster failure when it started to deteriorate.

Today, after a painstaking 20-year restoration effort, the refectory is again open to the public. You can now view what's considered the archetypal Renaissance "fresco" painting (though it's not a true fresco — he used a mix of oil and tempera on dry plaster, instead of applying paint to wet plaster) for its sophisticated use of perspective; emotional, expressive figures; and an unusual scene. Read more about *The Last Supper* in Chapter 14.

Burlington House Cartoon

Date of Creation: Between 1499 and 1500

The *Burlington House Cartoon* is only a sketch, to be sure, a drawing in charcoal and chalk of the infant Christ, Mary, St. Anne, and a baby St. John. But Leonardo's use of a pyramidal structure and the inner emotions radiating from the figures make it a truly remarkable work.

You can read more about the *Burlington House Cartoon* in Chapter 13, and if you find yourself in London, meander on over to the National Gallery, the drawing's current home.

The Virgin and Child with St. Anne

Date of Creation: Between 1508 and 1510

Leonardo painted *The Virgin and Child with St. Anne* between 1508 and 1510. Despite the awkward poses of the Virgin and St. Anne (what's the Virgin *hiding* under that muumuu-like garb?), this oil painting is, again, considered highly realistic and innovative for its time. Head to Chapter 13 for more details.

Like the *Mona Lisa*, *The Virgin and Child with St. Anne* is also in the Louvre, Paris.

Adoration of the Magi

Date of Creation: Between 1481 and 1482

Leonardo clearly had some mind block against actually finishing things, but even his half-completed paintings (such as this one) are among the most famous in the world. This Adoration scene, half-finished in brown ink and yellow ochre groundwork, is recognized as one of Leonardo's most important works for its combination of religious and pagan themes, use of perspective, and highly realistic, expressive figures. You can read more about *Adoration of the Magi* in Chapter 13, and you can find the actual painting at the Uffizi Gallery in Florence.

Virgin of the Rocks

Date of Creation: Version #1: Between 1483 and 1486; Version #2: Between 1495 and 1508

Leonardo found himself painting two versions of *Virgin of the Rocks*. He fully painted the first of these paintings, meant to adorn a chapel in Milan, between 1483 and 1486. The second, a more mature work that was completed between 1495 and 1508, shows probable workshop production. Both, however, remain unrivaled in their use of light and shadow, depth, and inner wisdom of the subjects.

You can compare the two versions yourself, if you've a mind — and the travel budget. The first version is in the Louvre, Paris; the second in the National Gallery, London. If you want a more immediate comparison, head to Chapter 13.

St. Jerome

Date of Creation: Between 1480 and 1483

Before you start weeping as St. Jerome rends his heart and soul, stop and look! *St. Jerome* is, admittedly, Leonardo's most tragic painting (even though it's only half-completed), rendered during an unhappy time in the artist's life. But be glad for the anatomical precision, the use of light and shadow, and heightened, heartbreaking expression — all which differentiate this painting from others of the time. *St. Jerome* is housed, befittingly, at the Vatican, in Rome. An image of it is also housed in Chapter 13 of this book.

Lady with an Ermine (Cecilia Gallerani)

Date of Creation: Between 1482 and 1483

The lady with an ermine, a young lady of unknown origin — Ludovico Sforza's wife? a mistress? — reflects Leonardo's unique approach to his subjects. He related the ermine, a symbol of virtue and purity, to his subject's chastity. Ironic considering her possible status as mistress, huh? This lady currently lives at the Czartoryski Museum in Cracow, Poland. Check her out in Chapter 11.

St. John the Baptist

Date of Creation: Between 1513 and 1516

St. John's pointy finger is perhaps one of the most copied poses in all of history. That appendage isn't what makes the portrait famous, however. Leonardo's soft modeling, realistic facial features, and contrast between light and dark marked *St. John the Baptist* as revolutionary for Renaissance painting. You can find this painting at the Louvre, Paris; flip to Chapter 13 for more information.

Ginevra de' Benci

Date of Creation: Around 1474

Leonardo painted *Ginevra de' Benci,* one of his earliest paintings (c. 1474), when he was still working, somewhat, with Andrea Verrocchio. Despite Ginevra's sulky countenance (she was about to be married, nonetheless!), the portrait is one of the best-preserved Leonardos and, though less famous than the *Mona Lisa,* shows his evolution as a painter. *Ginevra de' Benci* is housed at the National Gallery in Washington, D.C. See her for yourself in Chapter 11.

Chapter 18

Ten Plus Places to Find Leonardo's Original Works

*I*f you happen to be in the neighborhood — say, Paris; London; Washington, D.C.; or Munich, among other cities — why not see Leonardo's handiwork in the flesh? Consider this chapter your field guide to original Leonardos.

The Louvre Museum, Paris

The Louvre houses the world's largest collection of paintings attributed to Leonardo. The great museum, initially built as a fortress near the Seine riverbanks in the 13th century as a residence for French monarchs, started in Charles V's library. His successor, François I, started a new collection of art with 12 paintings from Italy, including Leonardo's *Mona Lisa* and a few by Raphael and Titian. The collection expanded under Louis XIII's reign; by the early 18th century, it contained more than 2,500 pieces of art.

The idea of an actual museum originated with Louis XVI, and in 1793, Musée de la République opened. The Napoleonic wars temporarily enriched the collection. In 1848, the museum became the property of the state. Today, it holds nearly 300,000 works. Its most famous recent addition is I. M. Pei's famous but controversial glass pyramid main entrance, which opened in 1989.

You can find these works of Leonardo in the Louvre:

 ✔ *Mona Lisa* (1503)

 ✔ *The Virgin and Child with St. Anne* (c. 1508–10)

 ✔ *Annunciation* (attributed to Leonardo and Lorenzo de Credi, 1478–82)

- *St. John the Baptist* (1513–16)
- *Virgin of the Rocks* (first version, c. 1483–86)
- *Bacchus* (also known as *St. John in the Wilderness,* c. 1510–15)
- *Portrait of an Unknown Woman (La Belle Ferronière)* (c. 1490–95)
- *Portrait of Isabella d'Este* (c. 1499)
- *Battle of Anghiari* (copy by Peter Paul Rubens, c. 1603)

Uffizi Gallery, Florence

Construction of the Uffizi palace began in 1560, under Duke Cosimo I de' Medici. Cosimo I commissioned Giorgio Vasari, painter and architect at the Medici court and famed biographer, to construct the building. Even though Vasari started it, the Uffizi took a few hundred years to complete. Today, this building is one of the most famous museums in the world. It's also home sweet home to a few of Leonardo's paintings:

- *Baptism of Christ* (c. 1472–75)
- *Annunciation* (attributed fully to Leonardo, c. 1472–75)
- *Adoration of the Magi* (c. 1481–82)
- *Leda and the Swan* (c. 1505–10)
- *Battle of Anghiari* (copy by an unknown artist, c. 1503–5)

Convent of Santa Maria delle Grazie, Milan

In 1465, Guiniforte Solari started to design a church and monastery, which eventually became the Convent of Santa Maria delle Grazie — *not* a museum in the standard sense. When Ludovico Sforza decided to make the monastery his family's burial place, he hired the architect Donato Bramante to redesign it (he added the apse, cloisters, and sacristy) and Leonardo to decorate it. "Our Lady of the Grace" now holds Leonardo's *The Last Supper,* painted between 1495 and 1498, on the north wall. (I devote a whole chapter to this masterpiece, so head to Chapter 14 for information that you can sink your teeth into.)

Today, the restored *Last Supper* is open to the public, but the monks, their silences, and their food have disappeared. It seems as if everybody and their mothers have been flocking to Milan ever since Dan Brown published *The Da Vinci Code,* so book your reservations to see the restored painting *months* ahead of time. Only 20 visitors can enter the refectory at any given period,

for a maximum of 15 minutes. If you visit, remember to sympathize with the guides. They have an especially tough job now that everyone wants to know if what Brown says is true: Is Mary Magdalene really in the painting, disguised as one of the apostles?

Musei Vaticani, Vatican, Rome

The founding of the Vatican Museums goes back to 1503, when Pope Julius II (Michelangelo's major patron) started decorating the courtyard with statues. Later, various popes organized and consolidated the growing art collection, giving rise to different branches of the museum. Today, the Vatican Museum is an expansive collection of many different museums and collections, ranging in scope and size from the Fabrica of Saint Peter's to the Gallery of Tapestries, Gallery of Paintings, Gregorian Egyptian Museum, Museum of Sculptures, and Vatican palaces, among others. Its highlight is perhaps the Sistine Chapel, but the Pinacoteca Vaticana (a painting gallery) also contains one Leonardo painting, *St. Jerome* (c. 1480–83).

National Gallery, London

One of London's major museums, the National Gallery holds one of the largest and greatest collections of western European paintings in the world — more than 2,300 paintings, in fact, dating between 1290 and 1900. It was founded in 1824 when the House of Commons purchased a collection of 38 paintings from a banker. The permanent gallery was established in 1831 in Trafalgar Square, which gave the masses access to high art. Since then, the museum has expanded and holds two Leonardos:

- *Burlington House Cartoon* (c. 1499–1500)
- *Virgin of the Rocks* (second version, c. 1495–1508)

The Hermitage, St. Petersburg

The Hermitage, the state museum in the heart of St. Petersburg, rivals the Louvre in the size, quality, and splendor of its art — with more than 3 million works! The baroque-style Winter Palace, the main building of the Hermitage completed in 1762, originally housed the Tsars. Peter the Great's private art collection formed the basis for the Hermitage's vast holdings. But Catherine the Great officially "founded" the museum in 1764, when she purchased more than 250 paintings. Her successors, including Nicholas II, who ascended to the throne in 1894, purchased more art from western Europe's aristocracy.

The museum opened to the public after the Revolution in 1917, but under the communist regime, it remained largely unknown to the Western world for many years.

Today, the Hermitage is renowned for its Italian Renaissance painting, including two of Leonardo's works:

- *Madonna Benois* (c. 1475–80)
- *Madonna Litta* (c. 1490)

Alte Pinakothek, Munich

The Alte Pinakothek museum got its start in the 16th century, when Bavaria's rulers began collecting works of art for their homes and palaces. The collection, which expanded over the years to about 800 European paintings from the 14th through the 18th centuries, opened to the public in 1836.

Among other northern and Italian Renaissance paintings, it boasts one Leonardo: *Madonna with the Carnation* (c. 1475–80).

National Gallery of Art, Washington, D.C.

The National Gallery of Art, associated with the Smithsonian Institution, was created by a government charter in 1937 with funds from philanthropist Andrew W. Mellon, who had previously purchased masterpieces from the Hermitage for this purpose. President Franklin D. Roosevelt dedicated the museum in 1941. The west building, housing European masterpieces from medieval times through the 19th century, is neoclassical in design, modeled after the Pantheon. The east building, designed by I. M. Pei (of the Louvre's new entrance), is more geometrical and contains contemporary art.

The west building contains at least one (maybe two) Leonardo paintings, along with some sketches and his *Treatise on Painting*.

- *Ginevra de' Benci* (c. 1474)
- *Madonna and Child with a Pomegranate* (also called *Dreyfus Madonna*, attributed to Leonardo or a follower, c. 1472–76)

Biblioteca Ambrosiana, Milan

Cardinal Federico Borromeo founded the Biblioteca Ambrosiana in 1607, with more than 12,000 manuscripts and 30,000 printed books from western Europe, Greece, and Syria. Along with Leonardo's *Codex Atlanticus* (see Chapter 16) and some other manuscripts, this library (also called the Pinacoteca Ambrosiana) houses one Leonardo painting, *Portrait of a Musician* (c. 1482–90).

Czartoryski Museum, Cracow

The collection at the Czartoryski Museum started in the early 1800s, when Izabela Czartoryski began assembling paintings and works of art for her private enjoyment. The museum, the first in Poland and originally located at Pulawy, was later moved to Cracow. It officially opened to the public in the late 19th century. In 1950, the state took over the museum and its associated library, incorporating both into the National Museum in Cracow. The museum's acknowledged highlight — in fact, the most valuable painting in Polish hands — is a Leonardo: *Lady with an Ermine (Cecilia Gallerani)* (c. 1482–83).

In Private Collections

Over time, private collectors hoarded Leonardo's drawings and notebooks in their own libraries and galleries, some open to the public — others not. In case you're hopeful and have been saving your lottery winnings, Leonardo's priceless paintings never hit the free market. But a few private collections here and there contain a Leonardo painting (or one at least attributed to him or his workshop).

- *Madonna with the Cat* (attributed to Leonardo based on sketches, c. 1480, Noya Collection, Savona)
- *Madonna with the Yarnwinder* (c. 1500–10, Drumlanrig, Scotland)
- *Salvator Mundi* (disputed authorship, c. 1506–13, Salvator Mundi Collection, Marquis de Ganay, Paris)

Extra, extra! Leo's workshop found in Florence!

In January 2005, researchers discovered a possible long-forgotten workshop of Leonardo's. It forms part of the Santissima Annunziata convent, which rented out rooms to Renaissance artists, and which the Institute of Military Geography now shares.

The rooms contain 500-year-old frescoes of flying birds, arches, and an outline of an angel resembling the one Leo painted in his *Annunciation,* as well a secret room that Leo possibly used to dissect cadavers.

Scholars conjecture that Leonardo may have used this studio — if, indeed, he did at all — sometime between 1500 and 1503.

Chapter 19

Ten Fun Facts about Leo

In This Chapter

▶ Tidbits from Leonardo's childhood and young adult years

▶ Speculations about his personality

▶ The résumé of a genius

▶ Famous rivalries and partnerships

Leonardo led a very full, very interesting, and very quirky life. In the previous chapters, I discuss in detail the essentials, from Leonardo's days in Renaissance Italy to his contributions to science, art, and mechanics to his religious beliefs and how he incorporated those ideas into his art. In this chapter, I add the frosting to the cake — it never hurts to know a few more little-known (and a few rather odd) facts about this beloved Renaissance man, does it? If nothing else, you can always use these tidbits to impress your friends at dinner parties.

Fresh Out of the Oven: The Story Begins

Not everyone's born under a lucky sign. Leonardo experienced some hardships, many relating to his birth. Yet, he survived, as most adolescents tend to do . . . even if they don't have all the answers.

Leo's first cries were in Italy (but his last were in France — perhaps in the arms of François I!). He was a love child and, as a result, couldn't enter most professions. Scholars speculate that had he been legitimate, he may have been a doctor, not an artist. But he made do with what he was given (and did a pretty good job of it, no less).

Facing Sexual Misgivings (Or Others', Anyway)

Not only did the genius Leonardo get a humble start, but he also had a rough ride at times. As if he didn't get enough bullying for his habitual procrastination

(a quality that I discuss in Chapter 1 and that is *not* to his credit), Leo took flak for a possible homosexual lifestyle, as he lived the singleton's life.

- He was accused of sodomy during his first period in Florence, although the charges were later dropped. This incident may have been one of the factors that contributed to his leaving Florence and heading to Milan.

- He never married or had children. Instead, he hung out with his student and companion, Francesco Melzi, for almost half his lifetime.

- He was the subject of one of Sigmund Freud's most famous case studies on dreams and homosexuality. Sigmund was in the "he's definitely homosexual" camp, but the truth is, Leonardo's sexuality is still up for debate; no one, not even Sigmund the great, has been able to conclusively prove, one way or the other, what Leonardo's sexual preferences actually were.

His Lovable Traits . . .

Yep, he had personality — besides charm, good looks, incredible strength, and unparalleled genius. Leonardo had some respectable qualities that made him endearing.

- He respected all life, animal and human — and was a vegetarian. (Despite his reverence for life, he fashioned himself as a military engineer and got a job designing weapons of war for Duke Ludovico Sforza of Milan. Go figure.)

- He loved maps and walked around towns like Imola, kicking up dust and measuring things.

- He was possibly a *synasthete,* meaning that he could "see" music or "feel" colors, which probably contributed to his artistic genius.

. . . and His Quirky Ones

Although he was amazing, to say the least, Leonardo had a few bad habits and oddities that put him on his own plane (or universe, maybe?).

- He was a perfectionist and terrible procrastinator, rarely finishing what he started. In many ways, these two tendencies conspired against him.

- He stalked handsome, ugly, or otherwise interesting-looking people on the street, recorded their features in his mind, and then drew them. His affinity for interesting visages partly explains why his sketches and portraits of people fall into essentially two camps: the beauties and the beasts — or, in art circles, Leonardo's *grotesques.*

✔ He was a prankster who enjoyed the last laugh. Giorgio Vasari, Leonardo's biographer, relates an incident in which Leonardo painted a monster of lizards, newts, and serpents breathing fire on a shield to scare his father. And in the court of Pope Leo X, Leonardo designed a terrifying lizard with quicksilver wings — which he kept as a pet.

Measuring Leo's Skill Set

There's nothing so special about being a jack-of-all-trades if you're master of none. Leonardo (not to diminish your own skills, of course) was master of all.

✔ He was a skilled musician and played a number of instruments from the lyre to the lira de braccia. He even tried to improve upon them in some of his designs.

✔ He wrote fables, like Aesop's. He used animals to offer lessons about human foibles, from jealousy to greed.

✔ He was a general handyman; in Ludovico Sforza's court, he fixed the plumbing and designed spectacular parties.

✔ He was a true intellectual. He studied everything, from how to square a triangle (basically, find a square with the same area as the triangle), why tree branches grow towards the sun, how rivers deposit fossils, and how birds move their wings.

✔ He carried out dissections, contrary to some of the Church's leanings. He wanted to map the site of the soul on the human body and understand the brain's role in human emotion.

✔ His beautiful angel in the *Baptism of Christ* (see Chapter 13) supposedly made Andrea del Verrocchio abandon painting forever.

Cultivating Those Contradictions

Leonardo was a bundle of paradoxes, which helps explain his genius and, in some ways, makes him more difficult to understand today.

✔ He had a peculiar, backward penmanship, called *mirror writing*.

You may have heard that Leonardo was so secretive about his work that he wrote it backward in Latin, thus making deciphering his musings that much more difficult. Well, that idea isn't entirely true. He did write backward (to find out why, head to Chapter 3), and one of his reasons may have been to protect his ideas from the casual observer, but he *didn't* write in Latin. The reason? Leonardo taught himself Latin only later in life, but probably never mastered it fully, as he was banned from a formal education because he was illegitimate.

✔ He was a pacifist by nature, but drew many military weapons — some of which, as befitting his disdain for war, he designed with faulty parts on purpose so they wouldn't work!

✔ He left thousands and thousands of pages in notebooks, which various people later rearranged loosely according to subjects. But he kept his notebooks a mess during his lifetime, scribbling thoughts about water, for example, next to drawings of figures.

✔ Despite the acclaim he garnered during his lifetime, he left around two dozen paintings.

Rubbing Elbows with Fame

Leonardo achieved great fame during his lifetime, but he also rubbed elbows with the likes of kings, dukes, duchesses, and, of course, the most acclaimed artists and scientists of the Italian Renaissance. Some of his friendships were — how shall I put it? — a little more *unusual*.

✔ He and Michelangelo were notorious rivals. Rumor has it (and Michelangelo recorded it in his letters, and Vasari in his biographies) that Michelangelo, of a younger generation, disdained poor Leonardo for rarely finishing a project. And Leonardo viewed both Michelangelo's profound religious faith, as well as his near-Mannerist artistic technique (theatrical, highly stylized figures), with contempt. They worked together only once, on battle murals for the *Palazzo Vecchio,* the seat of the government in Florence. Neither man finished his mural.

✔ He befriended political philosopher Niccolò Machiavelli, another visionary, while in the service of General Cesare Borgia. Together, Leo and Nick hatched a plan to alter the course of the Arno River. (Machiavelli, a name that is now synonymous with cruel abuse of power, wrote *The Prince,* explaining how a monarch could keep the loyalty of his subjects.)

✔ Although he never found lasting security in any of their courts, Leonardo worked with numerous patrons, from the Medicis of Florence to Ludovico Sforza, duke of Milan, and François I, king of France.

Besting All around Him: Leo's Firsts

Although Leonardo caught the wave of Renaissance innovation and built on many techniques, concepts, and tools, he had many firsts.

✔ He was one of the first Italian artists to use oil paints. He preferred the longer drying time, which enabled him to paint and repaint to his heart's content. He even had his own recipe for his paints.

- He invented the first real robot. It has a human figure dressed in armor and powered by water or weights.

- He was obsessed with flying and sketched flying contraptions and even a parachute (just in case one of his planes was shot down by one of his rapid-fire crossbows, I guess). Had human power not limited his endeavors, the airplane may have existed half a millennium before it did.

- He estimated the diameter of the earth to be about 7,750 miles, which wasn't too far off. (Actual diameter, as measured at the equator: 7,926.5 miles.)

- He wrote in his notebook that the sun doesn't move, a revolutionary concept for the time when people still believed that the earth was the center of the universe *(geocentric)* and all other heavenly objects revolved around it. But in other places in these same notebooks, he still believed in the geocentric theory of the universe.

Taking a Hit: Leo's Failures

His blunders were few and far between, but Leonardo, like you (and me, of course), was only human.

- *The Last Supper* was a disaster. It started to deteriorate almost as soon as he finished it because of the materials he used. Instead of using the traditional water-based paint on wet plaster (a combination known as *fresco*), Leonardo used oil-based paint over a combination of pitch, gesso, and *mastic* (a type of cement). Because of Leonardo's technique, the painting isn't even a real fresco.

- He never wrote any of the treatises he intended to write on myriad subjects, from flight and anatomy to hydrology and geology.

Going Pop: Leo's Leading Lady, Mona Lisa

As any great man does, Leonardo left himself open for some light mockery. It all started when the fine lady was stolen in 1912. The public was clearly upset, but maybe not *that* upset. Soon after her abduction, cartoons showed her eloping with Leonardo, waving goodbye, and thumbing her nose at France. Since then, the fun and games have only increased (and, some argue, vulgarized and devalued the original). Just remember, imitation (or is it insult?) is the most sincere form of flattery.

✔ In 1914, German composer Max Von Schillings wrote an opera titled *Mona Lisa,* which featured Lisa as a *femme fatale* with multiple lovers and a murderous streak.

✔ In 1919, Marcel Duchamp — in the spirit of the Dada art movement, which, among other things, ridiculed traditional art forms — added a mustache and goatee to his rendition of the *Mona Lisa.* He titled his creation the "L.H.O.O.Q.," a French pun meaning, "She has a hot ass" *(elle a chaud au cul).*

✔ In 1922, British writer Aldous Huxley wrote a short story (which later became a TV movie) about a wealthy man and his mistress titled "The Gioconda Smile."

✔ In 1930, French Cubist painter Fernand Léger painted *Gioconda with Keys.*

✔ In 1950, Nat King Cole sang the "Mona Lisa" ballad, a tribute to the painting. His song reached #1 on the charts and sold 3 million copies.

✔ In 1954, Surrealist painter Salvador Dali superimposed his features (including his signature mustache) in his *Self Portrait of Mona Lisa.*

✔ In 1963, Pop artist Andy Warhol recreated (and mass-produced) the *Mona Lisa* in a *serigraph* (silkscreen collage).

✔ In 1977, Colombian artist Fernando Botero painted a chubby Lisa titled *Mona Lisa at the Age of Thirteen* (not so cute).

✔ In 1982, Japanese artist Tadahiko Ogawa recreated the *Mona Lisa* in a toaster, using 65 pieces of white bread. (He went on to recreate Leonardo's *Last Supper* and Botticelli's *Birth of Venus* as well.)

✔ In 1986, Miss Piggy posed as Mona Lisa for Jim Henson Studios.

✔ In 1988, Gary Larsen used Mona Lisa as the model for his *Mona Lisa Cow,* which graced the cover of *The Far Side Gallery 3.*

✔ On February 8, 1999, the *New Yorker* magazine depicted Monica Lewinsky as Mona Lisa.

✔ In 2000, Lego artist Eric Harshbarger created *Mona Lego,* using over 30,000 Legos.

✔ In 2003, Julia Roberts starred in the movie *The Mona Lisa Smile,* about an art professor and her 1950s-era Wellesley students.

Also, consider all the *Mona Lisa* kitsch: T-shirts, jigsaw puzzles, watches, magnets, curtains, ties, beauty cream, pillows, cigarettes, cheese, and cafes and restaurants. Who knows when the Mona madness will end?

Appendix A

A Brief Chronology of Leonardo's Life and Times

• •

The timeline in this appendix reflects information from both archival and contemporary sources; you may see slightly varied dates in different places. And because Leonardo neither dated most of his work nor left complete records of his activities, some of his life's events are approximate.

Key Early Renaissance Events

Lots of important stuff happened before Leonardo was born. In fact, many harbingers of the Italian Renaissance, from the revival of classical literature to the growth of banking and the arts in Florence, set the stage for Leo's career. Sometimes more than one key event happened in a single year; no date appears by the subsequent event(s).

1341 The crowning of Italian poet and humanist Francesco Petrarch (1304–74) as Poet Laureate marks the start of the Renaissance.

1347–51 The bubonic plague (Black Death) sweeps through Italy and Europe, wiping out an estimated one-quarter to one-half of its population.

1397 Giovanni de' Medici, the papal banker, moves to Florence. He founds the Medici Bank and becomes involved in public life and the arts.

1401 The sculptor Lorenzo Ghiberti wins the commission for the northern bronze doors of the Florentine Baptistry.

1420 The papacy returns to Rome from France and starts to rebuild the city.

1434 Cosimo de' Medici (Giovanni's son) begins his 30-year domination of Florence.

1435 Andrea del Verrocchio, Leonardo's master and a renowned Florentine artist, is born.

1447 Pope Nicholas V starts to turn Rome into a Renaissance city by supporting the arts.

1450 Ser Piero di Antonio da Vinci, Leonardo's father, is recorded as a notary in Pistoia.

Francesco Sforza conquers Milan, turning it back into a monarchy after a failed experiment with a republican government.

1451 Ludovico (Il Moro) Sforza — future duke of Milan, successor to Francesco Sforza, and Leonardo's future patron — is born. So is Christopher Columbus.

Leonardo's Life and Work

The following timeline provides key information about Leonardo's life and the context in which he worked, offering information about key family watersheds, the Italian Wars, Leo's patrons and popes, and the general flowering of Italian art and literature.

April 15, 1452 Leonardo (Lionardo) da Vinci is born at Anchiano near the town of Vinci (or, in Vinci) in Tuscany, Italy, as the illegitimate son of a successful notary, Ser Piero di Antonio da Vinci, and a woman, probably a peasant, named Caterina. Shortly after, Ser Piero marries the 16-year-old Albiera di Giovanni Amadori.

1453 Constantinople, the heart of the Byzantine (eastern Roman) Empire, falls to the Ottoman Turks. Greek artists and writers flock to the Italian city-states.

The Hundred Years' War between England and France ends.

1454 Johann Gutenberg, credited with inventing the printing press in Germany, prints the *Gutenberg Bible*.

1457 According to a tax return declared by Leonardo's grandfather, who's living on the Piazzetta Guazzesi (now the Via Roma) in Vinci, Leonardo now resides with his father in their household in Florence. Caterina, Leonardo's birth mother, marries Accattabriga di Piero del Vacca, a lime burner.

1463 Venice begins a 16-year war with the Turks; Venice is eventually defeated.

1464 Albiera, Ser Piero's first wife, dies in childbirth.

1466 The sculptor Donatello dies. The Arno River floods Florence and surrounding areas.

1468 Leonardo's grandfather dies at the age of 96.

1469 Ser Piero da Vinci rents a house in Florence. Leonardo is registered in Vinci on his grandmother's tax declaration. Around this year, or shortly before, Leonardo starts his apprenticeship with Andrea del Verrocchio.

Lorenzo de' Medici (Il Magnifico) and his younger brother Giuliano rise to power in Florence after their grandfather Cosimo's death in 1464 and Piero de' Medici's short rule. Lorenzo rules until 1491, turning Florence into the quintessential Renaissance city.

Niccolo Machiavelli, author of *The Prince,* is born.

1470 Leonardo is registered on the tax declaration of his father, who now resides and works in Florence.

1471 The corrupt Sixtus IV becomes the pope.

1472 Leonardo enters the Company of Painters (the Compagnia di San Luca), indicating the end of his official apprenticeship with Andrea del Verrocchio. He assists with Verrocchio's *Baptism of Christ* and begins the *Annunciation* (see Chapter 13 for both paintings). Verrocchio is hired to install the ball on the dome of the Santa Maria del Fiore (Florence).

The humanist Leon Battista Alberti, one of the Renaissance's major philosophers, musicians, architects, painters, and sculptors, dies.

The first edition of Dante's *Divine Comedy* is published.

1473 Leonardo paints his earliest dated work, the *Landscape Drawing of the Arno Valley,* discussed in Chapter 12.

Ser Piero's second wife dies.

The astronomer Nicolaus Copernicus is born.

1474 Leonardo paints the small *Portrait of Ginevra de' Benci* around this time (see Chapter 11).

1475 Ser Piero marries Margherita di Francesco.

The famed painter and sculptor Michelangelo Buonarroti is born; the painter Paolo Uccello dies.

1476 Ser Piero's first legitimate child, Antonio, is born.

An anonymous charge is made against the 17-year-old Jacopo Saltarelli, a painter's assistant, for sodomy. Leonardo is named as one of his lovers. After a repeated accusation, all charges are dismissed.

Verrocchio completes his statue of David.

1477 Verrocchio works on the Forteguerri monument in Pistoia.

1478 The bubonic plague (also known as the Black Death) breaks out, and the Arno River floods Florence.

Leonardo, probably with his father's influence, receives his first important commission: a medium-sized altar painting for the Bernhard Chapel in the Palazzo Vecchio, Florence's seat of government. Leonardo never completes the work.

Sandro Botticelli, one of Andrea del Verrocchio's pupils, paints *La Primavera* for Lorenzo de' Medici.

1479 Leonardo draws the execution of Bernardo di Bandino Baroncelli, who participated in the 1478 Pazzi conspiracy (supported by Florence's Pazzi family and Pope Sixtus IV) to end Lorenzo and Giuliano de' Medici's rule in the Florentine state. (Giuliano was stabbed to death in the Cathedral of Santa Maria del Fiore; Lorenzo escaped unscathed.)

1480 Leonardo paints *Madonna Benois, Madonna with the Carnation,* and *St. Jerome* around this time (see Chapter 13 for the first and the last of those three paintings).

Lorenzo de' Medici allies himself with Naples and makes peace with the pope.

Ludovico Sforza assumes power in Milan.

1481 In March, probably with his father's help, Leonardo receives a commission from a monastery of San Donato a Scopeto, just outside Florence. Despite the importance of this commission, Leonardo doesn't complete the painting, the *Adoration of the Magi,* on time.

The painters Sandro Botticelli, Piero di Cosimo, Pietro Perugino, Luca Signorelli, Antonio Pollaiuolo, and Domenico Ghirlandaio leave for Rome at the pope's request, to paint frescoes for the Sistine Chapel walls (Leonardo, sadly, is left behind).

Leonardo writes a letter to Ludovico Sforza, duke of Milan, offering his services as a military engineer, architect, and sculptor.

1482 Leonardo moves from Florence to Milan to work for Ludovico. He starts his *Lady with an Ermine (Cecilia Gallerani)* and *Portrait of a Musician* (see Chapter 11).

1483 Leonardo, together with Ambrogio and Evangelista de Predis, is commissioned to paint an altar painting, *Virgin of the Rocks.* They complete a version of this painting around 1486.

The artist Raphael Sanzi is born in Urbino.

Charles VIII is anointed king of France.

1484 Pope Innocent VIII is elected.

1485 The bubonic plague breaks out in Milan. Leonardo starts designing his ideal city for Milan.

Hieronymus Bosch paints the *Garden of Earthly Delights;* Sandro Botticelli paints the *Birth of Venus* for the Medicis; the Venetian painter Titian is born.

1486 Girolamo Savonarola, a Dominican reformer, delivers his first sermons.

Humanist philosopher Pico della Mirandola, decried as a heretic by the Catholic Church, publishes his 900 treatises on all subjects, including the ability of humankind to make of itself what it will.

1487 Leonardo becomes a successful consultant architect in the Milan Cathedral competition. He designs plans for a stable, a domed church, various flying machines, and war machines. He also starts to study anatomy.

The first Inquisition tribunal, based on the Spanish model, is launched in Sicily.

1488 Verrocchio dies.

1490 Commissioned by Ludovico Sforza, Leonardo (the court artist) starts the equestrian statue of Francesco Sforza in Milan. He designs court festivities, begins *Madonna Litta* and *Portrait of an Unknown Woman (La Belle Ferronière)* (see Chapters 13 and 11, respectively), works on the stage design for the pageant *Il Paradiso* by Bernardo Bellincioni, and starts a treatise on hydraulic works.

1492 Leonardo visits Rome.

Lorenzo de' Medici dies; political and economic power is consolidated in Florence.

Pope Alexander VI is elected, leading to a general moral decline of the papacy.

Christopher Columbus, sailing for the Spanish Crown, "discovers" America.

Spain expels its Jews.

1493 Leonardo's clay model for the equestrian statue of Sforza is displayed in Milan.

Spain and Portugal start to divide up the New World.

1494 The Italian Wars begin. Ludovico Sforza allows Charles VIII of France to invade Italy (and go through Milan) in an attempt to weaken his enemy, the King of Naples. Savonarola replaces Piero de' Medici in Florence and installs a puritanical regime. Pisa becomes independent. These events spell the end of the Italian city-states' independence.

Luca Pacioli publishes *Summa de arithmetica . . . (Everything about Arithmetic, Geometry, and Proportions)*.

1495 Leonardo starts to paint *The Last Supper* in the refectory of the Dominican convent of Santa Maria delle Grazie, in Milan (see Chapter 14).

1496 Leonardo does the drawings for Luca Pacioli's *De divina proportione (Divine Proportion)* (1509).

At the request of the pope, Emperor Maximilian enters Italy.

1498 Leonardo designs the interior of the Sala delle Asse in the Sforza Castle in Milan. He also experiments with flying machines.

Louis XII succeeds Charles VIII in France.

Savonarola (the religious zealot who's running Florence) is excommunicated and burned at the stake.

1499 Leonardo begins *Burlington House Cartoon* for King Louis XII of France (see Chapter 13). He leaves Milan (now occupied by the French) in December.

Second Italian War; French troops defeat Ludovico Sforza and force him to flee.

Cesare Borgia becomes the duke of Valentinois.

The Turks threaten Venice.

1500 Leonardo stays with patron of the arts Isabella d'Este (who, at the death of her husband, ruled Mantua) and starts her portrait before moving on to Venice. He returns to Florence in April to begin his most productive period as a painter. He makes a cartoon of the *Virgin and Child with St. Anne* for the Servites at Santissima Annunziata in Florence and lives with the monks in their church.

The French take Ludovico Sforza prisoner.

1501 Leonardo delves into the study of mathematics. He works on a small painting, *Madonna with the Yarnwinder* (see Chapter 13), commissioned by Florimond Robertet, secretary to the king of France.

The French occupy Rome.

1502 The notorious Cesare Borgia employs Leonardo as military engineer and architect, and the two travel around central and northern Italy. Leonardo inspects fortresses, makes military maps for Borgia's campaigns, and befriends Niccolo Machiavelli. Here, he draws his *Town Plan of Imola* (see Chapter 12).

1503 Leonardo returns to Florence around March and starts a portrait of Francesco del Giocondo's wife, Lisa, which becomes the famous *Mona Lisa* (see Chapter 11). In the fall, he begins his greatest commission to date, *The Battle of Anghiari* (see Chapter 3), in the Grand Council Chamber of the Palazzo Vecchio (the seat of government) in Florence.

Pope Julius II assumes the papal throne, rebuilds Rome (and St. Peter's Basilica), and initiates the Roman golden age.

The Florentines, at war with Pisa, try to divert the Arno River — with a little help from Leonardo and Niccolo Machiavelli.

1504 Leonardo's father, Ser Piero, dies. Leonardo's uncle makes him his heir. During this year, Leonardo focuses on fortifications of Piombino and the study of hydraulics, geometry, and bird flight.

Michelangelo draws his cartoon for the *Battle of Cascina,* for the Palazzo Vecchio in Florence. A committee of artists that includes Leonardo decides on the site for his *David.*

Spain conquers Naples.

1505 Leonardo starts *Leda and the Swan* (see Chapter 10) and continues to study flight and birds.

Raphael Sanzi draws sketches based on Leonardo's *Mona Lisa* and *Leda and the Swan.*

1506 In May, Leonardo abandons work on *The Battle of Anghiari* and receives permission by the Florentine authorities to leave town for three months to return to Milan. There, he enters into the service of Charles d'Amboise, the French governor in Milan, at the invitation of French king Louis XII.

1507 Leonardo returns to Florence to work on *The Battle of Anghiari* (he later reneges on his commitment) and work out inheritance issues with his siblings. He recovers the vineyard given to him by Ludovico Sforza. Louis XII appoints him painter and engineer. He also paints (or supervises the painting of) a new version of *Virgin of the Rocks* and possibly begins *The Virgin and Child with St. Anne* (see Chapter 13 for both paintings). Leonardo also meets Francesco Melzi, his long-time friend and student.

1508 Leonardo works between Milan and Florence. He undertakes projects for the French governor of Milan, Charles d'Amboise. He submits his designs for the Trivulzio monument and carries out studies of hydraulic engineering, town planning, optics, and anatomy. He completes the second version of *Virgin of the Rocks* (see Chapter 13).

Michelangelo starts to paint the Sistine Chapel frescoes.

Pope Julius II forms the League of Cambrai against Venice, which includes Louis XII of France, Emperor Maximilian I, and Ferdinand of Aragon.

1509 Leonardo continues his studies of anatomy and hydraulics. Luca Pacioli and Leonardo publish *De divina proportione* in Venice.

Europe launches the first African slave trade with the New World.

1510 Around this time, Leonardo draws maps and geological surveys of the Lombardy region.

Sandro Botticelli dies.

1511 Giorgio Vasari (1511–74), the biographer of Leonardo and other Renaissance artists, is born.

Charles d'Amboise dies. Swiss troops reach Milan; Pope Julius II forms the Holy League against the French, who leave Milan after the Battle of Ravenna.

1512 The French are defeated; the Medicis return to power in Florence.

Michelangelo completes the Sistine Chapel ceiling.

Copernicus writes that Earth circles the Sun.

1513 Leonardo starts on *St. John the Baptist* (see Chapter 13).

Pope Leo X (Giovanni de' Medici) succeeds Julius II and becomes a great patron of the arts.

With the death of his supporter, Charles d'Amboise, Leonardo leaves Milan to work for Giuliano de' Medici (Pope Leo X's brother) in Rome. He lives in the Belvedere with Francesco Melzi and his young assistant, Giacomo Salai, experiments with mirrors, and finishes *Salvator Mundi*.

1514 In the papal court, Leonardo starts various scientific experiments, including reclamation of the Pontini marshes south of Rome.

1515 Louis XII dies. The French, under François I, recapture Milan.

Leonardo invents a mechanical lion for peace talks in Bologna between the French king and Pope Leo X.

Niccolo Machiavelli publishes the politically influential book, _The Prince_.

1516 When Giuliano de' Medici dies in March, Leonardo again loses his patron. In the winter of 1516, he takes up an invitation from French king François I to be a court painter in France. There, Leonardo works on scientific, architectural, and irrigation designs and projects, despite a stroke that paralyzes his right hand.

1517 Leonardo, Giacomo Salai, and Francesco Melzi move into the château of Cloux, near the royal Castle of Amboise. Leonardo works on his plans for a palace at Romorantin and draws his _Deluge_ series.

The Protestant Reformation begins with Martin Luther's _Ninety-five Theses_ in Germany, dividing the Roman Catholic Church.

1518 Leonardo organizes court festivities at Amboise.

1519 Leonardo draws up his last will and testament on April 23, 1519.

Leonardo dies on May 2 at Cloux.

1520–30 Melzi inherits Leonardo's manuscripts and starts to organize them. The most important of these documents is Leonardo's _Treatise on Painting_ (see Chapter 10). Salai inherits most of Leonardo's paintings. When Salai dies in 1525, his estate contains _The Virgin and Child with St. Anne, St. John the Baptist, Leda and the Swan,_ the _Mona Lisa,_ and _St. Jerome._ When Melzi dies in 1570, Leonardo's papers, drawings, and paintings scatter far and wide to collectors all over Europe; many have no idea of the manuscripts' importance, and many are subsequently lost.

1522 Magellan's ship returns to Spain, after circumnavigating the globe.

1527 Rome is sacked by the troops of the Holy Roman Empire, symbolizing the beginning of the downfall of Renaissance Italy.

Appendix B

Outside Reading (And More) for the Overachievers

● ●

*L*eonardo has been a hot topic for quite some time — believe it or not, even before Dan Brown's novel, *The Da Vinci Code,* and subsequent movie! Thousands of scholarly books, museum exhibits, Web sites, novels, and even children's books examine (and speculate about) the life of this true Renaissance gentleman. The following list, divided into different subject categories, by no means offers a comprehensive list of Leonardo resources. But it definitely gives you a place to start. Pick an area of interest and have at it!

Reading about Renaissance Italy

If you want to know more about the Renaissance and Renaissance art *before* you delve into Leonardo, check out one of these classics:

- ✔ *The Civilization of the Renaissance in Italy* by Jacob Burckhardt (Penguin Books, 2002): One of the most significant books ever written on the Renaissance. Burckhardt discusses all aspects of Renaissance life: art, culture, innovation, discovery, humanism, church and state, and the birth of the individual. Dated (it was originally published in 1860), but still a classic.

- ✔ *The Italian Painters of the Renaissance* by Bernard Berenson (Cornell University Press, 1980): This classic set of essays, originally published by the legendary art critic between 1894 and 1907, traces the development of Italian Renaissance painting from Giotto to Leonardo.

- ✔ *The Civilization of Europe in the Renaissance* by John R. Hale (Scribner, 1994): Hale, an acclaimed Renaissance scholar, offers a fresher examination of daily life in the period marking the end of Christendom and the birth of a modern European sensibility, between 1450 and 1620.

- ✔ *The Italian Renaissance: Culture and Society in Italy* by Peter Burke (Princeton University Press, 1999): A brilliant social and cultural history of the Italian Renaissance, seen through a sociological lens.

In His Own Words: Leo's Notebooks

Facsimile editions of Leonardo's writings crop up from time to time in various forms. Some editions excerpt his musings; others quote him word for word. Beware of bad translations!

- The popular edition is *The Notebooks of Leonardo da Vinci,* edited by Jean Paul Richter (2 volumes, Dover Publications, 1970). Other important volumes include those edited by Carlo Pedretti, the world's most prolific Leonardo scholar (published by Ashgate, 1982), and Irma A. Richter (published by Oxford University Press, 1998). Throughout this book, I rely on *The Notebooks of Leonardo da Vinci* edited by Edward MacCurdy (published by Reynal & Hitchcock, 1938), which organizes Leonardo's notebooks by subject matter for easy reference.

- *Treatise on Painting* by Leonardo da Vinci: Published in various editions, Leonardo's famed thoughts on painting — everything from perspective and anatomy to expression and color — remain one of the most valued contributions to modern art history. This book is still a great primer for art students! A few reputable editions include the ones translated by John Francis Rigaud (published by Kessinger, 2004, and Prometheus Books, 2002).

Biographies and Overviews of Leo's Life

Biographies of Leonardo are a dime a dozen. Is it possible to wade through this morass? In the following list, you'll find some classics — as well as a few newer, equally authoritative biographies, all worth reading. (Of course, you get all the need-to-know info in this handy book, to which I'm a bit partial. But if you hunger for more, check out some of these other books.)

- *The Lives of the Artists* by Giorgio Vasari (Oxford University Press, 1998): Originally titled *Lives of the Painters, Sculptors, and Architects* and published in 1550, this book is a major primary source on Leonardo and other Renaissance artists, from Giotto to Michelangelo and Raphael. It's a good, entertaining (if gossipy) synthesis of artistic talent during this period.

- *Leonardo da Vinci and a Memory of His Childhood* by Sigmund Freud (W. W. Norton and Company, 1989): In 1910, Freud's book was published, applying his psychoanalysis to Leonardo's childhood and suggesting that childhood dreams and infantile sexuality led to (speculated) homosexual tendencies.

- *Leonardo da Vinci* by Kenneth Clark, revised by Martin Kemp (Penguin Books, 1993): A classic survey on Leonardo's life, work, and intellectual development, originally published by one of the most famous British art historians in 1939. Now updated and revised by Kemp, an acclaimed

Oxford scholar. Still considered the best introduction to Leonardo (until this book hit the shelves, of course)!

✔ *Leonardo da Vinci, the Marvelous Works of Nature and Man* by Martin Kemp (J. M. Dent & Sons, Ltd., 1981): A serious look at Leonardo's genius in scientific, medical, and artistic discovery.

✔ *Leonardo: The Artist and the Man* by Serge Bramly, translated by Siân Reynolds (Penguin Books, 1995): A fascinating and sympathetic reconstruction of Leonardo's life. Bramly portrays major events and examines Leonardo's inner conflicts relating to sexuality and God.

✔ *Leonardo da Vinci,* edited by Claire Farago (5 volumes, Garland Publishing, 1991): A collection of archival and contemporary articles on Leonardo's art, scientific studies, and overall career, edited by a prolific Renaissance scholar.

Popular Nonfiction about Leo . . . and You

If you're not up for the good old academic treatise (though most of the specialized books mentioned in the following section *are* quite readable), you always have the popular study that relates Leonardo to life today:

✔ *Inventing Leonardo* by A. Richard Turner (University of California Press, 1992): Turner explores Leonardo's legacy in the last four centuries of Western thought. He examines how others (from Vasari to philosophers in the 1990s) portrayed the master, and how people can (should?) understand him today.

✔ *How to Think Like Leonardo da Vinci: Seven Steps to Genius* by Michael J. Gelb (Dell, 1998): Gelb, using Leonardo's artistic and scientific work as a springboard, formulates seven principles for channeling *your* creativity and brilliance — just like Leonardo. (Check out the companion notebook and CD, too.)

✔ *Becoming Mona Lisa: The Making of a Global Icon* by Donald Sassoon (Harcourt, 2001): In his examination of how the *Mona Lisa* became a global icon, Sassoon discusses marketing, vandalism, museum exhibitions, and the host of images that the fine lady has spawned. Want some trivia? You'll find it all here.

✔ *Discoveries: Leonardo da Vinci* by Alessandro Vezzosi (Harry N. Abrams, 1997): A small, beautifully illustrated, informative book about Leonardo's life.

✔ *Prophesies* by Leonardo da Vinci and Eraldo Affinati (Hesperus Press, 2003): A collection of Leonardo's word plays, parables, and riddles — many with modern-day lessons.

Specialized Studies of Leonardo's Work

If you're interested in delving into a particular aspect of Leonardo's life or work, say, his embryo or flight studies, never fear — plenty of these books are out there, too.

Art and architecture

Leonardo is perhaps best known for his paintings; the following books delve into his paintings, drawings, and lesser-known architectural studies:

- *Leonardo da Vinci: Master Draftsman,* edited by Carmen C. Bambach, with contributions by Alessandro Cecchi, Claire Farago, Varena Forcione, Martin Kemp, Anne-Marie Logan, Pietro C. Maran, Carlo Pedretti, Carlo Vecce, Françoise Viatte, and Linda Wolk-Simon (Yale University Press, 2003): A volume about Leonardo's work as a draftsman (never mind his engineering or architectural work!) produced in conjunction with "Leonardo da Vinci, Master Draftsman" at the Metropolitan Museum of Art in New York, 2003.

- *Leonardo da Vinci: The Complete Paintings,* edited by Pietro C. Marani (Harry N. Abrams, 2000): This book contains all of Leonardo's paintings, reproduced, examined, and analyzed by one of the world's leading Leonardo historians.

- *Leonardo da Vinci: The Complete Paintings and Drawings* by Frank Zollner and Johannes Nathan (Taschen, 2003): This 600-plus-page veritable doorstop contains reproductions of all Leonardo's paintings and many of his drawings, with detailed commentary about each one. No new scholarship, but a beautiful volume.

- *Leonardo da Vinci: Origins of a Genius* by David Alan Brown (Yale University Press, 1998): This book is the first comprehensive study of Leonardo's artistic origins, his work with Andrea del Verrocchio, and the meanings and techniques of his early paintings.

- *Leonardo da Vinci's Sforza Monument Horse: The Art and Engineering* by Diane Cole Ahl (Lehigh University Press, 1995): The first and only book-length study on Leonardo's never-built equestrian statue for Milan.

- *Leonardo: The Last Supper* by Pinin Brambilla Barcilon and Pietro C. Marani (University of Chicago Press, 2001): Written by the woman who undertook the most recent, 20-year, comprehensive restoration of Leonardo's *The Last Supper,* this book looks at the painting's history, deterioration, and restorations.

✔ *Leonardo Da Vinci: The Royal Palace at Romorantin* by Carlo Pedretti (Belknap Press, 1972): A detailed study of Leonardo's architectural ventures, done at the end of his lifetime for the king of France, François I.

✔ *Leonardo, Architect* by Carlo Pedretti, translated by Sue Brill (Rizzoli, 1985): A closer look at Leonardo's architectural theories, ideas, and plans.

Human anatomy

Leonardo's anatomical studies were unsurpassed in their time — after all, he based them on cadavers! These books provide overviews and detailed analyses of his work in anatomy:

✔ *Leonardo da Vinci* by Sherwin B. Nuland (Viking Penguin, Inc., 2000): Nuland, a surgeon and writer about medicine and the human spirit, interprets Leonardo's modern, empirical mind through examination of his anatomical studies.

✔ *Leonardo da Vinci: The Anatomy of Man* by Martin Clayton and Ron Philo (Bulfinch Press, 1992): The authors examine 41 of Leonardo's anatomical drawings from the collection at the Royal Library at Windsor, showing how he evolved as a scientist.

✔ *Leonardo da Vinci on the Human Body* by Charles Donald O'Malley (Gramercy, 2003): A collection of more than 1,200 of Leonardo's anatomical illustrations, organized by body parts and systems (for example, the heart or brain).

Nature, science, and technology

Throughout his life, Leonardo tried to find an underlying pattern in all of nature. His scientific studies and inventions, discussed in the books of the following list, show how he viewed the relationship between the micro- and macrocosmos in different fields, from botany to geology.

✔ *Leonardo da Vinci's Elements of the Science of Man* by Kenneth D. Keele (Academic Press, 1983): A more technical and academic, but brilliant, overview of Leonardo's scientific studies, from optics and mechanics to anatomy, written from the perspective of a medical historian. Have your high-school math and science books ready!

✔ *Leonardo da Vinci: Nature Studies from the Royal Library* by Carlo Pedretti and Kenneth Clark (Seven Hills Books, 1991): A sample of Leonardo's vast nature studies, with interpretive discussion by two greats.

- *Leonardo: The First Scientist* by Michael White (St. Martin's Griffin, 2001): White, a biographer of scientists including Isaac Newton, examines Leonardo's life from a scientific perspective, from anatomy and geology to hydrology and optics.

- *Leonardo da Vinci on Plants and Gardens* by William A. Emboden (Timber Press, 1987): A rare examination of Leonardo's botanical studies and theories, with interpretive text about his paintings' botanical images and symbols.

- *Machiavelli, Leonardo, and the Science of Power* by Roger D. Masters (Continuum International Publishing Group, 1996): Masters rethinks the origins of modern science and technology, using Leonardo as a prime example of this revolutionary shift in thinking.

- *Fortune Is a River: Leonardo da Vinci and Niccolo Machiavelli's Magnificent Dream to Change the Course of Florentine History* by Roger D. Masters (Plume Books, 1999): A readable account of Leonardo and Machiavelli's ill-fated plan to change the course of the Arno River.

- *Leonardo's Science and Technology: Essential Readings for the Non-Scientist* by Claire Farago (Garland Publishing, 1999): A layperson's introduction to Leonardo's multifaceted scientific thinking.

- *Leonardo da Vinci's Machines* by Marco Cianchi, et. al. (Becocci Editore, 1988): Introduced by Carlo Pedretti, this book is a collection of annotated illustrations from Leonardo's notebooks, together with interpretive essays.

Fictionalizing Leonardo: Literary Spin-Offs

People today know *some* things about Leonardo, but admittedly, not everything. There's a lot to be said for poetic license when it comes to fictionalizing the events of his life. Secret societies, anyone?

- *The Da Vinci Code* by Dan Brown (Doubleday, 2003): I devote an entire chapter to this thriller, which features Harvard symbologist Robert Langdon, Leonardo's paintings, secret sects, a murder, a beautiful woman, and some other mysteries. Go to Chapter 15 to find out more.

- *Da Vinci Rising* by Jack Dann (Fictionwise.com, 1995): In this Nebula Award–winning novella, originally published in *Isaac Asimov's Science Fiction Magazine,* Leonardo and Niccolo Machiavelli develop a deadly flying machine, possibly for battle.

- *The Man Who Stole the Mona Lisa* by Robert Noah (St. Martin's Press, 1998): This fictional thriller, based on the real 1911 theft of Lisa from the Louvre, features the Marquis de Valfierno, a Buenos Aires thief, and a master painter who copies others' works.

- *Chiaroscuro: The Private Lives of Leonardo da Vinci* (1995–96): A 10-volume comic book/graphic novel by DC Comics that explores Leonardo's fears, fantasies, rivalries, and secrets — all in cartoon form.

- *Mystery of the Mona Lisa* by Rina De' Firenze (Hastings House Book Publishers, 2002): A fictional, romantic look at Leonardo's relationship with his mother, Caterina, who was the source of inspiration for some of his studies and paintings, including the *Mona Lisa.*

- *The Medici Dagger* by Cameron West (Pocket Star, 2004): Reb Barnett, a Hollywood stuntman, risks his life to find out the secrets in Leonardo's *Circles of Truth,* a 15th-century map that could lead him to the Medici Dagger — the most dangerous weapon of all.

- *Leonardo's Horse* by R. M. Berry (Tia Chucha Press, 1997): As Leonardo lays dying in 1519, he wonders why he never built Milan's equestrian statue. Five hundred years later, amid social and environmental chaos, a historian writing a novel about Leonardo is asking the very same question.

Leonardo for Younger Readers

What, you thought Leonardo was only for adults? Shame on you. Younger readers will enjoy the following titles, designed to introduce them to different aspects of Leonardo's life:

- *Leonardo da Vinci* by Diane Stanley (HarperTrophy, 1996): Considered the best children's book on Leonardo and an award-winning, well-researched, and gorgeously illustrated introduction to the Renaissance and Leonardo's life as an artist, inventor, and engineer. Ages 9–12.

- *The Second Mrs. Giaconda* by E. L. Konigsburg (Rebound by Sagebrush, 1999): In this work of historical fiction, Leonardo's servant, Salai, tries to solve the mysteries of the *Mona Lisa.* Ages 9–12.

- *Leonardo, Beautiful Dreamer* by Robert Byrd (Dutton Books, 2003): An energetic mix of facts, dreams, and fantasies reimagines Leonardo's life and works. Lavishly illustrated. Ages 7–10.

- *Leonardo's Horse* by Jean Fritz, illustrated by Hudson Talbott (Putnam Publishing Group, 2001): A fictional biography of Leonardo, focusing on his dreams to build the great equestrian statue for Milan — and the 20th-century man, Charles Dent, who finally did! Ages 8–12.

- *Katie and the Mona Lisa* by James Mayhew (Orchard Books, 1999): What happens when Katie visits the Louvre with her grandma, sees a sad *Mona Lisa,* and decides to jump inside the painting? A good introduction to museums and paintings. Ages 3–7.

- *Leonardo and the Flying Boy* by Laurence Anholt (Barron's Educational Series, 2000): This fictional rendering features two of Leonardo's apprentices, Zoro and Salai, who decide to take Leonardo's flying machine out for a spin. Ages 4–8.

- *Leonardo da Vinci for Kids: His Life and Ideas* by Janis Herbert and Carol Sabbeth (Chicago Review Press, 1998): This beautifully illustrated biography of Leonardo includes 21 activities for children that offer insight into him as a scientist, artist, and inventor. Want to grow a Renaissance herb garden, anyone? Ages 8–12.

- *The Disappearing Bike Shop* by Elvira Woodruff (Bantam Doubleday Dell Publishing Group, 1994): Two fifth-graders find the courage to enter the strange Quigley's Bike Shop — and meet the shopkeeper who might just be Leonardo himself! Ages 9–12.

- *Limits of Vision* by Robert Irwin (Viking Press, 1997): An entertaining novel by a former professor of medieval history about a housewife who holds conversations with some past luminaries, including Leonardo. Ages 9 and up.

Informative Web Sites about Leonardo

Thousands of Web sites preach about Leonardo, mind you, and cyberspace seems to spawn more every day. Here are some of the better ones:

- www.alllearn.org: This site is the mother ship of many other Leonardo sites, with links to encyclopedia entries, images of drawings and paintings, and museum collections and exhibits on Leonardo. To access these links, type **Leonardo** in the search box on the left.

- www.museoscienza.org: This site, supported by the National Museum of Science and Technology in Milan, contains information about Leonardo's life, descriptions of his machines and manuscripts, and links to other Leonardo sites. To get to the Leonardo part of the site in English, click on the British flag at the top-right corner of the page and then on <u>Leonardo</u>.

- www.lairweb.org.nz/leonardo/: Comprehensive in its coverage, this Web site offers detailed analyses of everything from Leonardo's individual paintings, military machines, and anatomical and scientific drawings to his personal relationship with Andrea del Verrocchio, among other topics.

✔ www.metmuseum.org: In March 2003, the Met exhibited some of Leonardo's drawings in "Leonardo da Vinci: Master Draftsman." The Web site that resulted contains a detailed chronology of Leonardo's life and works, a scholarly bibliography, and an overall introduction to his genius. To get there, search under the past special exhibitions, March 2003.

✔ www.wga.hu: This searchable collection of art images allows you to look up specific Leonardo drawings or paintings by using keywords from different subheadings (such as "Maps" or "Drawings of engineering themes"). Brief, informative commentary often accompanies the better-known images.

✔ http://witcombe.sbc.edu/ARTHLinks.html: If you want to find out more about different periods or themes in art history, from ancient Greece to 16th-century Renaissance art, this site is a good place to start. Each topic generates dozens of more subtopics, and those generate even more subtopics.

✔ www.bl.uk: Curious about what a page from one of Leonardo's notebooks really looked like, mirror writing and all? This British Library site allows you to scroll through different pages of his *Codex Arundel;* an audio component offers some explanation. From the main site, just go to <u>Collections</u>, then <u>Treasures</u>, and finally <u>Turning the Pages</u>.

✔ http://easyweb.easynet.co.uk/giorgio.vasari/: Sure, Vasari's *Lives of the Artists* is excerpted and condensed, but what better way to find out about Leonardo and his colleagues than to read testimony straight from the horse's mouth?

The (Scholarly) Fan Clubs

Just in case you want up-to-the-minute information on new (new?) discoveries about Leonardo, here's where you'll find the scoop:

✔ *Accademia Leonardo da Vinci: Journal of Leonardo Studies and Bibliography of Vinciana:* For the brave! Contains some of the most important recent scholarship on Leonardo. Ten volumes, published between 1988 and 1997.

✔ The Leonardo da Vinci Society: www.bbk.ac.uk/hafvm/leonardo/.

✔ Armand Hammer Center for Leonardo Studies and Research, University of California, Los Angeles. For more information, check with The Center for Medieval and Renaissance Studies (310-825-1880, e-mail cmrs@humnet.ucla.edu).

Leonardo in 3-D: Video, CDs, and Film

Yes, Leonardo has finally come to the big (and small) screen. Sit back and enjoy . . . or tool around with an interactive CD.

- *Life of Leonardo da Vinci* (Questar Inc., directed by Renato Castellani, 1972): Originally a five-part PBS telecast titled "I, Leonardo," this film earned a Golden Globe award for Best TV Drama. It offers information on all facets of Leonardo's life and the history that shaped him.

- *Biography: Leonardo da Vinci* (A&E Entertainment, directed by David Janssen, 1997): This program charts Leonardo's life from boyhood to death, relying on his notebooks and interviews with biographers and art historians.

- *Leonardo da Vinci* (1997, CD-ROM developed by Corbis Publishing, after Bill Gates' *Codex Leicester*)

- *The Da Vinci Code: The Movie* (to be released): Sometime in 2005, fans of Dan Brown's book can see director Ron Howard's film based on the best-selling thriller. Rumor has it that Tom Hanks will star.

Index